Collections *for*
Excellence

Assuring a Vibrant Library

John and Idamae Schack
Endowment Fund
Arts

Modernists
& Mavericks

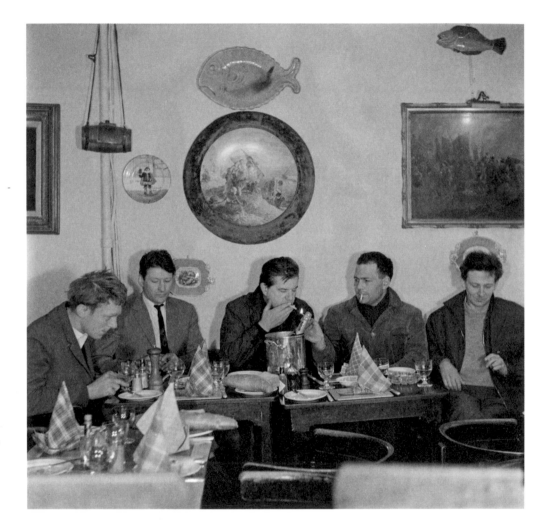

Timothy Behrens, Lucian Freud, Francis Bacon, Frank Auerbach and
Michael Andrews at Wheeler's restaurant in Soho, London, 1963. Photo by John Deakin

MARTIN GAYFORD

Modernists
& Mavericks

BACON, FREUD,
HOCKNEY & THE
LONDON PAINTERS

Thames & Hudson

Modernists & Mavericks: Bacon, Freud, Hockney & the London Painters
© 2018 Thames & Hudson Ltd, London
Text © 2018 Martin Gayford

First published in 2018 in hardback in the United States of America by
Thames & Hudson Inc., 500 Fifth Avenue, New York, New York 10110

www.thamesandhudsonusa.com

Library of Congress Control Number 2017959306

ISBN 978-0-500-23977-3

Printed and bound in Slovenia by DZS-Grafik d.o.o.

CONTENTS

Introduction 6

1 Young Lucian: Art in Wartime London 11

2 Pope Francis 22

3 Euston Road in Camberwell 40

4 Spirit in the Mass: the Borough Polytechnic 59

5 Girl with Roses 69

6 Leaping into the Void 88

7 Life into Art: Bacon and Freud in the 1950s 107

8 Two Climbers Roped Together 125

9 What Makes the Modern Home so Different? 137

10 An Arena in which to Act 158

11 The Situation in London, 1960 175

12 The Artist Thinks: Hockney and his Contemporaries 194

13 The Grin without the Cat: Bacon and Freud in the 1960s 206

14 American Connections 225

15 Mysterious Conventionality 246

16 Portrait Surrounded by Artistic Devices 267

17 Shimmering and Dissolving 290

18 The Non-Existence of Acton 313

Epilogue 334

Notes 340

Bibliography 344

Picture Credits 346

Acknowledgments 347

Index 348

INTRODUCTION

On the evening of 12 November 2013 Francis Bacon's *Three Studies of Lucian Freud* (1969) went under the hammer at Christie's New York. After a lengthy bidding war, the work sold for $142.4 million (£89.6 million). A picture painted in London well within living memory became, for a while, the most expensive work of art ever sold at auction.

This state of affairs would have been utterly unimaginable in 1969, when the picture was painted, let alone in the mid-1940s when Bacon and Freud first met. It would have stretched credulity even in 1992, the year in which Bacon died.

Of course, a price is just a number, and this one was perhaps a little freakish: an outlier. After all, few would claim that this triptych is even the greatest of Bacon's works. Nonetheless, that such a record could be set at all makes a point: painting done in London in the decades after the Second World War has come to seem hugely more significant – internationally – than it did, for the most part, when it was being created.

Those twenty-five years or so, from about 1945 to around 1970, are the subject of this book. It is not written in the belief that the pictures produced within reach of the Thames were greater or more important than those made in New York, Rio de Janeiro, Delhi or Cologne. But, rather, that this was a fascinating time and place for painting and painters; and one that, despite being so close and – in some ways – familiar, is still little known.

For me, to speak personally, it has all the attractions and mysteries of the day before yesterday. At one time or another I have met and talked to many, indeed most, of the more prominent artists discussed in the following pages. Some have become good friends. With a few, I have spent uncountable hours in conversation. I was alive for some of the years covered in the chapters to come, though my interest in the contemporary art scene only came later. So, in a way, this is my investigation into what these fascinating people did before I encountered them.

Yet, even for participants, the past is a place that needs constantly to be recreated and re-examined. Talking about the late 1940s some sixty years later, Frank Auerbach – one of the principal witnesses who have contributed to this text – remarked: 'I'm speaking here for a young man who no longer exists and of whom I'm a rather distant representative.' Something of the sort is true of all of us when we reach far back in time. Conversely, part of the art-historical attraction of this subject is that, unlike Cubist Paris, say, or Renaissance Venice, there is a plethora of first-hand testimony. Some of this is from people who have scarcely spoken about it before.

Modernists & Mavericks is, then, a collective interview, or multiple biography, that includes at least two generations and numerous individuals. In aggregate, this amounts to an archive of many thousand words, recorded over three decades. The book is drawn from interviews, often unpublished, with important witnesses and participants, including Frank Auerbach, Gillian Ayres, Georg Baselitz, Peter Blake, Frank Bowling, Patrick Caulfield, John Craxton, Dennis Creffield, Jim Dine, Anthony Eyton, Lucian Freud, Terry Frost, David Hockney, Howard Hodgkin, John Hoyland, Allen Jones, John Kasmin, James Kirkman, R. B. Kitaj, Leon Kossoff, John Lessore, Richard Morphet, Victor Pasmore, Bridget Riley, Ed Ruscha, Angus Stewart, Daphne Todd, Euan Uglow, John Virtue and John Wonnacott.

This book was undertaken in the view that pictures are affected not only by social and intellectual changes, but also by individual sensibility and character. There was no historical inevitability, for example, about the advent of Francis Bacon. Indeed, his psychological and aesthetic constitution was so unusual, so strange in some respects, that it still remains difficult to comprehend. Yet without Bacon – or the equally idiosyncratic

contributions of Freud, Riley or Hockney – the story that follows would surely have been quite different.

All histories have boundaries that are, to some extent, arbitrary. Time is a continuum; almost nothing starts or finishes neatly at a particular date. Books, however, often have to do so, if only to prevent them sprawling *ad infinitum*. The chronological parameters of this one – from the end of the Second World War to the early 1970s – correspond to notable turning points in British history, both political and cultural.

The first marked not only the end of hostilities, but also the advent of the Attlee government and the beginning of a long period of steadily, if slowly, increasing optimism and prosperity. The second turning point was less sharp but, nevertheless, the end of the 1960s signalled the conclusion of that era of hope and the start of a decade of crisis and decline.

In the arts, too, these were moments at which change occurred. After 1945 there was a great opening-up. A London art world that had previously been small and provincial turned its attention to what was happening elsewhere; at the same time, a much larger and wider group – in terms of both gender and origins – began to pour into the capital's art schools. The mid-1970s, in contrast, were an era in which painting of all kinds was out of fashion, neglected in favour of a variety of new media that included performance, installation and a radically redefined type of sculpture.

On the other hand, no single moment in art history represents a clean break. Several of the most prominent figures in these pages began their careers in the 1930s, including William Coldstream, Victor Pasmore and Bacon himself. Arguably several more, such as Freud and Gillian Ayres, produced their finest work well after the end point of the book. Some, Hockney and Auerbach among them, are energetically at work at the time of writing, still trying to outdo what they have done before.

In addition, the scope of *Modernists & Mavericks* is defined in two other ways: by place and by medium. Of course, the focus on London is not intended to imply that nothing important happened elsewhere in the United Kingdom, in Edinburgh, Glasgow or St Ives, for example; on the contrary, it clearly did. These are excluded because they were different centres, with their own stories. Consequently, when certain painters move – as Patrick

Heron and Roger Hilton did – out of town, they also exit the narrative. Other talented individuals, such as Joan Eardley and Peter Lanyon, don't feature at all because their mature careers were spent far from London. Admittedly, I have followed certain individuals on journeys – Bacon to St Ives, Hockney to Los Angeles – my justification being that, in doing so, they remained London painters but, to use Hockney's phrase, 'on location'.

My other self-imposed choice of focus means that this book is almost all about paint. The rationale is not that sculpture made in London in these years is not worthy of attention, but that it belongs to another story. And again, where the border zone becomes blurred, I have allowed myself some wriggle room – for instance, when painters such as Allen Jones and Richard Smith moved into three dimensions, or sculptors, including Anthony Caro, used the very painterly ingredients of bright colours and flat shapes.

One reason for concentrating on the quarter-century after the end of the war is that this was an era in which the community of painters in London was still a village. Not that everybody knew everybody else well – they don't in most real villages – but that it was a relatively small world crisscrossed by friendships and acquaintances, some quite unexpected. Nor were the divisions between generations as sharp as they might, in retrospect, appear. It is intriguing to note that in the early 1960s Bacon was meeting and talking to students and graduates of the Royal College of Art who were more than twenty-five years his junior.

I believe the proposal made by R. B. Kitaj in 1976 that there was a 'substantial School of London' was essentially correct. There was indeed a critical mass of major artists then at work in the city. Kitaj's phrase caused confusion, however, because it seemed to imply that there was a coherent movement or stylistic group when there was no such entity, and this was not, in fact, Kitaj's thesis. He meant the term, he told me, 'in the way one had always used "School of Paris" or "School of New York" in quite a wide-ranging, loose way'.

'School of London' has often been taken to refer only to figurative artists, but, even among those, there was great diversity: a range that encompassed both Leon Kossoff and Patrick Caulfield. However, there were also important abstract painters working in London. No stylistic label could be stretched

to cover Francis Bacon and also Bridget Riley. Moreover, as Kitaj pointed out, in this period London became, like New York and Paris, a cosmopolitan centre in which 'a lot of interesting artists work upon each other'. And many came from distant places: Kitaj himself hailed from Ohio, Frank Bowling from British Guiana and Paula Rego from Portugal.

One of the underlying themes of *Modernists & Mavericks* is that the barrier between 'abstract' and 'figurative' – which seemed, at the time, a positive Iron Curtain – was in reality much more porous. There were individuals who crossed this line in both directions, more than once; others, such as Howard Hodgkin, whose work makes nonsense of the distinction. The truth – which lies at the core of the book – is that they were all obsessed with what Gillian Ayres has defined as 'what can be *done* with painting'. They all shared a belief that with paint they could accomplish works that in other media – photography, for example – they could not. This was the common factor binding them all together: the confidence that this ancient medium could do fresh and marvellous things.

CHAPTER ONE

YOUNG LUCIAN: ART IN WARTIME LONDON

He was totally alive, like something not entirely human, a leprechaun,
a changeling child, or, if there is a male opposite, a witch.

STEPHEN SPENDER ON THE YOUNG LUCIAN FREUD

In 1942, London was partially in ruins. Robert Colquhoun, a young painter who had arrived from Scotland the year before, was astonished by what he saw. 'The destruction in the West End is incredible,' Colquhoun wrote, 'whole streets flattened out into a mass of rubble and bent iron.' He noted 'a miniature pyramid in Hyde Park' constructed from the wreckage of destroyed buildings. One suspects that, like other artists, he found the spectacle beautiful as well as terrible.

Graham Sutherland, then one of the most celebrated British artists of the generation under forty, travelled into London by train from his house in Kent to depict the desolation. He would never forget his first encounter with the bombed City of London during the Blitz in the autumn of 1940: 'The silence, the absolute dead silence, except every now and again a thin tinkle of falling glass – a noise which reminded me of the music of Debussy.' To Sutherland's eyes, the shattered buildings seemed like living, suffering creatures. A lift shaft, twisted yet still standing in the remains of a building, struck him as resembling 'a wounded tiger in a painting by Delacroix'. This was a city under siege that had just escaped armed invasion. The arts, like every aspect of life, were rationed and much reduced. At the National Gallery, just one picture a month was on display.

Yet, amid the destruction, new energies were stirring. The war isolated London from the rest of Europe and exacerbated the endemic insularity of Britain as a nation. But new ideas were germinating in the minds of artists-to-be who were currently in the services, prisoner-of-war camps, schools or digging potatoes in the fields as conscientious objectors. A few, like Colquhoun, were already at work among the bomb sites of London.

In the same year in which Colquhoun penned his description of the ruined city, two young painters, just past their nineteenth birthdays, moved into a house on Abercorn Place in St John's Wood in North London. It was a fine terraced building in the early nineteenth-century classical style. There were three floors, providing room for a separate studio each (the ground floor being occupied by a classical music critic who became increasingly irritated by his new neighbours). The tenants' names were John Craxton and Lucian Freud. Neither was in the armed services: Craxton had failed the medical examination, while Freud had been invalided out of the Merchant Navy. And so, with financial support from a generous patron, Peter Watson, they were free to live *la vie de bohème*, Second World War-style.

Suitably enough, given the devastation that lay around, the environment that Freud and Craxton created for themselves was full of shattered forms, sharp-edged vegetation and the smell of death. The decor at 14 Abercorn Place was, as Craxton put it, 'very, very bizarre'. The two painters would buy job lots of old prints at the nearby Lisson Grove saleroom, where fifty or sixty items would go for ten shillings. Among these were some that had nice frames, which they would keep, breaking up the rest and making a fire with them. 'We'd lay the glass on the floor – a new sheet of glass for a special guest – so the entrance to our maisonette, [as] they were called, had dozens of broken sheets all over the floor which went crunch, crunch under your feet – which very much annoyed the man living underneath.' The whole effect was completed by an array of headgear hung on hooks in the hall – 'any sort of hat we could find' – including police helmets, while on the upper floor there was a selection of 'huge spiky plants that Lucian had growing up all over the place'. Freud also owned a stuffed zebra head, bought from the celebrated taxidermist Rowland Ward on Piccadilly. This was intended as an urban substitute for the horses he had loved since he

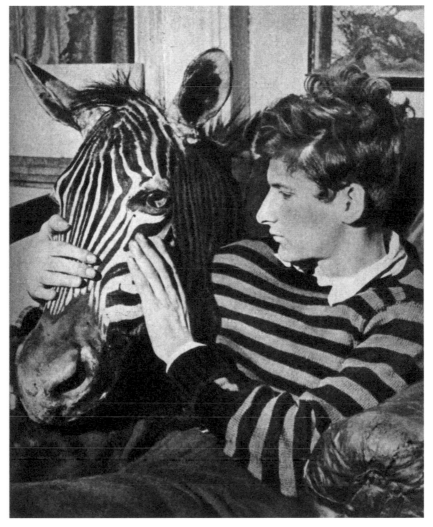

Lucian Freud, c. 1943. Photo by Ian Gibson Smith

learned to ride them as a child on his maternal grandfather's estate outside Berlin. Various kinds of dead animals, not mounted or preserved, were favourite subjects for both Freud and Craxton. From time to time, the nostrils of the music critic were offended by a stench of decay wafting down from upstairs.

Once, an important art dealer, Oliver Brown of the Leicester Galleries, made an appointment to inspect Craxton's work in his studio. Unfortunately, however, the painter had forgotten the arrangement and was still asleep at his parents' house. 'Brown arrived wearing a bowler hat and carrying a briefcase and a rolled-up umbrella, rang the bell and, to his amazement, a naked Lucian, walking on this broken glass, opened the door.' This apparition must doubtless have startled Mr Brown. From early on, Freud had struck people as a remarkable personality. Craxton remembered the sixteen-year-old Freud dropping in at his family home in the late 1930s:

> Lucian was very on his own, reacting against everything. He *horrified* my parents, because he had an enormous amount of hair – a wild, untamed appearance – he was a very odd character in those days. My mother said, 'My God, I don't want any of my children looking like *that*'.

The photo editor Bruce Bernard – brother of the journalist Jeffrey and poet Oliver – met Freud during the war and was struck by his 'exotic and somewhat demonic aura' (Bernard's mother, like Craxton's, thought this youth might be dangerous to know). Freud's earliest work, whether done from observation or from his imagination, had an intensity that marked it out as unmistakeably his. The critic John Russell, looking back on these years, compared the young Freud to the figure of Tadzio in Thomas Mann's novella *Death in Venice* (1912), a 'magnetic adolescent' who seemed 'to symbolize creativity'. In the circles around the periodical *Horizon* and its backer Peter Watson, 'everything was expected of him'. But neither his true path, nor the importance of what he was eventually to do, would have been easy to predict in 1942. Who could have guessed that, to quote Bernard again, he would eventually become 'one of the greatest portrayers of the individual human being in European art'.

Both the Freud and Craxton families lived in St John's Wood, near Abercorn Place (hence Craxton's choice to return to the family home every night to sleep). Harold Craxton, John's father, was a professor at the Royal Academy of Music; Freud's father, Ernst, was an architect and the youngest son of Sigmund Freud, founder of psychoanalysis. The Freuds had lived in Berlin, but left Germany shortly after the Nazis came to power. Consequently, Lucian had a privileged and cultured Central European upbringing until the age of ten, after which he went to a succession of progressive English boarding schools, getting expelled from all of them for wild behaviour.

Craxton and Freud were both from backgrounds that were highly unusual, in that the arts were seen as an integral part of everyday life. Elsewhere in London – and Britain – in the early 1940s, things were very different. To be an artist was a choice of career so rare as to be incomprehensible. According to Freud, 'Being a painter in those days was not considered a serious occupation. When I told people at parties what I did, they would reply "I wasn't asking about your hobbies".' At that time, he estimated, there were perhaps half a dozen painters in Britain making a living entirely from their work – Augustus John, Laura Knight, Matthew Smith and possibly one or two others. The big Edwardian portrait painters had done well for themselves, as the young Freud was aware: 'Augustus John writes in his memoirs that William Orpen used to keep a plate of money in his hall for less fortunate artists to help themselves from – although when I asked John about it he explained, "They were coppers".' The meagreness of this largesse indicates the low levels of local artistic aspiration.

The best of British artists instinctively looked to France for inspiration and fresh directions. Walter Sickert, who died in January 1942, just as Freud and Craxton were moving into Abercorn Place, was one of the most talented and serious painters at work in London in the first half of the twentieth century. Yet he always felt that the 'genius of painting hovers over Paris, and must be wooed on the banks of the Seine'. Accordingly, he spent lengthy periods on the other side of the Channel. Essentially Sickert was correct. In the 1930s and 1940s, Frank Auerbach recalls, 'people in Paris had the intellectual energy, the standards and the industry'. Artistically, London had long been a backwater, even before the war.

If simply being a painter seemed strange to the people Freud met at parties, being a Modernist would have been doubly incomprehensible. Puzzlement and incredulity were certainly the reactions of the character played by George Formby in *Much Too Shy*, a film from 1942 in which the comedian and singer played an aspiring commercial illustrator. In one scene he stumbles into a 'School of Modern Art' where various students are producing work of a Surrealist nature. 'Where's his arms and legs?' he exclaims in comic bewilderment on seeing one particular picture. 'Oh,' a painter played camply by Charles Hawtrey explains, 'we *abstract*.'

By a strange chance, *Much Too Shy* was one of a couple of films in which Freud got work as an extra, playing the part of an art student. Meanwhile, in real life, Peter Watson had sent the two young artists off to life-drawing classes at Goldsmiths' College in South London to sharpen up their skills (Craxton felt his own drawing was 'chaotic' and Lucian's, at that stage, just 'very bad'). Freud, indeed, considered he had an 'almost total lack of natural talent'. His early drawings, nonetheless, had energy and – what many artists never achieve – an individual line. He aimed to discipline this by observation and by drawing constantly. Graphic art, at this stage, seemed much more feasible than painting, which he felt he could not control at all.

The classes Freud and Craxton attended were conducted on more traditional lines than those in the 'School of Modern Art' in *Much Too Shy* and their unconventional efforts attracted some critical attention, as recalled by Craxton:

> We both decided, probably because of Picasso, that we were just
> going to put one line down. The common way of drawing was to
> stroke the side of the nude with about twenty-five lines; your eye
> picked out the one that was the right one. We thought that was a
> cop-out, so we sat down to do absolutely one-line drawings of all
> the nudes. Shading was done with dots, so of course we got lots of
> remarks like, 'How's the measles?'

*

The social world that Freud and Craxton inhabited was intimate, in that almost everyone knew everybody else. It was crisscrossed by complex amorous relationships that took little account of gender or marital status. This was a district of London's bohemia, which was – as David Hockney has noted – 'a tolerant place'. Attitudes were prevalent there, in the mid-twentieth century, which did not reach the wider population for another fifty years. In its acceptance of idiosyncrasy and excess it was a microcosm of the future. Life in wartime London, Craxton remembered, was 'like scrambling up a crevice – everything was narrowed down to practically nothing. Everyone went slightly mad with the bombs.' He and Freud would bicycle down from Abercorn Place to Soho, where much of what remained of London's literary and artistic population would gather, and every night there was a hectic, spontaneous party:

> Soho was very useful during the war if you wanted to have an existence; it had an element of danger, which was nice. It was where you ran into all your friends; there was a conspiracy to go drinking together. And they were all drinking hard – as you were yourself. All I can remember about Dylan Thomas is this swaying figure with pints of beer in his hand. But they were all swaying. Colquhoun and [Robert] MacBryde went on a sort of pub tour up into Fitzrovia. But on the whole, Lucian and Dylan and I stuck to Soho.

Known as 'the two Roberts', Colquhoun and MacBryde were Scottish alcoholic painters, who were effectively – though in those days, of course, not legally – married to each other and were accepted and revered despite behaviour that was, on occasion, wildly aggressive. MacBryde, on being introduced to the poet George Barker, held out his hand and crushed the glass that was in it into Barker's palm. The poet, in response, punched MacBryde so hard on the head that he claimed he was deaf in one ear for days afterwards (the evening nonetheless ended very amicably). Craxton 'found Colquhoun and MacBryde very good company at times, when they weren't too drunk'. Colquhoun never hit him in the face, 'though he did a lot of other people. They were always railing against the English, but I quite liked that, it was rather fun.' Freud saw a more serious side to Colquhoun's character. There

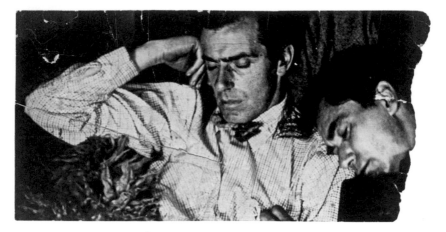

Robert Colquhoun and Robert MacBryde, c. 1953. Photo by John Deakin

was 'something absolute' about him, he thought. 'He seemed very doomed and had a certain grandeur. He saw how tragic his situation was and also that it was irreversible.'

The London art world was a small pool, and one that had shrunk even further since 1939. Some important figures had departed; the abstract painter Ben Nicholson and his wife, Barbara Hepworth, left with their young family for the safety of St Ives in Cornwall, never to return. Others, who will feature prominently in the pages to come, were in 1942 experiencing the varied fortunes of war. Roger Hilton, a significant figure in 1950s abstraction, was captured by the Germans during the Dieppe Raid in August 1942 and taken to prisoner-of-war camp Stalag VIII-B in Silesia. Victor Pasmore, then a Romantic landscape painter, had tried to register as a conscientious objector, been rejected and conscripted, then attempted to desert. He spent some time in prison before being released at a tribunal where Kenneth Clark, director of the National Gallery, gave evidence in his favour, testifying with curious precision – and some justice – that Pasmore was 'one of the six best painters in England'. Meanwhile, Pasmore's friend William Coldstream had become an army officer and was engaged in painting camouflage, among other tasks.

The remaining painters in London were those who, for one reason or another, had been rejected – or ejected – from the armed struggle. In 1942 John Minton – an aspiring artist whom we will meet often in the pages to come – was hopelessly miscast as a member of the Pioneer Corps. The following year he was commissioned, but was discharged shortly afterwards as psychologically unfit, having – according to one story – lain down on the parade ground and refused to get up. In the later years of the war, Minton was to become one of the most successful young artists in London, sharing that position with the inseparable duo of Colquhoun and MacBryde and the youthful Craxton and Freud. In retrospect, these artists look like a group – sometimes dubbed the 'Neo-Romantics'. But, at the time, there was no manifesto, nor sense of a movement at work.

There were, however, certain qualities they had in common. All of them, at this stage, were essentially makers of drawings, not paintings. Often their works were illustrations to books and magazines, so the imagery was intimately connected with literature. Their affiliations were as much to do with publishing as with visual style. The works of Minton, and his friends Keith Vaughan and Michael Ayrton, often appeared in *Penguin New Writing* and other books produced by John Lehmann. Freud, Craxton, Colquhoun and MacBryde gave their allegiance to *Horizon*, Peter Watson and his coterie. The editor was Cyril Connolly and he was assisted, early on, by the poet Stephen Spender, who was bisexual and at least a little in love with Freud, as was Watson. 'Through his singular talent and personal magnetism', Bruce Bernard noted, Freud had attracted the attention of 'the important homosexual stratum in British cultural life'. Bernard pointed out that such figures – Watson and Spender among them – were almost the only people encouraging brilliant but unorthodox young painters. As a result of their enthusiasm, one of Freud's drawings had been published in *Horizon* in 1940, when he was just seventeen.

There was also a mood shared by most of the artists listed above (apart from Freud): an uneasy combination of nostalgia and nightmare. Craxton's ink and chalk drawing *Dreamer in Landscape* (1942) was one of the earliest – and most memorable – works he ever made. The sickle moon was borrowed from the nineteenth-century Romantic Samuel Palmer, whose work was

enjoying a revival (Minton joked about how half-moons were 'in' during the war), while the menacingly spiky vegetation is closer to the world of Picasso's *Guernica* (1937) than to a rustic idyll.

Although the slumbering figure in *Dreamer in Landscape* was based on a German-Jewish refugee, Felix Braun, who was staying with the Craxton family, this is a work that essentially comes out of other art, as well as from Craxton's imagination. According to his mentor, Graham Sutherland, the goal for an artist was to make pictures of a private, inner world of imagination:

> Sutherland said you've got to invent in painting so much, he
> was adamant about that. He'd take some elements of a landscape
> and put them together and invent, using the natural forms.
> He was only topographical when he was painting a face.

This focus on the imagination was something that distinguished Craxton from Freud. These young men, sharing the same patrons and collectors and the same address, naturally struck many observers as a pair. Even in art-market terms, for some time at least, they were regarded as a unit, sharing exhibitions. But they were not a couple. Nor were they, as it slowly became clear, at all the same kind of artist. This was an advantage to their friendship, Craxton believed. 'What kept us together, I think, was the fact that we were painting our own kind of painting', he then added, a little maliciously, 'Lucian of course, *never* invented. He finds it very hard to.' In Craxton's view, this was a deficiency. But this was not entirely correct. There was a good deal of fantasy to be seen in Freud's early sketchbooks and paintings. In *The Painter's Room* (1943–44), for example, the zebra's head from Abercorn Place becomes gigantic and pokes in through the studio window. But, as the years went on, Freud became more and more wedded to actuality – what he saw in front of him – and increasingly averse to what Sutherland called invention: making subjects up.

Goethe called his autobiography *Dichtung und Wahrheit* – poetry and truth. But, of course, the two are not mutually exclusive. Freud came to find his own idiosyncratic poetry in truth. Innumerable contrasts and combinations of visual truth and poetry were explored by painters in London

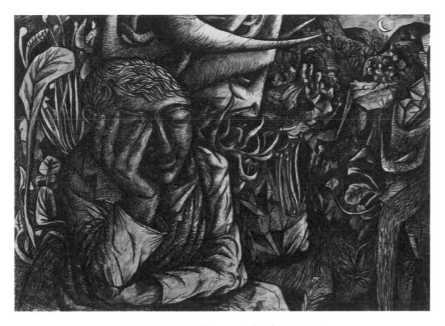

JOHN CRAXTON *Dreamer in Landscape*, 1942

over the years to come – abstraction and social realism; the discipline of geometry, richness of colour and the free-flowing expressiveness of the pigment itself; Pop art and optical truth.

Some of these developments were connected to what had gone before – to Sickert, for example – but, with the end of the war, the little world of artists in London suddenly became much wider. No sooner had the peace in Europe been declared on 8 May 1945 than Craxton and Freud set off for the Continent, although initially they did not get very far. That summer they went to the Scilly Isles, which, after wartime conditions, seemed almost abroad. Then they tried, and failed, to get across the Channel on French fishing boats to see a Picasso exhibition in Paris (the coastguards spotted them and hauled them out). In 1946, they both finally made it to France. That year, however, they met someone who was to matter more to Freud, both as a person and a painter, than Picasso or anyone working in Paris: Francis Bacon.

CHAPTER TWO

POPE FRANCIS

*The arbiters of taste pointed upstage right and said, 'Graham Sutherland's going
to be the next important artist'. Then downstage left, picking his nose, Francis
sauntered on. And the whole scene was changed.*

FRANK AUERBACH, 2017

L ucian Freud was at Graham Sutherland's house in Kent one day
when, 'being young and extremely tactless' – not, he reflected sixty
years later, that that was any excuse – it came into his head to ask
Sutherland a question: 'Who do you think is the greatest painter in England?'
Of course, with the natural egotism of a major artist, Sutherland probably
considered he was that person himself – and many would have agreed,
including Kenneth Clark and John Craxton.

However, Sutherland gave an unexpected answer: 'Oh, someone you've
never heard of. He's like a cross between Vuillard and Picasso. He's never
shown and he has the most extraordinary life. If he ever does a painting
he generally destroys it.' His name was Francis Bacon, and he sounded so
interesting that Freud quickly arranged to meet this mystery man.

*

This was in the mid-1940s. It is a little surprising that Freud had not come across
the work – or even the name – of Bacon before. In retrospect, the postwar era in
British painting seems to begin with a group exhibition in April 1945 at London's
Lefevre Gallery, in which Bacon had shown two works, one of which was a
triptych entitled *Three Studies for Figures at the Base of a Crucifixion* (c. 1944), now
in the Tate.

Visitors to the exhibition were stunned by Bacon's paintings. In the words of John Russell, they caused 'total consternation'. The central figure, anatomically like a dis-feathered ostrich, had a human mouth, heavily bandaged, set at the end of its long, thick tubular neck. Like its companions on either side, it seemed both cornered and on the attack, 'only waiting for the chance to drag the observer down to its own level'. Here were 'images so unrelievedly awful that the mind shut with a snap at the sight of them'. This was art that might put the spectator into shock, but was hard to ignore. The nightmare was not just lurking unseen in a landscape, as it did in the works of the Neo-Romantics: it was here, huge and horrible, coming at you.

Even so, at this point, Bacon had a certain amount in common with Sutherland and several other British artists of his generation. His primary influence, as he freely admitted, was Picasso, in which he was hardly alone. The same could be said of the sculptor Henry Moore, another, better-known British artist also included in the Lefevre show. Moore's point of departure was the monumental classicism of Picasso's women of the early 1920s and the strange nudes, like primitive sea creatures, that he produced a little later. Moore, however, characteristically transformed these into something calmer and duller. David Hockney summarized it by saying that 'Henry Moore comes out of about a couple of weeks of drawings by Picasso.' Sutherland also owed a debt to the great Spaniard. Indeed, virtually every artist in Britain – and Europe – who was not a descendant of Victorian salon painting borrowed freely from him.

Poor Duncan Grant, the favoured painter of the Bloomsbury Group, failed hopelessly in his efforts to follow the Picasso of the pre-1914 era, except when it came to interior decoration. Ben Nicholson did better, taking Picasso's late Cubist still-life paintings, removing all their power and energy and replacing them with charm and wit (a very British exchange). Nicholson was typical of his fellow Britons in removing the aggression, the sexual violence and the sheer ferocity that were the emotional dynamo of Picasso's art. The unusual thing about Bacon was that he did not tone these qualities down; if anything, he increased them. Picasso, he said, was 'nearer to what I feel about the psyche of our time' than any other artist.

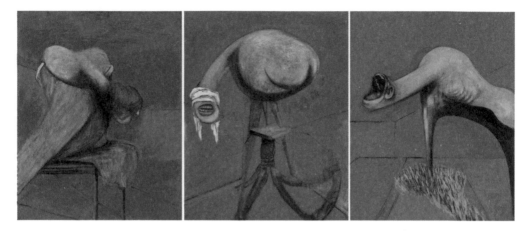

FRANCIS BACON *Three Studies for Figures at the Base of a Crucifixion, c.* 1944

An encounter with Picasso's work, he later claimed, had helped to trans-form him into an artist. At the age of sixteen, Bacon was a drifting teenager with no sense of direction, little education and no apparent talents except the ability to attract and exploit older male lovers. But then, he reflected much later, if you don't drift when you are young, you may never find your real self and true direction. Having been thrown out of his family house in Ireland after a furious row with his father, Captain Anthony Edward Mortimer Bacon – who caught him wearing his mother's underwear – he took to wandering around Europe. In France in 1927, he started looking at art. Nicolas Poussin's *Massacre of the Innocents* (*c.* 1628) in the Musée Condé at Chantilly – an image of terrible cruelty distilled into epigrammatically classical form – stayed in his mind. An exhibition of Picasso drawings he saw in Paris made, if anything, an even stronger impact. He seems to have resolved – if not then, a year or two later (much about Bacon's early life is vague) – to become an artist.

Most professional artists begin as children who love to paint and draw (this was true of Freud, for example, and David Hockney). At school Bacon had taken little interest in art or, according to his contemporaries, anything much else. The epiphany that made him a painter came from experience of painting at the highest level, and this eventually led him to take two

audacious decisions. The first was to try – with no prior training, or even much sign of aptitude – to do everything himself. Secondly, he felt that there was little point in painting unless one aimed to rival the very greatest, to aim at the standard of Poussin and Picasso. Being quite a good painter was not good enough. Paradoxically it was the seriousness with which he took the task of painting that made Bacon – who at a casual glance might have seemed a dilettante who spent much of his time drinking champagne and gambling – distinct from many other British artists of his generation.

Frank Auerbach, who arrived on the London art scene a couple of years after *Three Studies for Figures at the Base of a Crucifixion* had been exhibited, diagnosed a slightly lazy amateurism as the besetting sin of the senior generation of British artists he encountered.

> I remember artists asking one another in pubs, 'Are you working?', as much as to say it was a matter of choice; sometimes you'd be working, sometimes you weren't. It wouldn't really be gentlemanly to try too hard or make too heavy weather of the whole business. There was a lot of that.

Bacon, in contrast, felt strongly that the only point of the business was to create a masterpiece. He dreamed of painting a picture that would annihilate all the others he had done. His difficulty was that almost nothing he did seemed, to him, good enough.

<p style="text-align:center">*</p>

In a pick-up bar in Paris, as a teenager, Bacon met a man who remarked to him that the crucial thing in life was how you represent yourself. He was greatly struck by the observation and seems, indeed, to have lived by it. To an extent even greater than most artists he was self-invented. Bacon's improvised careers, moreover, were at first remarkably successful. Initially, he set himself up as a designer of modernist furniture, in the manner of Bauhaus design and the more advanced Parisian interiors. Having attracted some attention with these, he abruptly changed course and – still in his early twenties – began to work as a painter. One of the startling aspects of this new course was that, with the possible exception of a few informal classes, he still had no training at all.

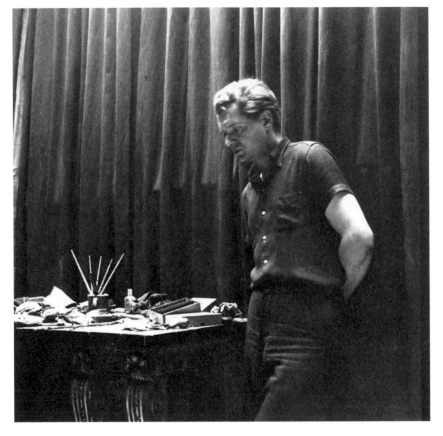

Francis Bacon, 1950. Photo by Sam Hunter

Bacon picked up some information about the subject from Roy de Maistre, an Australian-born painter fifteen years his senior with whom he had a close relationship in the late 1920s and early 1930s: a friendship that may not have been sexual, but certainly involved artistic mentoring. De Maistre could answer Bacon's questions about how to put paint on canvas, although he was puzzled as to how someone with such a sophisticated understanding of art – gained entirely by looking at it – could ask such childishly simple questions about how it was made. What de Maistre did not do was instruct Bacon in how to draw, in the way drummed into students at art schools. Consequently, as other artists and friends are united in agreeing, Bacon couldn't draw very well. Lucian Freud put it like this:

> Francis depended entirely on inspiration, which made him rather
> brittle. He was completely untrained, and couldn't draw at all but
> was so absolutely brilliant that through sheer inspiration he could
> somehow make it work.

While he had little facility with line, Bacon had a great intuitive feeling for paint – its substantiality, its fluidity, the things it could do. This, apart from the emotional charge – the grotesque horror – made *Three Studies for Figures at the Base of a Crucifixion*, and the other picture Bacon exhibited at the Lefevre Gallery in 1945, *Figure in a Landscape* (1945), stand out. They were what art historians call 'painterly'.

One of the points about Bacon, simple but fundamental, was that he loved paint. It got everywhere. His working environments were splattered with it. In the 1940s he was occupying a ground-floor flat at 7 Cromwell Place, between South Kensington Underground station and the Natural History Museum. This was a place – part of a mid-nineteenth-century house that had previously been occupied by the Pre-Raphaelite John Millais and later the photographer E. O. Hoppé – that greatly struck everyone who visited with its mixture of faded opulence and anarchic disarray. The dowdy chintz and velvet sofas and divans with which the cavernous room was furnished gave it, the painter Michael Wishart felt, 'an air of diminished grandeur, a certain forlorn sense of Edwardian splendour in retreat'. Two vast, glimmering Waterford chandeliers produced a mysterious illumination.

It sounds like a stage set for some gothic drama. What in fact took place there was an extraordinary, subversive parody of the conventional family. Bacon's protector and lover, a wealthy older man named Eric Hall, funded the household. But Bacon supplemented the funds he got from Hall with the proceeds of illegal gambling parties and, if necessary, a little shoplifting, both the latter activities assisted by his ex-nanny, Jessie Lightfoot, who had already been living with him for a decade and a half. At Cromwell Place, she slept on the table. It seems Nanny Lightfoot filled the role she had always had: that of Bacon's surrogate mother. Eric Hall was a substitute father, not angry and rejecting but affectionate and generous.

John Craxton described the Cromwell Place studio as 'rather marvellous'. He picked out a detail, a blend of luxury and disorderly squalor that was entirely typical of the man and the artist: 'Francis had this huge Turkey carpet on the floor, and there was paint all over the carpet.' Kathleen Sutherland, who dined there roughly once a week with her husband, Graham, recalled that 'the salad bowl was likely to have paint on it and the painting to have salad dressing on it' (but 'the food and wine were good and the conversation wonderful'). It was true the flat and its furnishings got mixed up with the paint and vice versa, and both were integrated into *Figure in a Landscape*.

This did not in fact represent a figure at all, but only part of one – a single leg, an arm and his lapel – the rest having vanished into a black void. What remains are sections of an empty suit. The painting was based on a photograph of Eric Hall, sitting in Hyde Park. But the location has apparently moved to the African bush, and an object resembling a machine gun has been mounted at one side of the figure – or, rather, the unoccupied clothes. The texture of the latter, Bacon explained to the critic David Sylvester, was the element of the picture that, in a moment of inspiration, got mingled with part of the room:

> Actually there is no paint at all on the suit apart from a very thin grey wash on which I put dust from the floor ... I thought: well, how can I make that slightly furry quality of a flannel suit? And then I suddenly thought: well, I'll get some dust. And you can see how near it is to a decent grey flannel suit.

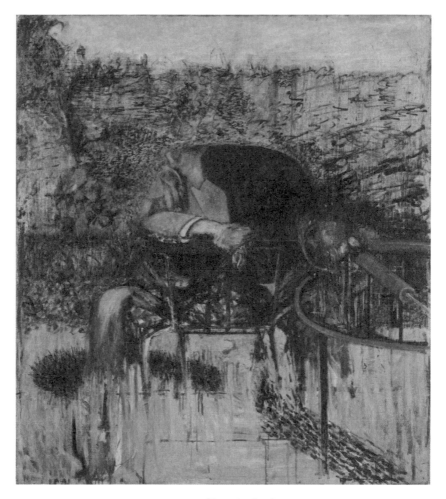

FRANCIS BACON *Figure in a Landscape*, 1945

All of this is characteristic of Bacon: firstly, the desire for sensual detail – a depiction of grey flannel that would not only look right, but look as if it would *feel* right, as if caressing fingers would encounter that 'slightly furry' surface. This pursuit of a realism that would activate the nervous system was one of Bacon's fundamental impulses as an artist (one, by the way, that distinguishes him from Picasso, which was doubtless why Sutherland added the more brushy work of Vuillard to his shorthand account of what Bacon's work was like). This comes up again and again in Bacon's interviews: his search for an image that would act more vividly or 'poignantly' on the nervous system. It was also typical that he would try something out on the spur of the moment, something as unheard of and, technically speaking, peculiar as sticking dust on his picture. Bacon loved improvisation and accident. In many ways his paintings grew out of the fertile chaos with which he surrounded himself – the dust on the suit was one example – in a direct and physical way.

Bacon thrived on mess. He had an unusually symbiotic relationship with his works. Just as bits of the environment got into the pictures, the paint got onto him. Lucian Freud remembered, 'Francis always used to mix paint on his forearm' (until he 'developed an allergy or something and couldn't'). This habit, according to John Richardson, gave him turpentine poisoning, which eventually led him to switch to acrylic paints. A student is said to have encountered Bacon, during a brief period when he worked at the Royal College of Art in the early 1950s, in the washrooms, cleaning paint off his shoulders.

Conversely, his use of make-up – utterly outrageous in mid-1940s London – was, in Richardson's opinion, a variety of body painting, almost performance art. Bacon would let his beard grow until it had sufficient texture to take the cosmetic in a way he likened to the unprimed back of a canvas (on which he preferred to work). Then he took pads covered with different shades of Max Factor make-up and applied them to his face 'this way and that across his stubble in great swoops', just like his brushstrokes.

This obsession with paint, then, was one of the qualities that set Bacon apart from many of his peers. In a community of painters who were, at heart, draughtsmen, or at least applied their pigments in a cautious and measured manner, he had an exuberant affinity for paint and what it could

do. For Bacon, this was the essence of the matter, which led him to become an unexpected advocate of a slightly unfashionable older artist, Matthew Smith, whose work was shown alongside Bacon's in the Lefevre exhibition in 1945. Smith's subject matter – opulently rounded female nudes and piles of ruddy, ripened fruit – was very far from Bacon's world. But the way Smith depicted them, with extrovert swirls and scoops of pigment, was exactly what the younger artist approved of. Bacon's only published writing was a short text in praise of Smith's work. The latter, he wrote, seemed to him,

> to be one of the very few English painters since Constable and Turner to be concerned with painting – that is, with attempting to make idea and technique inseparable. Painting in this sense tends towards a complete interlocking of image and paint, so that the image is the paint and vice versa.

This fusing, so that the brushstroke and the thing it is representing become indissoluble, was a holy grail for Bacon. Howard Hodgkin later spoke in very similar terms of the way 'a brush full of pigment is put down and *turns into* something' such as 'a piece of embroidery in a painting by Velázquez, or the edge of a curly hat by Rembrandt'. Hodgkin felt this was a phenomenon that was beyond verbal explanation or conscious planning. It was a magical metamorphosis: 'if one were always after that, one couldn't paint at all.'

Bacon would surely have agreed. You couldn't set out to get such an effect; it was something that happened while you were painting, almost as if the paint did it on its own as you moved it about. This was why, he felt, 'real painting is a mysterious and continuous struggle with chance'. For Bacon – an instinctive high-stakes gambler – chance lay at the heart of the matter, both in the sense of luck, good and bad, and of the creative potential of sheer randomness. He amplified what he meant by those two adjectives, mysterious and continuous. Painting was:

> mysterious because the very substance of the paint, when used in this way, can make such a direct assault upon the nervous system; continuous because the medium is so fluid and subtle that every change that is made loses what is already there in the hope of making a fresh gain.

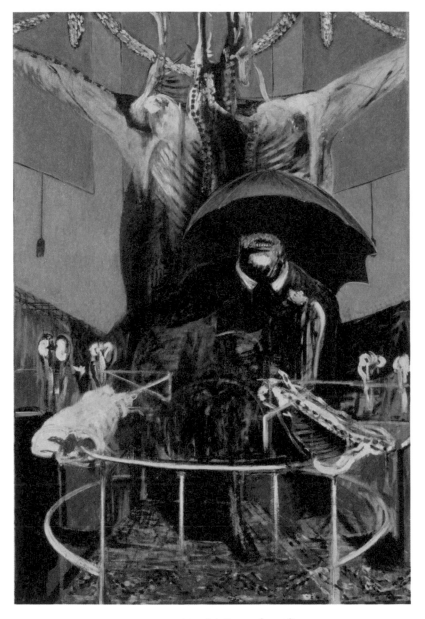

FRANCIS BACON *Painting 1946*, 1946

This conception of art was very different from the academic notion of a carefully planned picture, evolving slowly through studies and compositional sketches to the completed work. Bacon believed in painting as improvisation, even when he had a prior idea – and he was cagy, perhaps downright evasive, about the degree to which that was actually the case. In the paintings he showed at the Lefevre Gallery in 1945, however, he was still some way from achieving this ideal.

In *Three Studies for Figures at the Base of a Crucifixion*, the brushstrokes that make up the odd tripod arrangement in front of the central, blindfolded creature are loose and flowing and look as if they were rapidly executed (Bacon, once he got going, painted quickly). But the 'complete interlocking of image and paint' that Bacon sought was still some distance away. He got closer to this holy grail the following year.

In 1946, he achieved a masterpiece, one of the greatest pictures of his career and the first he had considered complete. This was the work that Lucian Freud saw when he visited the Cromwell Place studio, and which he remembered as 'the marvellous one with an umbrella'. Bacon, too, was stumped when it came to thinking of a title to describe this extraordinary work, which he ended up calling simply *Painting 1946* (1946). According to Bacon, it came to him 'as an accident'. He was working on another combination of imagery – a chimpanzee and a bird of prey – when, unexpectedly, the marks he had put down suggested a quite different image. 'It was like one continuous accident mounting on top of another.' Mind you, this account might or might not be entirely true or, perhaps, it might be a way of underlining what Bacon felt was the deeper truth about the picture: that its ingredients were random, that in aggregate they meant nothing.

They were not all novelties in Bacon's work, or his surroundings. The main figure – a man in a suit, the top of his head missing, his mouth gaping – seems to have been derived from photographs of politicians orating on podiums, among them senior Nazis, with microphones sprouting in front. The umbrella, a common accessory in snaps of early film directors in action, had already appeared in another Bacon painting, *Figure Study II* (1945–46). On the floor beneath, there is what looks very much like the Turkey carpet, drizzled with paint, from Cromwell Place.

In the background are pink and purple panels that have been connected with the tiles of an old-fashioned butcher's shop, in light of the butcher's wares that are on display in the painting – what look like two sides of lamb in the foreground and, behind, the crucified carcass of a whole, spread-eagled cow. The raw meat was a new motif for Bacon, but one that responded to deep feelings, both psychological and aesthetic. He loved meat, much as he loved paint. He would go to look at it in the food hall at Harrods, one of his favourite places, which he described to Sylvester:

> If you go to some of those great stores, where you just go through
> those great halls of death, you can see meat and fish and birds
> and everything else all lying dead there. And, of course, one
> has got to remember as a painter that there is this great beauty
> of the colour of meat.

Bacon thought meat a marvellous spectacle, while simultaneously it reminded him of 'the whole horror of life, of one thing living off another' – an unorthodox taste to mention, but scarcely a novelty in art. A long tradition of still-life painting, going back to the sixteenth century, had dwelt on the visual attractions of dead chickens and sides of beef. There was also a subsidiary tradition, including works by Francisco Goya and Rembrandt, which hinted at the link between butchered animals and human death, even holy martyrs. Francisco Goya's *Dead Turkey* (1808–12) puts one in mind of a murdered saint, and Rembrandt's *Slaughtered Ox* (1655) made a connection between food production and the most sacred theme in Christianity, the Crucifixion.

This, of course, was the link that Bacon evoked. But rationally speaking, this assemblage – Harrods food hall, totalitarian speech-maker, umbrella and Bacon's own carpet – made no sense. In a way, this was the message. Here was a crucifixion, but not one that led to resurrection and redemption; rather, it presented suffering and dead meat, presided over by a totalitarian despot. It was an altarpiece, sumptuous and sombre in colour, but one that dealt only with meaningless suffering and cruelty.

Bacon doubtless came upon the combination intuitively, if not quite as accidentally as he claimed. He was, in any case, throughout his career, militantly opposed to spelling out the meanings of his pictures. To do so,

he believed, would make them dull and literary. 'The moment the story is elaborated, the boredom sets in; the story talks louder than the paint.' In this, Bacon was in rebellion against a British art world that had long been fond of telling stories – an interest artists as different as the Pre-Raphaelites, Walter Sickert and even the Neo-Romantics all shared. Another departure in a nation that had not produced much in the way of religious art for centuries – a few, very literary works of Pre-Raphaelite storytelling aside – Bacon painted pictures that, even in a violently nihilistic way, looked like altarpieces.

*

In several ways, *Painting 1946* was an index of Bacon's ambition. One was its sheer scale. This was a size up from the *Three Studies for Figures at the Base of a Crucifixion*. It is some six feet high: very large for an easel painting, and too cumbersome – its alarming imagery apart – for most collectors' houses. Even more ambitious than its dimensions, though, were its artistic and philosophical goals.

Barnett Newman, the American painter who considered that art criticism was for the birds, also famously said, 'our quarrel was with Michelangelo'. This was perhaps absurd over-reaching. The critic Robert Hughes retrospectively responded, 'Well, you lost, Barney!' But Bacon – who was also fascinated by Michelangelo – would probably have agreed with Newman in aiming high. He too wanted to make a kind of painting that was adequate in emotional and artistic impact to reflect the human condition. And this, as he saw it, was defined by meaninglessness. God was dead, life was pointless, death was the end. Yet he wanted to carry on making pictures with the profundity and force of the old masters.

Again, American contemporaries such as Newman and Mark Rothko would have agreed – though they would not have seen eye to eye with Bacon about his determined retention of the human image. The avant-garde painters in New York – who were first dubbed 'Abstract Expressionists' in 1946 – aspired to make pictures that did not represent identifiable people or objects in the visible world, but through paint alone measured up to the seriousness and heroic power of the most monumental works of the past.

They wanted their pictures, as they put it, to be sublime. Bacon might not have used that term, but he wanted do something comparable through figurative paintings which represented nothing, or at least nothing that was easily nameable. The difference was that in New York there were several artists moving in parallel directions. No one else in 1940s London was aiming for sublimity. Bacon was working alone, and – despite being at the centre of a lively circle in the 1950s and 1960s, containing several hugely gifted fellow painters – he continued to feel he was a member of a group of one.

> I think it would be more exciting to be one of a number of artists working together, and to be able to exchange … I think it would be terribly nice to have someone to talk to. Today there is absolutely nobody to talk to. Perhaps I'm unlucky and don't know those people. Those I know always have very different attitudes to what I have.

*

Under the circumstances, it is not surprising that it took Bacon so long to get his nerve up. He was 'a late starter in everything', he told David Sylvester, 'I was kind of delayed'. He was also, as we have seen, a self-taught outsider in the world of painting. The consequence, not surprisingly, was paralysing self-doubt. He had begun his career as an artist – as he would eventually continue it – with a burst of improvisatory brilliance. In early 1933, when he was only in his mid-twenties, he came up with one of the most extraordinary British paintings of the era. It was entitled *Crucifixion* (1933) and represented a strange figure with sticklike arms, a pin head and the ectoplasmic body of a ghost or spirit. This was openly influenced by Picasso's work of around 1930, but had an eerie quality. The trademark *uncanniness* of Bacon was already there.

This *Crucifixion* found a buyer and – an extraordinary honour – was immediately reproduced in a book by the leading modernist critic in Britain, Herbert Read. This publication, *Art Now* (1933), presented Bacon's painting on a double-page spread opposite a contemporary picture by Picasso, thus pointing out the connection between the two, but also implying, 'here is Picasso's leading British disciple'. Then, within a year, Bacon had disappeared from view.

His first one-man show, self-organized, at the Transition Gallery in 1934, had not been a financial or a critical success. It received an acerbic review in *The Times* and few works sold. Bacon's reaction was to destroy all the rest, including a picture entitled *Wound for a Crucifixion*, which a collector had wanted to buy (and which he himself later regretted discarding). From 1936 Bacon effectively gave up painting and produced nothing more that survives until 1944, although it is rumoured that he destroyed many, perhaps hundreds of works. It is not unusual for artists to edit their work by weeding out weaker examples. Lucian Freud also did this, perhaps having got the idea from Bacon. But the latter's tendency to reduce to obliteration his own pictures is hard to parallel in art history. From Bacon's output of the early thirties, the initial phase of his artistic career, almost nothing survives.

Bacon's lofty ambitions were one of the reasons he destroyed such an extraordinarily large proportion of his works (since, to his mind, few, if any, of his pictures lived up to those expectations). And self-doubt was certainly another. In combination, these two factors resulted in critical standards that were stratospherically, masochistically high. Little or nothing he did – or, for that matter, anyone else did – was good enough. (One of the very few works he remained relatively pleased with was *Painting 1946*, of which he said, 'I don't like my paintings for very long. [But] I have always liked that one, it goes on having power.') In some ways, this attitude was salutary, as Frank Auerbach observed:

> Nietzsche says people who scorn the second-rate are to be valued.
> Francis scorned almost everything, including his own work –
> genuinely, although he did his best. He never thought that what he
> had done was good enough. Which, after all, is the only healthy frame
> of mind, because how are you going to go on unless you are fed up
> with what you have done already?

By the mid-1940s, Bacon was little more than a rumour. A few people who had been around the art scene in the early 1930s remembered him, notably Graham Sutherland, whose pictures had hung side by side with Bacon's in a mixed exhibition at Agnew's in 1937 (Victor Pasmore was one of the other painters included). It is even possible that Sutherland was influenced

by his brilliant younger contemporary at this early date (as he certainly was later on). *Figures in a Garden* (c. 1935), one of the handful of Bacon pictures from the 1930s that still exists, looks like a prophecy of all the aggressively spiky, Triffid-like vegetation painted by Sutherland and his followers over the following decade.

Few people knew more about Bacon than could be learnt from looking at the reproduction of *Crucifixion* in *Art Now*. Even that had its effect. John Richardson, later to become the biographer of Picasso, was then in his early twenties and fascinated by modern art. He and his friends 'worshipped this plate', but 'none of us could find out who this Francis Bacon was'. Eventually, one evening by chance Richardson noticed a 'youngish man with a luminous face' going into a house opposite his mother's on South Terrace, off the bottom of Thurloe Square in Kensington. It turned out to be this mystery man, Francis Bacon, carrying canvases from his studio on Cromwell Place to his cousin Diana Watson's house. From what he could see of these paintings, Richardson deduced they were by the same artist as the *Crucifixion*. He effected an introduction and soon he and Bacon became friends.

The anecdote is significant because it demonstrates how gradual, even by the mid-1940s, Bacon's emergence really was. John Russell's description of the exhibition of *Three Studies for Figures at the Base of a Crucifixion*, and the reaction of those who saw it, suggests the work must have made an enormous impact. In fact, it seems many – even those who were keen followers of the latest developments in painting, including Richardson and his circle – managed not to notice this showing at all.

It was *Painting 1946* that truly marked Bacon's arrival, and largely because of the impact it made on Graham Sutherland. Lucian Freud was not the only person he sent along to see Bacon. Kenneth Clark had visited Bacon's studio in 1944, accompanied by Sutherland, although his reaction was initially disconcerting. Clark looked at Bacon's work, remarked, 'Interesting, yes. What extraordinary times we live in,' and left. 'You see!' Bacon exploded, 'You're surrounded by cretins.' Later on, Clark gave his verdict to Sutherland: 'You and I might be in a minority of two, but we will still be right in thinking Francis Bacon has genius.'

Another visitor to Cromwell Place was Erica Brausen, an expatriate German art dealer. Having fled her native country in the early 1930s, she had spent time in Paris where she mixed with Alberto Giacometti and Joan Miró, then moved on to London. In 1946, bankrolled by a wealthy collector named Arthur Jeffress, she was considering opening her own gallery. She liked *Painting 1946* so much she bought it for £200, which was a large sum for an almost unknown artist at the time. Two years later she sold it to Alfred H. Barr of the Museum of Modern Art, New York.

So, in gambling terms, Bacon had broken the bank. With one wild throw of the creative dice, he had gone from obscurity to a place in the world's greatest collection of Modernist art. His reaction to the initial sale of the painting, however, was characteristic. Shortly afterwards, late in 1946, he departed for the French Riviera. He did not complete another picture – one that survives, at any rate – for two years. Having briefly appeared, as far as the London art world was concerned, Bacon had vanished again.

EUSTON ROAD
IN CAMBERWELL

People feel that it is very important for artists to have an aim. Actually, what's vital is to have a beginning. You find your aim in the process of working. You discover it.

BRIDGET RILEY, 2002

I
n the autumn of 1945 so many would-be artists flocked to the Camberwell School of Art in South London that extra buses had to be put on from Camberwell Green. The new Labour government was taking action against the five Great Evils enumerated in the Beveridge Report of 1942: 'WANT, DISEASE, IGNORANCE, SQUALOR and IDLENESS' (all set out in monumental capitals). Many people felt that, despite the devastation wreaked by the war, things were finally looking up, and a surprising number turned to art.

The school's capacity, pre-war, had been between eight and nine hundred students. Now there were nearly three thousand. Among these were many ex-servicemen – including Terry Frost, released from Stalag 383, an ex-Grenadier Guards officer named Humphrey Lyttelton and Henry Mundy, who had fought in the Far East. The directive from the Ministry of Education, the principal William Johnstone remembered, was 'to fit in as many servicemen as possible, to keep them quiet and happy', as the new government was keen to avoid a 'recurrence of the disillusionment following the First World War'. Frost, who had left school at fourteen and done a series of dead-end jobs in his native West Midlands, was a beneficiary of the new spirit of democratic opportunity after 1945:

It was so different from before the war when you had to doff your cap to people across the road and you daren't put your foot out of line or you got the sack. But the doodlebug didn't differentiate whether you had been to Oxford or elementary school. Bullets didn't differentiate. I found it a wonderful period, everybody helped each other. But it was destroyed.

At Camberwell illustration was taught for three days a week by John Minton. One of Minton's pupils was Humphrey Lyttelton, whose 'dramatic and romantic' drawings of scenes in books such as George Eliot's *Mill on the Floss* caused Minton to 'laugh most uproariously' – this would have been more gratifying, Lyttelton felt, 'if they had been intentionally humorous'. Lyttelton resolved to concentrate on comic art, but by and by switched from that to playing the jazz trumpet. In 1948, he formed a band with a fellow student, Wally Fawkes, and they began to perform regularly in a cellar club at 100 Oxford Street. A large contingent of supporters followed them from Camberwell, including Minton who was, according to Lyttelton, 'among the most formidable and dangerous' of the dancers. Gillian Ayres recalls 'Minton always at those evenings, dancing; later he got sad and sour, but he was quite unlike that in 1946 to '48 at Camberwell, he was full of life.' In 1949, Minton made a drawing of a scene at the club – known as 'Humph's' – for an arts magazine. He put his own, slightly frantic, features in the bottom right-hand corner, surrounded by a mass of wildly gesticulating, euphoric young people (many of them members of the all-male circle known as 'Johnny's Circus').

Ayres arrived at Camberwell in the autumn term of 1946, sixteen years old and determined to become a painter. She too remembers the atmosphere of hope and optimism despite the havoc wreaked by the war: 'It felt absolutely wonderful. There was tremendous enthusiasm. I think everybody felt that they could make a new world that was quite different.' However, her ebullient personality and intuitive way of working soon came into conflict with the prevailing method of instruction, confusingly referred to as the 'Euston Road School'. This was an approach to painting and drawing that took its name from a defunct private school of art that had briefly flourished near King's Cross station in the years before 1939. After the war it became the most influential artistic method taught in Britain, characterized by a way

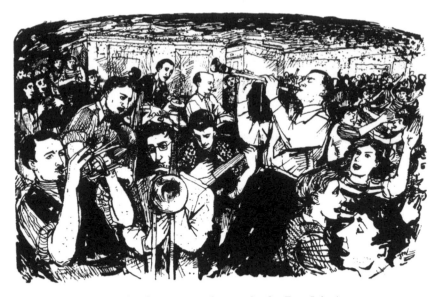

JOHN MINTON *Jam Session*, cover drawing for *Our Time*, July–August 1949

of working that was slow, inclined to be dingy in colour, and claiming to be unemotionally 'objective'; it is little surprise that Ayres found this approach stifling. Seventy years later, recalling many of her tutors at Camberwell, she still fumes: 'They were fascists, you were meant to work like them. I'm really horrified by them *to this day*.'

<div align="center">*</div>

The distinction between the 'Euston Road School' and less restrictive methodologies was the topic of earnest discussion on 17 October 1947 beside a canal in Peckham. There, three painters – William Coldstream, Victor Pasmore and William Townsend – went for a walk between the afternoon and evening teaching sessions at Camberwell, where they were all members of staff. The first two were among the most talented British artists of their generation, and contemporaries of Francis Bacon's: they were both born in 1908, Bacon in 1909. In contrast Townsend, these days, is remembered less for his pictures than for the voluminous diary that makes him the Pepys of the 1940s London art world.

Townsend made a detailed note of the conversation on the towpath that day: 'We talked about the difference of attitude, especially of attitude to the objective world, between realist painters of our kind and the contemporary romantics or the idealists of the *École de Paris*.' By 'contemporary romantics' Townsend meant what are now termed the Neo-Romantics – painters such as John Craxton, Graham Sutherland and (as most people would have assumed in 1947) Bacon; while by the 'idealists of the *École de Paris*' Townsend presumably meant Picasso, Fernand Léger, Henri Matisse and the Surrealists.

Coldstream, characteristically taking the lead in this discussion, took an example from the twilit landscape around them. He pointed to 'a crane, folded against one of the warehouses across the canal', using it to illustrate a lucid statement of his position. There was, he believed, 'a fundamental divergence between the painter interested first in a world outside himself and the painter interested in a world of his reactions'. This was the difference between someone trying to map the real world and an artist painting from inside – like Bacon – the images that, as he said, dropped into his mind 'like slides', or were suggested by the random splatter and slither of the paint itself. Coldstream explained:

> They start where we leave off. They believe they can draw that crane without any difficulty, the only problem is where to place it and in what picture. We are not sure we can draw it as we see it and the whole picture is our attempt to do so and we consider we have done well if we get somewhere near it.

This might seem a modest aim – representing an ordinary piece of industrial equipment through marks on a piece of paper – but it was much more challenging in practice than it sounds to non-painters. It runs directly into what David Hockney has termed 'the problems of depiction' which, he points out, are 'permanent, meaning you never solve them'. These difficulties are inherent in the process of making a flat picture of a world that is three dimensional, in constant flux, and interpreted in various ways by human psychological and physiological systems.

A decade before, Coldstream – in a quandary about how to paint and what to paint – gave up the struggle for a couple of years altogether.

Instead he worked happily with the General Post Office Film Unit, cooperating with the brilliant director John Grierson on documentaries about such subjects as the GPO Savings Bank and the procedures of telephone exchange operators. It was, however, a much more creative interval than these subjects might suggest. Benjamin Britten wrote the soundtracks for some of the films, and W. H. Auden the scripts. Meanwhile Coldstream continued to give private lessons in painting at the weekend. In February 1936, he received a letter from his old professor at the Slade School of Fine Art, Henry Tonks, advising him on how to instruct a pupil, a Mr Snipey of Birmingham.

> Of course encourage him also in expressing *himself* in what way he
> likes, but behind all this there must stand the expression of solid
> (three-dimensional) form upon a flat surface.

This, epigrammatically stated, was what could be called the Tonks doctrine. It had been taught to generations of British painters at the Slade – Stanley Spencer, Paul Nash, Gwen John, David Bomberg and Winifred Knights among them. It descended, through the French classicism of Ingres, from Raphael and the Florentine Renaissance, and was still being passed down in the late 1940s and early 1950s to a young Bridget Riley by her teacher at Goldsmiths' College, Sam Rabin, another pupil of Tonks.

The issue around putting 'solid (three-dimensional) form upon a flat surface' is that, strictly speaking, as we all know from arithmetic lessons, two into three won't go. Geometrically, there is no perfectly accurate and objectively correct way of representing the three-dimensional world on a flat canvas, panel or piece of paper, any more than there is a perfect solution to the problem of how to map a round globe on a flat atlas. Every way of doing so is an approximation or, you might say, an abstraction.

This is the basic problem, and – as Tonks's throw-away concession concerning Mr Snipey, who could, of course, express '*himself* in what way he likes', made clear – self-expression was a by-product of the struggle to condense three solid dimensions into a flat picture. This could no more be done without alteration, Coldstream's friend Lawrence Gowing once remarked, 'than an orange skin could be pressed flat on a table without splitting'.

Nothing further was heard about Mr Snipey and his work, but Coldstream himself took Tonks's advice very much to heart. Previously, as a student, and afterwards, as he strove to find his way as a painter, he had attempted a number of different idioms. He was brought up short by a dilemma that also presented itself to many others (and still does) and one that he had set out in a letter to a friend in 1933, before temporarily abandoning the effort in despair. On the one hand, Coldstream wrote, 'the logical development of the mainstream of European painting has led to photography'. He clearly believed that the world looks like a photograph; he admitted to 'amusing himself' with a reflex camera, through which 'everything looks wonderful'. On the other hand, in that case, what was the point of figurative painting? It could do no more than aspire to look, as much as possible, like a photograph. Some artists concluded that the answer was to give up the attempt to make pictures of the world altogether. The objective truth about paintings was that they were made of *paint*. A friend of Coldstream's argued that the logical response was to regard the canvas itself as an object, 'something to be worked as a carpenter works on a chair'. Yet if one did that, Coldstream thought, one had 'shelved' the question of painting altogether 'and become a sculptor'.

Coldstream's friends Rodrigo Moynihan and Geoffrey Tibble went down this path, and produced pictures they called 'objective abstractions' – the kind of thing that later, in postwar New York, were called 'Abstract Expressionist' and, in Paris, 'Tachiste'; pictures consisting of loose, visible brushstrokes; pictures about nothing but paint. Coldstream had a go too but, he reported, 'it came to *nothing*'. Victor Pasmore, Coldstream's friend and companion that day on the towpath in 1947, did not, at this point, get as far as total abstraction, but rather worked on the problem by painting a number of what he later described as 'imitation cubist and fauvist pictures'. Like Coldstream, he decided that this was leading nowhere:

> You can do about a dozen of those brushstroke pictures, and that's about it.
> You wonder what's going to happen next. We came to the conclusion that
> there was no future in it, that it was far too subjective, *totally* subjective.
> So we needed something to get back to an objective standpoint.

The only solution they could think of, as Pasmore put it, was going back to 'the old masters'. By that he meant painting a subject in the real world, something seen. He and Coldstream did so, however, in different ways. Pasmore carried on painting flowers, nudes and landscapes with a delicate romanticism that harked back not to Samuel Palmer, but to James Abbott McNeill Whistler and, most of all, his hero J. M. W. Turner.

Coldstream eventually – after his spell making documentary films – came up with his own, idiosyncratic way out of the impasse they found themselves in. As Pasmore recalled of an occasion in the 1930s when he sat to Coldstream for a portrait:

> Bill arrived with a plumb-line and ruler, I sat down. Instead of starting as you usually do, with an outline of the head then put in the eyes, he started with the eye then measured the distance to the next eye. He measured up every detail.

From then onwards, Coldstream did not paint as an old master or an Impressionist would: by looking at the subject, analysing it, and placing the product of this thought and observation on canvas. Having fixed on a system that was, as far as possible, totally objective, his paintings slowly condensed from a mass of delicate slanting sable brushstrokes.

The process is described by Coldstream's biographer, Bruce Laughton, as a mass of mainly straight, parallel marks, 'like a radar screen', scanning areas 'that either reflect or block the light'. To make these readings, he turned himself, as far as possible, into a human measuring instrument. Lawrence Gowing, a student of his at the time, went to see him while he was engaged in painting an interior of St Pancras station in 1938. Gowing wondered how he would find Coldstream amid 'that vast elevation of terracotta gothic' until he saw, through a window, 'a rigid horizontal arm gripping an exactly vertical brush handle, up which a square-cut thumbnail was creeping in minute adjustments of the length to the angle subtended'.

Christopher Pinsent, a student of Coldstream's in the 1940s, described the process with precision: the brush was held at arm's length, either horizontally or vertically, 'in such a way that it is in a place at right angles to the line from the artist's eye to whatever part of the subject he is looking

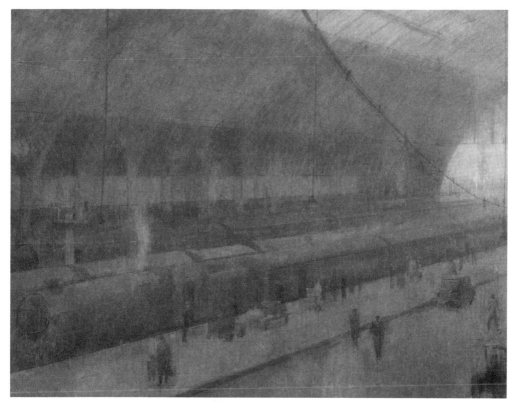

WILLIAM COLDSTREAM *St Pancras Station*, 1938

William Coldstream painting Bolton, *1938. Photo by Humphrey Spender*

at'. The thumb was then moved up and down to quantify a distance, and subsequently could be used to record a measurement – the distance from the bottom of a mouth, for example, to the chin – that could be compared to others on the subject's head, or elsewhere in the picture. The point was not to record a single measurement, but tirelessly to compare the scales of the objects in view.

The results of the endless measurements were left on the finished picture, rather as someone doing a maths test might jot the workings-out of a problem on the margins of the paper. These little spots and dashes – humorously dubbed 'dot and carry' – recorded the inner proportions that Coldstream discovered even in the most mundane view or model: 'a sure sense of interval', as Pinsent put it, such as is found in architecture and music. Through a totally, almost robotically, objective method, Coldstream found a secret beauty that was – effectively – abstract.

The rigours of his approach gave his students a sense of moral probity, as Anthony Eyton who studied at Camberwell from 1947, reflects: 'We

Coldstream pupils were rather bigoted lot. It was a close society. We felt we had something to hold onto: the certainty of drawing and the fact that you had to suffer a bit for it. You felt a bit you were on the track of the holy grail, but we didn't take in modernity.'

*

Nevertheless, Coldstream himself was afflicted by doubts about what he was doing – where to start, and how to carry on. As a result, he later confessed, he found it helpful to have a portrait subject, a paying customer, turn up at his studio, expecting to be depicted. 'If you have great difficulty in making yourself work, as I do, if the sitter's really going to arrive you've jolly well got to be there and be ready to paint whether you feel like it or not.' Confronted with an actual person's face, he found himself 'cornered into a problem which, although like all problems in painting is infinitely wide, in one sense appears to be narrower'. It was narrower in that there was a sitter present, so he could not spend time thinking, 'What am I going to do?', a question which threw up 'so many alternatives'.

Coldstream's approach to painting was, in its way, as idiosyncratic as Bacon's, though in most other respects it was as far removed as it could be. Bacon's art expressed existential rage, fear and horror with maximum drama; Coldstream's pictures reflected his own self-deprecating reticence, doubt and precise observation. There was one other important difference. Bacon's work was effectively inimitable; Coldstream's approach, though also the product of a unique temperament, proved highly teachable. Gillian Ayres remembers: 'Coldstream said that he could take anyone off the street and teach them to draw, if they did what he told them to do. And up to a point it was absolutely true.'

He began teaching in this way at a private school of art, set up in October 1937, and known from its address as the Euston Road School (later to give its name to the method so disliked by Ayres). The prime mover in the initiative was a fellow painter and friend of Coldstream's, Claude Rogers; Pasmore also gave lessons there, but Coldstream was the strongest influence among the teachers. After the war Pasmore, Rogers and Coldstream all found themselves on the staff at Camberwell, and then, from 1949, Coldstream

was principal of the Slade School of Fine Art. In the 1950s and 1960s his numerous pupils, and the pupils of his pupils, spread the method far and wide. As Frank Auerbach remembers, 'Euston Road' slowly changed from being a private language into a national cliché:

> There were slacker versions of Coldstream's drawings promulgated
> by almost all art schools. That is, the handwriting and the dot
> and carry, without the rigour and without the sensibility; without
> the fanaticism, and the nervous quality that Coldstream's own
> work had.

Euston Road painting had a downbeat, low-key mood: the colours were drab, there was an air of gloom. This was a feature of pre-war paintings such as Coldstream's *St Pancras Station* (1938), but it also matched the postwar mood. The obverse of the feeling of optimism, felt by Ayres among others, that after the war Britain could be a better place, was the reality of rationing, economic austerity and a sense, right or wrong, of national decline.

In 1947, Cyril Connolly, in a characteristically despondent *Horizon* editorial, described the London of that year as 'the saddest of great cities', with 'miles of unpainted half-uninhabited houses, its chopless chop-houses, its beerless pubs'. It was, he went on, a place full of 'care-worn people' who 'mooned' around cafeterias, 'under a sky permanently dull and lowering like a metal dish-cover'. To a student such as Gillian Ayres, with an instinctive yearning for light and colour, the Euston Road painters seemed positively to revel in the dinginess of South London in the 1940s:

> A working man's café and a tea-urn was what they most loved. They
> loved their models too, who were possibly lovable, they were a certain
> type of London woman. And they loved Camberwell, literally,
> opening a window and painting it.

Painting that reality had always been important to Coldstream and several of his Euston Road associates, including Claude Rogers and a South African painter named Graham Bell. The attitude had originated in the years before the outbreak of war, when the threat of Nazi Germany and Fascist Italy permeated. According to Pasmore:

The only really powerful, full-blooded opposition was the Communist Party. Their Social Realism began to infiltrate into London, so there was a division in the art world. The School of Paris, Picasso and abstract painting was felt to be completely 'ivory tower'.

Yet there was a hidden paradox. Paintings of working-men's cafés in exquisitely dingy greys and browns did not necessarily appeal to the viewing public. When more and more people began to attend art exhibitions in the 1950s and 1960s, it wasn't Coldstream or Rogers they queued up to see. It was Picasso and Bacon.

*

In the 1930s, Pasmore remembered, 'Coldstream got mixed up in the political mood'. In contrast Pasmore did not, as he was too busy working as a clerk at the London County Council offices. Unlike Coldstream and the others, he had not been to art school. His father, a doctor, had died when he was a teenager, and instead of going on to further education, after school at Harrow he went straight into a lowly office job, painting in the evenings and weekends. 'I was in an office, working full-time, so I had no time to monkey about with politics and worry about whether art was ivory tower or not.' Eventually Kenneth Clark came to his rescue, giving him a small income in exchange for pictures, and he supplemented this by teaching at the Euston Road School.

> I was just interested in being able to do pure painting all day, for
> the first time in my life. I couldn't care less about this political stuff.
> I refused to have anything to do with it. Although I was in the Euston
> School, I insisted on painting a bowl of flowers, if you know what
> I mean. I ought to have paid more attention to politics, probably,
> but I had no time.

At Camberwell after the war, it was Pasmore who was Gillian Ayres's favourite teacher. 'Victor was woolly-headed, delightful, imaginative. His friends all saw him as a sort of genius. And he could be belligerent to them, but by nature he wasn't really like that. He was fuzzy, intelligent and wayward.'

In the latter days of the war, after a short period in prison for deserting from the army, Pasmore was painting delicately romantic landscapes. *The Quiet River: The Thames at Chiswick* (1943–44) is a masterpiece that looks backwards to Whistler and Turner, but also forwards. It is, as William Hazlitt said of Turner's *Snow Storm – Steam-Boat off a Harbour's Mouth* (exhibited 1842), a picture of nothing, 'and very like'. Not quite a void, it is true, but certainly an image of nothing much: mist, a hint of pink in the sky, a gleam on the water, a few posts, someone cycling by. These marked off the inner harmonies of the painting, much like Coldstream's dot and carry. But there was a difference: Pasmore's painting was not based on obsessively careful measurement; it was more like Wordsworth's definition of poetry, 'emotion recollected in tranquillity'. He looked at a subject, such as mist hanging on the river, which was by its nature elusive, something on the way to turning into nothing. Then he went away and invented a picture.

The process was recorded by William Townsend in his diary, after a long conversation with Pasmore on the evening of 2 February 1947. They had sat and talked in the glazed terrace of the latter's new house on Hammersmith Terrace, while the light faded on the river and riverside gardens outside. Pasmore was not like their friend Bill (Coldstream), Townsend mused, 'who is never happy when his eye is not fixed on the subject he is painting'. In contrast, Pasmore began by looking at people, things and places, but at a certain point retired to his studio, where he carried on, making alterations and additions, painting what was now more of an idea or – Townsend wondered – 'a memory carried away, pure, of the object'. He might have added that this object was in the process of vanishing, like the Cheshire cat, leaving only an opalescent vagueness behind.

*

One of the attitudes of the – predominantly male – Euston Road crowd that particularly riled Gillian Ayres was their claim to be impersonal.

> They were obsessed with this thing of subjective and objective,
> and they claimed that they were objective. They were always on

VICTOR PASMORE *The Quiet River: The Thames at Chiswick*, 1943–44

about it. Coldstream and co. meant it, and I suppose up to a point some of them really did it, for a time. It was the opposite to Van Gogh in a way. It probably even extended to masculine and feminine with them if you were emotional – because you were supposed to be coldly objective and follow these rules.

Although the position was slowly changing, art and art schools were still extremely masculine worlds. A photograph taken at the opening of a student exhibition shows Ayres, sitting next to Henry Mundy – who was to become her husband – with a half pint in front of her while the men drink full pints. There are two other female students present, but the picture suggests the art world was full of chaps with ties and corduroy jackets.

To get to Camberwell, Ayres had had to blast her way through opposition from her headmistress and parents. Afterwards, she continued to override a welter of discouragement:

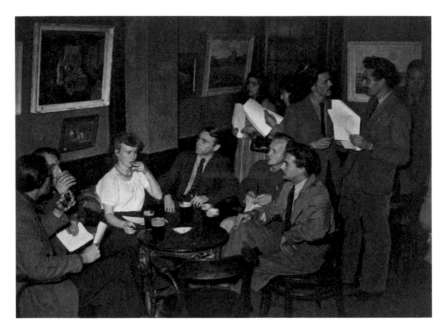

*The Walmer Castle pub, near Camberwell School of Art, with Gillian Ayres (centre)
and Henry Mundy (to the right of Ayres), 1948*

> I remember a woman saying, if you are female and you want to get
> on, you'd better teach needlework or graphic design or something.
> You certainly won't get a job teaching painting. And I can remember
> women saying that they wanted to give up their lives for their
> boyfriend, who was a great artist. I was always very ratty if there
> was any of that sort of thing.

In the mid-1940s another young woman artist named Prunella Clough was
crisscrossing London in a quest for suitable starting points for pictures very
similar to those drab urban scenes of which the 'Euston Road' painters
were so fond. As it happened, cranes – Coldstream's practical example in
the conversation on the towpath in Peckham – were among her choice of
subject matter.

 Clough visited the London docks to find material for her paintings.
When she got there, her biographer Frances Spalding points out, it was the
details of the scene – even more than the large pieces of equipment – that

attracted her: lorries arriving and departing, men loading and unloading, at work and at rest. Spalding writes, 'She closed in on the drivers in their cabs, catching moments of waiting, when the driver takes a nap or reads a newspaper, while pressing in on all sides are hints of the larger environment, a coil of rope, ladders, a factory chimney or segment of a crane.'

Her itineraries were very different from those of an artist such as Turner, in his search for 'Picturesque Views in England and Wales'. Clough's notebook records a series of journeys in search of unpicturesque sights, in nondescript suburbs and outer urban industrial zones. First she took trips to docklands along the Thames: Wapping and Rotherhithe, Greenwich and Gravesend. Then followed sights such as Battersea power station, Fulham gasworks, coke yards at Woolwich, cooling towers at Canning Town and chemical works at Redhill. She also made forays to Wandsworth, Pinner, Kensal Green, Willesden and Acton East. With her friend, fellow artist and Marxist art critic John Berger, she sketched at Willesden railway marshalling yards, drew the Peek Frean biscuit factory in Bermondsey and the light industry on the outskirts of the capital where London blends into Kent.

All of these dingy, workaday spots – and her close friendship with the eloquently left-wing Berger – might suggest that Clough was in search of the idiom approved in Moscow, Socialist Realism. Yet that was very much not the case. She painted cranes, cooling towers and gasworks because she liked them and they were familiar (as Giverny was to Monet). She explained in an interview for *Picture Post* in 1949:

> Each painting is an exploration in unknown country, or as
> Manet said, it is like throwing oneself into the sea to learn to
> swim. Anything that the eye or the mind's eye sees with intensity
> and excitement will do for a start; a gasometer is as good as a
> garden, probably better; one paints what one knows.

Clough's origins were curiously similar to Francis Bacon's; born in 1919, she was descended on her mother's side from minor Anglo-Irish gentry ('very minor' she would insist). But this was the only thing she had in common with the flamboyant Bacon. Clough was resolutely low-key. 'I like paintings', she said, 'that say a small thing edgily.' Her early pictures have a distinctly

Neo-Romantic flavour: fishing boats and spiky plants on the shore, a dead bird (a subject chosen around the same time by the young Lucian Freud). By and by, however, she found her starting points in Wapping and Woolwich. It was not their grimy atmosphere or the heroism of labour that she fixed on, but the *structure* of what she saw. 'The original experience must be reconstructed; it grows as a crystal or a tree grows, with its own logic.' That, and seeing the familiar afresh, as *un*familiar.

These were goals that many artists shared. Like Clough, some were eventually to find their way into a realm of art in which the inner logic of the forms became the most obvious subject of the picture. A form of art that, for want of a better word, we call 'abstract'. Clough was travelling on a similar trajectory to Victor Pasmore's, from urban landscape into something much harder to define.

*

At Camberwell, one Saturday morning, Gillian Ayres was working in Pasmore's still-life class on a painting of a skull, rather glumly because 'the still-life subjects they had were so *boring*'. There was a skull 'that stayed there forever' and a wax orange. Then Pasmore came along and said, 'I suppose you're painting this because you really *feel* something about it!' When he moved on, she thought, 'I don't feel a bloody thing about it!' Here was that essential issue again: what to paint and how to do so. It was a question to which there were numerous answers; as many as there were individual and intelligent painters. Pasmore's remark shook Ayres 'rigid', because it was so fundamental. Looking back, she conjectures that, in posing the question, Pasmore 'knew what he was doing at least subconsciously, because it was right at the time he went abstract'.

Steadily, the visible subject was disappearing from the pictures Pasmore was painting of the view outside. The sky and water were vanishing like mist on the Thames, the bushes turning into masses of dots – like flocks of starlings or swarming bees – and bare branches into networks of lines. 'I started being influenced by Pointillism, and that's what those late river pictures are: semi-abstract,' Pasmore recalled. 'They were leading up to the abstract art.'

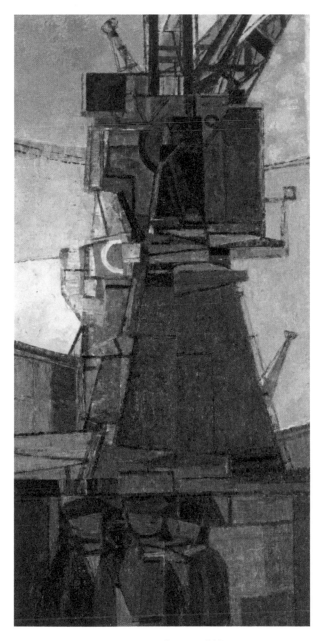

PRUNELLA CLOUGH *Cranes and Men*, 1950

VICTOR PASMORE *The Gardens of Hammersmith No. 2,* 1949

The Gardens of Hammersmith No. 2 (1949) was one of the very last paint-
ings of the visible world around him that Pasmore ever made (or, at least,
admitted making). He had already in 1948 had a first exhibition of some
abstract pictures; he did so again in 1949. It was, in the little world of art,
a conversion almost as dramatic as the defection to the Soviet Union of
the two spies Guy Burgess and Donald Maclean two years later, in 1951.

SPIRIT IN THE MASS:
THE BOROUGH
POLYTECHNIC

Reality is a slippery concept, because it is not separate from us.
Reality is in our minds.

DAVID HOCKNEY, 2016

The objective truth of what we see is elusive: in one sense we all see the same thing, in another we all perceive it differently, filtered through our emotions and memories. This explains some of the agonies of Coldstream and his followers as they attempted to measure and represent what was really in front of them. One problem, as Hockney has also pointed out, is that the eye is connected to the mind, and so the data passed through the optic nerve to the brain is interpreted in very different ways. Thus there are as many ways of seeing the world as there are people. What we see is coloured by memory, and also by feeling. No doubt Francis Bacon did not see the same way as William Coldstream or Victor Pasmore. All artists of powerful individuality see differently, as do all people of pronounced interests: they notice certain phenomena, particular types of information that fit into their own visual universe.

In the years following the war, a figure as charismatic as Bacon was at work in an obscure corner of South London. His name was David Bomberg and he taught life classes on two days and two evenings a week at the Borough Polytechnic Institute on Borough Road, near the Elephant

DAVID BOMBERG *Self-Portrait*, 1931

and Castle. Bomberg's classes, according to Frank Auerbach – who began attending them in January 1948 – were 'highly unpopular'. Yet Auerbach still counted himself 'lucky to have been a student of Bomberg's; this was someone worth listening to and a very profound thinker. In the way of young people my standards were to some extent formed by Bomberg.'

Leon Kossoff, who started attending Bomberg's evening classes at Borough Road a few years later, in 1950 – when he was in his mid-twenties – also found the experience shaped his future:

> Although I had painted most of my life, it was through my contact
> with Bomberg that I felt I might actually function as a painter.
> Coming to Bomberg's class was like coming home.

The lesson Kossoff learnt from Bomberg was as much spiritual as aesthetic.

> What David did for me, which was more important than any
> technique he could've taught me, was he made me feel like I could
> do it. I came to him with no belief in myself whatsoever and he
> treated my work with respect.

Another student at those sparsely attended classes was Dennis Creffield, who remembers the sense of mission that Bomberg handed on to the young would-be artists who found their way there. He has described how Bomberg 'placed his hand on me [and] said "You are an artist"'.

Creffield also commented on how Bomberg passed on a sense of the significance of painting, its moral value and its sheer difficulty:

> He was extraordinary in the way he loved painting, he really thought
> it was the most important thing in the world. That's what he gave
> you: a sense of great privilege as if you were involved in an immensely
> significant activity. Painting was the most important thing a human
> being could do. He put it right in the middle of history.

In this respect, his message was complementary to Bacon's, though in many ways they were opposites (indeed, Bacon was one of the fellow artists for whose work he had little time; he told Auerbach that he didn't think the 'vogue for Francis' would last for more than five years). However, where

Bacon and Bomberg concurred was in thinking that painting required intense effort and was to be measured by only the highest standards. On the other hand, in their different ways, both offered hope that great art could be made not only by old masters and famous artists in Paris, but also here and now, in the hidden corners of London, be they Cromwell Place or the Borough Polytechnic.

Most of the artists who had come to prominence in the short, heady era of Modernism before the First World War – Wyndham Lewis, William Roberts and Mark Gertler among them – were now running down as creative forces. Only Bomberg – at this point in his late fifties – continued to work at the height of his powers and passed on an electrifying message. And yet, by this time, hardly anyone had heard of him and no one was buying his work anymore. In retrospect, it is hard to comprehend the neglect that Bomberg suffered almost uninterruptedly from early middle age until his death in 1957.

Immediately before the First World War, he had been recognized as among the most brilliant painters not only in Britain, but also in the whole of Europe. At that moment Bomberg had been almost, but not quite, an abstract artist and one whose work was comparable with the best being done in Italy, Germany or the Netherlands. Bomberg's *The Mud Bath* (1914) easily equals works by such European contemporaries as the Italian Futurists Umberto Boccioni and Carlo Carrà or the Parisian Robert Delaunay. In 1914, Bomberg made a manifesto-like declaration, of an emphatic Futurist nature: 'I look upon *Nature*, while I live in a *steel city* ... Where I use Naturalistic form, I have *stripped it of all* irrelevant matter.' His *Mud Bath* quite literally frightened the proverbial horses; the animals drawing the Number 29 bus down the King's Road in Chelsea would apparently shy as they saw the painting displayed outside the Chenil Galleries. Bomberg's one-man exhibition there in 1914 – when he was still only twenty-three – was the greatest triumph of his life.

But Bomberg emerged from the First World War shaken and changed. He spent some time working for the Zionist Organization in Palestine as an Official Artist, where he found himself again – and one of his most important subjects – in the brilliant light and mountainous terrain of the

Mediterranean. Over the coming years, in Spain, he produced some of his finest works in vertiginous spots recalling the 'high places' of the Bible: the hill towns of Toledo, Cuenca and Ronda and the Picos de Europa mountains. Bomberg painted there with exultation. Bit by bit, in the reality of these landscapes, he rediscovered the vehement, dynamic structure of his early work. But instead of the smooth finish of his first phase, he now became a master of thick, loose, loaded brushstrokes. In the 1930s, when the fashion was for clean geometric abstraction or Surrealism, Bomberg's new manner was incomprehensible. Increasingly he was ignored.

In place of his early emphasis on hard, mechanical modernity – the 'steel city' – he now found inner, emotional and spiritual truths in the subjects he depicted. When at work on a landscape – according to his wife, Lilian – Bomberg would study the prospect for a long time after his easel was set up. Hours might pass; then, when he was ready, he would paint, as the critic and historian Richard Cork wrote, with 'prodigious speed and certitude'. Bomberg was prone to alternations of exultation and depression, sometimes producing little work for years on end, and then completing a series of masterpieces in a spurt of inspiration.

Late in life, Bomberg summed his thinking up in a gnomic phrase. Form, he believed, was 'the artist's consciousness of mass'. But what did he mean by that? As we have seen, Hockney has insisted that human beings do not see geometrically or mechanically, like a camera; we see 'psychologically'. There is no such thing as an objective view of anything. Bomberg believed that vision was also physiological, that our comprehension of what we see is derived not just from the information that comes though our eyes, but informed by our experiences as three-dimensional beings moving around in the world. Especially important in this process is our sense of touch. He expressed this in epigrammatic notes: 'The hand works at high tension and organizes as it simplifies, reducing to barest essentials ... Drawing flows from beginning to end with one sustained impulse ... The approach is through feeling and touch and less by sight.'

Bomberg had been struck by a thought expressed by the eighteenth-century philosopher Bishop Berkeley: 'The sense of Touch and associations of Touch produce on sight the illusions of the third dimension.' Then, as

the Bishop had before him, he made a leap, proposing that by 'sensing the magnitude & scope of mass & finding the purposeful entities to contain it on a flat surface', the artist was brought closer to 'God the Creator'.

For him, painting and drawing were nothing unless they were expressions of the 'poetry in mankind in contemplation of nature'. Here was the rock on which Bomberg stood. In the desolate landscape of the mid-twentieth century, he insisted painting was a way – perhaps the only way – to affirm man's spiritual significance. This, then, was the spirit that lurked in the mass: the human spirit. But to reach it, it was necessary to pare away the inessential. In so doing, the underlying structure, the most crucial element of all, was revealed. Bomberg might have had little time for his contemporaries but he revered the old masters, above all Michelangelo, the titanic inventor – or discoverer – of form. This was a lesson that stayed with Frank Auerbach:

> His idiom was deeply anti-illustrational, in a sense I suppose anti-
> realistic. He thought, what I suppose is to some extent true, that it
> is the architecture of the painting that finally determines its quality
> – as long as it is seized in the most daring possible way. I remember
> going to Bomberg's class, and him showing me – as much as to say
> how can I kick this student who doesn't understand what's going on?
> – Piranesi's *Carceri*. At that moment I remember suddenly seeing that
> there was a real excitement in the wordless and subject-less tension of
> the structure in space. That did affect me.

So much did this affect Auerbach that achieving this 'tension of the structure in space' remained the goal of his life's work from that day on. Bomberg did not found a school; he was not, as Auerbach points out, 'teaching people to paint Bombergs'. Auerbach himself feels he was not really 'a follower'. Yet Bomberg had taught a profound lesson.

*

By the early 1940s Bomberg was reduced to such menial occupations as part-time work at Smith's Motor Accessories Works in Cricklewood, North London. Between 1939 and 1944 he applied unsuccessfully for over three hundred teaching posts, before eventually finding his foothold in the

world of art education at the Borough Polytechnic. One of the reasons why Bomberg fell into such a black hole was the very thing that made him such a remarkable teacher. He combined extraordinary levels of self-belief with total disrespect for established opinion or reputation. 'He had an impossible temperament,' Auerbach reflects, 'in the sense that he managed to muck his own life up by being immensely aggressive and making enemies in every possible direction. But it worked very well for his students.' Despite the fact that Bomberg, much like Bacon, seldom had 'a good word to say for anybody else', he was prepared to take young beginners absolutely seriously:

> I remember when I was at his class, there was a show of Matisse, sculpture and drawings. He said, 'What do you think of it?' I answered, realizing that I wasn't supposed to like anything, 'Well, actually, I was rather impressed.' He said, 'Well, they are rather good, and no worse for being like the drawings done in this class!' That was the tone. He was capable of coming up behind students and saying, 'Sickert wouldn't be capable of this formal, architectural composition you are making.'

Even in his days as a fiery Modernist, Bomberg's combative temperament had been active. His mentor as a young man had been the Edwardian master of brilliantly loose brushwork and suave portraiture, John Singer Sargent. Bomberg confided to Auerbach, 'Sargent used to like me to go round and tell him that his work was like a pavement artist's' (although how much Sargent really enjoyed this seems doubtful). But, if he regarded the famous and distinguished with disdain, Bomberg was remarkably open towards the youthful and unknown. Auerbach remembers how Bomberg treated him and his contemporaries as his equals, sharing with them his vision of what art should be:

> I was eighteen or nineteen and he would talk to me about absolutely anything that came into his head as well as about painting. He would talk about the shape of someone's ear, run down other painters – which you're not supposed to do – and all the while behind it there were grand ideas about what the process of painting *was*.

DAVID BOMBERG *Evening in the City of London*, 1944

Bomberg's account of what an artist should aim for was – like most attempts to explain the objective of visual art in verbal terms – vague in the extreme.

Bomberg's *Evening in the City of London* of 1944 gives a better idea of what he meant. He painted the war-torn city as a shattered network of tensions and energies in which there was little that was immediately identifiable apart from the dome of St Paul's looming over the scene. The image is packed with feeling and what you might call moral emotion. The colours and forms, even the vehement traces of the brush, transmit the idea that this is a place that has survived an apocalypse. The painting is alight with energy and a sense that this picture *matters*.

<div align="center">*</div>

Like many notable teachers of painting and drawing, Bomberg preferred to instruct visually, by working on another person's drawing, showing not telling. Auerbach describes his classes as:

more like ballet teaching. He would demonstrate to you, he would never suggest that something was adequate because you were a student. That was the prime thing. Often you'd end up with a sort of chaos when the class finished, but you'd been given a glimpse of what the great possibilities were. That I think is proper teaching. One slowly gathered from what he was saying, what he was really talking about. It wasn't lucid, the philosopher A. J. Ayer laying out a theory of art.

Creffield felt much the same:

At other art schools the teacher would come up and ... make an elegant drawing in the corner, then go off leaving you with this thing 'how to draw the figure'. Bomberg didn't do that. He was always very polite, 'May I?'; then he would always paint with the painting you had made. Often just bring your attention to something, the definition of a head out of your cloudiness. The whole business of draughtsmanship was finding a specific sense of something.

Kossoff has described the experience of observing Bomberg the teacher at work: 'Once I watched him draw over a student's drawing. I saw the flow of form, I saw the likeness to the sitter appear. It seemed an encounter with what was already *there*.' This, of course, raises the tricky question of what is in fact actually there – the answer to which depends, to go back to Hockney's point – on who is looking. Simply mimicking appearances mechanically – what Bomberg described with characteristic disdain as the 'hand and eye disease' he believed was taught in other art schools – led not merely to bad art. It was corrupting. The Euston Road School's emphasis on measurement, to Bomberg, was a case of 'hand and eye disease' in its most advanced form.

Although the classes attended by Auerbach, Kossoff and Creffield took place in an unglamorous corner of South London, under the tutelage of a man whose worldly reputation had long since evaporated, there was a sense among the participants that something momentous was happening. Some of them exhibited together under the name 'The Borough Group'. But, although there was certainly a resemblance between the work of the

various painters involved – vehement brushstrokes, for example – what Bomberg was teaching was not a style so much as an attitude; or rather a connected series of convictions.

Among these was the belief that painting was an immensely important business – none more so – but also that it was an extraordinarily difficult one. This mindset, too, was passed on to Bomberg's students, several of whom went on to lead lives of intense effort, maintained decade after decade. Creffield recalls his teacher's way of saying goodbye:

> 'Keep the paint moving!' That was a real Bombergian farewell.
> That's all you can do. The important thing is to drag yourself to the
> task. The people who survive are the ones who carry on. Bomberg
> was as much as anything a moralist. It was like being brought up by
> Ruskin, certainly a nineteenth-century attitude. There was nothing
> permissive about it, nothing like self-expression: 'Just do what you
> feel like, darling!' I'm grateful for it, but it was a very severe education.
> He had a huge charge of the gravity of Jewishness and I am not
> Jewish. I'm an English Catholic.

<p style="text-align:center">*</p>

Bomberg's lessons were various – the sheer importance of painting as an activity, its immense difficulty combined with the possibility of achieving something of the highest quality here and now, the potential of loose, thickly brushed paint. His students at the Borough Polytechnic took away different lessons from his classes. All who had much to do with him, however, felt they had encountered an extraordinary personality. When talking about him Auerbach repeats the writer and historian Jacob Bronowski's remark about William Blake, 'he was a man without a mask'.

GIRL WITH ROSES

One wants to do this thing of just walking along the edge of the precipice.
FRANCIS BACON, 1962

C yril Connolly, editor of the magazine *Horizon*, described life in the London of the early 1940s in terms that were both emotional and visual, focusing on 'the dirt and weariness, the gradual draining away under war conditions of light and colour from the former capital of the world'. It sounds a little like a painting – perhaps an early work by Coldstream. So it's not surprising that those painters who loved light and colour, longed – as the despondent Connolly did – to get across the Channel to France, or further, to places brimming with light and colour: the Mediterranean, even the Caribbean.

John Craxton was one of these. In May 1946, he went to Greece and, on the advice of a new friend, the writer Patrick Leigh Fermor, eventually ended up on the island of Poros, where he lived with a Greek family. He was soon joined by his former housemate, Lucian Freud. 'Lucian turned up and we painted like mad, both of us. Greece was lovely then, it was a marvellous moment.' This stay in the Aegean had a lasting effect on Craxton, who spent much of the remainder of his life living in Greece. From then on, he frequently painted a Mediterranean idyll, refracted though a softened and sweetened version of Picasso's style. These were pictures of a dream: not a violent and disquieting Surrealist fantasy, but a tranquil reverie about rustic life in foreign parts.

JOHN CRAXTON *Beach Scene*, 1949

The same could be said of the works that resulted from John Minton's exotic excursions, beginning in August 1947, when – in company with the writer Alan Ross – he set out for Corsica with a commission from the publisher John Lehmann for an illustrated book about the island. Minton responded enthusiastically to what he saw. 'Corsica is proving very exciting, full of Italianate romanticism,' he wrote to a friend back in Britain. 'The drawings pile up.' Nonetheless, this remained tourist's art, the product of a flying visit, charming but full of a romanticism that was not so much Italianate as second-hand – as hinted by the title of the book, published in 1948, *Time was Away* (a line taken from Louis MacNeice's poem *Meeting Point* of 1940).

Freud complained that the figures in Minton's paintings and illustrations 'have the air of all being of the same boy'. He preferred art to be much more specific: pictures of distinct individuals, seen in all their particularity, and absolutely clearly. As he grew older, and his temperament became more sharply defined, a clear distinction appeared between Freud and the 'contemporary romantics', such as Minton and Craxton, with whom he had previously socialized. Where they invented, he observed, and ever more closely.

Although he enjoyed the stay on Poros, Freud was not greatly attracted to Greece. Partly, it was a political objection – he disliked the fact that the country was still being run by Fascists and that the King had been foisted on the Greeks. More crucially for his work, Freud was unsympathetic to classical Greek art, the style that had been elevated and idolized by generations of British artists even before Lord Elgin had brought the Parthenon Marbles to London. According to Craxton, 'Lucian thought the Greek gods lacked charm and were very inhuman-looking or rather *a-human-looking.*' Classical idealism – which homogenized individuals into a generalized idea – ran directly counter to Freud's tastes. This was why he found Botticelli 'sickening' and didn't think Raphael knew how to draw.

Freud's own abiding memories of the stay on Poros concerned the people he encountered, their psychology and the social economics of the place, and, as usual, he quickly found a lover. Looking back, he mused:

The Greek word for stranger is the same as the word for guest – which is very sophisticated, don't you think? They were always offering me things. 'Take this sheep!' But it was quite awkward, I was only living in a room. There was nowhere to keep a live sheep … I was with a Greek woman, quite a simple islander. One day she asked me how old my father was when he married my mother. It seemed to me to be a very strange question. I told her that I thought probably my mother was in her early twenties and my father a few years older. She seemed a little downcast at this, and finally I realized that in Greece men married when they had made or inherited their money, so the greater the gap, the greater the wealth. Getting married early was a sign of poverty.

*

Freud returned to Britain in February 1947 and, a little over a year later, was himself married, aged twenty-two. Thereafter, though he travelled from time to time and spent a brief spell in the Caribbean, he seldom worked away from London, which, paradoxically, he found rather romantic.

Perhaps I don't really want to go anywhere else because, having arrived here at the age of ten, I still feel like a visitor in the most exciting place I can imagine. Whenever I think of going somewhere else, I think it's mad to think of travelling anywhere when there are parts of London I haven't visited.

By 1944, he had left the flat he shared with Craxton in Abercorn Place and had settled in Delamere Terrace, Paddington. This put some distance between his studio and affluent, middle-class St John's Wood, where he and his family had lived since arriving in Britain in flight from Nazi Germany in 1932. The move to Paddington alarmed his parents and was, no doubt, intended to do so. The urge to get away, to 'have some sort of life' was strong in him.

Delamere Terrace, overlooking the Regent's Canal, though now in a prime part of Little Venice, was then known as 'bug alley', a zone of crumbling slum housing occupied by what the Victorians disapprovingly called the 'undeserving poor'. Freud was delighted to observe their indifference to rules and laws, and gleefully described some of his neighbours as burglars

and bank robbers. His social explorations, however, moved in both directions – up and down – from the educated bourgeoisie of North London. He became a close friend, though not, he insisted, lover, of Lady Rothermere, one of the most prominent society hostesses in London. She and some of the people he met through her were also soon to be his subjects. However, for the next couple of years, his most constant sitter was the young woman with whom he began an affair soon after his return from Greece, and later married: Kitty Garman.

Kitty was a child of bohemia. She was the daughter of the sculptor Jacob Epstein and Kathleen Garman, who had been Epstein's favourite mistress. Epstein was himself a person whom Freud scrutinized closely, though not as a subject for his painting. In this case, the roles were reversed and Freud posed for his father-in-law for a portrait bust. Even so, he was absorbed and amused by the great man's quirks:

> He was full of rivalry and jealousy of other sculptors – particularly Henry Moore – and painters. I remember him once looking through old copies of the *Illustrated London News* and exclaiming 'Augustus John is getting a lot of attention!' He hadn't noticed that they were old copies from the time of the First World War! Epstein lived in an enormous house on Hyde Park Gate, and his studio was on the ground floor and bedroom on the first. On the way out I asked him what went on on the second floor. He replied, 'How should I know? I haven't the faintest idea.'

Epstein's s wife, Margaret, was unable to have children and tolerated most of his lovers, except for the one who meant the most to him, Kathleen Garman, whom Margaret shot with a pearl-handled revolver (fortunately not fatally). Kitty frequently described this event, which she imagined to have taken place while her mother was pregnant with her, although in fact it occurred several years earlier. It added further complexity to the relationship between Kitty and Freud that her aunt, Lorna Wishart, had been the first great love of his life. Their romance had only recently ended. Given all this, it was not surprising if Kitty was a little anxious. Cressida Connolly recalled her as giving 'an impression of great fragility and delicacy, with

her soft, rather tremulous voice and slender, elegant hands, but there was also a hint of steeliness'.

Freud once mused on how many of the women in his life had so often been nervous. Nervous – even tremulous – girls were in fact his type, and Kitty's watchful unease was the common factor in all the pictures he did of her over the next few years. In *Girl with Roses* (1947–48) she grips the stem of the flower hard as her eyes dart sideways. She seems to vibrate with anxiety.

Freud's early drawings and paintings had been a mixture of observation and quirky imagination. By 1947 this had changed. His pictures of Kitty Garman are obviously done in her presence, and from extremely close up. In *Girl with Roses* every hair on her head and each eyelash has been counted, the patterns within the iris of her eyes carefully set down. Yet there is still a strange discrepancy in relative scales: her eyes are too big for her face, which in turn is too big for her head, and her head is disproportionate to the rest of her body. As time went on, Freud's pictures of Kitty steadily increased in visual information – detailed data about her appearance – and also in tension. In the spring of 1948 she and the artist got married; in July she gave birth to a child, their daughter Annie. At the time of the sittings she was newly pregnant, and about to take the step of marrying this man, so unsuited to the role of husband.

Photographs of Kitty show someone recognizably similar to the girl in Freud's paintings, but slightly different. It was a subtle matter. Cressida Connolly was 'taken aback' when she met Kitty to discover her eyes really were as big as they looked in a later painting, *Girl with a White Dog* (1950–51). They weren't, though, quite as enormous as the eyes of *Girl with Roses*; no human being's are.

The point is not that the lens reveals what she truly looked like – a photograph, as everyone is well aware in the epoch of Photoshop, can often lie, and even before digitization it always could. But, crucially, though they were increasingly detailed, naturalistic and based on examination of the subject in the most searching manner, Freud's pictures were not photo-graphically realistic.

Unlike Coldstream, for example, who had an uneasy sense that photog-raphy produced the ultimately accurate picture of reality, Freud wasn't much

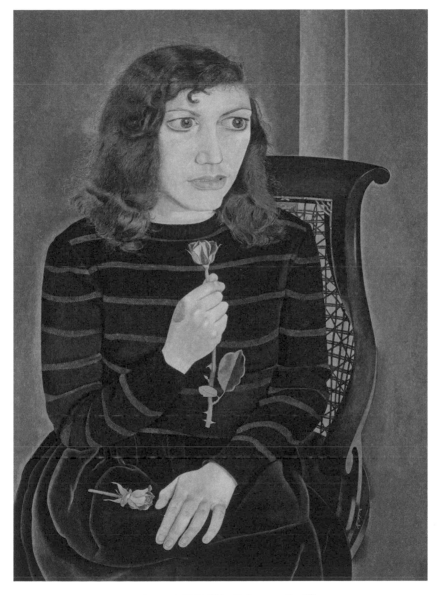

LUCIAN FREUD *Girl with Roses*, 1947–48

interested in it as a source for, or rival to, painting at all. 'A photograph', he said, 'contains a great deal of information about the fall of light, and not much about anything else.' He was more interested in what went on inside his sitters' heads. What he wanted to register in his painting were all the other aspects of Kitty, apart from the way the light fell – his feelings about her, hers about him, her tremulousness and inner steel, the way her presence affected his perceptions of her surroundings. (He observed that 'The effect in space of two different human individuals can be as different as the effect of a candle and an electric light bulb.') Since all painters had had to find a way of co-existing with photography since its invention in 1839, Freud – like his heroes Van Gogh and Cézanne – did so largely by ignoring it.

He did not, however, choose to explain what he was doing. His first statement about his approach to art did not come until 1954, and there was not much more for almost thirty years, until Lawrence Gowing published a book about him. Even to close friends, such as Frank Auerbach, Freud only occasionally talked about what he did, and why.

> Lucian was concerned, I think, with guarding his instinct and not
> making too many pronouncements, but when he did say something
> about painting it was very well worth listening to. You realized that
> there's a great machinery underneath that he's not going to expose.
> Sickert said something which seems to me as I've got older to be not
> untrue: he defines genius as 'self-preservation in a talent'. I think
> Lucian had a very strong sense of the self-preservation of his talent.

So it was not until 1982, when he was interviewed by Gowing, that Freud revealed his insouciance when it came to that fetish of Coldstream's and the Euston Road School – viewing the subject from a fixed position. Coldstream, on the one hand, was prepared to turn himself into a measuring instrument, a sort of human sextant. But, characteristically, Freud would not be pinned down:

> I take readings from a number of positions because I don't want
> to miss anything that could be of use to me. I often put in what
> is round the corner from where I see it, in case it is of use to me.

It soon disappears if it is not. Towards the end I am trying
to get rid of absolutely everything I can do without. Ears
have disappeared, before now.

Intuitively, he had found a way to reconcile two apparently opposing ways
to paint: he made observations as assiduously as Coldstream did, yet also
incorporated his feelings and thoughts within a picture severely restricted
to what he actually saw.

The art dealer E. L. T. Mesens, who showed Freud and Craxton's
work at his London Gallery, tried to persuade Freud that he was at heart a
Surrealist. The artist denied this – although as Mesens's then assistant and
jazz singer-to-be George Melly felt, this denial was 'suspect' because Freud's
work of the mid-1940s, 'dead birds, hares and monkeys; the intensity of the
early portraits, all displayed, whether he liked it or not, a surreal sensibility'.

Melly had a point. There is indeed a 'Surrealist flavour', as he put it,
in Freud's early work. But it is not so much *surreal* – beyond reality – as
more than real. That is, there is more reality in the picture than we would
normally see, and it is refracted though a remarkable sensibility. Freud
himself felt he was moving in the opposite direction to Salvador Dalí or
René Magritte: 'I wanted things to look possible, rather than irrational, if
anything, eliminating the Surrealist look.' Bit by bit, a feeling of strangeness
seeped into his images of reality. After all, he asked, 'what is more surreal
than a nose between two eyes?'

It is as if the intensity of the artist's attention acted like a magnify-
ing glass: the more he scrutinized an area, the more it grew. The sense
of human complexity, which in his grandfather Sigmund had led to a
revolutionary theory of how the psyche works, in Lucian's case all went
into his pictures. Unlike a true Surrealist, he disliked the idea of painting
anything that wasn't actually there – that was only in the mind. Where
a Surrealist might find inspiration in dreams or the visions induced by
opium, he found them a distraction:

I tried it [opium] once or twice in Paris with friends of [Jean]
Cocteau's in the forties, and it was very pleasant. But the problem
is that you have to keep increasing the dose to get the same effect.

And people say things such as 'It makes you see the most marvellous colours.' That to me is a horrible idea. My whole effort is to see the *same* colours all the time. Then they say that they are taken out of this world, but I don't want to be out of this world, I want to be absolutely in it, all of the time.

Freud found Stanley Spencer's fantasy pictures, the ones not painted from life, 'immensely boring, like someone telling you about their dreams' – a judgment both startling and funny, coming from the grandson of the man who spent an illustrious career listening to patients describe their dreams. But Lucian, though he greatly loved and admired his grandfather, was almost programmatically indifferent to psychology per se, including – or especially – his own. This was partly a defence against a persisting tendency to assume he was trading on a famous name. In Paris, Jean Cocteau used to refer to him, dismissively, as 'le petit Freud' (the little Freud). Lucian would often insist that he was 'not at all introspective'; on the other hand, he was immensely intuitive, a quality that he noted and admired in Picasso.

Freud's pictures of Kitty were his first great works, achieved when he was in his mid-twenties. His next exhibition, at the end of 1948, suggested that he was no longer just a promising artist, but that he had arrived. On 27 November 1948 William Townsend noted in his journal that he had 'visited some of the galleries'. That day he was much struck by one picture in particular, at the London Gallery: a pastel portrait of Kitty by Freud entitled *Girl with Leaves* (1948). This, he felt, despite the artist's 'painstaking exactness and neatness' had 'a large rhythm, a sense of the whole thing in each part like an early Florentine portrait'.

This was a perceptive analysis, and Townsend's enthusiasm was shared by one of the great arbiters of taste in twentieth-century art. On his first buying trip to London after the Second World War, Alfred H. Barr, of the Museum of Modern Art in New York, spotted the drawing of Kitty behind fig leaves while he was going through the London Gallery's stock. There was no hesitation; as soon as he saw it, Mesens told Melly, Barr 'pointed at it and said, "Wang, Wang, Wang!"' (Barr didn't really say that, Melly explained, that was just the way Mesens always imitated an American accent). It was

on this same visit that Barr bought Francis Bacon's *Painting 1946* from the dealer Erica Brausen for MoMA's collection.

<center>*</center>

Time was Away, the title of Minton and Ross's book about Corsica, would have been a fitting way to describe Francis Bacon's life in the late 1940s. No sooner had Brausen paid him the £200 for *Painting 1946* than he was off. He spent most of the next two years on an extended holiday, gambling in Monte Carlo – and usually losing – living on the Riviera, eating, drinking and ostensibly having fun. This was extraordinary behaviour for a major artist – a type of individual normally driven by talent and, thus, by the urge to work. What, then, was the reason for it? Partly, at least, it must have been because Bacon was once more stuck. His painting block had returned. Having achieved a masterpiece with *Painting 1946*, he was not sure what to do next.

Bacon depended, as Freud noted, on 'inspiration'. By his own account, *Painting 1946* had come into being – had virtually assembled itself – through a sequence of marvellous unconscious associations. How could he follow that? Naturally, he would have wanted to do something different – and better. His gambler's instinct urged him to push his luck. On the other hand, his extraordinary capacity for self-criticism would have led him to destroy anything less than superb. None of Bacon's pictures from 1947 survive, although he did attempt some unfruitful work on the Côte d'Azur. An undated letter to Erica Brausen's business partner, Arthur Jeffress, thanks him for an advance of another £200 against new pictures. Bacon added guardedly that he was currently busy on 'some heads which I like better than any I have done before'. He hoped that Erica and Jeffress would like them too.

This optimism didn't last. A second letter to Jeffress, dated 30 September 1948, asked for the exhibition of his work planned for Jeffress and Brausen's new Hanover Gallery to be postponed to allow more time to prepare. Bacon wrote that he would be back in mid-November, bringing some of the 'new stuff'. But he does not seem to have brought back much work, if any. There is just one extant Bacon painting dated 1948 – *Head I* – and that may well have been done back in his Cromwell Place studio.

Montage of material from Francis Bacon's studio, 7 Cromwell Place, c. 1950. Photo by Sam Hunter

Despite having toyed with the idea of settling in the South of France, and later trying and failing to work in Tangiers, Bacon discovered that he could not paint well anywhere except London. Indeed, even there, he didn't succeed just anywhere. The Cromwell Place studio, evidently, was inspiring; he had begun to make masterpieces shortly after moving in. Later he found a tiny upstairs flat at Reece Mews, Kensington, was also a fertile work-place. A more spacious apartment in London's Docklands, however, proved sterile. It was almost as if he needed to be confined. Or perhaps it was that his inspiration needed the correct growing conditions in order to blossom. Bacon once described 'the whole world' as 'a vast lump of compost'. This was certainly true of his own immediate working

environment, which was increasingly strewn with source imagery of the most bizarrely diverse kind.

More and more, the imagery in Bacon's paintings developed out of photographs – often tattered, creased and stained ones. The first person to document this habit was an American writer named Sam Hunter, who visited Bacon in 1950 in order to write about him for the *Magazine of Art*. He was struck by the piles of 'newspaper photographs and clippings, crime sheets like *Crapoulos* and photographs or reproductions of personalities who have passed across the public stage in recent years'. This was a strangely pallid way of referring to some of the 'personalities' in Bacon's image bank: the murderous Nazi ideologues, Heinrich Himmler and Joseph Goebbels, for example. They both appeared in one of the photographs Hunter took of Bacon's photographic archive, laid on the floor at Cromwell Place (while, Hunter recalled, Bacon looked on, apparently bored, or perhaps wary at having his creative processes examined).

Next to Goebbels, Hunter put down a reproduction of Velázquez's great portrait of Pope Innocent X, then Nadar's photograph of the poet Charles Baudelaire. All of these source photographs show visible signs of neglect, wear and – literally – tear. They are creased, scuffed, dappled with patches of oil and drips of pigment. Later Bacon explained this as the result of casual ill-treatment by his visitors – 'people walking over them and crumpling them and everything'. But, as the Bacon scholar Martin Harrison has pointed out, Bacon worked alone, had no models, and his cleaner was under orders not to touch his studio.

These neglectful 'people' must have been Bacon himself. Presumably he liked his working materials in this state; Freud went further and suspected Bacon actually 'improved' their tattiness a bit, adding a crease here and a dab of oil paint there. It would be characteristic if he had; he didn't draw in a conventional fashion, but he did doodles of found imagery, such as the cuttings and clippings Hunter arranged on his floor. It was perhaps a way of easing the transition of the found image into a painting.

Every modern painter has a relationship of some sort with photography. Bacon's – as with many of his relationships – was highly unusual. Like Coldstream, he accepted that photography had dealt with what he called

'illustration' – the everyday reality of things. Consequently, he did not propose to paint that kind of picture. Nor was he interested in photography as an art. In some ways, he was most interested in its failures: he liked blurring, and described how he chose to paint bodies 'slightly out of focus to bring in their "memory traces"'. This last phrase gets close to what he was after. 'I would like my pictures to look as if a human being had passed between them,' he once remarked, leaving a trace of human presence 'as a snail leaves its slime'. There was indeed a hint of mollusc-like secretion in the paintings he did in the late 1940s. The elderly painter Wyndham Lewis remarked on Bacon's liking for 'liquid whitish accents ... delicately dropped on sable ground like blobs of mucus'.

Memory was also important – not so much of what a thing or a person looked like, but of what it felt like to see them, the effect they had on 'the nervous system'. This was a piece of physiology of which Bacon was highly aware, and often mentioned. Presciently, he understood what psychologists such as Daniel Kahneman have since revealed. That we have not one mind but two: a narrating one which arranges our experiences, as far as possible, into an orderly story; and an experiencing mind – Bacon's 'nervous system' – which is constantly quivering with fear, rage, pain, pleasure or desire. Bacon wanted his pictures to bring back the feeling on the spectator's nerves of seeing something 'poignantly'.

The role of his photo library was, in the first place, to recall such experiences to his own nervous system. Bacon never worked, as many artists have, from photographs he took himself. And it was not until the early 1960s that Bacon would work from shots taken for him by other people. His anarchic archive consisted entirely of items he'd found, and which had taken his fancy, in books and the press. The array was, culturally speaking, eclectically democratic. Newspaper clippings lay side by side with photographic reproductions of great works of art, including Rodin's *Thinker* and Velázquez's *Pope Innocent X*. When Bacon used a great painting or sculpture as a source for his own work, he was never copying the original, 'painting paint' as Freud put it when he made a series of versions of Chardin's *The Young Schoolmistress* (?1735–36) many years later. Bacon, in contrast, was transforming a photograph of a great work of art into his own sort of painting.

*

Bacon's first exhibition at the Hanover Gallery finally opened in November 1949. It consisted of much starker works than the ones he had made in the mid-1940s. A series of six *Head*s were edited down to essentially one ingredient, which was not even as expansive as the titles suggested. They really portrayed just the lower part of a head: a gaping mouth, with prominent jagged teeth – with, appended, an ear and a suggestion of neck and shoulders. These were pictures of a scream – or perhaps a shout or a howl – in a black void. To Bacon the mouth was a crucial organ. Through it he obtained much pleasure – sexual, gastronomic, social – as a lover of food, drink and talk. It was also his prime means of aggression. He was a golden-tongued speaker, who would spend hours in conversation with a stranger in a pub, and also given to sudden bursts of verbal viciousness.

In some pictures these terrible jaws were presented on a small stage, backed by the thick curtains that can be seen in photographs of Bacon at Cromwell Place. Others were enclosed in a framework, like a rectangular wire cage. This 'space frame' appeared tentatively in *Head I*, the only work from 1948; and more clearly in *Head VI* (1949), which, like most of the works in the exhibition, was finished in a desperate rush in the few weeks leading up to the opening. It is possible, though not certain, that Bacon borrowed this idea from Alberto Giacometti, who was just emerging as the great artist of postwar Paris. Early in 1948 Giacometti had his first exhibition for thirteen years, at the Pierre Matisse Gallery in New York. A clear example of a work with a space frame, *The Nose* (1947), was included in this. The catalogue, with an essay by Jean-Paul Sartre and a letter written by Giacometti himself, was like a 'talisman', in the words of David Sylvester – another youthful London critic who spent a great deal of his time in Paris.

The space frame was not the most extraordinary aspect of *Head VI*. In this work, for the first but not the last time, Bacon spliced together two images that were lying about on those tables in his studio. One was of Velázquez's *Pope Innocent X*, clad in papal robes and seated on a gilded throne. The other was a film still of the screaming, wounded nurse on the Odessa Steps in Sergei Eisenstein's *Battleship Potemkin* (1925). This was

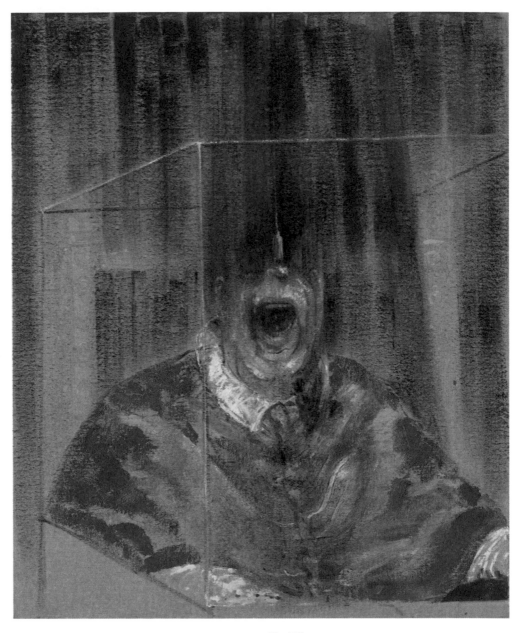

FRANCIS BACON *Head VI*, 1949

Film still from Battleship Potemkin, *1925*

lifted, like many of Bacon's sources, from a Pelican book called *Film* by Roger Manvell, published in 1944. Why did Bacon blend these utterly dissimilar pictures into one? Clearly, to him, they seemed to fit. They made his nervous system vibrate, as they have done those of innumerable viewers since. But perhaps he also merged them because they so dramatically *didn't* fit. He admired Marcel Duchamp's *Large Glass* (1915–23) partly because it was so 'impervious to interpretation'.

Head VI was only the first of Bacon's screaming popes, as they came to be known. This was an image he returned to again and again. Velázquez's picture 'haunted' him, he told Sylvester; he bought reproduction after reproduction because it opened up 'all sorts of feelings and areas of – I was going to say – imagination even!' In the end, however, he came to regret having done so, because he thought his now celebrated sequence of popes was unsuccessful; they were 'distorted records' of a great masterpiece, and he roundly, and characteristically, dismissed them as 'very silly'. Evidently, Velázquez's pope had some deep resonance for him, and it is not too hard to guess what it might have been. Angry, authoritative, older men were

emotionally very important to Bacon. The world in which he grew up had been violently disrupted by the dictators of the 1930s; closer to home, his father had thrown him out of his house. Even if some of the stories Francis told of Captain Bacon's brutality to him were fantasies, or part of his own invented mythology, it remains unquestionable that his relationship with his father was highly acrimonious.

Perhaps it was for this reason that Bacon was attracted to older men, as he told Lucian Freud around this time. Freud recalled, 'When he went with a younger man, Peter Lacy, I asked him about it, and he said, "I'm still attracted to older men, but now because I'm older, they're so old they can't do anything." Rather sad really.' Bacon's partnership with Eric Hall was apparently loving, but he was excited by violence and ill-treatment.

On the other hand, the nurse figure from *Battleship Potemkin* resembled Jessie Lightfoot, Bacon's old nanny, mother-substitute and partner in petty crime – they wore the same glasses, for one thing, and the character in the film is famously chasing a runaway pram at the moment she is shot. What's more, the papal robes look like a sort of dress, and wearing woman's clothes had been Bacon's ultimate crime, at least in his father's eyes. For all these reasons, the combination of screaming nurse and angrily glaring pope must have made Bacon's nervous system quiver. But he was at pains to deny that this was what the paintings meant – and rightly so. These were merely among the reasons they had come about.

Questioned about his screaming pope by some students from the Royal College of Art a couple of years later, Bacon grew agitated and came up with various 'absurd' explanations. More than once he said he had painted the pope because he wanted to use purple; that it was 'the magnificent colour' of the Velázquez that attracted him. It was, one witness felt, as if 'there was an aspect of his work he was anxious not to reveal or else that he really did not know consciously what he was doing'.

Perhaps what Bacon was struggling with was his sense – which he expressed lucidly in later interviews – that a good painting needed, in the words of the American painter Ed Ruscha, to be '*confounded*'. If it ceased to be enigmatic, the image would lose its power. Bacon himself said on one occasion, 'I can't explain my art, or even my working methods. It's like the

person who asked [Anna] Pavlova, "What does the Dying Swan signify?" and she answered, "If I knew, I wouldn't dance it".'

This view of Bacon's – a very strongly held one – was in part a legacy of Surrealism. It was also an attitude he passed on to several younger painters: painting wasn't a craft, nor merely a matter of turning out a saleable product. On the contrary, it was dark and it was immensely hard, and the inscrutability and difficulty were connected to what made it worthwhile at all.

CHAPTER SIX

LEAPING INTO THE VOID

The next time something as big occurred as Pasmore going abstract was probably
twenty years later, when the American Philip Guston did the same thing in
reverse, turning from an Abstract Expressionist to a figurative painter.

JOHN KASMIN, 2016

T owards the end of the war, Lucian Freud took Sandra Blow, a twenty-year-old art student, to the top of St Anne's, Soho. Blow recalled, 'The church was bombed but there were two towers left. One dreadful day he dragged me to the top and when we got there he leapt over this huge gap. Then he said, "Jump!"' She protested, 'You can't possibly expect me to do that', to which he replied, 'Just think of it as if you were on the escalator in Selfridges.' She jumped.

In 1947, Blow took another leap into the unknown. She travelled to Italy and settled in Rome. Italian art of the Renaissance and antiquity had been deeply familiar to British artists and art lovers for centuries. Indeed, it was a staple part of art education. As far as contemporary art was concerned, however, Italy was – and to an extent still remains – *terra incognita* to the eyes of London. In Rome, Blow made some enlightening international contacts including Nicolas Carone, an Italian American from Hoboken, New Jersey, who formed a bridge between New York and Europe. He had become part of a movement that was still not much more than a rumour in London: Abstract Expressionism. But he had also attended the Accademia di Belle Arti in Rome, at which he encouraged Blow to enrol. There she met another, even more remarkable artist, Alberto Burri, who was ten

88

years older than her. Blow had declined to be Freud's lover, but began a relationship with Burri that lasted for several years.

At this point Burri was just beginning his own journey into the unknown, in terms of art. From being a figurative painter, he moved to abstraction of an experimental type, using such materials as tar, sand, zinc, pumice, glue and aluminium. He was not depicting the materials of the world, but incorporating them physically into the surface of his pictures. A few years later he added sackcloth to his repertoire.

Together Blow and Burri travelled to Paris, where they encountered the beginnings of a new movement among some of the younger artists. It was a mood so diffuse that it did not yet have a name, but it soon gained several. In 1950, the critic Michel Tapié came up with the term 'Art informel', meaning an essentially abstract idiom without formal structure, not sharply geometrical like Mondrian or the works of the Russian Constructivists, but loose and free. The next year another term was coined: 'Tachisme' – from the French word 'tache', meaning stain. The year after that, Tapié returned to the naming game – somewhat despairingly – with a book entitled *Un art autre* ('Art of Another Kind', 1952), in which he described the wave of artists using gestures of the brush, the free flow of paint and their own painterly instincts to make pictures. These terms, particularly Tachisme, were much used in London in the mid-1950s – an era when few people had heard of Abstract Expressionism, let alone seen any.

Blow was thus catapulted into the heart of the avant-garde in several cities – all far away from London. In Paris, Rome, New York and elsewhere, many artists in the late 1940s and 1950s were tempted to make the leap into the unknown territory of abstraction. Though these developments were much talked about in Britain, the response they got was not necessarily a positive one.

*

In 1951, as part of the Festival of Britain's celebration of national creativity, the Arts Council organized a Festival of the Arts. This took place in London in May and June, with concerts of music by Edward Elgar, Henry Purcell and Benjamin Britten, alongside performances of works by William Shakespeare.

Sandra Blow, 1962

There was a great deal of discussion about what form the display of visual art should take. One suggestion was for a panorama of British life in the form of portraits of recipients of the OBE. Finally it was decided that sixty contemporary artists should be asked to enter a competition, out of which five would be awarded prizes of £500 each. The show was to be entitled '60 Paintings for '51' (although, in the end, only fifty-four artists took part, despite the then considerable inducement of free canvas on which to work).

The judges – a not particularly avant-garde trio including the art critic for *The Times* and the director of the Stedelijk Museum in Amsterdam – met on 16 April 1951 to make their choice. All of the works eventually submitted to the competition went on show on 2 May at the Manchester City Art Gallery. But even before they were unveiled, the event caused one of those outbursts of rage about modern art that punctuate postwar British life. On this occasion, the outrage was particularly provoked by just one of the successful entries.

Four of the five winning submissions – by Ivon Hitchens, Robert Medley, Lucian Freud and Claude Rogers – were received without much ado. It was the remaining winning entry, *Autumn Landscape* (1950–51) by William Gear, which caused consternation. This was, as its title suggests, a light and lyrical – albeit essentially abstract – piece of work with a strong hint of falling leaves and October sunlight about it. But these qualities were not enough to save it from the rage of the philistines.

The *Daily Mail* was furious that £500 had been spent on this picture, and reproduced it on its front page with the headline 'What Price Autumn on Canvas?' There were angry letters in the *Daily Telegraph* and sheaves of complaints were sent to the Arts Council. A committee of more conservative painters, including Augustus John and Laura Knight, protested publicly that the Arts Council was leaning 'too far to the left'. Gear himself responded that people should not be afraid of being labelled 'Bolshie' for admiring his work. Eventually a Liberal MP asked a question in Parliament, to which the Chancellor of the Exchequer, Hugh Gaitskell, made a written reply, pointing out – acutely – that the public criticism was founded largely on the basis of 'a small black and white photograph'. He added, blandly, that he'd been assured that, 'taken together', the five winners were 'widely representative in style'.

WILLIAM GEAR *Autumn Landscape,* 1950–51

*

In 1951 then, at least as far as certain sections of the British public were concerned – and some artists too – abstraction was an incendiary issue. This might seem strange, historically speaking. After all, at that point in the mid-twentieth century, the first abstractions in European painting were over forty years old. The great early Modern pioneers of the idiom – Kandinsky, Mondrian, Malevich, Klee – were all dead, their achievements widely known for decades. There had been abstract paintings and sculptures made in London before the First World War, and many more in the 1930s by artists such as Ben Nicholson and John Piper, among others.

The reasons for this cultural lag were complex. Britain had been cut off from the European avant-garde not only during the war, but for much of the rest of the time too by indifference and cultural conservatism. The works of Van Gogh, Gauguin, Matisse and Cézanne had caused a furious reaction when exhibited in London in Roger Fry's Post-Impressionist exhibitions of 1910 and 1912. King George V probably spoke for many of his subjects when, standing before an Impressionist painting at the Tate Gallery, he remarked to Queen Mary, 'Here's something to make you laugh, May.'

Amusement, however, could rapidly turn to rage. Gillian Ayres, who had a part-time job behind the desk at the mildly radical Artists' International Association Gallery (AIA) in Soho, remembers 'people saying the place ought to be burnt down and slamming the door. In those days people were terribly anti-, and I was frightened if I'm honest.' This was a common response to any type of Modernism, but abstraction was certainly most likely to provoke it. There was also a political dimension to the matter. Abstraction was linked, in the minds of at least some of its detractors – and its supporters – with the notion of building a new and better world. This, in turn, was part of the postwar mood, the spirit of the Attlee government and the new National Health Service and Welfare State.

In his prisoner-of-war camp, Stalag 383, Terry Frost had met and learnt from Adrian Heath, who was five years his junior but – rather than doing dead-end jobs in factories as Frost himself had done – had been to art school. After the war, Frost, already over thirty, studied at Camberwell himself and gravitated towards the heady company of Modernists: 'I didn't know

anything about abstract art but it was going on all around me when I went to London just after the war. It was talked about from breakfast time until dawn the next morning sometimes.'

Frost, Heath and Anthony Hill were drawn to Russian Constructivism, a movement that existed for a few stirring years after the Russian revolution, and aspired – quite literally – to construct a better future. Marx had observed that philosophers had previously interpreted the world, retorting that 'The point, however, is to change it.' Similarly, Constructivists were not interested in representing the world as it was, but in building a new one – preferably out of clear, geometric shapes and bold colours.

This, Frost related, was 'very much of a force on us':

> In that wonderful revolutionary period when they started work –
> thinking they were doing it for the people – the Constructivists had
> terrific structure, wonderful design that went through and everything
> they did – ceramics, Rodchenko's photography, El Lissitsky's
> typography – it was all absolutely fantastic.

Painting, obviously, was only a part of this project. But the utter, pared-down simplicity of Malevich's *Black Square* (1915), the greatest masterpiece of Russian revolutionary art, still stopped Frost's heart forty years later. 'Why should it be such a knock-out?' he asked himself, then answering his own question: 'It comes from a period when there was great hope and great opportunity. It's more than perfection. It's love and it's beauty, and it's poetry.'

For some, at least, the late 1940s felt like that too, a fresh beginning, a time of hope. Even for those who were not so optimistic about the future, nor so fired with idealism, abstraction seemed to provide the answer to many questions, most of all to the conundrum: what to paint and how to paint it? To 'go abstract', however, required a brave leap into uncharted waters, leaving behind all the traditions of painting and sculpture, almost everything that was taught at art schools. It took nerve.

A year or so before the Festival of Britain opened, Lawrence Gowing met up with Kenneth Clark, who had just returned from a visit to Victor Pasmore's studio in Hammersmith. The urbane connoisseur, Gowing recalled, was utterly confounded. 'Honest puzzlement shone from his eyes.

Victor Pasmore at work on a restaurant mural for the Festival of Britain, 1951

He said, "Victor really is extraordinary. Do you know he is scrawling spirals all over his pictures? Really, he is the most eccentric man! Great, rampant curlicues like nothing on earth."' Pasmore had 'gone abstract' – or, as we might put it now, 'come out'. The resulting shock was considerable. 'It caused a big stir,' Pasmore remembered, 'because I was well known as a landscape painter. I had a big reputation.'

In the middle of 1948, Pasmore had begun to make completely – as opposed to partly – abstract pictures. The moment of disclosure came in an exhibition later that year at the Redfern Gallery. It caused bewilderment among many of his admirers, but also engendered support from fellow artists. The first person to ring Pasmore up was Wyndham Lewis, perhaps the first British artist to paint an abstract painting, as early as 1913. Lewis said, 'At last …' Next David Bomberg rang to offer his congratulations, though both of these pioneer Modernists had, as Pasmore saw it, 'gone backwards' in their later work and become figurative painters. The last to call was Ben Nicholson, who had crossed over the same border in the 1930s, and was

now resident in St Ives, Cornwall, the doyen of British abstract painters. Pasmore's friend Coldstream and the Euston Road crowd were 'very good about it'. Having been abstract artists themselves, briefly, in the early 1930s, they understood what he was doing. Nevertheless, Pasmore felt, 'they were too far gone, they couldn't change'. Only stick-in-the-muds, he implied, did not understand that abstract art was the way forward.

Indeed, he could be as doctrinaire on this point as any prejudiced opponent of abstraction. Paula Rego, a young student at the Slade from 1952 to 1956, got, she remembers, 'a terrible ticking off' from Pasmore. 'He looked my work and said, "Nobody does things like that anymore! That is total rubbish."' Even at this stage neither could she follow the careful measuring and reticent objectivity of Coldstream, who was then principal of the Slade. Like so many of the painters in these pages, she followed her own idiosyncratic course, working from her imagination.

<p style="text-align:center">*</p>

The intriguing question was whether Kenneth Clark was correct in saying that Pasmore's spirals were 'like nothing on earth'. Were the spirals just invented shapes, 'pure form', or were they abstractions from something real, such as the vortex of Turner's *Snow Storm*? In other words, what *is* abstraction, really? It is a good question, one much debated in the 1940s and 1950s – and still not really answered.

On 26 October 1950, around the time that Clark paid his visit, William Townsend dropped in on Pasmore's studio and found it full of abstract pictures, 'no longer limited to rectangles and triangles' like Pasmore's earlier abstractions had been. The painter explained he had 'tried to invent more complex shapes "and it isn't easy"'. Several of these new pieces, Townsend noted, were 'composed with spirals'. He also saw the drawings and a model of Pasmore's design for the Regatta Restaurant, one of the buildings commissioned for the Festival of Britain. This he described as 'a vastly enlarged drawing, in black, white and grey lines, of a waterfall'. Apparently it was based on drawings of the sea done by Pasmore the previous summer at St Ives. So this, at least, seemed to be an abstraction from something seen in the real world.

A few months later, however, in a discussion at the ICA held on 9 Janurary 1951, Pasmore insisted that his new work was the result of 'a method of construction emanating from within'. Instead of depicting the world around him, he was working with 'formal elements which, in themselves, have no descriptive qualities at all'. Still, he admitted, his picture *The Coast of the Inland Sea* (*c.* 1950), though it had evolved from a spiral motif, had come to remind him of 'rocks, coast, sea and sky'.

The distinction between 'pure abstraction' and images 'abstracted from' something real was, and is, rather confusing (indeed it seemed to baffle Pasmore himself at times). The most perplexing aspect of it was that it is difficult to create any forms or marks that do not suggest *something* to the human eye and mind. Our brains seem to be primed to identify even random blotches and amorphous stuff – oddly shaped vegetables, or clouds – as images of people, animals or things. Sometimes, as Shakespeare put it, 'we see a cloud that's dragonish'. There was, however, a way out of this conundrum for abstract artists. What if, rather than depicting the surface appearance of things – as a photograph or a naturalistic painting did – they were dealing with what Noam Chomsky has dubbed 'deep structure'?

One probable source for the spirals that spun through Pasmore's art was the distinguished Scottish scientist D'Arcy Wentworth Thompson's book *On Growth and Form*, first published in 1917. This expounded the thesis that there were similarities that relate living creatures to machines, engineering and other forms fashioned by the laws of physics. Of these, the spiral, seen in sea shells and galaxies of stars alike, was one. This was an appealingly visual thesis and you could see it on the pages of Thompson's lavishly illustrated volume.

Two ex-students of the Slade School of Fine Art, Richard Hamilton and Eduardo Paolozzi, both organized exhibitions based on the idea. Hamilton was the curator of a display, also called 'Growth and Form', which was the contribution of the fledgling Institute of Contemporary Arts to the national celebrations of the Festival of Britain. Indeed, the patterns of the natural world were all over the Festival. Diners in the Regatta Restaurant would not only have been confronted by abstract, and near-abstract, art by Pasmore, Nicholson and John Tunnard, and have eaten off plates the

patterns of which were derived from the crystalline structure of beryl; as they dined they were also surrounded by textiles and wallpaper devised by the Festival Pattern Group at the urging of Dr Helen Megaw, a Cambridge scientist, based on diagrams of atomic structures.

The notion that art could work like nature, rather than merely imitate it, appealed to many artists. One was Kenneth Martin, a painter who 'went abstract' in 1948–49 and henceforth produced resolutely geometric pictures and sculptures. In 1951, Martin wrote that 'proportion and analogy' were fundamental to an art which did not attempt to represent 'the illusory and transient aspects of nature, but that copies nature in the laws of its activities'. 'Abstract' art, then, was more profoundly truthful than the other sort. However, Pasmore disliked the word, preferring to describe what he did as '*independent painting*: that is, art that is independent, like music'. An artist used basic forms in the way a composer used notes.

<p align="center">*</p>

Abstract art could come in many forms, and suggest many things without making a literal, photographic picture of them. Gear's prize-winning *Autumn Landscape* really was autumnal. Sandra Blow's paintings, when she returned to London in 1951, had a distinct feeling of landscape about them, emphasized by titles such as *Construction, Rock and Water* (1953). This is not exactly a picture of boulders on a hillside, but strongly puts you in mind of them.

A later work, *Painting 1957* (1957), is much looser and its references more elemental. Along with paint, in the manner of Burri – with whom Blow was still in friendly correspondence – she included sacking and plaster in the mix. It has the look of a primeval landscape, suggesting lava flows and magma, but turned on its side the horizon runs vertically downwards.

The lessons learned from *On Growth and Form* led some artists away from painting altogether. For Pasmore and fellow Constructivists such as Anthony Hill, it seemed more logical to make an object – a three-dimensional relief – than a picture, however 'abstract'. It is hard to separate painting from illusion, though many have tried. Indeed, the quest for pictorial flatness rather than illusory space was one of the hot topics of the day. Nonetheless, as Bridget Riley has noted, 'Depth is part of painting, to deny it is to deny part of what painting is.'

SANDRA BLOW *Painting 1957*, 1957

Any colour or tone, placed next to another, is prone to appear in front of the other or behind it. This is the 'push-pull' that the American artist and teacher Hans Hofmann argued any painter, abstract or not, had to work with. Many artists were trying to do so. Adrian Heath, for example – Terry Frost's friend and prison-camp mentor – was one. He wrote of how, to him, it was the 'process' that was the 'life of the painting'. The forms, the colours and their relationships all grew out of this; they came, in other words, from moving the paint around until it seemed right.

Gillian Ayres encountered perhaps the most impressive of all abstract painters in London in the early 1950s, as she sat at her post behind the desk at the AIA Gallery, chatting and smoking. His name was Roger Hilton. She and her husband and job-sharing partner, Henry Mundy, hung one of Hilton's paintings in the gallery, against the protests of the manager, Diana Uhlman. Ayres remembers, 'She came in and said "What's that up there? What the hell have you done?"' Then, amazingly, it sold and Hilton took Gillian and Henry out to celebrate:

> He admired proper gravy, so we had to go to a French restaurant, then we had to go back to his place. There were all his paintings there, the most abstract ones – totally non-figurative. I was wildly excited by them. It was incredibly pure painting: a voiding mood.

Ayres is echoing the way in which Hilton described the predicament of the abstract painter, who plunges 'entirely into the unknown … like a man swinging out into the void', a sentiment that – with the adjective 'abstract' deleted – would have resonated with Francis Bacon. So would another of Hilton's reflections: 'Very few artists know what they are doing: it is an instinctive, irrational activity.'

Hilton, born in 1911, was even more of a late starter than Bacon. It was not until the age of forty that he began to make any headway at all, having spent the 1930s and late 1940s either at art school, on extended visits to Paris and Berlin, or working at various odd jobs. He had tried frame-making, school teaching, had worked in a telephone exchange using his fluent French, and depended a good deal on his wife's earnings as a violin teacher. During the war years, he had fought as a commando and, as

mentioned earlier, spent three years in a prisoner-of-war camp in Silesia. He was an arrogant, eloquent man and an extremely heavy drinker. In 1951, in the eyes of the world, he looked like a complete failure. But he was beginning to make abstract art of remarkable force. Under the influences of some contemporary French artists, he had been working in an idiom he described as 'the sort of so-called non-figurative painting where lines and colours are flying about in an illusory space'. Then, having seen Piet Mondrian's work in the Netherlands, he began to do something bolder and starker.

Hilton's art and ideas – more than anyone else's – caught Gillian Ayres's attention, even though his conversation could be jarringly aggressive. Terrible experiences during the war and years of obscurity – plus large quantities of alcohol – had made him both volatile and cantankerous. She recalls:

> He was frightfully generous and nice a lot of the time, but he
> could also kill you with being beastly to you. I used to say he took
> the marrow out of your spine when he wanted to. Hilton talked
> a lot, and you realized that you were very ignorant. His line was:
> You don't know anything. The talk was good though, with art
> mixed up with everything else, rather like French gravy, but a
> lot of things would come out.

Among other disconcerting remarks, Hilton told Ayres that she couldn't be a painter because she didn't have a penis. Some of the insights he made about painting, however, were excitingly radical in early 1950s London. He talked, Ayres remembers, 'of forms flying out of the canvas and joining up with people in the room'. Around that time, he defined his works as 'space-creating' mechanisms, the effect of which 'is to be felt outside rather than inside the picture'.

This was a reversal of the standard assumption about painting: that it created a fictional space behind the canvas. Hilton was proposing the opposite: that a picture could propel its contents out into the real world around. Of course a baroque ceiling or a mighty mural such as Michelangelo's *Last Judgement* does just that: it seems to fill the air with *trompe-l'œil* saints and angels. But what Hilton was suggesting accepted the choice that Coldstream had outlined in his letter two decades before: if you give up the idea of

ROGER HILTON *August 1953 (Red, Ochre, Black and White)*, 1953

painting a picture of the world, you end up making an object, 'something to be worked as a carpenter works on a chair'.

Ayres marked a passage in a statement Hilton wrote, in which he mused on whether abstract painting could change the world. Could the artist, with just brushes and colours, create a boat 'capable of carrying not only himself to some further shore, but with the aid of others, a whole flotilla which may be seen eventually as having been carrying humanity forward?' Such ideas were in the air (even if, in retrospect, the answer is quite clearly, 'no'). But then, all sorts of ideas were flying around in the studios, galleries and pubs of London in this period. According to Ayres, 'It wasn't like the Americans who all got in a huddle and wanted to make Great Art. I don't think people in England behaved like that, I didn't mix with people who did anyway. They'd say a line, and you might like the line they said.' Hilton was one compelling talker at the time; another was William Scott. But there was no movement, even as diffuse and fissiparous as the ones that existed in New York and Paris.

The nearest thing to a manifesto that the London avant-garde ever got was a little book published in 1954 entitled *Nine Abstract Artists*. And this was more reflective of a polite agreement to differ than a united front. The nine divided broadly into two groups. On the one side, there were the Constructivists, whose work was based on geometry and mathematical proportion and who, in several cases, had made the step from painting into three dimensions and were making sculptures in relief. These included Pasmore, Anthony Hill, Kenneth Martin and his wife, Mary. In the middle was a sculptor, Robert Adams. On the other side were four painters, dedicated to juicy painting with visible brushstrokes, namely Hilton, William Scott, Terry Frost and Adrian Heath. These artists came up with the idea of the book themselves, and each contributed a personal statement (Hilton's contained the passage that Ayres had marked).

The nine artists approached a young critic, Lawrence Alloway, to write an introduction to the book. In his essay Alloway drew a distinction between 'pure geometric art' and 'a sort of sensual impressionism without things': an idiom, in other words, with all the pleasures of painting, the colours and textures, but no actual subject (which presumably was where Hilton,

Frost and Scott fitted in). However, Hilton – for all his bravado and talk of swinging out into the void – was deeply unsettled by the position in which he found himself. His notebooks reveal an artist wrestling with himself. 'The tyranny of the image must be overcome,' he proclaimed at one point; at another, he acknowledged that 'very often in the course of working your medium will say something you hadn't thought of', and by that, among other things, he meant 'subject matter'.

One problem was that real objects kept appearing, even in his most pure moments. The large red form in *August 1953*, for example, has contours very much like a naked woman's torso; a similar shape in *February 1954* has fairly unequivocally sprouted legs and breasts. After a short time, Hilton swung back out of emptiness, and became, as he put it, a figurative artist without being descriptive. He wrote to Terry Frost, announcing that 'I am going in future to introduce if possible a more markedly human element in my pictures.' The decision was a relief – 'I already feel much happier.' Soon he was painting nudes.

William Scott was a painter in a similar position: in the border zone between abstraction and figuration. Some of his paintings of the early 1950s fit Alloway's description of a 'sensual impressionism without things'; in others, the sensual brushstrokes are the same, but things – frying pans, tables, plates, bodies – are blatantly, distinctly *there*. For the rest of their careers, Hilton and Scott remained semi-abstract artists. What they did was often powerful and beautiful, but unlikely to change the world or, indeed, 'carry humanity forward'.

*

It was left to others to push ahead with Hilton's idea of forms that flew out of the picture and into the room. In 1956, two artists got together and arranged for this to happen quite literally: they orchestrated a whole gallery full of shapes that had escaped from the boundaries of the picture frame and entered the same zone as the people who were looking at them. The daring duo were Victor Pasmore and Richard Hamilton and the project grew out of a series of exhibitions Hamilton organized at the ICA. In 1955, he was the curator of 'Man, Machine and Motion', a show that examined the futuristic subject

WILLIAM SCOTT *Still Life with Frying Pan, c.* 1952

of automation. It consisted of over two hundred photographs of machines and mechanisms that somehow added to the powers of the human body. Prior to being shown in London, the exhibition had also been staged at the Hatton Gallery in Newcastle, the city where both Hamilton and Pasmore were teaching art at the time.

Pasmore was characteristically quixotic in his reaction to 'Man, Machine and Motion': 'It would have been very good if it hadn't been for all those photographs' (in other words, without most of the exhibits). In response, Hamilton proposed that he and Victor should put together an exhibition with no images, photographic or otherwise – 'a show which would be its own justification: no theme, no subject; not a display of things or ideas.'

This was to be a 'pure abstract exhibition': in other words, a display about nothing except pure form. Eventually, Hamilton and Pasmore put this project into effect under the title 'an Exhibit' (it was shown in Newcastle and also at the ICA in London). The display was made up of prefabricated acrylic panels of a standard size, forty-eight by thirty-two inches, in four varieties: transparent, white, red and black. These were suspended from the ceiling with piano wire, at right angles to the floor and to each other. The result was a walk-in Mondrian, a room-sized version of the relief constructions that Pasmore was making at the time. Underlying it was a stark message: the easel painting, as many people liked to say at this time, was dead.

LIFE INTO ART: BACON AND FREUD IN THE 1950S

I suppose I actually spoke about painting more with Francis Bacon than to anyone else, partly because he liked making statements, formulating dogma, laying down rules. Of course they changed all the time. We talked — slightly drunkenly and wildly — for about fifteen years. It was mostly about painting.

FRANK AUERBACH, 2009

Francis Bacon spent a great deal of time talking to many people; chance acquaintances, old friends, people he happened to meet in pubs. His life when he was not working was a mobile seminar, conducted on appropriately random terms, in which he would talk, often brilliantly, for hour after hour, most of his words disappearing into the smoky air of Soho.

The painter John Wonnacott – then an art student – was once walking down the street with him. It was, he remembers, 'one of those days when there is quite a strong sun coming down. Suddenly Bacon stopped and pointed at a horizontal shadow. He said, "Do you see the way that *eats* into the figure, like a *disease*?" The moment I heard that, I rethought shadow. That's proper teaching. It sent you back to Goya. Some painters see shadow as a way of making things real, creating an illusion, Bacon didn't.' On the contrary, he seems to have thought of them as spectres accompanying the living: ever present reminders of death. He once dreamed that he removed his own shadow from a wall, thinking, 'This will be useful for my art'.

Bacon's work of the 1930s and 1940s was entirely spun out of his head, from his imagination, starting off from extraordinary images that dropped into his mind, 'like slides'. He was much closer to the line of Symbolists, such as Gauguin, and to Surrealism than to naturalistic painters who worked from observation, from life. This remained true of many of his pictures throughout his career. But around 1950 there was a change. Bacon began to make portraits of specific people, though his was portraiture of a most unusual kind.

In a later interview with the American critic John Gruen, he began by confessing that he was 'very interested in painting portraits which now is almost an impossible thing to do'. The essence of the impossibility was that Bacon wanted to create a likeness that was not a likeness. That is, he wanted to create a powerful sense of a certain person – their presence – without in any conventional fashion documenting their features. The dilemma he had came in two parts. Firstly, 'how are you going to make a nose and not illustrate it?' Secondly, what stroke will make it a *strong* nose? It was a matter of continuous 'hazard, chance or accident'. Everything depended on the way the paint behaved and that, in this sort of picture, was not entirely under the artist's control.

The question then arises: What were those things he wanted to pack in? It was not by any means simply a question of likeness, or of the kind of meticulous observation that Coldstream or a Euston Road painter would have taken as a starting point. While struggling to explain to David Sylvester why he didn't admire Matisse nearly as much as Picasso, Bacon came up with a remarkable phrase. He'd always found Matisse 'too lyrical and dec-orative' – both minus points in Bacon's eyes; 'Matisse never had the – what can one say? The brutality of fact that Picasso had.' The remarkable point here is not so much his mention of brutality, which was, after all, Bacon's stock-in-trade, but his stress on the harsh facts that are the reality of this world – and not fantasies conjured up in the imagination.

Bacon had said much the same earlier in that interview, when talking about his own work of the early 1950s, especially a series he had painted that Sylvester characterized as 'men alone in rooms' with a claustrophobic quality, 'a sense of unease' that was 'rather horrific'. Bacon replied that he

Peter Lacy, c. mid-1950s. Photo by John Deakin

was not aware of this feeling himself but, he went on, those pictures were mostly of a man who was 'always in a state of unease', 'very neurotic and almost hysterical'. Those qualities, Bacon imagined, might have come across in the paintings because he had always hoped 'to put things over as directly and rawly' as he could. This could cause offence 'because people tend to be offended by facts, or what used to be called the truth'.

The man in those pictures was Peter Lacy, a former fighter pilot seven years Bacon's junior whom he met one evening around 1952 in the Colony Room. Lacy was, by Bacon's own account, the love of his life, and that was

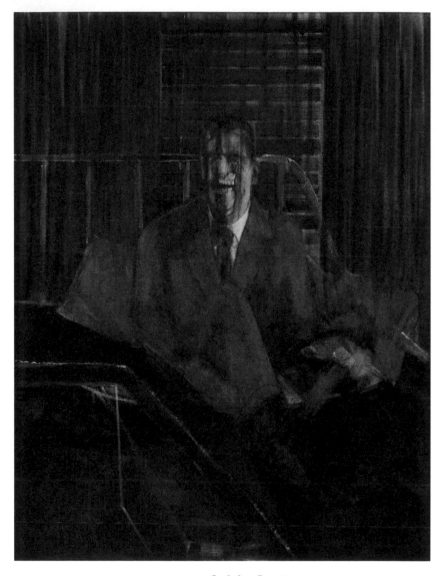

FRANCIS BACON *Study for a Portrait,* 1953

also Lucian Freud's view: 'He was only in love once really while I knew him, and that was with Peter Lacy.' But with Lacy, Bacon experienced 'four years of continuous horror, with nothing but violent rows'. In retrospect, he described him as 'marvellous-looking', witty, 'a kind of playboy', with plenty of money, a fact that made him feel the 'futility of life' more clearly. Lacy was also the most 'terrible kind of drunk'.

According to John Richardson, who knew them both, 'drink released a fiendish, sadistic streak in Lacy that bordered on the psychopathic'. Theirs was a sado-masochistic partnership with Bacon as the passive partner. Lacy would attack him, frequently and viciously. He hated Bacon's painting – which he probably saw as a rival for the artist's attention – and recurrently slashed his canvases to shreds and sometimes his clothes (this could have a comic side as, when they once went on a journey by sea, Lacy almost immediately threw all of Bacon's suits out of the porthole leaving him to spend the rest of the voyage in shorts).

On another occasion – in 'a state of alcoholic dementia', as Richardson put it – Lacy threw Bacon through a plate-glass window, with the result that the painter almost lost an eye. At that point, Freud decided things had gone too far: 'One day I saw Francis and he had been so badly beaten up – his eye was hanging out over his face – that I made a stupid mistake and went to see Peter Lacy and said, "This is really too much," and so on. Then they were both very angry and wouldn't speak to me.'

While all this was going on, Bacon's pictures were becoming more per-meated by a visible reality; less fantastic, but with an even greater charge of visceral aggression, menace and energy. The early 1950s saw Bacon achieve many of his greatest images. A particularly fertile year was 1953, which pro-duced a crop of Bacon masterpieces: blue-suited men, chortling, screaming, in a threatening state between despair and euphoria. These were all, more or less directly, portraits of Lacy. In *Study for a Portrait* this man in blue is seated on a bed, fully dressed, laughing the kind of laugh that might be heard in Dante's *Inferno*. Concurrently Bacon painted a magnificent series of pictures of animals in a state of aggression, such as snarling dogs, ready to spring, as well as apes and naked men copulating – or perhaps fighting – in the grass.

If his paintings seemed violent, Bacon mused, it was because most of us observe our surroundings through 'screens'. Lift those and immediately you are aware of the 'whole horror of life'. His was a vision of Hobbesian savagery: *Bellum omnium contra omnes*, the war of all against all.

It is a difficult question to decide: which of the two was the true victim in the relationship between Bacon and Lacy. The former suffered the violence – the destruction of his possessions, the near loss of an eye. Ultimately, however, it was Lacy who lost his life. He drank himself to death in Tangiers in 1962, 'destroyed' by the breakup of their love.

According to Freud, 'Francis complained that he spent the whole of his life looking for the roughest, most masculine men that he could find. "And yet, I'm always stronger than they are." He meant that his will was stronger.' It seems he not only saw life as a struggle – his ideal of a friendship was two people 'tearing each other to pieces' – he also fed off it, creatively.

The dreadful, alcohol-sodden, sado-masochistic affair with Lacy, and a similar relationship later with George Dyer, produced much of Bacon's finest work. It was a fight for domination in which the painter, and his work, came out triumphant, while Lacy and Dyer both lost their lives. As Bacon later reflected, 'People say you forget about death, but you don't. After all, I've had a very unfortunate life, because all the people I've been really fond of have died. And you don't stop thinking about them; time doesn't heal … one of the terrible things about so-called love, certainly for an artist, is the destruction.'

*

What Bacon was trying to do was enormously challenging. He wanted somehow to combine the compelling sense of reality that could be found in the greatest pictures of Velázquez and Rembrandt with the chance effects – the result of what the Surrealists called 'automatism' – of the artist ceding conscious control. Only in this way did he think that it was possible to create an image of reality that went beyond photography; a truly fresh, figurative painting. To bring this off, he rolled the dice again and again; usually, as at the roulette tables, he lost. Hence the paintings that were slashed, discarded, thrown away.

There is an intriguing eyewitness account of Bacon's working method at exactly this time. He had been brought in to fill in for John Minton at the Royal College of Art between 1951 and 1952 and, while he was there, a student, Albert Herbert, observed him painting. 'He was not secretive,' Herbert reminisced. 'He left the door of his studio ajar and during his very long lunches I often went in to see what he was doing.' Inside the studio were twenty or so canvases stretched the wrong way round. The student continued, 'At one stage he filled a bucket with black house paint and with a broom from the corridor splashed it over the canvases. It also went over the walls and the ceiling.' But then he took chalk and pastel and drew out the composition in a conventional fashion. So his methods, Herbert concluded, were not quite as spontaneous as Bacon would later claim.

Probably, however, Bacon wanted the spontaneity in the way the paint actually went on the canvas, not in the fundamental layout of the picture: that he had already visualized. Bacon seemed to rehearse the same type of image again and again. Herbert noted that most of these twenty paintings were 'naked men in the grass'. One day Bacon slashed many of them to fragments and gave the pieces to Herbert to use for his student work.

In fact, Bacon's only contribution to teaching at the Royal College was to attend a Sketch Club, where he was supposed to give an opinion on students' works. Bacon 'paced up and down in a bouncy way in his thick crepe soles, smiling amiably' (he was dangerous when smiley). Then he announced that he just could not think of anything to say about these paintings. He knew he was supposed to give three prizes, 'but as they all appear equally dull I can't do that'. He proceeded to answer some questions from the hostile audience he had created. In response to the query, 'Why are these paintings so dull?' he gave a revealing answer: 'Because they are all based on someone else's paintings.' Another sulky student wanted to know why then so many of Bacon's recent pictures had been based on Velázquez's pope. There followed 'an intense argument in which Bacon seemed to lose his cool and justify his work with impulsive, sometimes absurd explanations'.

It was, Herbert felt, as if 'there was an aspect of his work he was anxious not to reveal or else that he really did not know consciously what he was doing'. Paradoxically, Herbert found this in itself a profound lesson, the

most important he learnt during his time as a student. His other teachers had talked about painting 'as a craft which one went about in a rational, controlled way'. Bacon was indicating that this was not so; rather, 'real artists are driven by unconscious motives'.

*

In the early 1950s Bacon and Freud were a team, if not a couple. Freud's second wife, Caroline Blackwood – whom he married in 1953 – recalled or perhaps complained, 'I had dinner with [Francis Bacon] nearly every night for almost the whole of my marriage to Lucian ... we also had lunch.' There is at least one account of Bacon and Freud getting into a fight together to help out a painter friend, Robert Buhler, after a night at the Gargoyle Club in Soho. Buhler had offended the writer James Pope-Hennessy, who was accompanied by 'a couple of his paratrooper "rough-trade" boys'. Pope-Hennessy and his pals were waiting when Buhler left the club with Freud and Bacon and attacked them. 'Lucian was very brave. He jumped on the back of one of the bully boys while Francis kicked at his shins. Every time one of the paratroopers came near him, Francis just kicked – in a very lady-like way, I must say.' Probably, both Freud and Bacon enjoyed the aggro.

Their friendship did not get going properly, however, until Bacon returned from the Côte d'Azur in 1949, enjoying its most intense period in the years that followed. At this time, Freud was struck not so much by what Bacon painted as how fast he did so, and the intense criticism to which he subjected his own work. He would generally go round to Bacon's studio in the afternoon, he told the critic Sebastian Smee, and Bacon might say, '"I've done something really extraordinary today." And he'd done it all in that day. Amazing.' Freud recounted how Bacon would have 'ideas that he put down and then destroyed and then quickly put down again'.

*

Freud, on the other hand, could only ever work extremely slowly. Posing for him was like submitting to 'delicate eye surgery', as the painter Michael Wishart, who sat for him in the 1940s, described it. The procedure was intimate and prolonged, with Freud working on a canvas or panel balanced

on his knees. When he painted Bacon in 1952, however, he chose a small copper plate. Bacon subjected himself to his friend's minutely intense scrutiny, though Freud's memory was that the sittings were not inordinately prolonged:

> I always take a long time, but I don't remember it taking that long.
> He complained a lot about sitting – which he always did about
> everything – but not to me at all. I heard from people in the pub.
> He was very good about it.

The result, even more than Freud's paintings of his wife, Kitty, was clearly a masterpiece. For at least two decades it was Freud's best-known picture (stolen in 1988 and at the time of writing had still not been recovered).

In this painting the viewer is brought much nearer to the surface of the sitter's skin than one would be in a normal social encounter. Bacon's face almost fills the whole area of the picture, so that his eyes nearly touch the frame on either side. One is deprived of the normal distance that divides us from people we meet – and also those we see in pictures. That is part of the power to discomfort that these early Freuds possess. We are not used to being eye-ball to eye-ball like this with strangers. But, beyond that, the portrait had an extraordinary quality of inner tension, which led the critic Robert Hughes to describe it as resembling a grenade a fraction of a second before it explodes; paradoxically this feeling was intensified by the enamel smoothness of the technique.

A number of Freud's pictures of this era, including the portrait of Bacon, were painted on copper – a support that had been popular in the early seventeenth century for small pictures, but not much used since. Freud employed it for small works, almost tiny enough to count as miniatures. The fine sable brushes he painted with produced a glassy, untextured surface. Auerbach chose an archaic word to describe this phase of Freud's work, 'limning' – which is generally associated with Elizabethan and Jacobean miniaturists – and it fits.

Freud's portrait of Bacon is a testament to closeness in every way – physical, psychological, emotional. There was nothing in the least sexual in the relationship between the two, although Freud recalled that Bacon's elderly lover, Eric Hall, 'who kept him', was suspicious that there was. He never

LUCIAN FREUD *Francis Bacon*, 1952

felt the slightest hint of an advance from Bacon and the lack of any tension of that kind is confirmed by Bacon's *Portrait of Lucian Freud* (1951). In its way it is a remarkable compliment since it was his first portrait of a named individual (although based bizarrely on a photograph of Franz Kafka). For whatever reason, the result was utterly devoid of the violent energy and sense of menace that normally made Bacon's work so extraordinary.

By this time Freud, for his part, had developed his idiosyncratic way of working, a method that – as the English novelist Anthony Powell wrote of the world view of one of his characters – was probably 'ill-adapted for use by anyone but himself'. He explained it in a statement entitled 'Some thoughts on painting' published in the magazine *Encounter* in July 1954. First he defined himself as an artist who uses 'life itself' as his subject matter, translating it into art 'almost literally'. For this purpose, he worked with the subject in front of him or constantly in mind; later in his career, Freud would refuse to paint a brushstroke of a picture unless the model was there in the studio (this applied even to the floor boards or the furniture).

For Freud, his observation of the subject wasn't confined to formal sittings. It went on all the time he was with the person – or animal – he was painting, and when he was engaged on a picture 'the subject must be kept under closest observation', night and day if possible, so that he, she or it could reveal everything about themselves: 'every facet of their lives or lack of life, through movements and attitudes, through every variation from one moment to another'. In this Freud included their 'aura' – by which he meant the effect they have on the space around them. This could 'be as different as the effect of a candle and an electric light bulb'. Such a level of scrutiny sounds daunting, but for many models – those he was not having love affairs with, for example – it came down to spending a lot of time with the artist, eating meals together, chatting.

But now comes the twist. Up to this point, Freud sounded much like what he called merely an 'executive artist' – one who strives to imitate exactly what is there. But for him, all that observation was merely the beginning of the creative process. From everything he observed, he made a *selection*; and it was that choice that gave the picture its power. Yet, despite the close scrutiny – each follicle and fold of skin being documented from inches

away – Freud wasn't particularly interested in creating a good likeness. What he was after was quite different: a picture that would have a life of its own. And that was not achieved by an artist who merely copied nature superficially, it was necessary to change it. What the picture should contain was the artist's own feelings and thoughts about the subject, put together in such a way that it acquired a power and presence of its own:

> Since the model he so faithfully copies is not going to be hung up next to the picture, since the picture is going to be there on its own, it is of no interest whether it is an accurate copy of the model ... The model should only serve the very private function for the painter of providing the starting point for his excitement. The picture is *all* he feels about it, *all* he thinks worth preserving of it, *all* he invests it with.

Like Pygmalion, Freud claimed to 'dream' that his picture might actually come to life, and only when it reached completion did he realize that it was just going to be another picture.

In practice, however, despite Freud's lordly view of the artist's omnipotence in the studio, there might be disputes with the model. One such was generated by *Interior at Paddington* (1951), the first of a series of pictures for which the photographer Harry Diamond posed. Diamond was a close contemporary and – perhaps in some respects – alter ego of the artist. He was also Jewish but, rather than coming from a background of wealth and celebrity like Freud did, Diamond had grown up poor in Bethnal Green. He was, Freud believed, 'aggressive as he had a bad time being brought up in the East End and being persecuted'. But then Freud too, as a young man, was aggressive; indeed, this formed the bond between him and Diamond. 'He was helpful to me, having grown up ... with Mosley's Blackshirts around, in various fights I used to get into. He would sometimes say, "No, this is too dangerous, you had better get out", that kind of thing.' In this first picture Diamond's right hand is clenched into a fist although his gaze is thoughtful, if perhaps wary.

On the Soho scene, Diamond was known as 'the man in the mac' and had achieved the rare feat of being barred from the French House pub, having thrown a glass of beer at the proprietor Gaston Berlemont. He and

LUCIAN FREUD *Interior at Paddington*, 1951

Freud had known each other for years when, in 1950, Freud asked him to sit. *Interior at Paddington* was one of the artist's most immediately successful early works: it was a prize-winner in the Arts Council's exhibition '60 Paintings for '51', bought for £500 by the Walker Art Gallery, Liverpool, and shown at the Venice Biennale.

At this point Freud still painted sitting down, a constriction he soon came to find unbearable. But, at five feet high, it would have been impossible to paint this canvas with it resting on his knees. So he must have executed it while seated at an easel, peering intensely at the model and his surroundings.

This – and the alliance between these two young men, sealed by shared violence and disquiet – begins to explain the atmosphere of the picture: its tension and strangeness in which every fold of Diamond's mackintosh is studied with mesmerizing attention, so that it becomes as beautiful as the satin robe of a courtier by Anthony van Dyck. The plant is as much of a portrait as the man, every sharply angular leaf treated as an individual.

Even so, Diamond was 'slightly miffed' about the image: 'People come up and say what a great painting it is, and I say, "Yeah, but I don't really have short legs". In point of fact, my proportions are very good.' To this complaint Freud responded that 'the whole thing was that his legs *were* too short'. This might seem to contradict his stated position in *Encounter* that likeness was not paramount in his painting. The truth was that, to Freud, likeness both did and did not matter. 'My work is purely autobiographical,' he later declared, 'I work from people that interest me, and that I care about and think about, in rooms that I live in and know.' If the painter doesn't know the sitter, he said on another occasion, 'it can only be like a travel book'. That said, he reserved the right to make any alterations he saw fit, for the good of the painting.

*

What Freud and Bacon were united in opposing was something called 'illustration'. By this Bacon meant not just 'remaking the look of the image', but trying to 'open up so many layers of feeling if possible'. Mysteriously, this was done by great artists such as Velázquez, but could no longer be done 'for very many reasons', but particularly because of the advent of photography;

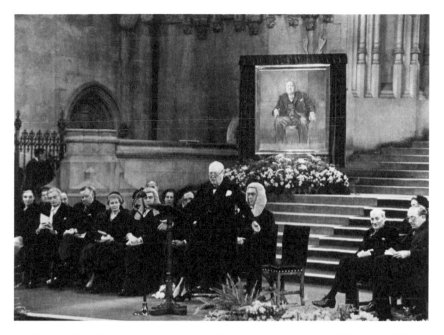

Winston Churchill at the presentation of the Graham Sutherland portrait at Westminster Hall on the occasion of his 80th birthday, 30 November 1954

worthwhile paintings could not be created by copying photographs. Freud, although he stuck much more closely to what was observable, essentially agreed. That was why he only depicted those he knew well: who else, he asked, 'could he portray with any profundity?'

Even so, the concept of illustration is a little elusive. As it happens, however, it is illustrated itself by the portraits done by Bacon's old friend and Freud's early mentor, Graham Sutherland. It was Sutherland who painted the most famous and controversial portrait of the decade. This represented the Prime Minister, Winston Churchill, and was commissioned in 1954 at a fee of 1,000 guineas. The plan was for it to hang in the Houses of Parliament after the Prime Minister's death, but it was to be given to him initially as a gift at a ceremony to mark his eightieth birthday. Notoriously, on seeing the painting, Churchill and his wife were appalled, so much so that the latter eventually had it destroyed. Churchill, with heavy sarcasm, described the picture as 'a remarkable example of modern art', but that, ironically, was

just what it was not. Sutherland's line was sharper than that of a jobbing portrait painter, and his characterization more incisive, but essentially he was offering a chic updating of the grand portrait tradition. On occasion Sutherland used photography as a tool, twice taking his photographer friend Felix Man along to sittings, since he felt 'Sir W' was unusually restless and he needed to use every means he could to 'gather information'. Even when he did not use photographs, there was something photographic about all Sutherland's portraits: an air of a luxuriously handcrafted snapshot.

This was illustration, though of an upmarket variety. Years later, on the last occasion Sutherland and Bacon met, the former remarked that he had been doing some portraits and wondered whether Francis had seen any. Came the deadly reply: 'Very nice if you like the covers of *Time* magazine.' They never spoke again, but Bacon clearly had a point. *Time* magazine covers were the epitome of illustration – obviously photo-based, executed with professionalism and panache. Strangely, Lucian Freud was eventually commissioned to produce one himself. Less surprisingly, the project was a failure.

This, however, did not happen until Freud had altered the way he painted, and fallen out of style. The proximity to the model and his immobility became intolerable to the artist himself. In the mid-1950s he felt an impulse to stand up, and also to paint in a looser, freer fashion. He complained 'my eyes were going completely mad' with the strain of depicting such a degree of detail; he could no longer stand the constriction of painting sitting down. So he stood at the easel, changed his sable brushes for hog-hair ones, and slowly his work began to change.

*

As he sought a new direction, Freud was impressed by what Bacon was saying about his own pictures at the time: 'He talked about packing a lot of things into one single brushstroke, which amused and excited me and I realized was a million miles away from anything I could do.' When, half a century later, he was asked to revise his statement for *Encounter*, Freud decided that the only point he wanted to add was about the importance of paint, that painting, after all, was all about *paint*.

The problem Freud then set himself, and it was a solitary task, was how to combine this sense of greater gusto and thicker, juicier paint with his own artistic project of depicting the distinct form and texture of each individual subject. It was not an easy one to solve, and the initial results pleased few, even the artist himself: 'I was very aware of the terrible things I was doing in the process.' He recounted:

> I had an exhibition at Marlborough Fine Art of paintings I had
> deliberately made much more free. Afterwards Kenneth Clark wrote
> a card saying that I had deliberately suppressed everything that made
> my work remarkable, or something like that, and ended, 'I admire
> your courage'. I never saw him again.

It was after this, in 1959, that Freud was approached by *Time* magazine to draw a cover illustration of the Swedish film director Ingmar Bergman. 'Francis Bacon advised me, very wisely, to agree only on the understanding that I would be paid whether or not the portrait appeared. I explained that I could work only very slowly and always from people I knew.' Freud asked for £1,000, then an enormous sum, and the *Time* representatives replied that they'd never paid anyone that much before and would have to hold a special meeting to discuss it. So Freud settled for a little less and asked whether, if he failed to produce a portrait, he could retain half the fee.

From the beginning the omens were not good. Bergman, who was notoriously cantankerous and dictatorial, had evidently never heard of Freud – or if he had, he was not impressed. As Freud told it, 'He kept disappearing to have his girlfriend, who was a very beautiful actress, for which I didn't blame him at all.' Freud did, however, resent Bergman telling him to put out a cigarette, instructing him to paint his left profile and – worst of all – not giving him the time he required, continually expressing surprise that the picture was not yet finished.

Finally Freud put it to Bergman that, since neither of them was enjoying this process, if the director would give him a decent, long sitting over the weekend he would do his best to get the picture done. Bergman responded that he liked to spend Saturday and Sunday mornings in bed with his wife. At this, Freud turned to the *Time* journalist who had accompanied

Bergman and said, 'I've no preconceived idea of how I should be treated, but I *know* it's not like this.' By mutual agreement, they abandoned the project. In retrospect, Freud felt the whole muddle had been his fault: 'I was in a false position; I did something that is only what a hack does, and I was treated like one.'

This incident must have been important to Freud, as he described it on several occasions. Perhaps this was because he had learned an important lesson. Never again did he accept any such offer, nor – with the rarest exceptions – paint a commissioned portrait. The path ahead looked dauntingly hard, but he stuck to it for many years until his reputation once again began to rise.

CHAPTER EIGHT

TWO CLIMBERS ROPED
TOGETHER

I remember the extraordinary effect of Auerbach's early paintings of Primrose
Hill, all in yellow ochre, grooved, engraved, as if in wet gravelly sand: as if one
had fallen asleep after long contemplation of some Rembrandt ... and then in a
dream found oneself actually walking in the landscape.

HELEN LESSORE, 1986

Art history occasionally throws up a couple of painters – such as Monet and Renoir with Impressionism in the 1870s, or Picasso and Braque with Cubism forty years later – who work out a new idiom together. Leon Kossoff and Frank Auerbach, who as young painters had both attended David Bomberg's classes at the Borough Polytechnic, had a similar synergetic and symbiotic relationship. Auerbach recalls that time:

> Although I don't think we were tremendously articulate about laying
> out our plans, there were fifteen, sixteen years when we went into
> each other's studios constantly ... I can't speak for Leon, but I was
> surprised by what he'd done, he may in turn have been surprised
> by what I'd done, so there was also that thing, like Picasso said of
> himself and Braque, of two climbers roped together.

They were outsiders, thrown together in a devastated city; the excavations for the new buildings that were rising all around became a subject for both of them, and one of their earliest themes. In those paintings the thick, glutinous oil pigment that Kossoff and Auerbach both favoured seems to metamorphose

FRANK AUERBACH *Rebuilding the Empire Cinema, Leicester Square,* 1962

into Thames clay. The pictures give an almost physical sense of a descent into cavernous excavations; of feeling your way around the churned-up chaos of a city half way between wartime destruction and postwar rebuilding. The shattered, half-reconstructed scenes looked, to the young Kossoff, 'awful but also rather beautiful'; Auerbach agreed:

> It was like a precipitous landscape. As you went in buses you saw the sites of bombed buildings with the pictures still on the walls, the fireplaces and so on, and great craters. As a formal theme it made a marvellous mountainous terrain. One couldn't help but be affected by it.

The teenage Auerbach was a wanderer in postwar London because his lodgings were not rooms 'anyone would want to sit in'. What he saw on his bus rides and walks around the city astonished and inspired him. Something like 110,000 houses in the urban area of London had been destroyed beyond repair; another 2,888,000 were seriously damaged. Virtually every structure between Moorgate and Aldersgate Street in the City had been flattened. Huge areas of housing in the East End were pulverized. The great town looked, the novelist Elizabeth Bowen thought, 'like the moon's capital – shallow, cratered, extinct'.

Auerbach had arrived in London in 1947, aged sixteen. For eight years prior to that, he had been at Bunce Court, 'a curious Quaker boarding school in the country that was run by idealistic people'. After he took his Higher School Certificate, he wondered, like most young people, what to do with his life. He had left Germany forever when he was seven, one of a group of children who were sponsored by the writer Iris Origo to be sent to school in Britain. He said goodbye to his mother and father on the dock at Hamburg and never saw them again. They were murdered in Auschwitz in 1943. Young Frank had an idea that he wanted to be an artist, and no one warned him that this was a difficult course in life. 'Parents, I believe, are worried about whether their children will make a living', but for him, there were none to raise any objection.

Once in London, he began taking painting classes at the Hampstead Garden Suburb Institute as well as acting in several plays, taking small parts. In 1948, he had a walk-on role in a play by Peter Ustinov called *House of*

Regrets; one of the more important roles was taken by a young widow – her husband had accidentally drowned in the Serpentine – with three young children. Her name was Estella Olive West, Stella for short, and she was thirty-one years old. She was struck immediately by Auerbach; 'Frank was a beautiful young man, looking very much older than his years, very mature,' she thought. 'If he hadn't been a painter he would probably have been an actor.' Auerbach moved into the boarding house she ran at 81 Earl's Court Road and, before long, they became lovers. Again, there was no one to stop them; their affair fitted the spirit of the times – improvising a new life among the bomb sites. Auerbach remembers: 'After the war, because everybody who was about had escaped death in some way, there was a curious feeling of liberty. It was sexy in a way, this semi-destroyed London. There was a scavenging feeling of living in a ruined city.'

Meanwhile, Auerbach was attending St Martin's School of Art and then the postgraduate Royal College of Art. It was at St Martin's that he first met and bonded with Leon Kossoff, five years his senior. He soon persuaded Kossoff to come along to Bomberg's evening classes, as neither felt entirely at home at St Martin's where the prevailing idiom seemed to them bland, as Auerbach recalls: 'Leon and I were perhaps a bit rougher and more rebellious than the other students. We wanted something a little less urbane, a little less tea-time, a little less limited and not so linear and illustrative.' When Kossoff failed the St Martin's exam at the end of the year, Auerbach was all the more impressed. He hadn't had an extensive education, but he knew what artists were: they were rebellious; they failed exams. He recognized 'a certain magnanimity of talent' in the older student.

Kossoff, born in 1926, came from a much more settled background. Although Auerbach had a few surviving relations, essentially he had been cut loose by the forces of history. Kossoff, on the other hand, grew up part of an East London Jewish world. His father – an immigrant from the Ukraine – ran a bakery. All of this affected the young Kossoff's approach to painting: whereas Auerbach became a painter of solitary figures, Kossoff often depicted groups, and when he was painting a crowd on the pavement he would find that – unintentionally and automatically – their faces would take on the features of people he knew.

Frank Auerbach in his studio with a portrait of Leon Kossoff, c. 1955

His was not in any way an artistic background. 'The world I grew up in was fairly medieval,' he recalls. His father struggled to support the family as a baker, and 'artists were considered wastrels'. Yet Kossoff was drawn to art by an inner urge; one day, at the age of nine or ten and quite by chance, he found his way into the National Gallery. 'At first the pictures were frightening for me – the first rooms were hung with religious paintings whose subjects were unfamiliar.' Then he discovered Rembrandt's *A Woman Bathing in a Stream* (1654), which seemed 'the only alive painting in the gallery and for a long time the only work that had any meaning for me'. For the boy Kossoff Rembrandt's picture opened up 'a way of feeling about life that I hadn't experienced before'. He resolved to teach himself to draw, learning from this painting.

Later on, in 1943, Kossoff had another epiphany when he stumbled by chance upon a life class in Toynbee Hall, an adult education centre on Commercial Street near Spitalfields. A model was posing and students were seated at easels, drawing her. Immediately and instinctively, convinced that he ought to be part of this, Kossoff joined the class. For him, learning to draw became a lifelong project, an almost unattainable ideal, because the standards he set for himself were so high. Years later, he explained what drawing meant to him in a statement for the catalogue of an exhibition of the work of his friend Frank Auerbach:

> Drawing is making an image which expresses commitment and
> involvement. This only comes about after seemingly endless activity
> before the model or subject, rejecting time and again ideas which
> are possible to preconceive. And, whether by scraping off or rubbing
> down, it is always beginning again, making new images, destroying
> images that lie, discarding images that are dead.

To some extent, this echoes Bomberg's opinion that art is not a pastime or a decorative addition to life, but a moral imperative, deeply connected with questions of truth and morality. Auerbach, talking about Kossoff's work in return, makes the point that:

> I think character is far more important than what is called 'talent'. It's
> very difficult for people to learn sensibility, they very rarely do. Leon's
> early paintings, done when we were students together, are already full
> of poetry and real sensibility. And he'd learnt how to work because his
> father laboured eighteen hours a day in the baker's shop.

Military service interrupted Kossoff's education at St Martin's, which was one reason why he found himself the contemporary of the younger Auerbach. He had served for three years in the Royal Fusiliers attached to 2nd Battalion Jewish Brigade, although he was not, according to his friend John Lessore, an ideal soldier. 'He was caught with his rifle upside down on guard duty', but he displayed his intelligence in other ways; 'these were Palestine Jews from Sandhurst, speaking Modern Hebrew and Leon picked it up just like that.'

It took both intelligence and endless application for Kossoff to become the kind of painter he aspired to be. According to Lessore, 'He's only really ever been interested in working, with the occasional visit to great paintings. He's never wanted to do anything social.' At the National Gallery he had been in the habit of making little pencil sketches of old masters on the newspaper he was carrying. But, 'much encouraged by the example of Frank Auerbach', his copies grew so vigorous that the attendants stopped him from drawing as he was making too much mess. Kossoff and Auerbach both chose to use charcoal for their drawings, the critic John Berger describing Kossoff's as 'heavily worked and very black'.

Kossoff's people, Berger thought, were 'brooding hunched-up figures', fitting as tensely into the wooden panels he painted on as 'mediaeval figures in their niches'. But Kossoff's paintings also had something in common with Rembrandt. It was as if the people in them had somehow turned into paint: great swirls, scoops, ropes and gouts of it, pigment that in Berger's words was 'shockingly thick'.

In the 1950s one of those figures was a woman twenty years Kossoff's senior called Sonia Husid, but better known by the name she wrote under, N. M. Seedo. Theirs was not a love affair, but nonetheless intimate for that. They watched each other with close attention. Seedo had had a life full of danger and adventure. Before coming to Britain in her mid-twenties, she had been a member of the (illegal) Romanian Communist Party and the socialist Zionist youth group Hashomer Hatzair, and was a scholar of Yiddish. She reminded Kossoff of a character from Dostoyevsky's novels; in turn, she found that his interest stimulated in her the ability to tell, as she recalled, 'the most exciting stories that I had ever read, or heard about; somehow in his presence I would gain the capacity of relating things, and he always listened with such animation'. Meanwhile, Kossoff, for his part, 'suddenly developed a great love and interest for Yiddish literature, about which he had known nothing previously'.

Eventually, the reason for Kossoff's fascination was revealed: he had sensed a suitable subject. One day he approached Seedo and asked her to sit for a picture that he wanted to paint. Having agreed, she found the process of sitting and watching Kossoff at work unsettling, but also inspiring:

LEON KOSSOFF *Head of Seedo*, 1959

The struggle that he was engaged in in his work was nerve-racking; he seemed to go through heaven and hell, falling in love with every happy stroke of the brush, and hating all the obstacles, all the distortions and misleading paths that the canvas, paint and brush put in his way to some unknown goal. The physical discomfort and mental strain of just watching, of just witnessing that spiritual torment, made me feel distressed; but I also envied him.

Seedo often fell asleep during the sittings, the images of her former life filling her dreams. Kossoff remarked that he would not really call what she was experiencing sleep; to him she had never appeared more awake. In the pictures it can look as if she is quaking with the force of those memories, as if from some seismic shock.

<p style="text-align:center">*</p>

In 1952, Auerbach, now aged twenty-one, began attending the Royal College of Art and was living a traditional penurious artist's life in pursuit of achieving something of significance. As penniless students, he and Kossoff 'simply assumed persistence, obscurity, the making of *le chef d'oeuvre inconnu* ... Poverty is very easily borne when one's young, but it does take up a lot of time.' Auerbach sometimes helped in the Kossoff family bakery and 'did all sorts of jobs – worked at the Festival of Britain, worked at the frame-makers, sold ice-cream on Wimbledon Common'.

That year, Auerbach became fully himself as an artist. One of his two breakthrough paintings was of a place near Stella's house (*Summer Building Site*, 1952); the other was a portrait of her, *E.O.W. Nude* (1952), though she is named in the title only by her initials, in a sort of discreet private code. Two elements were crucial to the step-change that Auerbach made while painting this nude of Stella: a feeling of intimacy and a sense of crisis. The fact that they were lovers, rather than painter and professional model, brought something to the work. 'The whole situation was obviously more tense and fraught,' Auerbach explained, because 'there was always the feeling that she might get fed up, that there might be a quarrel or something.'

Equally, knowing her so well, he had 'a much greater sense of what specifically she was like' than he would have done a professional model. This, paradoxically, made getting a likeness more difficult, not less. It was 'like walking a tightrope', with a 'far more poignant sense' of the likeness 'slipping away'. Auerbach found that painting the same person again and again offered more, not less variety:

> If you were to be introduced to a different person every day, after a few days the experience would have quite striking similarities. But

if you see the same person every day, the relationship develops and
changes, all sorts of extraordinary things come out, you behave in
every possible way that you can. It's an infinitely deeper and richer
experience. And the same is true, I think of subjects. A real sensation
of amazement or look of beauty or something comes I think from
familiarity – you see a familiar person for a moment as a strange
object and it's immensely moving.

Not only were the pictures themselves intimate, so was the way in which
they were made. 'E.O.W.' posed either in an easy chair beside the fireplace
or lying on the bed, surrounded by pots of paint, with Auerbach kneeling
on the floor and the picture resting on a 'very, very paint-y chair'. Auerbach
could only afford sombre earth colours – so ochres and browns predominated
– and was reluctant to scrape off costly pigment; so, as day followed day, the
surface became ever more encrusted.

The first successful nude of E.O.W. began timidly. Auerbach would paint
a bit at one session, then add some more at the next. One day, he found the
courage to repaint the picture entirely, 'irrationally and instinctively', and
found he'd achieved a portrait of her. This pattern – the long sittings, the
final crisis in which he went beyond what he knew into a realm of intuition
– was one he maintained thereafter. The tension in both of them made the
atmosphere fraught. She was sometimes in tears; 'Frank's painted me with
tears streaming down my face because he seemed so cruel and so far removed
from me, and I'd think: well, what am I? I'm nothing.'

He seemed violent, lost in his own world; when she was late for a sitting
she would arrive to find him pacing and biting his nails, wound up and, as
she remembered, 'so determined'. But there was an almost telepathic con-
nection between them, such as grows up between people who spend years
together. One day she was lost in thoughts of her difficult childhood when
'suddenly Frank said to me, *"Stop thinking that! Stop bloody thinking that!"'*

Painter and model were not just close emotionally, but also physically,
and this became part of the fabric of the picture. David Sylvester, reviewing
Auerbach's first exhibition, which was at the Beaux Arts Gallery in 1956,
noted that the pictures gave a sensation 'curiously like that of running our

FRANK AUERBACH *E.O.W. Nude*, 1952

fingertips over the contours of a head near us in the dark, reassured by its presence, disturbed by its otherness'. This remark might have been derived from conversations with the artist but, in retrospect, Auerbach hinted that he was trying to evoke a sensation more subtle even than touch: 'If you are in bed with somebody, you are aware of their substance in some way in terms of weight; I actually think that is the difference between good paintings and less good ones in whatever idiom.'

*

Kossoff and Auerbach matured into quite different artists. And their points of comparison even in those fifteen or so years during which they were constantly in and out of each other's studios were partly incidental. The thickness of the paint, for example, was a by-product of what they were doing. There was, however, agreement about some fundamental points. One was that to create a good painting was immensely hard – like finding a diamond, as Van Gogh had written. Hence the 'seemingly endless activity before the model', as Kossoff described it, 'always beginning again, making new images, destroying images that lie, discarding images that are dead'.

The essence of the problem, as Auerbach explains, is that 'only the true' looks new, otherwise it looks like a picture. But truth is a complicated business; not all that is true is full of sufficient vitality: 'there are also certain configurations on canvas that feel organic and alive and quivering, and others that seem inert.' The final picture – and this can be said for Kossoff as well as Auerbach – only comes into being as the result of a crisis. To create such a picture the artist has to go beyond the familiar, beyond what is already known, into a place where he does not know what he is doing. As a result, Auerbach concludes, 'a good painting always seems a bit of a miracle'.

Nor, of course, is everybody's truth the same. Some contemporaries of Kossoff and Auerbach's found theirs not in an intense struggle to record a familiar face or place, but in American magazines, advertisements, rock-and-roll and motor cars.

CHAPTER NINE

WHAT MAKES THE MODERN
HOME SO DIFFERENT?

*Being born just before the outbreak of the Second World War, I just thought
things naturally got better and better.*

ALLEN JONES

T he prevailing poverty in the years immediately following the war
could be seen by looking through a window of the art school in
Camberwell where, as Gillian Ayres remembers: 'It was poor, very
poor. People didn't always have socks and shoes, they drank out of jam-jars.'
Yet, perhaps for some, the reality was that western society was gradually
becoming more prosperous, especially across the Atlantic in America. To some
young and creative people the USA became a sort of real life Shangri-La:
the land of plenty and also of the future.

In the late 1940s, a group of young art students from the Slade that
included Richard Hamilton and his friends Eduardo Paolozzi, Nigel
Henderson and William Turnbull would often go to the American Embassy
library at No.1 Grosvenor Square. For them, the attraction was that, there,
'all the best magazines were freely available, spread out over the tables'.
In comparison with the delights of *Esquire, Life, Good Housekeeping, Time*
and *Scientific American*, British publications lacked 'glamour'. And, in
Hamilton's opinion, 'there was really very little happening in England.
Anything that was at all exciting was likely to be in the American maga-
zines or Hollywood films.'

He was not alone in taking this view. In the years following 1945, almost all Britons viewed America at a distance, through the glossy pages of magazines or on the cinema screen. In 1950, Britain accounted for ten per cent of the world audience for Hollywood movies. David Hockney remembers how the local Regal or Odeon picture houses 'showed a marvellous, different world from trudging through dingy Bradford streets to the cinema'. 'Going to the pictures' had already been a hugely popular pastime before the war, but now films were in full colour, and those colours were brighter and more saturated than those of the real world. Thanks to CinemaScope and other new technologies, the screen was sometimes larger than life too. It offered a view of another world: a land of plenty.

'Over the Atlantic lay the land of Cockaigne,' the artist and film-maker Derek Jarman reflected. 'They had fridges and cars, TVs and supermarkets. All bigger and better than ours. The whole daydream was wrapped up in celluloid … How we yearned for America! And longed to go west.' In contrast, Britain felt and looked old-fashioned: not 'Technicolor' but monochrome. This was a feeling shared not only by the generation of young students, born in the late 1930s, who were to become Pop artists, but also by their contemporaries, the first British pop stars. One of these was Reg Smith, better known as Marty Wilde. He remembered his childhood in chromatic terms: 'You were brought up with three colours – grey, brown and black. They were all the colours I associate with the war. Almost everything was grey. It wasn't until the '50s that all colours started to come: in clothes, colours in cars.'

*

The music that would inspire Marty Wilde – early American rock-and-roll – was apparently first heard in Britain one evening in 1953, in a building on London's Dover Street. The listeners, however, were not Teddy Boys, singers or dancers, but a small gathering of intellectuals and aesthetes at the Institute of Contemporary Arts. This brash new idiom was then analysed – according to Richard Hamilton, who was present – 'as a sociological phenomenon' (though he recalled that the audience rather enjoyed the discs too).

The occasion was a meeting of the 'Independent Group' (originally referred to as the 'Young Group'), which consisted of a handful of the more radical junior artists and writers connected with the ICA who were allowed to arrange lectures and discussions – partly, it seems, as a way of keeping them quiet and giving them something to do. Hamilton was one of the driving forces, along with the abrasively brilliant critic Lawrence Alloway and Toni del Renzio, an anarchic Russian-Italian artist and agitator who had once unsuccessfully attempted to take over the London branch of the Surrealists.

At the very first meeting in April 1952, Eduardo Paolozzi – also one of the group's inner circle – fed images from American magazine advertisements into an epidiascope, which projected them in front of the dozen or so enthusiasts who constituted the audience. The pages were culled from Paolozzi's large collection of transatlantic publications, and he presented them rather as an anthropologist might slides of life in New Guinea. The effect, according to Hamilton, was 'startling'. We can get an idea of what it might have looked like from a series of collaged pictures by Paolozzi. The technique of collage had been much favoured by an earlier generation of Surrealists and Dadaists, such as Max Ernst and Kurt Schwitters. However, the effect of Paolozzi's works was not to create a dreamlike sense of unreality, nor to prompt a revolutionary attack on the conventions of academic art, as his forebears had done.

Rather, Paolozzi's collages of the later 1940s and early 1950s offered a kaleidoscopic vision of an imagined future in which swimwear models mingled with cartoon characters, surrounded by automobiles, domestic appliances, soft drinks and packaged food-stuffs. You could argue that this was not surreal at all, but actually quite an accurate prediction of what H. G. Wells had called 'things to come'. In fact, Paolozzi's collages were a kind of realism: they showed the new world that was emerging in postwar Europe. If you stepped out of an Independent Group gathering and walked down Dover Street, you would soon encounter, as noted by the architectural critic Reyner Banham, himself a regular attender, such phenomena as 'hi-fi, CinemaScope, the lights in Piccadilly Circus, curtain-walled office blocks'. Here was the truth of modern existence. A few years later, writing in 1959,

EDUARDO PAOLOZZI *Dr Pepper*, 1948

Banham would dub the late 1950s as 'the Jet Age, the Detergent Decade, the Second Industrial Revolution'. However, in the highbrow world of modern art, in which such items as detergent, cookers and cartoon characters never featured, this vision was revolutionary.

The ICA was the headquarters of what had, by the early 1950s, become the Modernist establishment. It had been founded in 1947 by, among others, Peter Watson, E. L. T. Mesens, the die-hard holder of the Surrealist flame, Roland Penrose, friend and intense admirer of Picasso, and Herbert Read. The last was the most prominent art critic of the 1930s, the author of the influential and ubiquitous *Art Now* (with its illustration of Francis Bacon's early *Crucifixion*). To the Independent Group, it seemed all rather old-fashioned.

Alloway finally became deputy director of the ICA in 1957, appointed by Penrose. He was a natural dissident, and Read (who was knighted in 1953) was one of his targets. Read supported and spoke for classic Modernism: Picasso, Brancusi, Mondrian, Ben Nicholson, Henry Moore. He advocated formal values and the idea that the pared-down forms of Moore or Brancusi represented an ideal in art and life. Alloway summarized Read's argument tersely and somewhat sarcastically: 'geometry is the means to a higher world'. The young critic would, in due course, also part ways with Penrose, as Gillian Ayres remembers: 'Eventually he and Penrose fell out and he wrote Picasso right down. Penrose was furious. Alloway was very bright, very quick, but he could be savage and catty.'

The Independent Group members were in revolt too against another, newer, type of orthodoxy articulated by the American critic Clement Greenberg in a celebrated essay of 1939, *Avant-Garde and Kitsch*. Greenberg's thesis was that highbrow art was difficult, hard to assimilate and fiercely innovatory, a description that certainly covered the new art by Jackson Pollock and his contemporaries that Greenberg championed in the 1940s and 1950s. Abstract Expressionism – provocatively novel and imported from across the Atlantic – would have gone down well with the Independent Group audience.

The other part of Greenberg's thesis, however, would not. According to him, all other forms of art, fiction and drama, as appreciated by the bulk of

the population, was just sentimental pap. Greenberg included in this category 'popular, commercial art and literature, with their chromeotypes, magazine covers, illustrations, advertisements, slick and pulp fiction, comics, Tin Pan Alley music, tap dancing, Hollywood movies, etc.' This was a concise list of much that the Independent Group found most interesting and inspiring.

Alloway took the opposite point of view in his 1958 essay *The Arts and the Mass Media* for the journal *Architectural Design*. Popular arts, he argued, were fascinating in themselves: indeed, they were 'one of the most remarkable and characteristic achievements of industrial society'. More than that, they were a better index of what was happening 'right now' than the other, more conventional, middle-class variety. In support of his argument, Alloway – who, like many of his Independent Group friends was a sci-fi enthusiast – quoted John W. Campbell, the editor of the magazine *Astounding Science Fiction*: 'A man learns a pattern of behaviour – and in five years it doesn't work.' In other words, innovation was ever more rapid, and the consequence of this was that things were likely to become outdated with ever increasing speed.

*

Seated in the audience for these talks and events at the ICA was an art student named Peter Blake. He would have taken a more than academic interest in such subjects as Rock and Roll because he was what Alloway, Hamilton, Paolozzi and the rest were not – a true fan. This is, he admits, 'One of the reasons I paint. It's to celebrate.' Blake had, and has, a simple love of popular music, 'particularly the Everly Brothers, Chuck Berry, and later the Beach Boys'.

Such enthusiasm was unusual in the early 1950s, in art schools at any rate. There, Blake remembers, Trad Jazz – as played by Humphrey Lyttelton and danced to enthusiastically by Camberwell students and their tutor John Minton – was more the thing. When he was at the Royal College of Art, Blake recalls, 'all the dances were always Trad bands, it was George Melly, and Chris Barber'. At that stage Blake himself was keener on Bebop, then a more metropolitan and esoteric taste. But, as rock-and-roll emerged onto the scene, he found he 'liked the characters – Little Richard, Jerry Lee

PETER BLAKE *Got a Girl*, 1960–61

Lewis. I painted Elvis, although he might not have been my favourite; if you were painting about icons and celebrity it had to be Elvis, although I preferred Bo Diddley as a musician.'

These musical tastes were part of a wider love of the sort of amusements that the general public actually liked – fairgrounds, wrestling matches, boxing booths, Hollywood movies – as distinct from the detached intellectual curiosity of Alloway and the Independent Group. Such enthusiasms were nothing new among artists, as Blake points out: 'There was fandom before; Sickert was a fan of the music hall, for example. I probably picked up on it, but I brought it forward a lot.' Blake came to such pastimes in a natural way; they had always been part of his life. When he first began art school, at the age of fourteen in Gravesend, he 'wouldn't have known what the phrase popular art meant, but I did like fairground painting and I did like boxing booths'.

Born in 1932, Blake came from Dartford, by the Thames Estuary, to the south-east of London. Almost by chance, he found himself at art school after the war. It was an opportunity that just presented itself, as it did to

Terry Frost when he was released from his POW camp, and to many others.

> Because I was evacuated during the war, I failed the examination for
> the grammar school. At the interview for the Technical school, they
> said if you want to go to art school there's one just round the corner, you
> just have to take a drawing test. It was more or less presented as a gift.

To the young Blake, it was the highbrow culture, not the popular sort, that
was unfamiliar:

> My teachers were great enthusiasts of Cézanne, so I was being
> taught about him, about Beethoven, about James Joyce's *Ulysses* –
> things I wouldn't have known about at all. At the same time I was
> living the life of a fourteen-year-old boy in Dartford, doing
> working-class things.

Blake comes – socially and geographically – from fertile pop-music territory.
Marty Wilde's birthplace, Blackheath, is a few miles to the west. A much
longer-lasting rock star was a near neighbour in Dartford Heath. Blake
remembers that Mick Jagger, eleven years his junior, was growing up 'about
fifty yards away'.

From Gravesend Technical College and School of Art, he found himself
at the Royal College of Art from 1953 to 1956. His contemporaries included
Frank Auerbach, Leon Kossoff and also the abstract painters Robyn Denny
and Richard Smith, but Blake took an idiosyncratic course distinct from any
of these. At the Tate's exhibition of contemporary American art in 1956,
when almost everybody's attention was focused on Abstract Expressionism,
he was hugely taken by the work of Honoré Sharrer, Ben Shahn and Bernard
Perlin: 'It was a kind of Surrealism but without Daliesque symbols. I wanted
to make the sort of magic they were making.'

*

Seen in retrospect, Blake's work is usually fitted into the wider category
known as 'Pop art' – a term which, like almost all such stylistic descrip-
tions in art, is broad, vague and often applied after the art in question
was created. Contrary to what one might imagine, the phrase 'Pop art'

originated in London rather than New York. There are a number of versions of how it began, what anthropologists call a 'foundation myth'. One involves Lawrence Alloway and Peter Blake at a dinner party in London. In the course of conversation, Blake found himself explaining to Alloway what he was trying to do. When he had finished his account Alloway said, 'Oh, you mean a kind of *pop* art?' And that, Blake contends, was how the phrase originated (although Robyn Denny, who was also present, failed to remember this exchange at all).

Another version has the term originating in a conversation in 1954 between composer Frank Cordell and the artist and collagist John McHale, co-convener with Alloway of Independent Group meetings. When Alloway moved to New York in 1961, his use of the phrase 'Pop art' flummoxed local artists Claes Oldenburg and Jim Dine, the former of whom is certainly seen in retrospect as one of the principal figures in the movement. Dine, too, often features in Pop art exhibitions, but vehemently rejects the label. He remembers: 'Lawrence Alloway kept talking about "pop art". We were standing there and then I asked Claes, "What's he speaking about?" Oldenburg and I heard the same thing, we thought he meant "Pop" Hart.' (George Overbury 'Pop' Hart, an American primitive painter.) Dine 'grew up appreciating popular culture – the popular art of advertising etc. – and it interested me'. However, he didn't 'look at it as art'. Rather, it was what the wrestlers, tattooed ladies and rock-and-roll records were to Blake – part of everyday reality.

*

In 1957, Richard Hamilton produced the first written definition of Pop art, formulated in a letter to Alison and Peter Smithson, the architects to whose work Reyner Banham first applied the term 'Brutalism'. High on Hamilton's list came 'transient (short-term solution)', and 'expendable (easily forgotten)'. The other characteristics included 'low-cost, mass-produced, young [aimed at youth], witty, sexy, gimmicky, glamorous', and 'Big Business'. Almost all of these – with the exception perhaps of 'sexy' – were calculated to appal the left-wing and highbrow arbiters of Modernist taste such as Herbert Read. The critic John Russell saw this new mood as a social, as well as an intellectual

and artistic, rebellion: he described 'Pop' as a firing squad aimed at those who 'believed in Loeb classics, holidays in Tuscany, drawings by Augustus John ... and very good clothes that lasted for ever'.

Evenings at the ICA were now spent talking about rather different cultural idols from Piero della Francesca or even Mondrian: one talk was devoted to the styling of American cars, an obsession of Reyner Banham's; on another occasion Toni del Renzio talked about fashion. Alloway encouraged everyone to read Marshall McLuhan's *The Mechanical Bride: Folklore of Industrial Man* (1951), a study of contemporary culture, each chapter analysing an advertisement, magazine article or newspaper story. Another piece of compulsory reading was John von Neumann's *Theory of Games and Economic Behavior* (1944). From this Hamilton took away a subversive conclusion: value judgments were irrelevant. 'We can't take a moral position anymore because it's all to do with flipping coins and roulette wheels and chance.' So the thing to do was to not make judgments, but simply observe what was happening. Be cool, in other words.

Richard Hamilton's own contribution to these evenings was a talk on 'white goods', such as washing machines, dishwashers and refrigerators. Doubtless their blend of functional design and elegant functionalism appealed to him. Hamilton was an artist whose career had been, like Francis Bacon's, 'delayed'. Born in 1922, he was the same age as John Craxton and Lucian Freud, but he emerged – rather slowly – onto the London art scene over a decade later than them. One of the things that held up his progress as a painter was the war. In 1940, Hamilton – a student at the Royal Academy – was too young for conscription when the RA Schools closed, so he went to the Labour Exchange. 'I was asked, "What can you do?" I told the man I was an art student, and he said, "Can you use a pencil?"' When Hamilton replied, 'Yes, that's what I've been taught to do,' it was decided he should become a technical draughtsman. He came to specialize in jig and tool design.

Hamilton thus received a lengthy training in a discipline outside the conventional world of art. Unexpectedly he found designing tools enthralling. 'It's like making a world: you're kind of following the processes of nature through mechanical engineering. It's the human equivalent of controlling

the creation of a flower or a tree, and I found it a very exciting kind of experience.' Following this, he was 'dragged screaming' into the Royal Engineers for eighteen months of National Service before he finally arrived at the Slade School of Fine Art. Here, his experience of the cool objectivity of technical drawing was followed by an encounter with the more fastidious objectivity of William Coldstream's 'Euston Road' school of painting. At the end of this long and unusual apprenticeship, Hamilton had become a unique hybrid – part-pupil of Coldstream, part-engineer, part-disciple of Marcel Duchamp.

The last, an unfashionable enthusiasm in the 1950s and early 1960s, appealed to Hamilton because of his philosophical detachment. Duchamp was a master of ideas as much as a maker of images and objects: the same could be said of Hamilton. Both men had a predilection for recondite symbolism. Fridges and Hoovers held a hidden eroticism for Hamilton, as coffee-grinders did for Duchamp. This mixture – sex, intellectual cool, the sensuous curves of commercial design – can be seen in paintings such as *Hommage à Chrysler Corp.* (1957) and *Hers is a Lush Situation* (1958). These have the detached air of illustrations in an academic treatise or a commercial brochure, but also a lightness of touch reminiscent of Coldstream. These were not pure collages, like Paolozzi's, but they were closely allied. Hamilton frequently stuck images onto his pictures – which made them partially at least, collages – but he more often painted by hand elements from magazine illustrations or advertisements. The two techniques, collage and painting, are interconnected and have been since the early days of photography; many Victorian painters were, effectively, copying photographs. Blake and Hamilton both used them alternately, or indeed, side by side in the same picture.

These pictures by Hamilton share with Duchamp the apparent clarity of a technical diagram combined with the free-floating sensuality of a dream. Even the titles are packed with double meanings – *Chrysler Corp.* being a play on the French word for body – and the paintings themselves abound with visual puns. The voluptuous curves of the Imperial and Plymouth ranges of Chrysler automobiles are rhymed with the shapes of hips and busts. Behind the swelling forms of headlight, bumper and bonnet in *Hommage à Chrysler*

RICHARD HAMILTON *Hommage à Chrysler Corp.*, 1957

Corp. rises the spectral figure of a woman, reduced like the car to sexualized components: a pair of bright red lips like a butterfly fluttering in the air, and a series of concentric circles, like the contours of a conical hill on a map (which were used in publicity to illustrate the structure of 'Exquisite Form' bras). The odd, egg-shaped element on the left, which might be an angry insect eye, is in fact a piece of collage, an enlarged photograph of the air-intake of a truly futuristic jet car.

Actually, painting a car of any kind was unusual in 1957. Hamilton later reflected on how hard it was to find an image of the automobile in art – even though it was the one object that had transformed twentieth-century life more than any other. That neatly illustrated the novelty of the ideas that were coming out of those evenings at the ICA. Modernism had produced all kinds of new ways of making art, yet one thing it had failed to do was represent modern life. By the mid-1950s, Hamilton had begun to do just this. But there was a paradox about *Hommage à Chrysler Corp.* and similar works. This was a clever, subtle, allusive type of painting. It could perhaps be called Pop art, but it was definitely not popular. A mass audience would be no more likely to go for it than for a dingy Euston Road picture of a working-man's café.

The Firebird II, General Motors' experimental gas turbine passenger car, 1956

In the 1950s Hamilton was a prime mover in the organization of a remarkable sequence of exhibitions. Collectively, these gave a glimpse of what the future might look like, not only of art; none more so than 'This is Tomorrow', which opened at the Whitechapel on 9 August 1956. One of the propositions it advanced was that in times to come life might take many and varied forms simultaneously. Therefore, rather than displaying the works of individual artists – or even separate works of art – 'This is Tomorrow' was made up of a sequence of separate environments created collaboratively by twelve small working parties of painters, architects, sculptors and designers. Not surprisingly, the prophecies these disruptive talents came up with were very different.

Among them, the contribution of Group 2, put together by Hamilton, John McHale and an architect named John Voelcker, made the biggest impression. This managed, if not to predict the destiny of humanity, at least to foreshadow several of the idioms that would dominate art in the next decade. Firstly it presented something that looked very much like Pop art (as opposed to the earnest discussions of popular culture in which the Independent Group had specialized). One of the most eye-catching items on show was a large cut-out from a poster depicting the character of Robbie the Robot from *Forbidden Planet* – a successful science-fiction movie of the same year. The robot was carrying a swooning blonde in the manner of King Kong, while on a smaller scale below was an image of Marilyn Monroe, her skirts flying upwards, taken from another movie poster – this one for *The Seven Year Itch*, which had been a hit the year before, in 1955. In front stood a giant Guinness bottle, and around the space there were collages of food advertisements, film posters, and screens showing war films and TV commercials.

Leading up to this area, Group 2 created a space that foreshadowed elements of Op art and environmental installations. The visitor approached Robbie the Robot and Marilyn via a corridor of mind-bending black-and-white optical illusions, and there were also whirligig discs, that had been supplied to McHale by their inventor, Marcel Duchamp. The very walls on which these were placed were leaning and sloping in a disorientating manner. Fluorescent paint was dribbled around, the floors were soft and

RICHARD HAMILTON
Just what is it that makes today's homes so different, so appealing?, 1956

the whole space was permeated with an odour of strawberries. It was just the sort of freaky fun-house in which the 1960s would delight.

For the catalogue, and to publicize the exhibition, Hamilton made a collage that has a good claim to be the first masterpiece of Pop art: *Just what is it that makes today's homes so different, so appealing?* (1956). It was composed of an assortment of images such as he and his friends had pored over in the magazines at the American Embassy library, although in this case they were culled from John McHale's private archive of Americana.

Prominent on the left of the picture is the figure of the body-builder Charles Atlas; across the room a bare-breasted woman with a lamp-shade on her head reclines on a sofa. Around them is a phantasmagorical array of contemporary accessories and consumer goods. On the coffee table, in place of an ornament, is a gigantic tin of ham, and below it, on the floor, is a tape recorder; the stairs are being cleaned with a vacuum cleaner. The standard lamp is decorated with the Ford logo, emblematic of the car, that most crucial of all status symbols in both 1950s Britain and America. Above, the ceiling is composed of a photograph of the moon as if to imply there is no limit to the possibilities of modern existence, whether in travel, the accumulation of technological gadgets, or sexual ostentation. In his right hand the muscle man holds a bright red phallic tennis racquet, wrapped like a lollipop, on which is inscribed in capital letters the word, 'POP'. Hamilton's collage is funny, memorable, bizarre, more than a little surreal and, in all those qualities, very British. In America Pop was a reflection of real life, as we have seen; in the UK it was always more of a dream.

Another of the working parties that contributed to 'This is Tomorrow' – Group 6 – was made up of Nigel Henderson, Eduardo Paolozzi, and the husband-and-wife architectural team of Alison and Peter Smithson. They posed for the catalogue sitting on modernist chairs in an East End street. Behind them is a random sample of cars typical of London in 1956, not supplied by the Chrysler Corp and certainly not jet-powered. They look as if they had been kept going since pre-war days by cash-strapped owners. The whole picture presents the homely and dingy face of postwar Britain, grey and drab, rather than the colourful, exuberant energy associated with either the Independent Group or Pop.

*

This homeliness was the chosen subject of a group of young painters who – unwillingly – went by the name of the 'Kitchen Sink School'. At the time they were more prominent by far than Hamilton, Blake or the Independent Group and they were championed by another articulate and opinionated critic, John Berger. In 1952, Berger organized an exhibition at the Whitechapel Art Gallery called 'Looking Forward', a title which, not coincidentally, echoed a policy document issued by the Communist Party of Great Britain, *Looking Ahead*. Though never a party member, Berger was closely allied with the Marxist political project. He espoused 'social realism', a softened, humanized version of the Socialist Realism idiom approved in Moscow.

'The question I ask is,' Berger wrote, 'Does this work help or encourage men to know and claim their social rights?' This was not, it is fair to say, a subject uppermost in the minds of Bacon, Freud, Hamilton, Pasmore or Hilton, who were just some of the large contingent of contemporary paint-ers not selected for 'Looking Forward'. This exhibition, Berger informed the readers of the left-wing magazine *Tribune*, was 'not for the critics and the Bond Street art-fanciers, but you, and all your friends, who can't stand modern art'. If *Tribune* readers did indeed detest modern art, Berger went on, they were right. 'I think it's modern art and not you that's to blame.'

Accordingly, when Bryan Robertson, the director of the Whitechapel, suggested some other artists for inclusion in 'Looking Forward' – Freud and Coldstream among them – Berger offered his resignation by return of post. He wrote that what he admired was painters 'who draw their inspiration from a comparatively objective study of the actual world', which for him meant artists who were concerned with 'the reality of the subject not the "reality" of their subjective feelings about it'. As those sneering quotation marks around the word reality imply, Bacon and Freud were among Berger's 'bêtes noires'; in his opinion their feelings were thoroughly bourgeois. Alberto Giacometti and Jackson Pollock were among his other targets, a fact that infuriated another critic, David Sylvester, also an ardent advocate of Bacon. This feud between critics had lasting consequences.

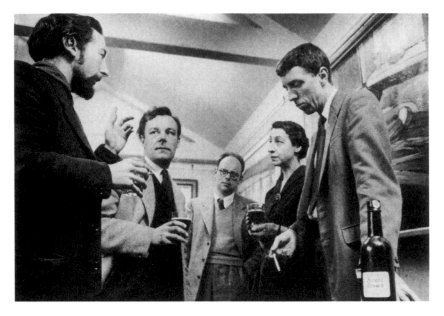

Jack Smith, Edward Middleditch, John Bratby, Helen Lessore
and Derrick Greaves, 1956

Berger thought he had found some painters who displayed the correct political tendencies when he reviewed 'Young Contemporaries', an exhibition of work by students at the Royal College of Art, in January 1952. He picked out two, Edward Middleditch and Derrick Greaves, and praised their 'deliberate acceptance of the everyday and ordinary'. Going a step further, he suggested that their works 'imply an acceptance of the revolutionary theories of the last forty years'. In other words, these were soundly Marxist pictures. This would have come as news to Middleditch and Greaves, as it would have done to John Bratby and Jack Smith, the two other youthful painters with whom their names were soon inextricably joined.

They were, rather than revolutionaries, somewhat traditional painters who carried on the heritage of Sickert and his Camden Town associates. All four were shown by Helen Lessore of the Beaux Arts Gallery, a fact that led to their being given an alternative label, the 'Beaux Arts Quartet'. None of them wanted to make a political point; they painted what

surrounded them. And what surrounded them were the sorts of houses and streets to be seen behind Paolozzi, Henderson and the Smithsons in the 'This is Tomorrow' photograph. 'That was my life at the time,' Jack Smith explained. 'I just painted the objects around me, I lived in that kind of house. If one had lived in a palace, one might have painted chandeliers.' When Middleditch depicted *Pigeons in Trafalgar Square* (1954), he did so with a sky just as described by Cyril Connolly in 1947, 'permanently dull and lowering like a metal dish-cover'.

Bratby, on the other hand, had been much affected by a Van Gogh exhibition at the Tate Gallery in 1947–48; so much so that his early work – the best – looks like a crude but energetic pastiche of what Van Gogh might have painted if he'd been living in cheap accommodation in 1950s London. Some of the results have a certain brio, if little of the great Dutchman's sense of structure. *The Toilet* (1956), for example, is a choice of subject almost as unusual in art as the motor car (and almost as ubiquitous in life). His still-life pictures dwelt on other objects then hardly known in painting, such as cornflake packets, which later featured in Pop art. Bratby, though, approached these consumables not in the spirit of the Independent Group, fascinated by advertising and product design, but as part of the cheery squalor of his surroundings.

Neither Bratby nor the others were, as Berger hopefully claimed, 'painting with great sympathy the few possessions of the dispossessed'. They were, as young and struggling painters, dispossessed themselves. This, however, did not save them from suffering collateral damage in the battle between critics. Sylvester, irritated by Berger and taking note of his point about these painters' nobly Marxist 'acceptance of the everyday and ordinary', wrote a rejoinder in the December 1954 issue of the magazine *Encounter*. In retrospect, he admitted his real target had not been the painters themselves but Berger, 'a marvellous and very eloquent and persuasive writer, a much better writer than I am', but a 'bloody awful judge of the art of his own time'.

Sylvester described how these painters often chose to depict nothing more interesting than 'a very ordinary kitchen, lived in by a very ordinary family', dwelling on 'every kind of food and drink, every kind of utensil and implement, the usual plain furniture, and even the baby's nappies on

JOHN BRATBY *The Toilet*, 1956

the line'. It was all too mundane. Bratby's paintings, to his mind, were just 'an enthusiastic mess'. Sylvester concluded his inventory with a rhetorical flourish. Did these painters indiscriminately throw everything into their pictures? 'Everything but the kitchen sink? The kitchen sink too.' And that was it; they were named. 'The wretched critic's term haunts us all,' Greaves reflected bitterly, thirty years later, 'seeking its encapsulating vengeance.'

However, the damage was not immediate. By 1955, these four youthful painters were beginning to be known abroad as well as at home; that year they were shown in Milan and Paris. At the Venice Biennale of 1956, Bratby, Smith, Middleditch and Greaves made up four out of the five British painters represented. In 1957, Jack Smith was the very first winner of the John Moores Painting Prize, a new, lavishly funded award that was, in 1950s Britain, equivalent to today's Turner Prize in its power to generate fame and publicity. Smith received £1,000, while Bratby won the junior award of £500. But their moment of fame passed rapidly.

In retrospect, like many art historical labels, 'Kitchen Sink School' seems accidental. There was really no such movement. By the mid-1950s, the drabness of their early works had begun to brighten and – as Marty Wilde said – colours had begun to come in. The Zeitgeist was beginning to change and kitchens no longer seemed, even to these four painters, a suitable subject for modern art.

AN ARENA IN WHICH TO ACT

*I think that if there are major turns in art history — and I don't know if there are, I don't
even know if that's the right way of looking at it — then what they did in America was the
first major turn since the beginning of the century, since Cubism.*

FRANK AUERBACH, 2017

In the late 1950s, Patrick Heron found himself in a London restaurant
with an important curator. He was enumerating a list of artists – all
abstract painters – that he suggested should be included in a survey of
the contemporary scene. He heard from behind a sound of protest, almost
feline as he remembered it, and looking round saw Lucian Freud standing
there, listening, aghast, with a very beautiful companion. By that time, Freud
– and indeed, Minton and most figurative painters, apart from Bacon – were
rapidly going out of fashion.

By the mid-1950s a radically new way of painting was making an impres-
sion on young and adventurous artists in London. This was why, towards
the end of November 1956, at the Royal College of Art, John Minton lost
his temper. The occasion was a 'Sketch Club', at which work by students
in the Painting School was presented so that the tutors could deliver on-
the-spot critiques. By this stage Minton was no longer the carefree
and charming – if frenetic – figure Gillian Ayres had encountered at
Camberwell School of Art in 1946. A decade later, Minton was nearing forty,
his work out of fashion, his drinking out of control, his mood increasingly
despairing and desperate.

The following January he committed suicide, leaving the portrait of
himself he had commissioned from Lucian Freud four years before to the

Royal College, where for years he had been a senior member of staff. In retrospect this picture looks like a prediction of the psychic disintegration Minton was to suffer. He was already close to the end of his tether and his patience snapped at the sight of an outrageously up-to-date creation by a student called Robyn Denny.

At that point in his career, Denny – then twenty-six and in his final year at the Royal College – was making works that he first painted on hardboard in a loose, wild fashion, perhaps scrawling on them words from newspaper headlines, and then set alight, obscuring the imagery. Minton's response was a sarcastic attack on the attitudes and art of this new generation. First, he suggested, addressing his audience, 'You put on the Nescafé and begin to paint your board on the floor not on the easel. That's original, no one else does that! Then you jump on it, off centre, that's to show you're sensitive!'

His words were jotted down by Anne Martin, one of the students present, who later recalled that Minton seemed 'beside himself'. He railed on: 'Then you paint a few dozen, pay someone to write a preface to the catalogue, number them, give them names.' At this point, his eye lit on a newspaper lying on the floor, with the headline 'Eden Come Home' (this was at the height of the Suez Crisis, after the invasion, but before the British and French forces had begun to withdraw). Why, Minton exclaimed, you could call a picture like this anything, 'you could call it, *Eden Come Home!*'

The next day, when Denny – who had actually missed the Sketch Club – heard about Minton's outburst, he took a fresh sheet of hardboard, brushed on the words 'Eden Come Home' in bitumen and then set fire to it. As a final touch, and to add insult to injury, a like-minded fellow student named Richard Smith signed the finished piece – which of course had the title Minton had suggested – in a spirit of furious scorn.

*

Minton's outburst came towards the end of a pivotal year in the miniature world of London contemporary art: it was the point at which the gaze of those interested in the absolutely latest thing in painting shifted decisively from Paris to New York. Scarcely had 1956 begun, when on 5 January an exhibition opened at the Tate Gallery with the far from sensational, not

to say fusty, title 'Modern Art in the United States: A Selection from the Collections of The Museum of Modern Art, New York'. This, however, presented an exciting opportunity for ardent followers of the most modern painting.

'At last we can see for ourselves', wrote Patrick Heron in the March edition of *Arts* magazine, 'what it is like to stand in a very large room hung with very large canvases by Jackson Pollock, Willem de Kooning, Mark Rothko, Clyfford Still, Franz Kline and others.' In fact, these artists were only featured in the last room in the show, but it was this gallery that created all the excitement. Here was the first proper view of what came to be known as (but was not yet generally called) Abstract Expressionism, or AbEx. The art dealer John Kasmin remembers, 'We didn't talk about Abstract Expressionism then, we talked about *action painting*.' Another term much used in the studios and arty pubs of London at the time was 'Tachisme'. As we have seen, this was, roughly speaking, the French equivalent of Abstract Expressionism.

Up to that point, the names Heron listed in his article about the Tate show had been largely just names. Not many people in Britain had seen their work. One painting by Pollock had been displayed at the ICA in 1953, and, Heron noted, 'De Kooning got as near to us as Venice a summer or two ago'. A few – a very few – British artists had already crossed the Atlantic, met these artists, seen their work and returned to spread the news. Naturally there had been a good deal of discussion in the art press of this phenomenon. Even so, there are limitations to the information that can be transmitted by a photograph of a painting in a magazine. For one thing, it is hard to gauge scale, precisely the revelatory aspect of the experience that Heron stressed when he wrote about standing 'in a very large room hung with very large canvases'. Yet, looking back, Frank Auerbach feels the impact of the Tate show has been exaggerated. 'People always suggest that artists were influenced by exhibitions, but painters usually know about whatever it is already. I certainly knew about the Abstract Expressionists before they were shown at the Tate.'

*

ALAN DAVIE *Birth of Venus*, 1955

One British artist who had actually stood in front of Pollock's paintings very early on was Alan Davie, a Scot from Grangemouth, who had studied art in Edinburgh after the war and then – in the time-honoured manner – travelled in Italy to learn more about art. Ending up in Venice in 1948, he met the gallerist and collector Peggy Guggenheim, who had recently moved there from New York, and saw the pictures she owned by Pollock. These were works from the early 1940s, before Pollock's Abstract Expressionist phase, a period when Guggenheim had the artist on a retainer. These paintings were executed with a brush and charged with psychological symbolism derived from a blend of Surrealism, Freudian delving in the subconscious and heavy borrowing from Picasso – and they made a powerful impression on Davie.

After he returned to Britain, he began making big paintings on the floor of his studio. He explained why they had to be made like that. 'To produce something spontaneously, one had to work very fast, and to work

fast one had to use liquid paint.' And for obvious reasons, 'You can't use liquid paint with a canvas on an easel'.

Davie's work of the early and mid-1950s was visceral, organic and, though non-figurative, somehow ominous. Stylistically it suggested not only early 1940s Pollock, but also Bacon – though a Bacon without the figures, with no recognizable subject, just a sense of urgent, menacing energy, and sometimes a hint of butchery. One was left with a suspicion of some meaning impossible to put one's finger on. The paintings were, Davie emphasized, 'not preconceived'. The process was more like playing a jazz solo (Davie had worked as a jazz saxophonist) than anything Poussin or Sickert would have understood.

Davie defined his sense of painting in a way that would have made sense to a jazz musician like Charlie Parker, as well as to Pollock or Bacon. For him, painting really was about *action*, even if some of that action took place in the mind: 'I was trying to produce something very spontaneous. I had an urge to paint, much like a sexual urge, or another urge that one doesn't have control over.' In the notes to the catalogue for his Whitechapel Art Gallery exhibition of 1958, he wrote: 'One must concern oneself with the activity of painting, be it a physical one (like a dance) or an improvisation with ideas or concepts.'

Though he considered himself a Scottish artist, Davie was for a while based in London – he taught at the Central School – until he moved to Hertfordshire in 1954. Indeed, he was a remarkably cosmopolitan figure. With his interest in Zen, his beard and his proficiency at jazz he would have fitted in as well in California as he did in London – or better. He sold no works at all in his first seven years of exhibiting commercially in Britain, but his initial show in New York in 1956 was a sell-out. Davie was an outsider among the artists in London, but in New York de Kooning, Yves Klein and Pollock came to the opening of his exhibition.

Another British painter who got an early view of the revolution in American painting was William Scott. He visited New York in 1953 and became, apparently, the first European artist to meet with the Abstract Expressionists. The sheer size of many works by Rothko, Kline, Pollock and de Kooning blew Scott's mind. 'My impression at first was bewilderment,

it was not the originality of the work but it was the scale, audacity and self-confidence – something had happened to painting.'

Certainly, as Heron reported, the AbEx room at the Tate show three years later was 'the talk of the town'. Even *The Times* explained that these sensational painters had 'gained for the United States an influence upon European art which it has never exerted before'. In January 1956, Professor Meyer Schapiro of Columbia University in New York was flown over to give a talk on BBC radio about this extraordinary new movement.

Schapiro also 'gave four lectures: on recent American art, particularly the abstract work' in London, and had 'numerous discussions with artists, critics and scholars'. This he reported to the organizer of his trip, a bureaucrat in the International Educational Exchange Service (a subdivision of the State Department), as well as giving a precise account of his flight times and confessing he had wasted US government resources by consulting some medieval manuscripts in the British Museum (these being an art historical interest of his). Schapiro was paid $256.63 for his services.

Abstract Expressionism was thus actively promoted by the American government at the height of the Cold War as a way of extending its cultural influence and prestige. This fact – when it was eventually discovered – led to suspicion that the shift of art world attention from Paris to New York was the result of political manipulation. There is no doubt that Pollock and the others were used to increase the soft power of the USA. This would not have worked, however, had it not been for the visual impact of the pictures themselves. William Scott felt this without having to be told about it by art historians or critics. He saw the paintings, met the painters, and 'returned convinced that the Americans had made a great discovery and that the mood in England – a longing for a nice comfortable realist art – would not last much longer'.

So it proved, two years later, when the giant works were put on show at the Tate, followed by a series of exhibitions that displayed new American art to the eyes of London. From then on, increasingly and almost automatically, aspiring artists looked across the ocean for clues and inspiration. David Hockney, a nineteen–year-old about to do his National Service, remembered the change. Students such as himself quickly 'realized that

American painting was more interesting than French painting. The idea of French painting disappeared really, and American Abstract Expressionism was the great influence.'

When a large Pollock retrospective was held at the Whitechapel Art Gallery at the end of 1958, Hockney hitchhiked down from Yorkshire to see it. Allen Jones, then a student at Hornsey College of Art, saw it too and his ideas were completely rearranged by the experience. Jones went to the show with Ken Kiff, a fellow student. Afterwards, he said to Kiff, 'Ken, you know, I think we could sue the art school for fraud.' At Hornsey College Surrealism and Futurism were 'regarded as the most recent moment in art; but in 1958 they were thirty or forty years old'. Even those who were not drawn to abstraction, such as the young John Wonnacott, could not ignore this aesthetic earthquake: 'Jackson Pollock at the Whitechapel had an enormous effect on me. It worried me sick, gave me a headache. I went back four or five times.'

However, at least one visitor to those pioneering Abstract Expressionist exhibitions emerged unconvinced. Francis Bacon was 'terribly disappointed' by his first sight of paintings by Rothko. He had expected to see 'marvellous abstract Turners or Monets', and he conceded that there was 'a marvellous vitality in the way those artists put paint on canvas. It had that living quality.' The energy of loose, even flying paint, the creative accidents that might happen when pigment moved on the canvas, had long been what Bacon aimed at himself. And yet, when he saw them, he couldn't admire pictures without some sort of figurative subject. To him, they were just 'decorative': a dead end.

Typically, the more prevalent the vogue for Abstract Expressionism, the more mischievous Bacon became. 'I suppose Jackson Pollock was the most gifted, and yet, even with him, when I saw his work, I found it to be a collection of old lace.' He was fond of this gag; on being introduced to Pollock's nephew, he exclaimed, with his customary gender reversal, 'So you're the lace-maker's niece!' Frank Auerbach recalled Bacon going 'so far as to say that Elinor Bellingham-Smith [a still-life and landscape painter and wife of Rodrigo Moynihan] was better than Jackson Pollock, which is fair nonsense'.

Auerbach himself took the opposite view. To him the new American painting represented a reaffirmation of the formal qualities he responded to most deeply: 'the wordless and subject-less tension of the structure in space' that he had seen in the Piranesi that David Bomberg had shown him one day at the Borough Polytechnic; the frisson he had felt at the 'tangible, three-dimensional mountain of line'. In his eyes, the developments across the Atlantic were of great significance:

> People in the first half of the twentieth century wanted something surprising. As Diaghilev said to Cocteau, 'Surprise me!' And I think what the Americans did was to reassert the standard of grandeur – of very grand forms, which was what Michelangelo, Rembrandt and Titian would have done.

*

By 1956, even if they had not actually seen it, many younger artists were thinking hard about the way Jackson Pollock worked and trying it out for themselves. William Green, another member of John Minton's tutorial group at the Royal College, was one who did so, thereby achieving a degree of notoriety that in the long term proved highly damaging to his career. The following year, his activities – which included using a bicycle to make marks on his paintings – were the subject of a newsreel item by British Pathé films entitled *Action Artist*. This showed Green in his studio, placing a board on the floor, just as Minton had disdainfully described ("That's original, no one else does that!'). He then walked over the board, manipulating the pigment with his feet, before adding sand to produce additional texture. The commentary, though more good-humoured than Minton's outburst, was equally ironic, ending by expressing bemusement at the information that this piece of 'modern art' might fetch as much as one hundred pounds.

After this was screened in cinemas across the nation, poor Green became the target for a great deal of derision. In 1961, *The Rebel*, a film starring comedian Tony Hancock as an untalented would-be artist, was released. It featured a more elaborate version of Green's process, in which the comedian, wearing a sou'wester, rode a bicycle over a large painting on his studio floor,

William Green, still from Action Artist, *1957*

as Green had done, while a cow stood in the background. Soon after, Green retired from the bear pit of the art world to teach in South London. Little was heard of him for decades, although he began to exhibit again shortly before his death in 2001. His experience is a counter-example to the adage that all publicity is good publicity; although it is possible that his talent was just not strong enough. Denny, on the other hand, shrugged off Minton's ridicule to become, as we shall see, one of the most prominent artists of London in the 1960s.

'Action painting' was most definitely not a joke. By 1956, and well before the Tate show, it had become a crucial phrase in discussions of contemporary art. In fact, it had been a hot topic ever since the American critic Harold Rosenberg published a celebrated article in the New York magazine *ARTnews* in December 1952, writing that:

Tony Hancock on the set of The Rebel, *1961*

At a certain moment the canvas began to appear to one American painter after another as an arena in which to act – rather than as a space in which to reproduce, redesign, analyse or 'express' an object, actual or imagined. What was to go on the canvas was not a picture but an event.

The idea travelled more quickly than the works that had inspired it, accompanied by another sort of image – photographs and film of Jackson Pollock at work taken by Hans Namuth in 1950. These had the opposite effect to the shots of Green with his bike in his cramped student's studio; they were compelling positive publicity. The pictures of Pollock flinging paint, almost dancing as he created a picture, went around the world and helped to cement his fame.

Gillian Ayres was fired by the news of this astonishing procedure:

The whole idea of the canvas as an arena in which to act – an area
and what one does with it; I wanted to find out about that,
obsessively. I did find that tremendously exciting. But I think I
took it first from what was said and written and the photographs –
in fact I think I was doing it even before I saw the photographs.

Her opportunity to do so on a grand, Pollock-like scale came within a year
of Minton's withering diatribe to his students, and almost by chance. By
1956, Ayres had moved from painting geometric abstractions with a hint
of landscape about them, somewhat in the manner of Roger Hilton, to
including in her work a new element of spatter and drip derived ultimately
from Pollock.

Ayres's work was included in a large exhibition at the Redfern Gallery,
a show that would prove to be one of the artistic landmarks of the decade.
It was entitled 'Metavisual Tachiste Abstract', the first word having been
thought up on the spur of the moment by Patrick Heron's wife, Delia, who
was advising Redfern director Rex Nan Kivell about the show. 'Metavisual'
meant nothing, but 'abstract' and 'Tachiste' of course did, although their
definitions were extremely loose.

Subtitled 'Painting in England Today', the exhibition was a panoramic,
indeed rambling, overview of the work of British non-figurative artists. A
number of the older generation were included, among them Ben Nicholson,
Victor Pasmore and Rodrigo Moynihan who, after a period as a 'Euston
Road'-style figurative artist had again 'gone abstract'. Also among the
twenty-nine artists selected were representatives of the next generation
– Sandra Blow, Peter Lanyon, Terry Frost, Roger Hilton, Patrick Heron
and Alan Davie. The following year the show travelled to the Musée des
Beaux-Arts in Liège, where it was given the more cautious description
'Peinture Anglaise Contemporaine' and works by Francis Bacon and Graham
Sutherland were thrown in.

The critic Mel Gooding observed that there are exhibitions that define a
new movement, or reveal a fresh style, but that '*Metavisual Tachiste Abstract*

was not one of them'. Rather, it was a demonstration of the sheer quantity of abstract painters in Britain, some of them young and radical. One of these was Robyn Denny, who was still a student and had had his brush with John Minton only a few months before. And in the largest gallery, right in the centre of the exhibition, was the work of two other young artists, little known and – in London terms – highly audacious: Gillian Ayres, by then twenty-seven, and the twenty-three-year-old Ralph Rumney.

The latter was one of those people who contrive to inhabit the avant-garde, conceive and transmit novel ideas, but never produce a great deal of art that lasts. At twenty-one he had already set up the London Psychogeographical Association and a weekly review, *Other Voices*, hailed by Barry Miles as the forerunner of the underground press of the 1960s. Rumney was also the only British founding member of the Situationist International movement, an incendiary blend of anti-authoritarianism, Marxism, Surrealism and Dadaism (all the most radical 'isms' in one brew). He attended the inaugural Situationist meeting in Italy in the summer of 1956, along with the leader of the movement, Guy Debord.

A little later Rumney arranged a memorable screening at the ICA of Debord's film *Hurlements en faveur de Sade* ('Howls for Sade', 1952), which contained – unusually for a work of cinema – no visual images at all, only dialogue and lengthy periods of silence during which the screen was blank. The protests of the audience after the first performance were so loud that they were heard by those queuing up outside for the second showing. All in all, in 1956, Rumney must have seemed a figure to watch. He had certainly caught the eye of Nan Kivell, who had put him under contract to the Redfern Gallery. Once a week Nan Kivell sent his Bentley and chauffeur to collect the young artist from his squalid lodgings in Covent Garden, lit only by gas, and take him to the gallery to receive his cheque.

*

Rex de Charembac Nan Kivell, a New Zealander born in 1898, had been running the Redfern for many years, during which time he had been a staunch supporter of Modernist art. Though rich and successful, with a mansion in

Morocco as well as a London residence, and eventually knighted, he was not quite part of the establishment (a term which, by the way, had just become current, following an article on the subject by Henry Fairlie in the *Spectator* of 23 September 1955). Nan Kivell has been described as 'an archetypal outsider – illegitimate, homosexual, self-educated and antipodean', and he had an affinity for mavericks.

The impeccably dissident Rumney was just one protégé of Nan Kivell's. Denny was also an awkwardly nonconformist character. From a rather grand background – his father was a baronet and clergyman, the Revd Sir Henry Lyttelton Lyster Denny, 7th Bt – he had spent much of his National Service in prison, having declared himself a conscientious objector. His first mention in the press, three breathless paragraphs in the *Glasgow Evening Citizen* of 17 April 1957, noted that Denny worked 'always to the sound of "pop" music':

> As he kneels or crawls round his huge, brightly coloured canvases, laid flat on the floor in his studio, a radiogram blares out rock-and-roll records. The words 'go, go, go' much used by skiffle addicts are scrawled over one design.

Journalistically speaking, Denny was a startling manifestation of anarchic youth.

Gillian Ayres, who also struck a chord with Nan Kivell, recalls how receptive he was of her huge paintings covered with puddles, spatters and dribbles of paint:

> I used to go into the Redfern with these bloody great things – six foot strips of hardboard – and Nan Kivell started to like all this stuff. I don't think it was about sex in the least, because he was gay, but he was tied up with Galerie Maeght in France and he knew about Tachisme. We became very friendly, and he said, 'Bring them in dear! Bring more in!' So I kept carting them along.

When Nan Kivell made the decision to give Rumney and Ayres the main room in the 'Metavisual Tachiste Abstract' exhibition, she remembers him saying, 'We're going to annoy the older ones.' He was entirely correct. 'When they saw it, the other artists were all furious; Patrick Heron burst into the Artists International Association, absolutely livid.'

Rumney's exhibit, *The Change* (1957), was executed on the floor, like much new painting of the time. Rumney later claimed this was simply the only practical way to work in his cramped flat on Neal Street. He was unwilling to acknowledge the direct influence of Pollock, preferring to see himself aligned with a European tradition of political engagement and dissent. This was in fact truer than he intended. *The Change* does not have the looseness and energy of Pollock or his American contemporaries. Somehow, despite his use of drip and splatter, a grid of lines has made it into the finished work, like the ghost of Mondrian. In retrospect, it looks a little stiff, dry, even old-fashioned.

In contrast, Gillian Ayres's works of the late 1950s were, visibly, the creations of someone in love with paint – its fluidity, its variable consistency or, as Rumney put it, its *matière* – its rich thick substance and potential to create space and movement. At least one visitor to the exhibition was impressed, a young architect named Michael Greenwood, who was doing some work for South Hampstead High School for Girls in North London. The sight of Ayres's expansive paintings gave him an idea.

Murals, like public art, were in the air, part of a prevalent vision of a new Jerusalem. In 1956, writing in a prospectus for a new and better world entitled *The Future of Socialism*, the rising Labour Party intellectual Anthony Crosland had called for 'more murals and pictures in public places' as one element in a long list of desirable improvements to Britain. Assuming the years to come would see an unending improvement in prosperity, Crosland argued that Socialists should turn their attention to 'personal freedom, happiness and cultural endeavour'. Ayres recalls how Greenwood approached her about doing a mural for the school in Hampstead:

> This architect was my age. He just came into the AIA and said, 'I'm redecorating this school and let's do a mural in the dining room. He got all the materials, and these panels prepared, and they were all very good too. I used Ripolin enamel paint, simply because Picasso used it. I thought what was good enough for him … It was a top French household paint, and there was a shop on the King's Road that sold it.

She made no formal preparations, no sketches. 'I would have hated to do a little bit on paper to blow up. I want to *feel* it.' Her methods were, like Davie's and Pollock's, essentially, improvisatory. There was no blueprint, no preliminary ideas worked out in advance, as painters making big public works had done from Giotto's time to Picasso's. The big scale was a given, not out of an urge to imitate the New York painters, but simply because of the size of the walls in the school dining room. 'I lay awake wondering how on earth I was going to deal with that size.'

In the event she took, as Pollock did, an initial leap and then started from the way – partly chance – the pigment had fallen. 'I just threw all the paint and turps all over the surfaces.' After that there came contemplation, adjustment, additions and subtractions. This way of working, she has explained, is a process of 'evolving something, rather in the way perhaps that a bar of music or a line of poetry follows from the last, developing and changing'. This is not entirely a matter of chance, more of intuition. Action does indeed come into it too. Ayres has used the analogy of tennis. 'You can suddenly sense that you are going to make a shot better than you usually do,

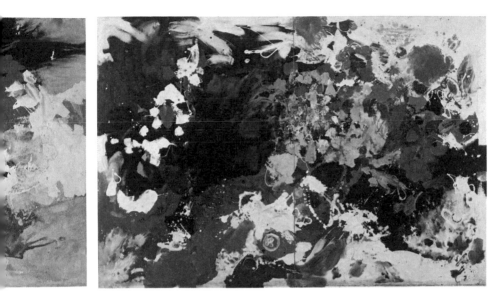

GILLIAN AYRES *Hampstead Mural*, 1957

and then you can't do it again.' 'Abstract' is an inexact word to describe this kind of painting, but it is the one that has stuck in our collective vocabulary.

Ayres's working methods caused the assembled decorators and school staff as much consternation as Minton had felt about Denny's and the makers of the Pathé newsreel about Green's: this struck them not as art but as insanity. She was working in one of the schoolrooms on a hot day in July, with the windows open. To begin with she covered all four panels with an initial layer, throwing on the paint and turps. At that point, 'the workmen came in, took a look and rushed out'. After another hour Michael Greenwood came in and said, 'They've all gathered out there; they think you're a madwoman.' So they opened the door and the assembled workmen were all there listening. 'We just laughed.'

The process of beginning with chance marks as an imaginative starting point has been used by painters since the fifteenth century: Leonardo da Vinci described how he could see faces and battles in the stains on an old wall. In works by Ayres or Pollock there is nothing so specific. There are, though, *suggestions*. Dancing figures seem to emerge in the latter's pictures;

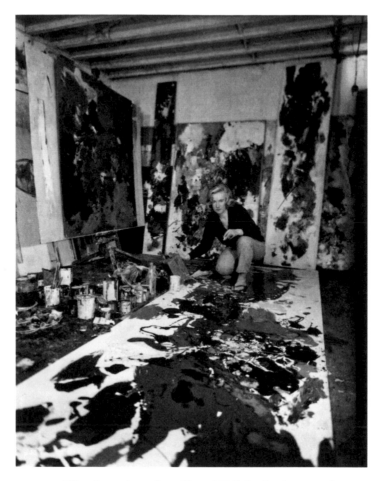

Gillian Ayres at her studio on Chiswick Mall, London, August 1958

looking at the Hampstead mural puts one in mind of blossoms, vegetation reflected in water, flowers, the night sky, many things in fact, but it does not exactly depict any of them. Although public art works – even strikingly modern ones – were fashionable in the 1950s and 1960s, it is hard to think of any quite as radical as Ayres's *Hampstead Mural* (1957). Its four large panels add up to one huge work: a masterpiece, though not one that has often been seen, except by the staff and pupils of the school where it still enlivens the walls.

CHAPTER ELEVEN

THE SITUATION IN LONDON, 1960

Abstract painting, that is painting that is not about subject matter, if it is any good
should be as diverse, and complex, and strange and unaccountable and unnameable as
an experience, as any painting of any consequence has been in the past.

ROBYN DENNY, 1964

E arly in 1959 the Tate Gallery held another exhibition, this time more simply titled 'New American Painting'. By this date there was little question that the USA was the principal fountainhead of exciting new developments in art. Lawrence Alloway was enthused: 'No other country in the world could put on an exhibition of postwar paintings' to equal this, he wrote. He remarked, crushingly, that a similar display of British work would, 'to put it mildly', lack the 'purpose, power and vitality' demonstrated by these artists from across the Atlantic.

John Kasmin, then a junior employee working for various London art dealers, was inspired by the sheer scale of their work: 'I was interested in big, bold pictures, the whole idea of aiming for the sublime and painting things bigger than the easel paintings that fitted into ordinary houses.' He began to think of opening his own gallery, to promote 'big American paintings and the kind of English artist who admired that sort of painting, if not painting in exactly the same way'.

Increasingly, this was the type of painting that was the height of art world fashion. The second John Moores Painting Prize competition, held in 1959, was won by Patrick Heron with his abstract *Black Painting – Red, Brown and Olive: July 1959* (1959). The work of both the runners-up, William

Scott and Peter Lanyon – scooping awards of £500 and £400 – was at least somewhat abstract too. Heron's winning canvas consisted of large, fuzzy rectangular forms in the colours listed in the title. In contrast, Scott and Lanyon tended to retain vestiges of – respectively – still life and landscape in their work, while the human figure had reappeared in the paintings of Roger Hilton, who was only awarded a prize of £100. The lesson seemed to be that abstraction now ruled, and the more resolutely non-representative the better. Something had shifted; the Zeitgeist had changed imperceptibly in the second half of the 1950s. Robyn Denny defined the new mood: 'Suddenly art was future-orientated; it was no longer historically-oriented.'

One day in that same year, 1959, Heron had a shock while walking down the street in St Ives. There, in this little seaside town on the north coast of the furthest tip of Cornwall, was the very last person he would have expected to see: Francis Bacon. 'Good God! Francis!' Heron exclaimed, 'What on earth are you doing here?' Heron's astonishment was understandable. St Ives, of course, was then a headquarters for the abstract wing of British art, while Bacon, as we have seen, disdained non-figurative art as merely 'pattern-making', 'an illustration or accident about nothing'. As we have seen, 'decoration' – as opposed to violence, tragedy and making a powerful effect on the viewer's nervous system – was something Bacon despised; Heron, in contrast, thought decoration was 'the height of art'.

In addition, the abstract art of St Ives was often derived from landscape. That was mostly the point of living in such a remote spot, in close contact with the sweeping sea and granite hills. Bacon's views about landscape can be gauged from his response to a suggestion he might live in Switzerland: 'All those fucking views!' Nonetheless, there he was in Cornwall, with his then partner, a young man named Ron Belton. 'We've just come from Penzance,' Bacon explained to Heron, 'which we simply *loathed* so we thought we'd come here.' 'To stay *here?*' Heron echoed in even greater amazement. 'Well, you see,' Bacon explained, 'I had to get away.'

At that point in his career, Bacon certainly had plenty of reason to go somewhere quiet to work. His life, and art, had been in crisis for some years. His relationship with Peter Lacy had always been turbulent, abusive and alcoholic; eventually, it had proved impossible. Lacy was now in Tangiers,

playing piano in a bar and drinking himself to death. Bacon also had an important deadline coming up. He had left the Hanover Gallery, whose proprietor Erica Brausen had long nurtured his career, and signed instead with the larger Marlborough Fine Art, which had offered to pay off all his debts. His first exhibition at Marlborough was to be in March 1960 and, as yet, he had very little work to show (Lacy had cut one batch to ribbons on Bacon's last visit to Tangiers).

What is not so clear, however, is why out of innumerable out-of-the-way spots he had selected St Ives. Did he want some contact with those despised abstract painters? If so, he denied it to Heron – 'I had no idea that *you* were all here, *dear!*' – though this was almost certainly a tease. In 1959, Bacon was in transition as a painter. His work of the early 1950s was magnificent but almost monochrome. By the latter part of the decade he was searching for something new; in 1957 he had produced a series based on Van Gogh's lost *Self Portrait on the Road to Tarascon* (1888, destroyed). These were obviously derived from his experience of the powerful sun of Morocco; however, he was not happy with the result. Bacon didn't like his Van Gogh paintings, he admitted to the critic Angus Stewart. Perhaps he intended to reboot his work, and thought abstract art might provide some clues.

At that moment Heron and abstraction were in the ascendant, while privately Bacon might well have harboured fears he had lost his way. According to the Irish painter Louis le Brocquy, on spotting Heron in a London gallery, Bacon announced 'Look! Here comes the Prince of Painters and he simply *loathes* me.' Bacon's disdain was doubtless genuine, but relations between the two were cordial enough for Heron to invite Bacon and Ron to Christmas dinner at his house, Eagles Nest, on the cliffs above the village of Zennor. Heron, a gifted mimic, could do a vivid impression of Bacon volunteering to light the pudding. He swayed rather unsteadily to his feet, and sloshed most of a bottle of brandy over it with the unsettling words, 'I'm very good at starting fires!'

Bacon joined in the St Ives social life with his usual amiable combativeness. He drank, like the other painters, in the Sloop Inn. William Redgrave, a local artist, overheard an exchange with the notoriously heavy-drinking and cantankerous Roger Hilton, who remarked: 'You are the only non-abstract

painter worth consideration, although of course you are not a painter – you don't know the first thing about painting.' 'Good,' replied Bacon, 'I think my work is perfectly horrible. Now we can get together; you teach me how to paint and I'll lend you my genius.'

The notion that Bacon might have learned something from Heron and the painters of St Ives is not as fanciful as it might seem. His reaction to Rothko and Pollock had been one of disappointment because he had expected to like them more. Several of the painters whom he admired were also idols of Heron's, Pierre Bonnard being one. The painter and critic Giles Auty spent a sunny afternoon with Bacon in St Ives, drinking whisky and talking mainly about Bonnard, until one of Bacon's other activities intervened. 'The discussion was interrupted by the return of Ron, who fingered his belt and enquired, "Are you ready for a thrashin' yet, Francis?"'

Bacon, unlike his friend Lucian Freud, had an appetite for strong colour. He had praised the chromatically rich paintings of the veteran Matthew Smith. From this point, Bacon, like Heron, painted colour fields – but colour fields inhabited by the human figure. He rented a spacious late Victorian place to work – No. 3 Porthmeor Studios – almost next door to Heron, who occupied Ben Nicholson's old workplace at No. 5. It would be hard to imagine more different working conditions from those in his cramped London studio, which was only thirteen feet square. Here, Bacon got down to work on some pictures quite unlike his paintings of a few years before – and quite possibly affected by those of his neighbour Heron. The Bacon scholar Martin Harrison has pointed out that in a sketch from *c.* 1959 a reclining figure is splayed out in front of three abstract, horizontal zones that look very much like the horizontal stripe paintings Heron had recently been producing just two doors away.

If Bacon learned something from his neighbours in Cornwall, they, in return, don't seem to have thought much of his efforts. One is rumoured to have recycled unfinished Bacons, left behind when he returned to London, as a backing for his own pictures; another to have used some of Bacon's paintings on hardboard to mend a hen-house roof.

It seems that – no matter how much he scorned abstraction – its relationship to his own art of brutal fact and tragic despair continued to

trouble Bacon after his return to London. The threat it posed was that his work, which had seemed novel and astonishing a decade before, might be starting to look old-fashioned. An encounter with his then friend Frank Bowling in 1960 gives some insight into Bacon's state of mind. Bowling had temporarily been expelled from the Royal College of Art for marrying the assistant registrar, Paddy Kitchen, and sought solace from Bacon. The older painter invited Bowling up to his studio and cooked him an omelette, much to Bowling's delight: 'I've never eaten another omelette quite like it, so beautiful and tasty, he was a very good cook.' Bacon, in avuncular spirit, offered as consolation the notion that Robin Darwin – the principal who had kicked Bowling out – was the worst painter who had ever lived. He took the view that Bowling should pay no attention to the art school establishment, which had been after all his own strategy, and concentrate on his own way of painting. Then, after quite a bit of drinking, Bowling and Bacon 'locked horns' about two- and three-dimensional space. Bowling recalls:

> I said that Modernism had come to underline that, in painting, the task was to manoeuvre the material – paint – on the canvas across *flat* space. The dynamics of the picture had to be all over, and the space flat. It was the first time I had articulated something I was feeling instinctively. Bacon's space, I was convinced, was Renaissance space – a stage with figures on it. I carried on like that, unaware by how disturbed he was by my saying this.

Their friendship ended soon afterwards, and the fact that Bowling had been saying – in effect – that Bacon's work was outmoded may well have been the underlying reason. It cannot have gone down well.

These issues around space, and flatness, in painting were the vital questions of the moment for artists. For some avant-garde tastes, even Heron's John Moores prize-winning work was still a bit too European, too English. Though resolutely non-figurative, it still had an atmospheric haze, a lingering hint of air and cloud. Perhaps, also, at around three feet by four, it was on the small side in comparison with the epic scale of American painting. Size – like flatness – was becoming a critical matter.

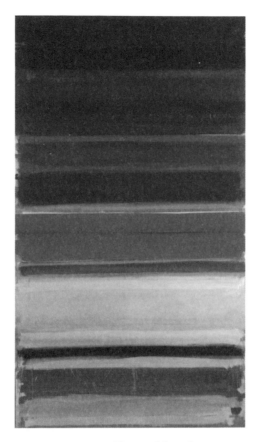

PATRICK HERON *Horizontal Stripe Painting:*
November 1957–January 1958, 1957–58

Also in 1959, the same year the Tate was showing 'New American
Painting' and Heron won the John Moores, an exhibition called 'Place'
was held at the Institute of Contemporary Arts in London. It consisted of
work by three younger painters: Robyn Denny, Richard Smith and Ralph
Rumney. To them Heron and his contemporaries looked old-fashioned and
American art much more exciting. But 'Place' was radically unconventional
as much – or indeed more – for the way the paintings were presented. Instead
of being hung on the walls, they were bracketed back to back, and arranged
in two parallel zigzags. There was even a map of the floorplan on the reverse
of the invitation card. It was a maze of pictures. Roger Hilton had talked

FRANCIS BACON Sketch of reclining figure, c 1959

about 'things flying out of the canvas and joining up with people in the room'. Here were paintings that were actually jostling with the viewer for space, looming close and personal, almost trapping the spectator.

'Place' was planned as a sort of game. The rules were agreed by the three painters before they began work: each exhibit would be a panel of seven feet by six feet, colours would be restricted to three – red, green and black – which could be used singly (since monochrome pictures were now a possibility) or in any permutation the artists saw fit. Within these restrictions, the participants were to work as close to their usual idiom as possible.

As the spectators moved around the space, new works – or parts of works – came into view. Roger Coleman, the young critic who wrote the catalogue essays, expounded the theory of a 'game environment' through which the viewer could plot his or her own path: '"Place" can be looked at, through, over, between, in or out.' Every path through the labyrinth resulted in a different experience. And the whole show added up to make one environment, what came to be called an installation. It was an intriguing conception, but the veteran critic Eric Newton, writing in the *Observer*, did not enjoy this game. He greeted 'Place' as 'the silliest exhibition I have ever seen in my life'. Nonetheless, it troubled him. 'To ignore it would be unforgivable,' Newton conceded, but 'to praise it would be impossible.'

Even leaving aside the challenging presentation, 'Place' was disconcerting viewing for anyone with conventional expectations of what painting could do. For one thing, the works in it were all 'hard-edge' abstractions. This was a term that, though he had not exactly invented it, Lawrence Alloway had picked up from a passing reference in an American catalogue, refined and then publicized with brilliance. These were paintings made up of flat forms with hard, sharp contours. There was no illusion, no fictional space. The edge was a 'clear hinge, unsoftened by atmosphere, unbroken by overlapping'. A hard-edge painting with a round form in the middle was not a picture of a disc: it was a big, unified sight that confronted you, an object in itself.

Hard-edge painting aimed to do away with the distinction between figure and field, subject and background; and the young Denny and his friends were not the only ones to promote it. For example, *15 – 1959 (Red Saturation)* (1959) by Alloway's close friend William Turnbull has a form at its centre, a round area of slightly deeper red. But are we looking at a circle or a sphere – the red planet, for example – or a disc-shaped void in a crimson surface? The relationships flicker in the manner of the duck/rabbit illusion. Now you see a hole, now a sphere.

This was not an image, but a thing: a flat, coloured, abstract sculpture made with paint. Indeed, earlier in his career, Turnbull had been known as a sculptor; in 1952 Herbert Read had included him in an exhibition at the Venice Biennale called 'New Aspects of British Sculpture'. In 1958 and 1959, Turnbull produced a series of hard-edge paintings, often simply

WILLIAM TURNBULL *15 – 1959 (Red Saturation)*, 1959

numbered and dated rather than titled. He was cutting painting down to a minimum. Less of everything – except scale – was more; accordingly, he used only two colours, or even just one, per picture. *No. 1 1959* (1959) is almost six feet square, and all the same mustard yellow, with variety and interest provided by the brushstrokes. It was like a very big Van Gogh with no discernible subject: *Sunflowers* without the sunflowers.

As an ideal, however, flatness was as difficult to achieve as most of the other objectives painters set for themselves. Even Turnbull's *Red Saturation*, whether you see it as a red planet or a void in an orange plane, has a little bit

of space in it. The darker red either recedes or bulges out; and the edges are slightly hazy, suggesting the tiniest hint of atmosphere. Predictably, American painters were ahead in the race to be flattest. Some, such as Ellsworth Kelly and Frank Stella, made paintings that were remarkably lacking in any suggestion of depth. The British found it harder to expel the last hint of Turnerian haze: there is even a shimmer of it in the all-yellow *No. 1 1959*.

<div style="text-align:center">*</div>

Hard-edge painting was perhaps too austerely – or, for its detractors, aridly – lacking in content to reach a mass audience. It was, though, in tune with the mood of the times in one way: modern art, instead of being a joke or an outrage, was beginning to become a hot ticket – what Robyn Denny had described as 'future-orientated'.

A sign of this came that same year, in 1959, when Denny was asked by the men's outfitters Austin Reed to create a mural for the lower-ground floor of their flagship shop at 113 Regent Street in London. A middle-of-the-road – not to say staid – retailer, Austin Reed had become alarmed by a new type of competition: clothes for men that were hip, flamboyant, in a (new) word, trendy. Shops selling this unheard-of novelty were advancing towards Regent Street with alarming rapidity. In 1957, John Stephen, son of a Glaswegian shopkeeper and in the vanguard of this army, opened a branch of His Clothes, the ultra-fashionable boutique he ran, on a previously quiet backwater of western Soho, Carnaby Street. A visitor described it as full of 'fantastic daring colours [in] loads of different styles and fabrics'. Despite the Menswear Association's condemnation of Stephen for selling the 'codswallop fashions of perverted peacocks', by 1967 he had ten shops on Carnaby Street alone, and the address was world famous as shorthand for 'swinging London'.

Searching for a response, Austin Reed commissioned a firm of architects – Westwood, Sons & Partners – to brighten up and modernize its image. The architects thought of Denny, perhaps because he had already designed a mosaic mural, consisting of a jumble of letters and numbers, for a nursery school in South London. The artist's brief was to produce a work 'adopting the signs of metropolitan novelty'. Denny began with a cubist collage with

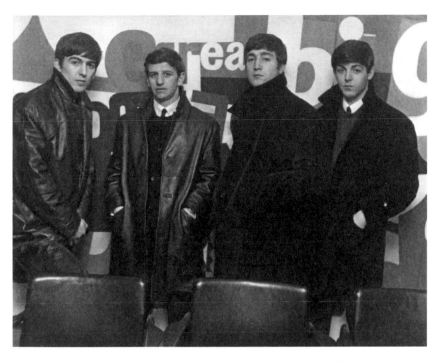

The Beatles in front of Robyn Denny's Austin Reed mural, 1963

a distinctly abstract look, incorporating a few broken phrases – as Picasso and Braque had done – but turning it into something far more brash and direct: a bold word-soup of positives and superlatives, jostling with each other and painted in the red, white and blue of the Union Jack. The mural's title was *Great Big Biggest Wide London*. When a pop group from Liverpool hit town a few years later, one of their first photo-shoots was in Austin Reed, in front of Denny's mural. The Beatles look entirely in context there.

Clothes were increasingly part of the way artists, and even critics, promoted an image. Alloway and Coleman favoured smart imported American suits in futuristic Dacron (polyethylene terephthalate). Turnbull had returned from a trip to New York – where he had met Newman, Rothko and others – with an electric-blue gangster suit. Gordon House, a graphic designer and painter of the hard-edge school, favoured the 'Madison Avenue' look from Cecil Gee; while Denny himself went in for preppy cool.

Hand-in-hand with this forward-looking attitude in painting went the desire to work on a large scale. Great, big, bigger canvases were the common factor in an artist-run show that opened in the early autumn of 1960. 'Situation: An Exhibition of British Abstract Painting', at least in the minds of the artists involved, stood for 'the situation in London now'. Their predicament was that they were producing these huge pictures – but no one was exhibiting them, let alone buying them. Accordingly, in the words of William Turnbull, one of the prime movers, they took 'their destiny into their own hands' and organized their own show.

The galleries of the Royal Society of British Artists on Suffolk Street were available in September that year, so they booked them, formed a committee and organized the exhibition. The main criterion for including a work was that it should be abstract and 'not less than 30 feet square': that is five feet by five feet, rather large for most walls in private houses and thus, from the art market's point of view, a tricky proposition.

It was, in its way, revolutionary. Denny, who was the Secretary of the committee, hoped it would enable artists to be 'independent of all the normal channels for exhibiting and informing'. Alloway, the Chairman, wrote in *ARTnews* that 'the purpose of "Situation" is to make public what the public has not been seeing' (among this 'public' he included the art critics). There were all these huge abstract pictures stacking up in studios, but kept from view by the filter of the commercial galleries. Let them be seen!

In that respect, in the short term at least, 'Situation' was almost a complete flop. Over the month of the show, Denny noted, just 885 visitors came and 621 catalogues were sold. Many of those who did come probably did so on the opening night. Otherwise, the footfall was very low. Gillian Ayres remembers, 'We rented this divine gallery, and we paid for it thinking people were going to burst in, but they bloody didn't! If you went in there, you were lucky if one person was walking round. We were just left with this enormous bill.' She was still sending Denny cheques for her share several years later.

*

GILLIAN AYRES *Cumuli*, 1959

If abstraction was the norm, it was a language that numerous painters were tempted to subvert by transforming it back into an image of something real. The boundary was always porous. Is that stripe in a Heron picture actually a sunset or just paint? Part of the ambiguity came from the fact that paint is inherently prone to look like something. That is part of its charm and its nature. Any brush mark put down on a surface is liable to resemble an object – a face, a tree, a cloud, a muddy excavation. This fact is the basis for, among other traditions, the kind of landscape painting practised by Turner, Constable, Claude and Poussin.

Not only was Gillian Ayres the sole woman artist included in 'Situation', she was also the closest to being a painter whose abstractions seemed

actually to represent something (although it is an intriguing and insoluble conundrum whether they do or not). In 1959 and 1960, Ayres produced a sequence of paintings varying in size between large and gigantic, whose titles – *Cumuli, Cwm Bran, Cwm, Unstill Centre, Muster, Nimbus* – refer to geological features and atmospheric phenomena. At the time, she and her husband, Henry Mundy, would often travel – when they were not going to Paris to look hard at paintings – to go walking in the mountains of Wales.

In retrospect Ayres admits that a certain feeling – of being high in Snowdonia, looking down at the landscape beneath or the sky above – might have 'got into' particular works. Yet, despite their titles, she feels those pictures '*weren't* landscapes in a way'. They were purely abstract and, to an extent, the effects in them were random.

HOWARD HODGKIN *Memoirs*, 1949

I used to say they painted themselves, I would throw turps over
the whole bloody thing, go and have coffee, and who knew what it
might do. It was quite mad. There were these sorts of *runs* it used
to make ... In those days that one was on top of mountains, I was
probably quite full of these things inside, but it was never a literal
thing. It was almost like – if the mist does *that*, then probably if you
chucked turps over the whole bloody lot why can't the turps do it too?
It went together. In a mad sort of way I saw *nature like paint*.
And so probably did Turner.

During the early 1960s Ayres taught part-time at the Bath School of Art
and Design, based at Corsham Court in Wiltshire. Among a number of
other notable painters assembled to teach at Corsham by Clifford Ellis, the
principal, was Howard Hodgkin. Ayres was living in Barnes at the time,
while Hodgkin and his wife had a house at Addison Gardens in Kensington.
Often, Ayres and Hodgkin would drive down to Wiltshire and back – a
journey that took two or three hours – talking about painting all the way.

The pair had known each other since art school. Ayres remembers the
young Hodgkin at Camberwell in 1948, 'walking around wearing short
trousers, looking' (the shorts were probably a hangover from his time at
Bryanston School, where short trousers were worn into the sixth form).
Hodgkin described the experience of being at art school as 'like being
squeezed out of the wrong end of a tube of toothpaste'. But it was there
in 1949, at the age of seventeen, that he painted *Memoirs* – a little picture
representing a man and a woman in a room. He sits on a chair, his head
turned to her; she is lying on a sofa with her head, so to speak, out of
shot. Her hands, conversely, are greatly enlarged. It is an indoor setting,
though not one depicted naturalistically: a precocious anticipation of a
kind of picture that was to occupy Hodgkin for much of his career,
an 'emotional situation' in an interior, tense with elusive undercurrents,
situated in a border-territory between abstraction and representation.
One day, William Coldstream asked the teenaged, and perhaps still short-
trousered, Hodgkin why he had painted *Memoirs*. Hodgkin answered that
he didn't know – a perfect answer if, like Auerbach, Bacon, Kossoff and many

Howard Hodgkin, c. 1965

other artists, you believe that to do something good you must go beyond your conscious knowledge.

Hodgkin and Ayres are not often grouped together, art historically. But they occupy positions that are quite close – each just to one side of the invisible frontier between abstraction and representation. Ayres did not consciously imitate a real sight, but was willing to allow chance and the paint itself to create rhymes and metaphors for things – a mountainous landscape, for example. To Hodgkin, on the other hand, a subject – a real sight, or more often how he felt about people or places – was crucial. He always began with 'a very firm – or very exact – visual memory'. But in the process of the painting's evolution, sometimes extremely prolonged, this memory was metamorphosed into something quite different: circles, rectangles and triangles, swirls and brushstrokes that – at first or even second glance – might look completely or partly 'abstract'.

In 1960, Howard Hodgkin portrayed Robyn Denny and his wife Anna in an idiosyncratic portrait. Denny wears a vertically striped jacket, horizontally striped tie, his face is yellow, his glasses red. He and Anna appear

against a field of curving blue and white shapes: a hard-edge couple in a hard-edge world. This looks like an in-joke: a playful depiction of an artist in terms of his own work, in which Denny's militantly abstract idiom is transformed into a quirky kind of portraiture. Even so, Hodgkin observed that it was also 'a good likeness'.

Mr and Mrs Robyn Denny (1960) is one of the first mature paintings Hodgkin painted. He was twenty-seven in 1960, but – like Francis Bacon – a late developer, belonging to no movement or group: 'I felt a complete outsider everywhere, someone who did not really much exist. I was a total non-joiner. I didn't know where I could possibly join.' It took him a long time to find a personal style. No works at all survive from several years in the mid-1950s. He continued to feel like an outsider, and be treated like one: 'The 60s was when somebody pointed out to me that I appeared in a book on Pop art. I looked up my name, and it said "he wasn't one". Everything was very slow.' Yet that did not prevent him from being one of the more distinctive and memorable painters of the decade.

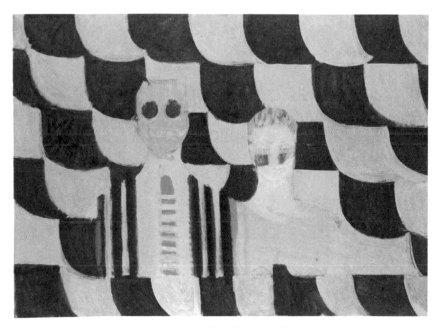

HOWARD HODGKIN *Mr and Mrs Robyn Denny*, 1960

*

It was a strange irony that the close alliance between Alloway and his carefully assembled team of hard-edge painters was finally shattered partly at least because of a portrait – and a much more naturalistic one than any by Hodgkin – painted by Alloway's wife, Sylvia Sleigh.

Although few went to 'Situation', there was a reprise of the show – with changes and additions – the following year, at the smart Marlborough New London Gallery, an off-shoot of the main gallery intended to show-case the cutting-edge art that was now appearing, unexpectedly, in this previously staid city. For the catalogue of the second 'Situation' exhibition, it was proposed there should be a frontispiece: a group portrait of the artists by Sleigh, a figurative painter who – though she was already in her mid-forties – had not gained much attention up to that point. The picture depicted Alloway's 'team' as it was in March 1961, or at any rate most of the principal players: Mundy and Ayres are at the left, Denny, wearing glasses, centre right, Alloway himself is in the bottom right-hand corner.

Several of the painters were extremely unhappy about this picture – so far from abstract, instead rather quirky and almost naive in style – being at the front of their resolutely hard-edged, contemporary catalogue, with its own hard-edge typography and design by Gordon House (front centre in Sleigh's painting, next to Alloway). Henry Mundy described what happened next:

> People were a little bit scared of Alloway, because he was so
> powerful. But at some time or other several painters got together
> and said they didn't want it. I had heard they were going to come
> out with it, and was very pleased about that. It was a *terrible* painting.

Ayres concurs with this verdict, although she adds that the head of Alloway in the portrait is 'a bit less bad', Sleigh having spent more time on it. They had a point, since the painting is spatially incoherent – all the figures obviously studied separately and stuck awkwardly together. According to Ayres, Sleigh herself reacted by saying 'that all the men were being beastly because they were men'. She too had a point, since the 'Situation' team, whatever else they were, were unquestionably overwhelmingly male. Looking back,

SYLVIA SLEIGH *The Situation Group*, 1961

Ayres feels that it was outrageous that she was the only woman among a long roster of male painters – that Tess Jaray, for example, a prominent hard-edge painter, wasn't included too.

Alloway later argued that it was the idea of being swept up willy-nilly into a team of 'Alloway's boys' that caused the trouble: 'They felt I was taking over their art. I lost all my friends in one go.' The artists were so negative that Alloway refused to write the catalogue essay, and withdrew from the group completely.

He and Sleigh moved to the United States, where he became a curator at the Guggenheim and she became a prominent and successful figure in the women's art movement of the following decade, her painting gaining confidence and brio from the change in continent. Her portrait was a portent of things to come. Abstraction remained an important idiom, but content – sexual politics, sex without politics, politics without sex, humour, individual identity – was about to flood back into art (if, indeed, it had ever really gone away).

CHAPTER TWELVE

THE ARTIST THINKS: HOCKNEY AND HIS CONTEMPORARIES

The illusion of the art centre tends to drift from one place to another. Back in the '60s
I thought that London was where it was going to settle.

ROBERT RAUSCHENBERG, 1997

C hanges in the Zeitgeist tend to take place gradually. This certainly applies to the slow brightening of British life over the years that followed 1945, as we have seen. It was in part a literal alteration in clothes and interior decoration, in which greys and browns were replaced by ever-stronger reds, greens, yellows and blues. But it was also a shift in mental attitude. By the end of the 1950s, young people in their early twenties could barely remember the war. To them, it seemed natural that life should become better and better, fuller and fuller of opportunity. They had grown up in a Britain that was becoming steadily more prosperous. In 1957, the Prime Minister Harold Macmillan observed, with some justice, that most of the population had 'never had it so good'. Enough clearly agreed to re-elect him in 1959.

Although such shifts happen incrementally, over time, there is often a moment when they suddenly become obvious. One such episode took place in the Royal College of Art life-drawing studio one afternoon, suitably enough, exactly as a new decade was dawning. In September 1959, a fresh batch of students had arrived in the RCA's painting school, among them

Frank Bowling, Derek Boshier, R. B. Kitaj, Peter Phillips, Allen Jones and David Hockney. These would become, over the course of the 1960s, 'artists who dominated the decade in British art', to quote Allen Jones. However, that was not how their teachers saw it. According to Hockney, the staff thought this particular intake of students was the 'worst they'd had for many, many years'.

That afternoon, Jones was working in the life-painting studio 'investigating Fauvism', as he saw it. This was not, on the face of it, a revolutionary thing to do – the Fauves had caused consternation in Paris over half a century before with their vivid, non-naturalistic colour. But, even in 1959, this was a long time ago, before the First World War. By and by, the teacher, Ruskin Spear, came in, looked at the painting on Jones's easel and exclaimed, 'What's going on here? What's all this bright colour? Look, this is a grey room, with a grey model, it's a grey day, it's a grey prospect. What *is* this green arm and red body?' But to Jones and his contemporaries, the world wasn't necessarily grey: 'I thought he was joking, then I realized that actually he was serious about this, and I was appalled. He just said, "Decoration!" and went off to berate somebody else.'

Jones's painting *The Artist Thinks* of 1960 is organized around a crashing colour chord of red and green. The self-portrait at the base of the composition is assembled from stripes and swirls, mainly in blue and grey. Jones borrowed the 'thought bubble' convention from cartoons, using it to suggest the thoughts within his head, which seem to consist not only of clouds of colour, but also – as is hinted at by the green breast like mounds – of sex.

Clearly Jones, and several of his contemporaries, were also thinking hard, and with great self-confidence, about what art could be. This was not something that more senior members of the Royal College of Art necessarily did, at least not in the deep and intellectually ambitious fashion of some of their students. Malcolm Morley, who attended the RCA from 1954 to 1957, recalls that although he loved the painters – such as Ruskin Spear and Carel Weight – who were teaching there, describing them as 'terrific painters', 'the Royal College of Art was a dreadful place in terms of education. You didn't learn a damned thing. What you learned was how to hold your drinks with the teachers.' It was not until Morley moved to

ALLEN JONES *The Artist Thinks*, 1960

RODRIGO MOYNIHAN *Portrait Group*, 1951

New York in 1958 (and thus out of the terms of reference of this book) that he encountered 'really philosophical thinking' about art, having arrived in America 'without ever hearing who Marcel Duchamp was'. Other students at the RCA noted the same failure to treat painting as a subject for hard thought. Frank Auerbach recalls that Robert Buhler, 'who was in a sense a *really* bad painter', once 'more or less suggested that Monet and Van Gogh were all simple souls sloshing away, and a few of them had something in their genes that made their work grand or remarkable'.

The senior instructors at the RCA had not changed much since Rodrigo Moynihan had painted them in *Portrait Group* (1951), a gloomy depiction of the painting school staff that was his submission for '60 Paintings for '51', though it did not win any prizes. Moynihan painted the despondent figure of John Minton seated on the left, with Carel Weight – bespectacled and teddy-bear-like – standing contemplating him. The others in the picture included Robert Buhler, Colin Hayes and, on the right, Ruskin Spear, bearded and seated with his legs stretched out on a chaise longue.

Allen Jones in his studio, London, c. 1965. The painting in the background is **Man Woman**, *now in the Tate collection.*

Moynihan's group portrait is a distinguished work in its way, perfectly capturing the drabness of postwar London. Moynihan himself was far from being an unthoughtful or unadventurous artist and by 1959 he had turned back to abstraction. But the contrast between this picture and Jones's *The Artist Thinks* – chromatically, emotionally, conceptually, historically – is total.

Unlike Moynihan, the new crop of painters at the Royal College took abstraction as their starting point. This was one of the things that infuriated both Spear and Weight, who was head of the painting school, and who summoned all the students together and underlined that in the first year they didn't expect anyone to be experimenting. That was reserved for later on. Weight told Frank Bowling that if he painted abstracts, he would be thrown out. But abstraction, Allen Jones remembers, 'was the thing you cut your teeth on, you had to deal with it. I still come out of Abstract Expressionism really but I misuse it for figurative ends. I've never been able to dump the figure.' This attitude was doubly irreverent, thumbing its nose

equally at the standard methods of figurative painting and the avant-garde approach of Pollock, Rothko and Newman. Bowling describes his contemporaries as all 'making jokes about abstraction'. Sometimes this group of younger painters at the RCA is termed the second generation of British Pop artists, though few accepted the 'Pop' label happily or for long. But they were willing to bring to the epic solemnities of Abstract Expressionism their own mix of humour, sex and humanity, ingredients that *The Artist Thinks* contains in abundance.

<div align="center">*</div>

In 1960, opportunities seemed to be opening up for more and more sections of the population, and while social barriers of class, gender and race still existed, they were beginning to weaken or be broken down. In the coming decade, creative people – artists, designers, photographers – came to be seen as a class in themselves, a group defined not by their origins, but by talent and energy.

At the Royal College, Derek Boshier's circle, for example, was full of such individuals: David Hockney, with whom he shared a studio, the future film director Ridley Scott, who was studying graphic design, and Ossie Clark, who would become one of the leading fashion designers of the 1960s (he was briefly Hockney's partner and the subject of one of his most celebrated portraits, *Mrs and Mrs Clark and Percy*, 1970–71). Another close friend of Boshier's was Pauline Boty, who was studying stained glass, having been discouraged from applying to the painting school because she was a woman. Within a few years, however, she had given up stained glass to become one of the most innovative painters in London.

Many of these students were from backgrounds in which art did not play a prominent part, and often they did not come from London. Boshier himself was from Portsmouth and had been intending to take up a post as a trainee butcher in a branch of Dewhurst when his art master suggested he should go to art school instead. At eight years old, in his home town of Bradford, Hockney had watched his father reconditioning old bicycles, dipping his brush into paint and putting it on; the child had loved something about the process, the feel of 'a thick brush full of paint coating something'. He knew that there were pictures made with paint, which could be seen in museums

and books, but he could not conceive that anyone could make such things for a living. He 'thought they were done in the evenings, when the artists had finished painting the signs or the Christmas cards', or whatever it was they did to earn their wage.

Naturally enough, given the concentration of talent at the RCA in 1959, the new students were impressed by each other. Jones saw himself as 'rather a slow learner compared with the students around me'. Their achievements, he felt, seemed to be more significant than his at the time. On the first day of the term in September that year, he had noticed one pupil in particular, partly because of his age: 'There was this older man, a real-life American, Kitaj – when you are twenty-one or twenty-two someone who is twenty-seven seems much older – who was painting along the corridor in a little booth.'

Ronald Brooks Kitaj – usually 'R. B.' for public purposes and 'Ron' to his friends – was much closer to being a mature artist than the rest of the new arrivals. He was also married, with a child on the way. Kitaj was brought up in Cleveland, Ohio, but was by instinct, and choice, an expatriate wanderer. As a teenager he had alternated between periods as a merchant seaman and intervals studying art at the Cooper Union institute in New York and the Academy of Fine Arts in Vienna, with journeys to Spain in between. After being drafted into the US Army in the early 1950s (spent peacefully in France), he took advantage of the GI Bill, opting to study at the Ruskin School of Drawing at Oxford, partly because he liked the idea of being an American in England, like T. S. Eliot, Ezra Pound and Henry James before him.

His teacher at the Ruskin, Kitaj remembered fondly, was 'a gentle Cézannist called Percy Horton, who had been a protégé of Degas, who had been a student of [Louis] Lamothe, who had been a student of [Jean-Auguste-Dominic] Ingres – all that lineage'. He also encountered the distinguished Oxford professor of art history, Edgar Wind, known for his interest in iconology – the study of the history of images – who sent him in turn to the Warburg Institute Library, where he researched quirky byways of the visual past. From the beginning, he was interested in the meanings of pictures and not just their form.

Kitaj, Hockney remembered, was 'a great influence stylistically on a lot of people, and certainly on me'. It was not only a matter of what he did, it was Kitaj's *attitude* that impressed Hockney: his seriousness about painting. This quality made him slightly 'formidable'. 'He used to put up a kind of front against people as though he couldn't tolerate fools.' He and Hockney struck up a friendship based on the fact that, in Kitaj's words, they were both 'great readers' and young socialists – with a lower case 's' – by upbringing as well as inclination. Kitaj's grandfather had routinely read the *Daily Forward* in Yiddish back in bleak, industrial Cleveland; Hockney's father, Ken, had read the left-wing *Daily Worker* in gloomy, industrial Bradford. Kitaj felt that he and Hockney 'were both ambitious exotics'. One was American, partly Jewish, wholly cosmopolitan, the other a Yorkshire homosexual; both were instinctively intellectual and loaded with talent.

Initially, Hockney had been overawed by the admissions process for the RCA: 'I naturally thought I wouldn't have a chance, because all the London people would be better than me.' Having been accepted, he still felt ill at ease: 'At first I didn't know what to do, so I spent about three weeks doing two or three very careful drawings of a skeleton. Just for something to do.' When Kitaj saw them, he was struck by the work of this boy 'wearing a boiler suit':

> I thought it the most skilled, most beautiful drawing I'd ever seen; I'd been to art school in New York, and in Vienna, and had quite a lot of experience, and I'd never seen such a beautiful drawing. So I said to this kid with short black hair and big glasses, 'I'll give you five quid for that', and he looked at me and thought I was a rich American, as indeed I was: I had $150 a month on the GI Bill to support my little family.

Hockney's skeletons, his first works at the RCA, did indeed already demonstrate the clarity and subtlety of line that made him one of the great exponents of drawing in the twentieth and twenty-first centuries. His skills had been honed by four years spent studying drawing at Bradford School of Art. Such spectacular ability to do what artists traditionally were supposed to do protected Hockney from clashes with the college authorities. At the end of the third term, when the principal, Robin Darwin, demanded expulsions, one of those selected was Allen Jones, but the equally awkward Hockney

was too brilliant a draughtsman to be given the boot. Looking back, the latter surmised: 'Being the way they were, they thought, he can draw; if he can draw then there's something there.' Frank Bowling concurs: 'If David hadn't drawn those skeletons he'd have been sacked.'

*

After the first few weeks of settling in, Hockney began, like several other students – Peter Phillips for example – by painting big, loose paintings in an Abstract Expressionist idiom. He did some twenty of these in a style he summed up as 'Alan Davie cum Jackson Pollock cum Roger Hilton'. 'I thought, well, that's what you've got to do,' but then he ran into a dead end. He couldn't carry on; it seemed pointless, 'barren'. 'I used to think, "How do you push this? It can't go anywhere. Even Jackson Pollock's painting is a dead end."'

Having reached this point, Hockney had a crucial conversation with Kitaj, who pointed out that the younger man was interested in all sorts of things – politics, vegetarianism – so why didn't he paint those? Hockney thought: 'It's quite right; that's what I'm complaining about, I'm not doing anything that's from me.' He needed to make pictures about something that mattered to him. And this was what he began to do, cautiously at first, because the dogma of abstraction was then so powerful that, to start off with, he dare not depict actual human figures. Ironically, the staff at the Royal College would have welcomed that, though not perhaps in the way that Hockney eventually did so.

Hockney proceeded warily. His initial solution was to smuggle personal messages into his pictures in the form of words. A word, he felt, was like a figure, in that it was something human. When you put a word on the surface of a painting, the viewer immediately reads it and it becomes 'not just paint'. One of the first words to appear in his work was 'Tyger' from William Blake's poem of the same name (1794). Hockney's fellow-students would come to take a look at what he was doing and say, 'That's ridiculous, writing on pictures, you know, it's mad what you're doing.' But Hockney was thinking, 'I feel better; you feel as if something's coming out.' In fact, it was he who was coming out.

David Hockney and Derek Boshier in front of
Hockney's We Two Boys Together Clinging *(1961), 1962*

His paintings of the next few years became increasingly confessional, the words on them referring to his life as a young gay man – and revealing that that was what he was. *The Third Love Painting* (1960) contains phrases from the lavatory wall at Earl's Court Underground station, as well as the artist's exhortations to himself: 'Come on David, admit it.' Just as outrageously, the figure reappeared in his work, in pictures such as *We Two Boys Together Clinging* and *Doll Boy*, both from 1961. Rough and raw, these paintings are a gallimaufry of diverse influences – from Jean Dubuffet to Francis Bacon, Abstract Expressionism to Kitaj – yet something individual, and remarkable, was slowly emerging.

*

Despite his expulsion, Jones was chosen to be secretary of the 1961 edition of the annual 'Young Contemporaries' exhibition. This initiative, ironically under the circumstances, had originally been suggested by Carel Weight in 1949. He proposed that the RBA Galleries in Suffolk Street – the venue for the 'Situation' exhibition – would be a good place for a regular show of work by art students. To begin with, it had been dominated by work from the Royal College, but members of other art schools infiltrated over the years.

Peter Phillips was president of the committee; the treasurer was Patrick Procktor, a student from the Slade. Jones and Phillips were in charge of the hanging but, as Jones remembers, their first attempt at it looked like a jumble:

> After we had hung the show, Peter Phillips and I looked at each other and said, 'This just looks like Sketch Club.' We thought, 'Why don't we hang all the stuff which we think is good painting on one wall?' and faced them off against, essentially, the Slade paintings.

They gave one wall to Kitaj, who was evidently considered the most significant artist among them. Then they hung as a group the other paintings by students from the Royal College, with the Slade pictures – all, Jones recalls, influenced by Bomberg and Auerbach – on the opposite side of the gallery. Hockney remembers the arrangement slightly differently, recalling that Procktor – with whom he became friendly – called attention to his own works and suggested they should be put in a more prominent place.

It was clear, as soon as the exhibition was unveiled in January 1961, that something exciting was going on at the Royal College. Hockney thought 'it was probably the first time that there'd been a student movement in painting that was uninfluenced by older artists in this country'. Lawrence Alloway, who was on the selection jury – with Anthony Caro and Frank Auerbach – wrote the catalogue essay. He defined the connection between the artists on show in a more measured manner. These artists, he argued, 'connect their work with the city'; they incorporated such elements as commercial design and graffiti, giving their work 'urbanity' and 'contemporaneity'.

The exhibition created, as Hockney put it, 'quite a stir'. John Wonnacott, then a student at the Slade, remembers talking to Frank Auerbach, one of

his tutors, about Hockney's recently completed series of 'love' paintings. 'I said, "What on earth is this?" I'd never seen anything like it. Frank said, "Yes, they are very good." There was a strange sensibility in them.' Visitors began coming into the Royal College to see – and perhaps buy – the work of the students that could be seen there. Soon Hockney had a dealer, Kasmin – a brilliant and charismatic new presence on the London art scene. Allen Jones's career also suddenly took off. He was put under contract by Arthur Tooth & Sons and Peter Cochrane of Tooth's brought E. J. 'Ted' Power – one of the few wealthy collectors of contemporary art in Britain – to Jones's studio. 'This gruff Northerner came in, put his hand out and said, "Power's the name"; it was a great thing to say. I wanted to reply, "Mine's Poverty".' But this would not be true for long, either for Jones, or for his contemporaries.

A year or two later, Jones had another, even more illustrious visitor in the figure of Joan Miró, an artist he admired greatly: 'I loved that idea of the colour floating free of its form, in [Alexander] Calder and Miró.' It was, then, an exceedingly gratifying experience to be visited by such an established artist:

> Roland Penrose rang up and said that Miró was in town for his
> exhibition at the Tate and wanted to see some young artists' work.
> For me it was wonderful to have someone who could have been an old
> master, come to my studio, grip my arm and say, 'Bravo!'

It was certainly a completely different response from the one Jones had received, just a few years earlier, from Ruskin Spear on a grey day in a grey room at the Royal College of Art.

THE GRIN WITHOUT THE CAT: BACON AND FREUD IN THE 1960S

'The naked truth'; I've always rather liked that expression.

LUCIAN FREUD, 2010

I n 1962, at the age of fifty-three, Francis Bacon had a retrospective exhibition at the Tate Gallery. This came about through the diplomacy of Harry Fischer of Marlborough Fine Art and Bacon's own friendship with John Rothenstein, director of the Tate. The Tate Trustees agreed to the show, Rothenstein noted, with 'a conspicuous lack of enthusiasm'. One, John Witt, wrote him a letter complaining – in essence – that it was a mockery to call this a retrospective since Bacon had destroyed virtually all his early work. Rothenstein was warned that the painter would be a headache to work with; but, within limits, he proved highly cooperative, affording 'the utmost help' and producing new paintings especially for the occasion.

The exhibition was scheduled to open in the last week of May. Towards the end of March, Rothenstein received an urgent invitation to Bacon's studio. The artist had finished a large painting, a triptych in fact, which he hoped the director would like enough to include in the show. When Rothenstein was admitted to Bacon's tiny new flat at 7 Reece Mews, he saw an epic painting, on the scale of the largest Renaissance altarpieces: 'A huge triptych (it is eighteen feet wide) stood across the studio like a

wall of lurid orange, red and black; two Nazi-like figures with butchers' carcasses on the left panel.' In the centre was a 'crushed, bleeding body on a shabby bed'. To the right there was another carcass – perhaps human, perhaps animal – hanging suspended, with a dog's head silhouetted at the bottom. Rothenstein was indeed sufficiently impressed to make this work the culmination of the exhibition.

Bacon later told David Sylvester that he had painted the entire triptych in a fortnight, 'in a bad mood of drinking'. Sometimes, the artist added, he was so drunk that he hardly knew what he was doing. But what did it all mean? Bacon, typically, was extremely careful to avoid giving more explanation than afforded by the work's title: *Three Studies for a Crucifixion* (1962). For some years, a celebrated American scholar of modern art and curator at the Metropolitan Museum, James Thrall Soby, had been strug-gling to write a book about Bacon. Marlborough Fine Art had proposed the publication even before the artist had agreed to work with them. Such a project was an integral part of elevating an artist's status, just as arranging exhibitions in major museums was. It was reported that Bacon used to do imitations of Fischer [who came from Vienna] saying, 'We vill make you famous, people vill write books about you.' Ostensibly, he thought this was hilarious. Soby, author of studies of Joan Miró and the Cubist Juan Gris, was just the kind of writer who could help raise Bacon into the international pantheon of modern art.

However, the painter had not made it an easy process. He might have found Fischer's blandishments funny, but his behaviour suggested that the prospect of the book also made him anxious. Bacon flatly refused to meet the author. Instead Soby had to communicate via correspondence with Fischer and the critic Robert Melville. They, in turn, would ask Bacon questions and report back. Progress was slow. Soby still hadn't finished his text when Bacon produced *Three Studies for a Crucifixion*. Everyone agreed that this was an important work, a turning point, and that Soby would have to describe and analyse it. He guessed that the central panel was a deposition from the cross, and that the figure on the right was an image of St Peter, since it seemed to be crucified upside down. The left panel, however, had him stumped.

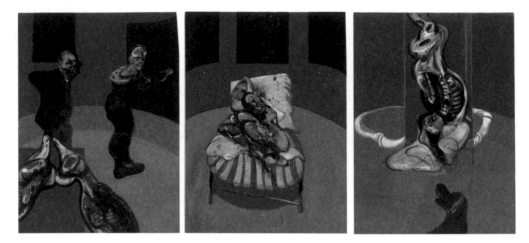

FRANCIS BACON *Three Studies for a Crucifixion*, 1962

Fischer questioned Bacon about it, and reported back that 'the two figures on the left are Himmler and Hitler opening the doors of the gas chambers – that you may quote'. But when Soby did just that, Bacon immediately back-pedalled. He complained that Soby's text misrepresented his art and asked for publication to be postponed. Furthermore, he insisted that the two figures on the left weren't Himmler and Hitler after all. Perhaps, Fischer wrote wearily to the long-suffering Soby, he hadn't been serious when he said that in the first place. At any rate, it was agreed that 'the iconography of the Triptych is difficult to ascertain'. Soby's book never appeared. In 2008, the Bacon scholar Martin Harrison pointed out that there was still no consensus about the subject of *Three Studies for a Crucifixion*.

Obviously, this was what Bacon wanted. Yet a few clues hint at the fact that the triptych may not have been created in quite such an alcoholic cloud of unknowing as the artist later claimed; that there may have been, if not exactly a nameable subject, at least a series of linked images in his mind before he picked up his brushes and began to work. A list of potential subjects for paintings in Bacon's notes from earlier in 1962 includes 'Butcher shop hanging meat'; and on a sketch from around the same time he wrote 'Collapsed image of Christ/Pool of flesh'.

There are also some (rather faint) echoes of old master paintings scattered throughout the three panels. The carcass on the right recalls Rembrandt's great *Slaughtered Ox* (1655), itself a poignant metaphor for the Crucifixion, which had been paraphrased in Bacon's breakthrough work, *Painting 1946*. In the triptych, however, Rembrandt's ox has been turned upside down and melded with another of Bacon's touchstones, Cimabue's serpentine Crucifix of the thirteenth century in Santa Croce, Florence, in which, as he admiringly said, the Christ figure seemed to crawl down the cross like a worm. The dog at the bottom brings to mind the scene from one of Goya's Black Paintings in which a little dog is gazing into a gulf of nothingness. The mangled body lying on a bedstead in the centre panel makes one think of the nudes of Walter Sickert, such as *L'Affaire de Camden Town* (1909), which refers to sexual murder. And, whatever Bacon may have insisted, the figure on the extreme left does bear a resemblance to Heinrich Himmler (and to the photographs of Hitler and his entourage that Bacon kept in his image bank). He told David Sylvester that he had been looking at them before he painted another triptych, *Crucifixion*, three years later, in 1965. These images gave him the idea of putting a swastika armband on a figure in this later work, but he claimed, disingenuously, that he intended by this not that this was a Nazi, but simply to make it work 'formally'.

While Bacon may have been extremely keen to rebut the idea that his pictures were – in the Victorian manner – telling a story, he nevertheless didn't want to remove *all* hint of a narrative. Bacon liked to quote Paul Valéry's remark that 'modern artists want the grin without the cat', explaining that 'I want very, very much to do the thing that Valéry said – to give the sensation without the boredom of its conveyance. And the moment the story enters, the boredom comes upon you.' This statement gives some idea of why Bacon disliked being interrogated about the meaning of his work. He had put together an image that imparted the emotional charge of tragic drama – horror, suffering, sadistic violence, the existential void – but with no script, no key, just an overwhelming *sensation* of a story. It wasn't meant to be decoded, by Soby or anyone else; it was meant to confound.

Though the triptych format of *Three Studies for a Crucifixion* was an obvious reference to late medieval altarpieces, its sheer size, simple geometric

shapes and strong colours had a good deal in common with the work of the hard-edge abstractionists shown in the 'Situation' exhibitions. It was, however, even bigger than the largest works by Richard Smith or Robyn Denny – and into it Bacon had introduced all the anguish and terror of human existence.

Perhaps that was why, when Bridget Riley made a list of her artistic heroes, it included Francis Bacon. The others she named – Mondrian, Klee and Pollock, for example – were all more or less abstract painters. She added Bacon because, in her opinion, he had 'a great deal of an abstract painter in him'. Indeed, for her, this was the most expressive aspect of his art. Riley revered these great predecessors because they had kept painting alive in the hostile environment of the modern world. 'The extraordinary thing about those brilliant men,' she said, 'was that they above all wanted to continue *working* in this visual medium. So that meant finding out what to do.'

The problems for handmade art – and for painting in particular – were already evident in the early nineteenth century. It had a dangerous rival in photography, first announced in 1839. It was also menaced by – in Nietzsche's phrase – the death of God. The philosopher Hegel, among others, had argued that serious art could not exist without a spiritual tradition such as religion. 'Art,' Hegel concluded, 'considered in its highest vocation, is and remains for us a thing of the past.' Of course, painting and sculpture might continue to be made but they would be trivial, offering 'fleeting play' and 'decorating our surroundings'.

Bacon, too, talked about the predicament of the painter in the modern age, faced with the extreme difficulty of what to paint and how to paint it. Echoing Hegel's words, 'decorative' was his favourite term of denigration for abstraction, and, as we have seen, he dismissed most figurative art as mere 'illustration'. The first had no connection with the drama and tragedy of human life; the second was just duplicating the work of a photograph. Bacon strove to walk this tightrope – and to do so while using photographs as a source and loudly protesting that he believed in nothing, not God nor conventional morality nor the afterlife, and that life was meaningless and pointless.

As an art student in the late 1950s and early 1960s, the painter John Wonnacott spent a good deal of time 'making Francis talk about painting.

I must have been extremely irritating. As soon as he came into a bar, I'd pounce on him.' Wonnacott's conclusion from these discussions was a surprising one. 'In an odd sort of way I think Francis thought of himself as a religious artist.' Certainly, Bacon's beliefs and behaviour were wildly out of line with those of any known denomination. Nonetheless he reverted more than once to the most important of all Christian subjects, the crucifixion. But his was a Calvary with no salvation, only cruelty, evil and suffering.

*

When Bacon's Tate exhibition opened on 24 May 1962, it included ninety-one paintings, nearly half the number that had survived his own destruction of his early work (and the slashing and burning of others by Peter Lacy). 'The impact is immediately shattering,' wrote Eric Newton in the *Observer*, and it became more so as one went through the five galleries of the show. Others denounced the exhibition as a sensationalist chamber of horrors but, despite the doubts – indeed horrified distaste – expressed by some critics and visitors, the exhibition was a triumphant success, all the more extraordinary since almost nobody had heard of the artist a decade and a half before. A copy of the catalogue was sent to Picasso – another high-voltage painter and Bacon's principal inspiration – who responded with 'an admiring message'.

When the paintings were all installed, Bacon took his friend Daniel Farson on an after-hours tour of the exhibition galleries. Farson sensed that 'Francis was deeply content, possibly as satisfied with his work as he had ever been – yet overwhelmed too, and possibly frightened.' The next night Bacon arrived at the formal opening wearing a check shirt and jeans, with the result that he and an equally casually dressed friend were initially refused entry (something that amused Bacon no end). Though drunk, the artist behaved with poise. The following day, the public began to pour in, including – according to Rothenstein – unprecedented numbers of 'teddy-boys', though since this youth style was by then at least a decade old, perhaps Rothenstein simply meant informally attired younger people. In any case, their attendance indicated the breadth of Bacon's appeal.

Farson had missed the opening party since he had been in Paris on a television assignment. Returning, he headed straight for the Colony Room

in Soho only to find it 'full of tearful drunks'. He was seized by Elinor Bellingham-Smith, who tremulously asked him if he had heard the news. Thinking she was overcome by the triumph of the exhibition, he replied 'Isn't it wonderful? Francis must be delighted.' At which she slapped him hard across the face. Bacon himself then appeared and took Farson to the privacy of the lavatory, where he explained that in among the telegrams of congratulation that morning he had found one announcing the death of his lover Peter Lacy the previous night, the same day as the opening party. He had succumbed to drink. Lacy's consumption, according to Bacon, had reached three bottles of wine a day, 'which nobody can take', and eventually his pancreas had simply 'exploded'. To Bacon, it seemed a clear case of suicide, as well as an act of fate.

Bacon may not have had faith in God, but he does appear to have believed – or half believed – in the Greek Furies, the Eumenides or Erinyes, the trio of female goddesses of vengeful pursuit. Bacon wrote in a letter to the Tate Gallery that the terrifying creatures in his *Three Studies for Figures at the Base of a Crucifixion* (the painting that had made his reputation and which the Tate had acquired as a gift from Eric Hall in 1953) were 'sketches' of the Eumenides. At the very moment of success, the furies had struck; they were to do so again – with the same precision of timing – on the eve of his next great exhibition a decade later.

*

We have seen that Bacon often used photographs as the starting point for his imagery. For a long time these were all images he had found while riffling through books and magazines: the still from *Battleship Potemkin* of the screaming nurse, reproductions of old masters, images of Nazi orators and so on. However, from 1962 onwards, Bacon used photography in a different way, commissioning his friend John Deakin to take pictures for him in highly unusual photo shoots. The subjects were the artist's friends and fellow habitués of Soho: Muriel Belcher, Isabel Rawsthorne, Bacon's new lover George Dyer, Lucian Freud and Henrietta Moraes. Bacon would specify the poses he wanted but was not present at the photo sessions. In this way he built up a private image bank of people he knew well and saw almost every day.

It was a highly idiosyncratic way of working, and its explanation takes us to the heart of what he was trying to do. The question for him, when painting a portrait, was 'how can I draw one more veil away from life and present what is called the living sensation more nearly on the nervous system and more violently?' This assault on the nerves might involve intense distortion, which was easier to achieve when the subject wasn't there sitting in front of him. He didn't like people watching him committing 'the injury that I do them in my work'. Bacon also felt he could record 'the fact of them more clearly' in their absence. By working from photographs of people he knew immensely well, he could 'drift' more freely from the literal facts of what they looked like.

Once Deakin's prints were delivered to the artist, a metamorphosis began. They joined the mulch of debris that thickly covered his studio, and would become torn, crumpled and spattered with paint, as if they were already turning into paintings. Bacon was not copying Deakin's photographs as a photo-realist might; he was using them as an *aide-memoire*. When he painted a picture of Belcher, Freud, Moraes or Rawsthorne, his mind would have been full of fresh impressions of their recent encounters. David Sylvester asked him if he was really painting these memories when he was working, rather than the images captured in the photographs? Bacon's answer was 'yes and no'. In a way he wasn't after either, but something more elusive – the actual experience, vivid and raw. He was trying to find a configuration of paint, probably not a literal resemblance at all, which – just as Proust's *madeleine* dipped in tea would bring back the sensation itself, not merely what it looked like, but how it *felt*.

Henrietta Moraes was, in one respect, the most unusual of Bacon's subjects, his only female nude. This was perhaps an odd choice for a man who had virtually no sexual interest in women. Indeed, it was not he who had a relationship with her but Lucian Freud, who recalled, 'Francis met her through me, but I don't think he saw all that much of her.' Moraes – born Audrey Wendy Abbott in 1931 – christened herself with her first name and gained the second from a marriage to the poet Dom Moraes. She was a staple figure in Soho from the late 1940s until the 1960s; subsequently she had a brief career as a cat burglar, resulting in a term in Holloway Prison.

Henrietta Moraes, late 1950s. Photo by John Deakin

The qualities that appealed to Bacon (who painted her some sixteen times) were perhaps the combination of shamelessness and utter lack of inhibition – a mixture of pride and degradation – that Freud no doubt told him about:

> Henrietta was attracted to everyone: young and old, straight and queer, no matter what nationality. She was an exhibitionist and liked to go with couples so it didn't matter to her whether someone had a boyfriend or a girlfriend. You don't necessarily mind that sort of thing if you like someone. She was very greedy for people and for drink.

Moraes's way of life fitted well into Bacon's own 'gilded gutter' existence as he liked to describe it. Perhaps those sixteen pictures were so many surrogate self-portraits; after all, he was a man who routinely reversed gender

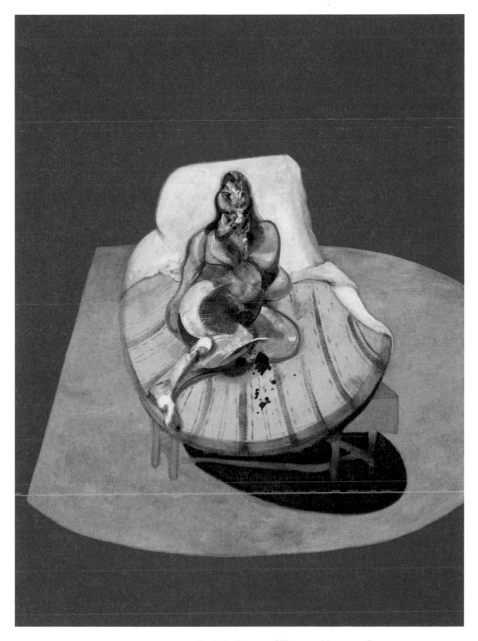

FRANCIS BACON *Study for Portrait of Henrietta Moraes*, 1964

pronouns and would refer to himself as 'she'. At all events, in his paintings of her, Bacon foreshadowed one of Freud's greatest themes in the years to come: the female naked portrait.

*

In the wake of his grand retrospective at the Tate, which had travelled to the Guggenheim Museum in New York and the Art Institute of Chicago, Bacon had ascended to the pinnacle of art world fame. In marked contrast, Freud's reputation at that time was much lower than it had been a decade before. In the late 1940s and early 1950s, his work had been highly fashionable. But by the early 1960s, according to the gallerist Kasmin, 'Lucian Freud was no longer a big name. He was a famous character, and really admired for the early portrait of Francis Bacon – and also talked about a great deal for his priapism.' But there was little interest in his recent painting.

Around this time Freud realized that he had no income. 'I had a dealer, but he wasn't really selling my pictures.' James Kirkman, then a junior employee at Marlborough Fine Art, Freud's gallery, confirms this was true. 'His paintings would stay in the racks, unloved. Nobody would ask to see them. They'd be there for years, priced at a few thousand pounds. Nobody wanted them.' This discouraging situation continued for well over a decade. It was a period that Freud later described as 'when I was completely forgotten'. With courage, or what some might consider reckless insouciance, Freud carried on regardless, working very slowly, indulging his passion for gambling for high stakes on horse races and in private clubs (including one run by the Kray twins). Meanwhile, he lived on money he didn't have. 'The feeling of being in debt made me feel padded or insulated against the world, despite the horrible people I owed money to and who tried to get it back from me. I felt I was living on a private income.'

Kirkman saw Freud's gravity-free finances rather differently:

It was my job to go to the directors and say, 'We need another advance for Lucian Freud.' I'd say, 'He's promised he'll have another picture finished in three months' time.' Finally, we'd get another £500 or maybe £250. Part of Lucian's problem was that he always wanted a

show of work that had already been sold, mostly sold by him at no
profit to the gallery, so it wasn't surprising that he wasn't very popular.
His catalogues were the skimpiest.

The artist later claimed he found this oblivion entirely congenial: 'there was
something exhilarating in being forgotten, almost working underground.
I've never wanted attention so I didn't find it in the least unnerving. His
dealer James Kirkman's memory of the situation is different: 'He was keen
as mustard at that stage to see critics and be written about, to be picked.'

Freud had only three exhibitions with Marlborough – in 1958, 1963 and
1968. They charted not so much a steady progression as the work of an artist
repeatedly searching for a solution to a problem he had not yet completely
solved. In place of the meticulous, almost microscopic precision of his work
of a decade before, Freud's pictures of the early 1960s – though still very
slow to execute – sometimes looked as if they had been done in a matter of
hours. The boldest were constructed of big scoops and whorls of pigment,
the bristles of the hog's hair brushes still clearly visible in the paint.

In retrospect, it is not hard to see that he was looking for ways to make
paint create a sense of solid, three-dimensional form. The freedom of Bacon's
brushwork, he admitted, made him feel more 'daring'. Simultaneously, he
was working out how to get paint to do something he often talked about
later, to 'act like flesh', so that it didn't just imitate the model, it seemed
to embody them. He was trying but, as yet, he wasn't reliably succeeding.
Few people paid much attention to his efforts. As Bacon's star rose, Freud's
continued to sink.

*

John Deakin staggered into the French House pub at lunchtime one day in
1963 'ashen-faced', not – for once – as the result of a severe hangover, but
because he had just received bad news. 'It's that bloody portrait,' he moaned
to Daniel Farson. 'Lucian has just decided it isn't going right and wants to
start again.' Deakin had already been posing for Freud for a long time, and
if they really were to begin again, he would have perhaps another six months
of sitting ahead of him. During all this time, according to Farson, Deakin

LUCIAN FREUD *John Deakin*, 1963–64

was collected from his flat in Soho at dawn and driven to Freud's studio in Paddington, 'where he was force-drunk with retsina to keep him still'.

The dates of the Deakin portrait, 1963–64, tell their own story. Yet it looks as if it might have been polished off in a session or two, so loose and free had Freud's brushwork become in comparison with the precision of his portrait of Bacon of a decade earlier. By the time he came to paint Deakin, his brushstrokes had become visible swirls and arcs of pigment that reconstitute the sitter's broken veins and purple drinker's nose, his clown's ears and spaniel eyes. What has not altered is the intensity of the painter's scrutiny.

Freud was not formally interviewed by a critic until 1977, but in the early 1960s he agreed to talk with Michael Peppiatt, then a student at Cambridge University. The conversation did not go well but, according to Peppiatt's much later memory, Freud's theme was that, in the present situation, the only thing for painters to do was to search for 'a certain truth'. A decade later Freud told John Russell, 'I am never inhibited by working from life. On the contrary, I feel more free; and I can take liberties which the tyranny of memory would not allow.' His stance was the exact opposite of Bacon's. Where Bacon felt more inhibited in the presence of a model, Freud felt it liberated him. The goal, however, was similar: a truth that was not banal or predigested; as Freud put it, 'I would wish my work to appear *factual* not literal.' Talking about how his work was in part – but only in part – a 'truth-telling' exercise, Freud recalled a moment from the Deakin sittings: 'I remember that when I was painting John Deakin one day, his mouth went in very well. But it was not the way his mouth really was, so I wiped it out and did it again.'

<p style="text-align:center">*</p>

While other painters working at the same time, such as Allen Jones, David Hockney and Richard Smith, were in love with the glamour and freedom of the United States, Freud located his studios in a small area of West London. It was, in urban terms, the opposite of New York or Los Angeles. If LA stood for the speed and energy of the future, the slums of Paddington represented the nineteenth century, dark and decaying. When Freud first moved there, the district had reminded him of Gustave Doré's views of London in the 1870s.

The force moving Freud from crumbling address to crumbling address was, in a way, modernity. The streets in which he settled, and much of the working-class area of run-down Georgian houses, were successively bought up by the local authorities and pulled down. As a solitary artist, a person with no evident economic or social value, Freud tended to be allocated condemned buildings. 'The council warned me that I was not a unit – a unit being a family with young children, or an old retired person. So I was put in buildings that were scheduled to be demolished,

Clarendon Crescent, Paddington, under demolition

which suited me fine.' Clarendon Crescent, to which he moved in 1962, was already disappearing and its inhabitants being relocated outside London to places like Slough and Crawley.

When Lord Snowdon photographed Freud standing pensively beside his Bentley on 17 June 1963, the street – as beautiful as a terrace in Bath – looked deserted. Other images, however, reveal that the district was still lively, full of working-class people who, as Freud recalled approvingly, were not servants or employed in menial capacities, but worked for themselves, often on the borders of legality – or beyond. Quite a few were criminals, according to Freud, among them one 'really clever bank robber'. The painter too was leading a wild life, beyond the margins of respectability. 'At Clarendon Crescent,' Freud recalled, 'I was painting from 4 a.m. to lunch, then off gambling. Lots of playing, night and day, horses and dogs. I was completely broke.'

Bit by bit, however, the wrecking crews came closer. Eventually, Frank Auerbach remembers:

> Lucian was the only inhabitant except for squatters and people
> clambering over the roof. But he stayed there with remarkable
> stoicism. It's amazing that so few pictures have disappeared
> because they were in such perilous situations. It was a heroic life.

Freud, too, spoke about that precarious time. 'The demolition men got closer and closer. I was working on a painting in the studio. In the end I passed down some whisky bottles and they agreed to let me have another couple of days. It seemed important at the time.' Indeed, it would have been crucial. For Freud, the conditions in which a picture was made had to remain constant. Once it had begun, the times – and hence lighting conditions – at which it was painted had to be adhered to. The sittings for an evening picture, by electric light, had to be after dark, and the reverse for a work painted in natural light. Equally, the sitter's clothes could not change and the space in which the sessions took place had to be kept exactly the same. Consequently, if the wrecking ball had come through the wall of his studio before that picture was finished, months – maybe years – of effort would have been wasted.

During those years Freud made a crucial transition. This was the point at which, viewed retrospectively, what one might call 'late Freud' began; in his fortieth year, the middle of his life. This was the time when he really found ways to make thick, substantial paint 'work as flesh'. His brushstrokes became more like those of artists he admired – Gustave Courbet, Titian or Frans Hals – rather than the smooth, miniaturist effect of his early work. During those years, as always, his subjects were few and all people in his life. The most significant development was that he began to paint some of his subjects entirely without clothes. It might seem surprising that Freud, who by the end of his life came to be seen as one of the supreme exponents of this subject, did not attempt it until he was in middle age.

The few exceptions in the 1950s and early 1960s are pictures of women, semi-naked, bare-breasted, that now look somewhat tentative. Then, in 1966, Freud produced one of the most extreme pictures in his career, in its utter exposure, its complete lack of any vestige of idealism. It shows a blond girl lying on a bed. Its title, *Naked Girl* (1966), is important. She is *naked*,

not nude, a distinction that Freud insisted upon. In so doing, he preferred to speak of a category new to art history, the 'naked portrait'.

> I think of the people in my own pictures as more naked than nude. The notion of the 'nude' has in a way a self-conscious artistic feeling and 'naked' is more to do with how the people are actually made. When I'm painting someone without clothes I think more of portraiture, of the form being specific to the person.

In a celebrated book, Freud's erstwhile mentor Kenneth Clark (who had abandoned his support when the painter changed his style) had made just this distinction between the nude and the naked figure. The former, according to Clark, was an invention of classical Greek artists, a blend of anatomy and geometry. It was not how any real human being actually looked, but how they *should* look assuming the universe was in accordance with Plato's ideal forms. Instinctively, Freud had always had an aversion to the classical tradition. That was why he loved French art more than Italian, because it had a greater sense of the physical substantiality of bodies (consequently, he made his beloved Titian an honorary Frenchman).

The pictures he now began to create were among the most radically unclassical ever seen. Somehow, in that doomed space on Clarendon Crescent, he managed to purge his mind and eyes of every received way of depicting the human form. His new paintings seemed to take a journey to the surface of each new body, looking at it as if he had never seen such a thing before and discovering that not only did people look dissimilar from Greek statues, and from each other, but also that every aspect of a person was individual. In a way he was painting portraits of toes, knees, shoulders and all the other bodily parts (sexual ones very much included). David Hockney once reflected on the uniqueness of Freud's vision, in 'looking at the person in front of him sexually'. But it had not been so clear, up to this point, that that was what he was doing.

With *Naked Girl* it became obvious. This is plainly a highly charged picture, full of intimate sentiments and sensations – so much so that the viewer feels like an intruder. All Freud's works are – to use Howard Hodgkin's phrase – pictures of 'emotional situations'. In this case, the intimacy might

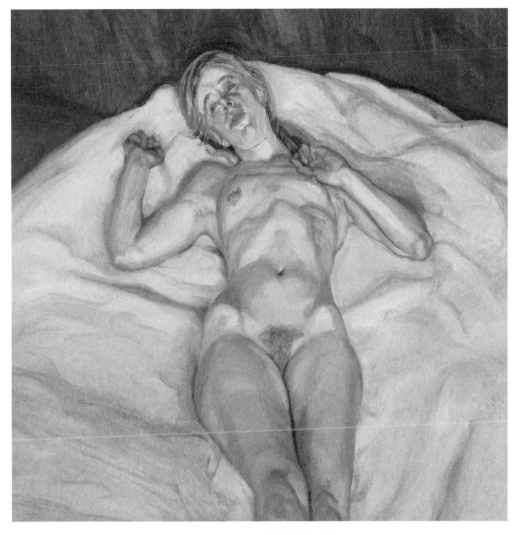

LUCIAN FREUD *Naked Girl*, 1966

seem shocking, the scrutiny certainly ruthless. Freud's long-term assistant David Dawson, however, sees the painting quite differently:

> Lucian didn't like the word psychological, but with some of his portraits you feel you know what's going on inside his head. In his first nude he did of a girl lying on a bed, there's so much there: how much the sitter was giving Lucian and how much Lucian gave the painting. She's so vulnerable, it's heart-wrenching.

Before this picture, Freud felt that 'in a way I was a frustrated painter of the nude'. Afterwards, he came to see nakedness as the norm, the essential truth. 'When I'm painting people in clothes, I'm always thinking very much of naked people, or animals dressed. I like the nakedness to come through the clothes.'

He was opposed, morally and aesthetically, to all forms of pretence and covering up: false feeling, false behaviour, even too much powder and rouge covering the skin. The model for *Naked Girl* was Penelope Cuthbertson, a celebrated beauty of the mid-1960s. In October 1966, around the time she was posing for Freud in Paddington, a very different image of her appeared in *Vogue* magazine. A feature on cosmetics entitled 'Beauty Bulletin' described her as 'fresh-skinned with straight blond hair', these features being enhanced with 'crème glow', 'café frost' below her brows and 'natural honey' lipstick. It was exactly what Freud wouldn't have wanted. After meeting a woman wearing heavy make-up, he once complained that he felt he couldn't properly see whom he was talking to. What he wanted was to observe what was there, all of it, with no obstacles or barriers of any kind.

Freud and Bacon, though friends, were very different artists. Bacon, as we have seen, admired Picasso more than Matisse because the former's work had more of the 'brutality of fact', which he himself was aiming for. Freud, in contrast, preferred Matisse, whose work he found less theatrical: not, like Picasso's, intended to shock and amaze. In Freud's own work there is certainly a sense of fact, but no brutality. It is the utter honesty of his pictures that sometimes shocks and can make it feel as though no one has ever looked at a face or body so unflinchingly before.

CHAPTER FOURTEEN

AMERICAN CONNECTIONS

If I'd been the same age in 1910 I might have gone to Paris instead of New York:
you just want to see the centre of the contemporary art world.

ALLEN JONES

L
ate in 1961 a young man called Richard Morphet was just down from Cambridge and newly installed in a job at Robert Sharp and Partners, 'a fashionable, far-out advertising agency, so much so that occasionally it was the subject of satirical columns in the *Guardian*'. In the intervals of living the life of *Mad Men*, early 1960s Mayfair-style – in which 'terrible, drunken client lunches' featured heavily – he explored the art world, which lay all around. Later in life he was to become Keeper of the Modern Collection at the Tate Gallery and curator, among many other activities, of major exhibitions on Richard Hamilton and R. B. Kitaj.

Across the road from Robert Sharp were the premises of Marlborough Fine Art, and around the corner on Dover Street was the ICA. In November 1961, Morphet attended a memorably rowdy evening event there. Its point of departure was a showing of a documentary entitled *Trailer*, which had been made by the painter Richard Smith and a brilliant young photographer named Robert Freeman. For a London audience at the start of the 1960s, *Trailer* seemed startlingly fresh and novel with its focus on the modern environment that was appearing all around. Morphet remembers his own youthful enthusiasm: 'The film went out into the street recording cars moving, hoardings. There was a lot of pop music on the soundtrack too, I was incredibly, almost embarrassingly, excited by it.' This 8mm colour film is sadly now lost.

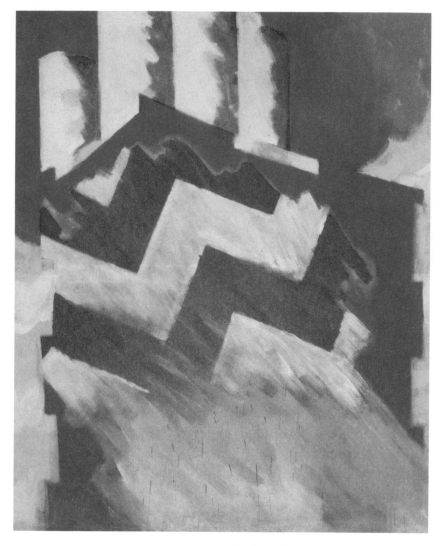

RICHARD SMITH *Flip-Top*, 1962

The imagery in *Trailer* was the raw material of Smith's art. 'I paint about communication,' he stated at the time. 'The communication media are a large part of my landscape. My interest is not so much in the message as in the method. There is a multiplicity of messages (smoke these, vote this, ban that), but fewer methods.' It was the visual language in which the message was presented that Smith loved: the alluring surfaces of consumer society, especially packaging and the softly sensual manner in which products were lit for publicity purposes. Smith, like Richard Hamilton and his companions at the ICA, was a keen reader of Marshall McLuhan's *Mechanical Bride*.

For *Trailer* Freeman had shot many still photographs of cigarette packets, including a novel type invented by Robert Brownjohn, an American graphic designer living in London, for the brand Bachelor, which revealed the interior of the pack crammed with alluring rows of fags within. Freeman also photographed several American 'flip-top' brands and, in 1962, Smith painted a picture over six feet high of a subject vaguely suggesting skyscrapers or towering factory chimneys, but actually inspired by a cigarette packet. Its title was *Flip-Top*.

Another work from this period, *Panatella* (1961), used a similarly huge scale – at over eight feet by ten – to focus in on a tiny detail of product branding: the hexagonal logo on the paper band around a cigar. It was thus very much like the big abstract paintings exhibited in 'Situation', or the works of Robyn Denny, Smith's good friend, fellow student at the Royal College of Art and co-participant in the 'Place' exhibition – except that it was subtly distinct from these in being actually representational, not abstract. To an enthusiastic observer such as Morphet, a lot of the excitement of Smith's work lay in its transatlantic flavour, both in the *way* it was painted – the sheer size of his pictures – and what it depicted: logos, packaging, advertising imagery. 'He was perceived', Morphet remembers, 'as bringing the scale and the excitement of America into British art.'

After he had finished work on the 'Place' exhibition, Smith had set sail for New York, where he spent two years on a Harkness Fellowship. In Manhattan, Smith shared a spacious, ex-industrial loft on Howard Street with another painter. The rent was fifty dollars a month. Smith felt a kinship with Piet Mondrian, another European painter who had moved to New

York less than twenty years before, in 1940. Like his great predecessor, he felt 'enamoured and exhilarated' by this excitingly modern city, by its rhythms, its architecture and the clear sunshine of the Eastern seaboard. 'New York is an immensely bright city,' Smith enthused. 'The light there is tremendously *sharp*.'

Strangely, although his paintings appeared highly American to British eyes, to an actual New Yorker they also seemed alien. His art dealer in Manhattan at that time, Richard Bellamy, put it like this: 'Richard's paintings had a breathiness and colour and a kind of newness absolutely separate from Pop art. Those paintings were suffused with light, a different kind of light than I had ever seen.' In part, it was to do with that elusively personal aspect of painting, 'touch'. Francis Bacon, struggling to explain what was so special about the work of Michael Andrews, ended up simply saying, 'It's just his touch I suppose ...' It was the same with Smith for the few years in the early 1960s when he was at his peak; he had a wonderfully loose, free and subtle way of putting on the paint.

Frank Bowling saw it in 1959, while he was working in a studio next door to Smith's at the Royal College. 'Dick Smith befriended me while he was preparing for the 'Place' exhibition at the ICA, and what attracted me to his work was the way he was so *relaxed* about brushing the colour in, with no anxiety, as if it was the most natural thing to do.' And this was before Smith had even set out for New York. For all his admiration of the scale of American painting, his delight in New York and his adoption of the essentially American subject of commercial packaging and marketing, there remained something un-American about his work. This was the vision of an outsider, in love with the USA, its life and its sights, in a way no native would be.

There was also a difference in the way that American and British artists painted, even those Britons who were most in love with all things trans-atlantic. For Jim Dine, a young artist from Cincinnati of much the same generation, it came down to the way that the art of the United States was 'like a sign: it's flatter, more graphic'. Allen Jones found the same thing when he spent over a year in New York between 1964 and 1966. For him, there was an:

American idea of flatness that wasn't a part of my formative life. That was an essential difference ... What I learned was that being European was different, it wasn't that you were a paler shade of what was happening in New York. It seemed plain that there was a huge, noticeable difference. For me, it came down to the fact that I can't think of a single British artist of that generation – and maybe later – who was able to dump illusionism.

It was this European – or perhaps British – quality that, for a short period, made Smith's paintings stand out in New York. His works had many of the qualities of Ellsworth Kelly or Barnett Newman: they were big, clear in colour and geometric. But they were not quite flat, and there was a particular atmosphere to them, a vestigial wisp of Turner's haze or Monet's fog on the Thames. Smith's brushwork was softly romantic, giving his monumental blow-ups of cartons and packaging a quality like drifting smoke or melting ice cream. Indeed, while keeping more or less to the idiom of the Situation group, Smith was something unexpected and unusual: a romantic Pop artist.

Unlike the work of his friend Robyn Denny, for example, Smith's art referred to real, commercial things such as logos on cigars and cigarette packets. On the other hand, in Pop terms, his imagery, as he later observed, was softly vague, a matter of 'form and mood and shape and colour'. Mainstream Pop, as he saw it, 'was all about supermarkets and stuff'. But he wasn't attracted to this kind of 'low-grade, debased imagery' – Andy Warhol's soup cans and Brillo boxes, for example. Smith was intrigued by what he called 'the high end': 'beautiful ads for Smirnoff vodka and glamorous films and store windows and CinemaScope'. American Pop was fundamentally realistic. It was about everyday life and familiar sights. The British variety tended to be about something imagined or aspired to: the American dream, as seen through foreign eyes.

Smith returned to London in 1961, not because he had fallen out of love with America but because his visa had expired. When he got another visa, he went back and continued to go back and forth, exhibiting in both cities until he finally settled on the western side of the Atlantic in the mid-1970s. He was one of several British artists who ultimately spent much of their lives in the United States. David Hockney would be another.

*

After the screening of *Trailer*, as often occurred at ICA events, there was a row, which Richard Morphet still remembers: 'There was this unbelievably acrimonious discussion in which some people were very keen on it, and others thought it was absolutely outrageous because its subject matter was advertising.' 'It's not as if I'm being inspired by Majorcan pottery or something', Smith responded, 'This is something that's all around us!' The transatlantic scene was the hot topic of the moment. The next event on Dover Street featured the architect Cedric Price talking about 'his recent impressions of everyday America' under the title 'Supermarket USA'. American life held a fascination for London highbrows; someone who had seen a real US supermarket was regarded as an explorer who had had a glimpse into the future.

Of course, not everybody liked the look of this brave new, commercialized world, nor approved of the vogue for large, simple abstract paintings. At one ICA discussion, the painter Bernard Cohen remembered his fellow artist Peter Blake accusing the rest of the audience – presumably made up of exponents of large-scale, more or less hard-edge abstraction – of being 'third-rate American copyists'.

While Allen Jones was in New York, the American critic Max Kozloff published an essay discussing the current wave of European artists settling in New York, suggesting that they were not helping themselves by doing so. To belong to the Manhattan painting community, he argued, an artist had to follow certain rules. Looking back, Jones, who felt that Kozloff probably had him in mind, summarized these stipulations: 'paint should be flat or at worst egg-shell finish, it had to be hard-edged, the colour clear and so on. Labels such as "Pop" or "Abstract" had nothing to do with it; from Ellsworth Kelly to Roy Lichtenstein, New York painters followed this recipe of pictorial flatness.' At the time, Jones thought, 'it's really shockingly true'. In fact, it wasn't an entirely fair description of Richard Smith's work, as we have seen. His pictures retained their distinct, un-American identity. This can also be said for the work of Smith's friend Peter Blake, but then he wasn't a fan of New York paintings so much as of American films, music and fashion.

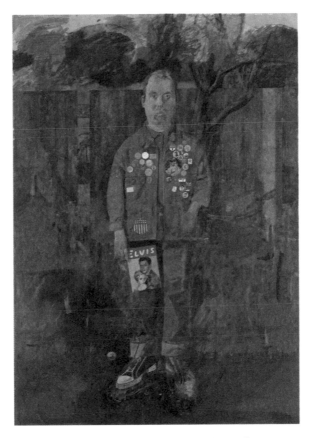

PETER BLAKE *Self-Portrait with Badges*, 1961

When Smith came back to London in 1961, he and Blake shared a house and studio. This was the year that Blake painted *Self-Portrait with Badges*, with the garden of this house as a setting. In this strange image of himself – which almost qualifies for the Yiddish term 'nebbish', meaning 'ineffectual, timid or submissive' – Blake is clad in blue, a colour recalling the costume of Thomas Gainsborough's *The Blue Boy* (*c.* 1770). However, he is not wearing the Van Dyck-silks and satins of the eighteenth-century sitter, but cowboy denim and baseball boots. In the mid-1950s, when they were still young art students, Smith and Blake had seen Bill Haley and His Comets at the Kingston Empire, as well as the pioneer of rock-and-roll,

Johnnie Ray, at the London Palladium. Smith had a 'buzz cut' modelled on the hairstyle of the jazz baritone saxophonist Gerry Mulligan. Half a century later, and by then bald, he remained nostalgic about this 'wonderful haircut'.

The clothes he and Blake wore were hard to source. 'You liked to dress in an American way, which was immensely problematical,' Smith remembered. Blake had found his denim jacket while in the South of France in 1956 (on a scholarship, studying folk art). It came from a US Army surplus store. In his painting, Blake wears Levi 501s, the original classic aficionado's jean, with the bottoms stylishly turned up. To paint the self-portrait, Blake put the jacket on a tailor's dummy and covered it with his collection of badges, which numbered among his many private accumulations of bits and bobs of popular life, and were not for everyday wear. In the picture, however, Blake shows himself festooned with a positive embarrassment of badges, including a giant one of Elvis Presley – and he also clutches a Presley fanzine. The Stars and Stripes are emblazoned on his jacket pocket, much larger than the Union Jack, which appears in the form of a tiny badge.

Nonetheless, the whole ensemble is ironically downbeat and British. One badge, in that telling American term represents a 'loser': Adlai Stevenson, unsuccessful presidential candidate in 1952 and 1956. The painter's pose suggests Jean-Antoine Watteau's *Pierrot* (formerly known as *Gilles*, 1719), the wistful outsider, more than Gainsborough's confidently aristocratic *Blue Boy*. Ironically – or perhaps, appropriately, considering how much British pop music consisted of young Britons such as Mick Jagger, Blake's neighbour from Dartford, mimicking Americans while subtly sending up themselves – this picture helped to make Blake an art world star. It was reproduced on a full page of the very first edition of another harbinger of things to come: the inaugural *Sunday Times Colour Section* of 4 February 1962. This illustrated an article on the artist by John Russell, entitled 'The Pioneer of Pop Art', in which Blake was described as 'a quiet red-bearded young man with the looks of an intellectual gardener'. The other person featured in the magazine was the fashion designer Mary Quant, who was also a leading figure in what was soon being talked of as 'Swinging London'.

Seven weeks later, on 25 March 1962, Blake's self-portrait appeared in a BBC television documentary, 'Pop Goes the Easel', as part of the arts series *Monitor*. This was the first full-length film directed for the programme by Ken Russell, who was quickly rising to prominence himself, and it effectively introduced a hip new art movement – and way of looking at the world – to the British public. Along with Blake, three younger artists were included in 'Pop Goes the Easel', all students at the Royal College of Art: Derek Boshier, Peter Phillips and Pauline Boty.

*

Through the film's soundtrack, Peter Phillips was presented as the most cool. Behind shots of the artist and his works was heard some of the most abrasively cutting-edge jazz of the moment: Cannonball Adderley, Charles Mingus and a raucous yet lyrical free jazz performance by Ornette Coleman. Such fine points mattered in 1962. In that year Kasmin travelled to New York, hoping to sign up artists for the gallery he was planning to open. He took a suite at the Chelsea Hotel and threw a party. He found, though, that Kenneth Noland, a painter of colour field abstractions whom he was courting, did not want to mix with Larry Rivers, a figurative painter in a Pop idiom and jazz saxophonist, who also lived in the hotel. Noland told Kasmin: 'I don't know if I want to be in your gallery if you talk to Larry Rivers – he likes the wrong sort of jazz and paints the wrong sort of pictures.' Although, as we have seen, Pop and abstraction had a great deal in common, there were still sharp divisions between them.

In his work, however, Phillips found ways of squaring this circle by painting real objects – such as pinball machines – that were flat and had hard edges. Unlike Blake – or indeed Smith – Boshier could not be described as a fan of all things American. On the contrary, he was at this time a critic of the creeping Americanization of British life. Boshier had read studies of advertising and mass media such as Vance Packard's *The Hidden Persuaders*, and McLuhan's *Mechanical Bride*. Packard's bestselling book, published in 1957, described trends in advertising based on psychological research. This enabled brands – from cereals to cigarettes – to be given a distinct identity, constructed in such a way as to appeal to certain personalities. In

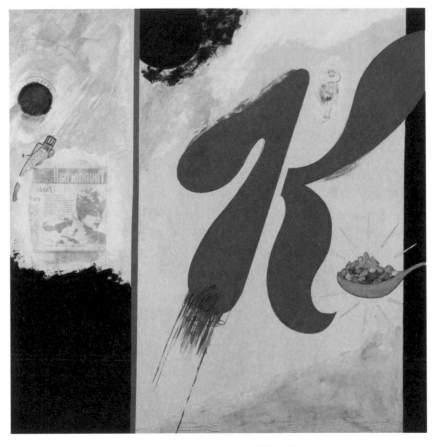

DEREK BOSHIER *Special K*, 1961

advertising terms this was described as an 'image' – a visual appearance – and this image, like any other, could be the subject of art. This, in a nutshell, was the intellectual underpinning of Pop art.

In 'Pop Goes the Easel' Boshier is seen musing uneasily at the breakfast table:

> I think the Englishman probably starts with America at the breakfast
> table, starting with corn flakes, which are American in design,
> American in packaging, American in the whole set-up, the give-away
> gifts, the something for nothing technique.

One of his first distinctive works, *Special K* (1961), featured a box of the Kellogg's cereal. Boshier got the idea, he recalled, from seeing a packet of corn flakes on the table in a 'Kitchen Sink' interior by John Bratby. But his own cereal packet was not approached in a spirit of squalid realism. It was a more turbulent commodity: the bottom of the red 'K' seeming to spurt with flames; the space above appearing atmospheric, like a sky filled with US military planes and missiles.

Boshier made his stance patriotically clear in another picture from 1961, *England's Glory*, featuring a brand of matches of the same name, in which the Victorian design of the matchbox is metamorphosed into the Stars and Stripes. Anti-Americanism, of course, was the flipside of the yearning for everything from the USA. The two emotions not only divided the British public, they were often to be found within the same sensibility. Boshier, for all his early suspicion, soon joined his contemporaries in making an 'American Journey' – the mid-twentieth-century equivalent of the eighteenth-century European Grand Tour – and has spent much of his life living in the United States. Even in those early pictures, what is clear, visually speaking, are not the artist's political misgivings, but his willingness to make packaging the main subject of his art. That giant K is the protagonist, if not the hero, of the picture.

At the RCA, as we have seen, Boshier shared a studio with David Hockney. They also had in common, for a while, what you might call a 'grocery theme'. In 1961 and 1962, Hockney produced a series of pictures of packets of tea, which were – he confessed – the closest he ever came to Pop art; but even in these he wasn't interested in the phenomenon of consumerism

or advertising. The packets were to hand because Hockney was in the habit of making himself cups of tea in the morning. His mother's favourite brand of tea was Typhoo, so he was also making a picture of something familiar and personal, to do with his own feelings and memories. Where Boshier transformed a cereal box into a battle scene, with dripping blood and puffs of smoke, Hockney made the packet of tea into a miniature room – whether a sanctum or a cell is not quite clear.

In the third work in the series, *Tea Painting in an Illusionistic Style* (1961), the canvas itself is shaped to resemble a box-like space with the lid open, as if it were a house in a fresco by Giotto. It is painted, intuitively, in isometric perspective, rather than the conventional, Renaissance-type view with a single, fixed vanishing point. The lines of the top of the Typhoo packet don't recede towards a distant vanishing point, they *converge* towards the viewer; in other words, this is reverse perspective, an early mediation on a problem that still fascinated the artist over half a century later.

Inside the box sits a naked man – a self-portrait, perhaps, or an object of desire – like a miniature version of a figure in a painting by Francis Bacon; an existential hero trapped in a mundane box of tea. Or perhaps, changing the metaphor, he is waiting to come out. Hockney's lack of true interest in commercial design is suggested by an engaging slip. On the side of the packet, he misspelled the word 'tea', writing it as 'TAE'. Hockney is not, he later confessed, a good speller, but misspelling a three-letter word that was the subject of his painting was quite something.

*

Pauline Boty was not quite a Pop artist when she was included in 'Pop Goes the Easel' – that came later. She was chosen, one guesses, because she looked like a star. Her good looks were, in a way, her subject and her dilemma. The November 1962 edition of a magazine entitled *Scene* featured her on the cover. The text began with a statement in large print at the top of the page, which, over half a century later, seems outlandish in the casual prejudice it betrays. 'Actresses often have tiny brains. Painters often have large beards. Imagine a brainy actress who is also a painter and also a blonde, and you have Pauline Boty.'

DAVID HOCKNEY
Tea Painting in an Illusionistic Style, 1961

PAULINE BOTY *The Only Blonde in the World*, 1963

This crass piece of writing is a demonstration of what Boty was up against. She was sensationally beautiful in a way that precisely coincided with the fantasies of the age. Early on, she had been known as the 'Wimbledon Bardot' because she came from that south-west London suburb. It was not the French star, however, with whom she seemed to identify herself. Boty painted Marilyn Monroe several times: *The Only Blonde in the World* (1963) could almost be a self-portrait. Most of the surface of the picture might be an abstract from the 'Situation' exhibition. But two-thirds of the way across, around the point of the golden section, it opens like a screen or the curtains of a stage – and in walks a figure. If this were an allegory, she would be a personification of sexuality, fashion and youth. Effectively Boty was Andy Warhol and Marilyn wrapped up into one person. This was an impossibly dissonant combination for journalists – and the public – in the early 1960s.

The interview in *Scene*, despite its archaic sexism, contained a memorable statement of how Boty saw her art. Many people, she explained, were nostalgic about the past – Victoriana – whereas she and her circle felt 'a nostalgia for NOW'. It was, she went on, 'almost like painting mythology, but a present-day mythology'. The contemporary equivalents to Mars and Venus, she believed, were film stars like Marilyn.

The phrase 'nostalgia for NOW' pinpoints one distinction between what Boty was doing and the work of American Pop artists such as Warhol. He wasn't interested in nostalgia, more in worship (his pictures of Marilyn are related to the icons of the Eastern Catholic Church to which he belonged) and the way the images of the famous are created and multiplied by the mass media. Boty's approach, in contrast, was distinctively British. Nostalgia is a warm and romantic emotion; Boty's images of stars, though based on photographs, are softly evocative, as if publicity shots were turning back into flesh and blood. Like Peter Blake, her mentor in painting (he was in love with her, but she was not with him), she sometimes painted as an ardent fan. *With Love to Jean-Paul Belmondo* (1962) is a love letter in paint, in which the French actor – who played the doomed, criminal outsider hero in Jean-Luc Godard's *A Bout de Souffle* (1960) – is crowned by roses and surmounted with pulsing red and green hearts.

Like Blake, Boty also made herself the subject of her pictures, but took this one step further. Working with her photographer friends Lewis Morley and Michael Ward, she posed with her paintings, acting out the part of model. Thus she was her own work of art, come to life. With her painting of Belmondo as a backdrop, she posed naked as Sandro Botticelli's *Birth of Venus* (1482–85) and François Boucher's nude *Mademoiselle O'Murphy* (1751). It seems that in such photographs, Boty was presenting herself as model and creative force in one.

In Boty's art we can see a new subject – sexual politics – emerging from the template of Pop art. This was no longer art about advertising or packaging, but about who you were. Appropriately, one of her most memorable works uses an image that more than any other came to symbolize the changing sexual mores of the 1960s. It was entitled, *Scandal '63*. There was no need to explain which scandal.

On 4 June 1963 the Secretary of State for War, John Profumo MP, confessed that he had 'misled' the House of Commons and resigned from office. He had been accused of having an affair with a young woman named Christine Keeler, who had also had a liaison with Captain Yevgeny Ivanov, naval attaché at the Soviet Embassy in London and a spy. Early in 1963, rumours began to circulate about this heady mix of politics, espionage, high society and the possible leaking of state secrets across the pillow. The Profumo affair was about many things – impatience with a ruling class who seemed corrupt, old-fashioned and hypocritical, as well as weariness with a government that had been in power for over a decade. But it was more than anything else about sexual hypocrisy, in a climate of increasing openness.

In the autumn of 1963, an unknown patron commissioned Boty to paint a picture about the Profumo scandal. She began work, using as her principal source a newspaper photograph of Keeler leaving her flat; halfway through, however, she changed this for what became a much more celebrated shot, one that had been taken by her photographer friend Lewis Morley in May that year. It had been intended as a publicity still for a film about the Profumo affair, with the film's promoters insisting that Keeler should pose naked. She was reluctant; eventually, as a compromise, Morley suggested that she take her clothes off, but hid most of her body – modestly yet provocatively – behind the back of a modernist Jacobsen-style chair.

Boty's painting is a collage in paint like some of Peter Blake's works. The red zone that fills much of the picture is reminiscent of a bedspread as well as a news placard; Keeler floats in front on the chair, with an array of figures and faces around her like the ghosts of a wild party. In an early version of the painting, Keeler walks across space rather as Marilyn Monroe does in *The Only Blonde in the World*, but then Morley showed Boty the contact prints from his photo session. From those she chose an image, not the famous shot in which Keeler rests her head on both hands, but a more tentative alternative.

At the top of the picture, on a strip of blue space, are the heads of the leading male characters in the drama – not only Profumo and Stephen Ward, who had introduced the cabinet minister to Keeler, but also Rudolf Fenton and a jazz singer named 'Lucky' Gordon, two black men who had

Pauline Boty posing with Scandal '63, 1964. *Photo by Michael Ward*

been caught up in the scandal and unjustly imprisoned. There, again, is a touch of protest. Everybody in the picture, in one way or another, was a victim of hypocrisy. A further layer of complication was added by the fact that Boty posed in her studio, her body hidden by the finished painting, perhaps making an implicit comparison between herself and the star of the scandal, Christine Keeler. The picture itself has disappeared. No one knows who commissioned it and why, or where – if it still exists – it now is.

Boty was on her way to becoming a genuine star herself in the years before her early death. Perhaps, had she lived, she would have combined all her talents and activities – as actor, painter, social commentator – to become

Frank Bowling in 1962. Elements of his art theory are painted on the wall behind him.

a new kind of artist, one who did not yet exist. A decade later, the notion of the artist as 'living sculpture' was patented by Gilbert & George, while Cindy Sherman presented herself in a series of works acting out roles from art history. In the early 1960s the idea of performance art did not exist in London, but Boty did have a flourishing second career as a performer on stage and in film (although she told the writer Nell Dunn that painting came first, if she had to choose). As it is, hers was a poignantly brief career, cut short just as it was beginning. She died of cancer, aged only twenty-eight, on 1 July 1966.

*

If David Hockney and Peter Blake had travelled a long distance geographically and culturally from, respectively, Bradford and working-class Dartford to reach the RCA, Frank Bowling had moved even further. He was born in February 1934 in Bartica, a small town in British Guiana. His father was a policeman, his mother ran a shop – called Bowling's Variety Store – in the main street of New Amsterdam, a port about sixty miles from the capital, Georgetown, where the family moved while he was a child.

Frank boarded a ship for Europe in 1953, and the moment he arrived in London he knew he was home. His trajectory into art, however, was oblique. Almost immediately on arrival he joined the Royal Air Force, but left three years later having acquired an interest in painting from a fellow recruit. Subsequently he worked as an artists' model before moving to the other side of the easel and studying at Chelsea and the RCA.

Bowling progressed through many idioms over his student years and those that followed. In the mid-1960s, however, he briefly worked in a highly idiosyncratic version of Pop. *Cover Girl* (1966) is in a way a quintessential product of Swinging London. Its principal source was a cover of the *Observer* colour magazine. The image showed the model Hiroko Matsumoto wearing a dress by Pierre Cardin. This in itself was a manifestation of a newly globalized world. Matsumoto, Cardin's muse at the time, was the first Japanese mannequin to work for a Parisian couturier. The clothes she was wearing were startling to the eyes of mid-1960s Britain; the *Observer* reporter commented that Cardin's design was 'rather a shock'. His rival, André Courrèges, had produced a range that the press dubbed 'Space Age' and he had called 'Couture future'; Cardin had countered with a unisex look in which both male and female outfits consisted of tunic and hose.

The target motif on the dress in Bowling's painting looks very close to paintings by Kenneth Noland (shown in London in the Kasmin Gallery). Thus, Bowling translated the photograph of Matsumoto into a painting, much as Boty had done, but added an extra layer of irony by transforming the outfit back into a colour field painting, setting it against a sequence of stripes that look rather like a work from the 'Situation' exhibition.

Bowling's choice of colours – red, gold, green, white and black – by accident or design were those of the flag of the newly independent nation

FRANK BOWLING *Cover Girl*, 1966

Bowling's Variety Store, New Amsterdam, Guyana

of Guyana, the land of Bowling's birth, which first flew in May 1966, just as he was painting this picture. The building to be seen in the background, in the manner of a silkscreened photograph in a work by Andy Warhol, is Bowling's Variety Store in New Amsterdam. The artist calls this building 'mother's house'.

The photograph on which it is based was taken on a doubly significant day, 2 June 1953: the Coronation of Queen Elizabeth II, and also the day that Bowling first landed in London. Times were changing, the old world and the new were merging together. 'Pop art' could express many things – dreams, protests, hopes, fantasies, fears or, as here, disguised autobiography.

CHAPTER FIFTEEN

MYSTERIOUS
CONVENTIONALITY

London, like the paint I use, seems to be in my bloodstream. It's always moving —
the skies, the streets, the buildings. The people who walk past me when
I draw have become part of my life.

LEON KOSSOFF, 1996

D espite the vogue for Pop and the artists of Situation, in London, perhaps more than anywhere else, many painters remained engaged with the great past: the old masters, the Renaissance. If the Kasmin Gallery on Bond Street, mainly showing colour field abstraction, its white space expanding like Doctor Who's Tardis, seemed to stand for the future, then the opposite pole of art and taste was represented by the Beaux Arts Gallery on Bruton Place. Richard Morphet remembers that 'It was like stepping from the humdrum urban scene into a shrine or a temple. The moment you entered the gallery you seemed to be leaving the world you'd been in and entering a much longer timescale.' The art critic Andrew Forge was one of many who described the atmosphere that awaited the visitor who climbed the dark staircase from the street into the upper gallery, looking down on a larger space below, with creaky boards and a smell of paraffin stoves. The desk of the owner, Helen Lessore, was on the right, 'and she was almost always there, pale, beaked, a melancholy bird'.

Lessore was also a painter and, years later, after the gallery had long been closed, she painted an imaginary group portrait of the artists who were close to her heart. She called it *Symposium I* (1974–77). Starting with the sole sculptor, Raymond Mason, at the top left and travelling clockwise, it portrayed Lessore's son John, Francis Bacon, Lucian Freud, Michael Andrews, Frank Auerbach, Leon Kossoff, Euan Uglow, Myles Murphy and Craigie Aitchison. The people in this picture probably never all gathered together in one room, drinking wine and talking. Some barely knew each other. There was no one way of making art that bound them all together. Some worked from living models, some from imagination, a few from photographs – or perhaps a blend of all three. The bonds that connected them – apart from showing, at one time or another, with the Beaux Arts Gallery – were loose. These artists belonged to several overlapping circles, both social and stylistic. Apart from the fact that they were all figurative

HELEN LESSORE *Symposium I*, 1974–77

artists, no generalizations fit every person in the group. They weren't excited by the thought of America and what it had to offer, as Jones, Hockney and Smith so clearly were. Popular culture was not an interest. On the whole, they were more engaged by art from the European past – Rembrandt, Velázquez, Piero della Francesca – than the American present. But even in that, there were exceptions: Frank Auerbach, as we have seen, revered the work of Pollock and de Kooning.

The artists gathered around Helen Lessore's imaginary table were, more or less, those who were included in a nebulous grouping known as the School of London. In the 1960s, one thing that they did have in common was that, with the exception of Bacon, they were all deeply unfashionable. The painter John Virtue, who began studying at the Slade aged seventeen in 1965, remembers that in those days 'pared back, brilliantly coloured, hard-edge painting was everywhere'. Conversely, the paintings of Uglow, Andrews and Auerbach – all among his teachers at the Slade – were considered 'fringe activities associated with the past, reactionary art; Lucian Freud was regarded as a slightly eccentric irrelevancy'.

In retrospect, of course, the landscape looks different. Freud, like Bacon, now seems a towering figure in the recent history of painting. So too does Auerbach. The others – Andrews, Kossoff and Uglow in particular – have perhaps still not been given the position they deserve.

<p style="text-align:center">*</p>

Another, slightly different, group portrait with a smaller but similar cast was made in March 1963 – just as the long winter was easing and the Profumo affair was about to come to a head. The location for the photograph was Wheeler's restaurant at 19–21 Old Compton Street, Soho, and the subjects were arranged around two sides of a table, a champagne bottle and ice bucket in the middle. At the end, on the left, was Timothy Behrens, an expressionist painter who stylistically had little to do with the others; next to him is Lucian Freud, in conversation with Francis Bacon, then Frank Auerbach chatting to Michael Andrews on the far right. The photographer was John Deakin, a habitué of Soho who would often have been found seated at the table himself. But like many good photographs, this one was staged, part of

Timothy Behrens, Lucian Freud, Francis Bacon, Frank Auerbach and Michael Andrews at Wheeler's restaurant in Soho, London, 1963. Photo by John Deakin

a photo shoot for *Queen*, a glossy magazine favoured by younger members of the British Establishment, known as the 'Chelsea set'.

Frank Auerbach recalls:

> Francis Wyndham – who worked for *Queen* – thought that there was some sort of group of people who knew each other and painted, and he commissioned John Deakin to take a photograph of us at 11 o'clock in the morning. The table was laid but we weren't going to have a meal. We all turned up rather bad-tempered, and Deakin got up on the bar and took photographs, which were rejected because they weren't entirely in focus.

Apart from the inclusion of Behrens, Francis Wyndham was not mistaken. There *was* a group of painters, who all knew each other, met quite frequently, and were dedicated – though in very different ways – to painting something highly elusive: life. Such lunches really did take place, quite frequently. Wheeler's was a very good place to eat. It specialized in oysters and fish, and maintained an excellent wine cellar even during the war. Lucian Freud remembered that 'we all went there a great deal, and we all had accounts'.

According to Auerbach, the photo shoot at Wheeler's ended early: 'Tim Behrens, thinking that this was going to be some sort of party, suggested that a bottle should be opened. Rather grudgingly, because he realized he'd be paying for it – not that he would usually have minded that – Francis agreed. Then we all went away before lunch.'

*

One of the places they might well have ended up later that day was the Colony Room, just round the corner from Wheeler's at 41 Dean Street. This was a drinking club that functioned – like the Beaux Arts Gallery and Wheeler's – as an informal headquarters for a certain circle of painters but not the whole 'School of London' group. Leon Kossoff, for example, seldom, if ever, ventured there. For Francis Bacon in particular it was a perfect environment: bitchy, drunken, with all inhibitions left at the door. It was like – in the words of John Minton – 'being in an enormous bed, with drinks'. John Wonnacott encountered the Colony Room as a nineteen- or twenty-year-old art student. Nearly sixty years later, he still feels it was 'extraordinary':

> On the one hand, it was a bit like the Eugene O'Neill play *The Iceman Cometh*, about alcoholics in a New York rooming house. There were all these people who looked semi-derelict, who hung around at the Colony, with Francis ordering champagne for everyone all round.
> On the other hand, it was full of people who otherwise you only heard of as names – Anthony Burgess, John Hurt, the Bernard brothers, Jeffrey and Bruce.

It was a coterie, almost a family. If there was not much talk about art, the world of Soho provided plenty of raw material for it. Many of Bacon's major

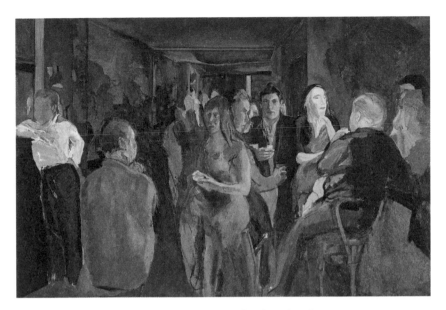

MICHAEL ANDREWS *Colony Room I*, 1962

pictures of the late 1950s and 1960s depicted the trio grouped near the centre of Michael Andrews's painting *Colony Room I* (1962): Henrietta Moraes, Freud and Muriel Belcher, founder and proprietor of the establishment.

In the early 1950s, Michael Andrews, a shy art student and son of a Methodist insurance salesman from Norwich, had ventured into this Soho world. Bruce Bernard remembered meeting him around this time, describing him as a 'thoughtful, dedicated and, in his way, very ambitious painter, but ... also socially quite manic, drinking and behaving with an engaging, and of course entirely sensitive, recklessness.'

Andrews's picture shows a typical scene at the Colony Room, with its throng of drinkers deep in conversation. It is evening or, perhaps, late afternoon; the curtains are drawn, the conversation roaring, the speakers closely packed, and possibly in some cases swaying. Muriel Belcher is perched on her stool next to the bar, Francis Bacon turned towards her on one side, Lucian Freud next to him, looking outwards. To the left of Freud is Bruce Bernard, who later recalled that Andrews had first made him the

central figure, then wounded his vanity 'by bringing in Henrietta Moraes to obstruct the view'. Bruce's brother Jeffrey leans nonchalantly smoking against the bar on the left; the diminutive John Deakin is standing next to him, his back to the viewer. To the right of Bacon, and behind the bar, are Belcher's lover Carmel Stuart and the barman Ian Board.

Although Andrews made studies – including a delicate pencil drawing of Bruce Bernard – much of the picture seems to have been done, as Paul Gauguin used to say, *de tête*, out of his head, from memories. That explains some of the anomalies of the completed image: the way, for example, in the finished version Bruce's face seems to grow out of the back of Henrietta Moraes's head. The painting conveys how it feels to *be* part of a crowd in a club; jostled, slightly drunk, exhilarated.

For a while, social occasions – the energy, the interaction of egos, of what Bruce Bernard called the 'Soho merry- and sorry-go-round' – became Andrews's subject in a series of 'party' paintings of which *Colony Room I* was the first. This social interaction is the true subject of the Colony Room picture and of the large paintings that followed: *The Deer Park* (1962), *All Night Long* (1963–64) and *Good and Bad at Games* (1964–68). In the last of these, realism is vanishing and the figures, portraits of friends, seem to dangle in the air like more or less inflated balloons. The effect recalls a phrase Andrews discovered in a book by Alan Watts on Zen Buddhism, the 'skin-encapsulated ego'.

*

Few painters find it easy to complete a picture, but Andrews found it more than usually difficult. Frank Auerbach commented that his paintings 'were very ambitious, but appeared very rarely, one or two a year'. His second exhibition was scheduled to be held at the Beaux Arts Gallery early in 1963, just before the photograph at Wheeler's was taken. The Colony Room picture was one of the works intended for inclusion. The problem, as John Lessore remembers, was that 'Mike was so neurotic that he couldn't finish anything'. With the exhibition due to open within weeks, Helen Lessore issued an ultimatum. The gallery would shut for two weeks over Christmas, and during that time she proposed Andrews would paint every day in the

gallery and get everything ready. She offered to provide 'coffee and sand-
wiches and anything else you need'.

So for two weeks Andrews painted – while John Lessore watched:

> There were no distractions of any kind apart from me, and I wasn't
> really a distraction. It was phenomenal. He could paint quite
> complicated things from memory, the tone and the colour absolutely
> beautiful. Then he'd think, 'Oh, I don't know', scrape it off and do
> another version. Then he'd scrape that off, go back to the first version,
> repaint it again. He knew it all by heart.

In January 1963, reviewing the exhibition at the Beaux Arts Gallery, Andrew
Forge mused that Andrews seemed to be trying to achieve 'a neutral style,
a language without overtones'. His motive, Forge thought, was 'to evade
style, to make what is represented doubly real by removing all tension and
all mystery from how it is represented'. In 1960, Andrews had used a phrase
that perfectly summed up what he was seeking to achieve: 'mysterious
conventionality'.

His technique as a painter owed a good deal to William Coldstream, by
whom he had been taught at the Slade. But the point of Andrews's pictures
was not so much to record just what he was seeing and where it was located
– like Coldstream did – as to capture what it felt like, physically, psycho-
logically, viscerally. In that, he was far closer to Bacon, Kossoff, Auerbach
and Freud. He wanted to paint the world around him as it looked, but also
something more – deeper than that – something that he called 'the nature
of being'. 'Art is a revelation of life', he insisted, 'as it really and truly is.'
Not only was he 'mysteriously conventional' but he was also something
approaching a mystical realist.

In Andrews's portrait of Tim Behrens, the subject steps into a room in
the manner of a messenger, handsome and melancholy. As was often the
case, Andrews spent a long time agonizing over how to achieve a sense of
harmony in his pictures. Originally, John Lessore remembers, it had 'this
green lawn outside and he could not make it work. Then one day it snowed
and he painted it white. It was wonderful.' Andrews combined the reticent
impersonality of Coldstream's painting – the subtle, beautiful touch – with

MICHAEL ANDREWS *Portrait of Timothy Behrens*, 1962

Bacon's insight that painting should be about matters of vital importance: life, death, tragedy. But, of course, Andrews understood that such matters are subjective; 'truth' was a question of 'what ones sees' filtered by 'one's interpretation' of that sight.

*

The Colony Room was not the only forum in which talented and diverse figurative artists could co-exist. At the Slade School, William Coldstream, the principal, was a gifted administrator and talent-scout. John Wonnacott, himself a student there, remembers:

Bill knew who all the best painters were. He got Auerbach, he got Uglow, he got Mike Andrews, anyone who was any damn good, to run a room. They'd come in over a period of, say, a month, virtually as many days a week as they wanted.

The result was that many ways of picture-making were to be seen, side by side, in the corridors off Gower Street. Some students, like Wonnacott, were attempting to be like Van Gogh or Cézanne, others were doing pastiches of Franz Kline or de Kooning. In one life room, for a month, you might have Auerbach being enthusiastic, in another Andrews being tentative. Daphne Todd, another Slade student in the mid-1960s, thought Auerbach's life room 'probably the most high-powered', but she also found it 'a fearsome place ... it was very dark and there was paint all over the walls and piles on the floor underneath everybody's easels. Nobody spoke, and they grunted while they painted. It was very intense. There was no colour.'

Todd was more affected by Euan Uglow, not so much because of what she learnt from his formal teaching, but by being turned into a work of art, in other words posing for a painting. The picture in question, *Nude, 12 vertical positions from the eye* (1967) is, you might say, the opposite of a Jackson Pollock: a masterpiece of *inaction* painting. In order to keep Daphne's head and body in precisely the correct position, always crucial to Uglow's pictures, he placed her neck between two pegs, and suspended a plumb line in front of her.

In addition, for the picture of Todd, he constructed what was essentially a purpose built viewing structure with steps at six inch intervals, corresponding to lines marked on the wall behind the model. In this way he could map the naked body of the young woman in a fashion never before attempted. Todd herself stood on a large box. Uglow later described the procedure in detail:

> I climbed up and down, my eyes focused successively on the nearest part of her body and the nearest division on the board. These distances are indicated by a sort of code based on the dull yellow bands: the broader the band behind her, the further that part of her body projects from the board. In order to make the various distances between body

and board still clearer I introduced arrow shapes, and to enhance
the two-dimensional form I used the plumb line to enable me to
view the body from two slightly different angles.

For her part, Todd found this arrangement uncomfortable, but not as excru-
ciating as his first idea:

> He originally tried me out in a pose bent double with my arms
> running down my legs. Of course within five minutes my legs were
> completely dead. It was horrible: really, really painful. Looking at
> some of his pictures it's hard to understand how anyone could have
> posed for them. At least I was just standing upright, with my weight
> on one leg admittedly. The painting took a year and a half. We did
> eight painting hours a week.

Despite the discomforts of the process, however, Todd feels she learnt more
from posing for Uglow 'than from anything at the Slade'. Uglow, as many
of his students would testify, was an inspiring teacher.

The objective of Uglow's extraordinary procedure was to eliminate the
distortions caused by viewing the subject from a single fixed position. Not
all painters would find this as much of an issue as Uglow did, nor begin
to contemplate such a tortuously complicated solution. The quandary was
generated by Coldstream's method of attempting a precise measurement of
the position of each item he was painting. For him – and for Uglow, who
had been his pupil – the model represented a problem that, Coldstream
resignedly noted, 'is infinitely wide'. Strictly speaking, what both men were
attempting was geometrically impossible. By measuring a three-dimensional
scene at arm's length, the painter was effectively surveying a concave, curved
arc of space. Once, while painting a reclining nude, Coldstream became
agitated, explaining to his model, 'I've lost some inches somewhere and I
will have to dock you together like a spaceship.'

Uglow took these anomalies much more seriously than Coldstream did,
scrutinizing what was in front of him with the ingenuity of an amateur
scientist. His home studio in Clapham was filled with set-ups for paintings,
invariably with a plumb line dangling from above, as with the Daphne Todd

EUAN UGLOW
Nude, 12 vertical positions from the eye, 1967

picture, so that he could get his eye 'in the right place'. By which he meant precisely the same place every time. He would then make observations using an instrument of his own devising, which had begun life as a music stand. With this contraption resting against his cheek, and one eye closed, he could take sightings of relative measurements of the model's anatomy – or perhaps a still life of a pear or peach – with the precision of a sailor with a sextant.

Obsessively accurate though the measurements were, the final image was anything but naturalistic. As a result of Uglow's struggle to transcribe exactly what he perceived when he looked at Todd, she grew from her actual height of five feet nine inches to an elongated giantess of seven feet in the painting. But, curiously, realism was not the point.

In some ways, what Uglow was doing was far from naturalistic, as he explained: 'If the pictures are not abstract, they're no good at all; they've got to have that basis, not of abstraction as in "abstract art", but of a thing *living in itself.*' Achieving this was like solving a complex equation. Uglow's painting had to be based on direct experience. For example, he would not use photography as a starting point, because he loved 'the poignancy of the right light at the right time hitting a bit of colour'. The colours had to 'ring'. On the other hand, the jazzy striping caused by Uglow's code for representing his measurements of Todd's naked body, unconsciously or not, gave the completed painting a strong period look: a spiky, hard-edged abstraction seems to be encroaching on the figure.

There was a strong element of Piero della Francesca in Uglow's artistic make-up, and a considerable amount of Euclid too. His works were based on geometry in a more rigorous fashion than any by Mondrian – or Robyn Denny. He began with the proportions of the canvas, which he preferred to be either a perfect square or a 'golden rectangle' – that is, one where the sides are related according to the golden ratio, 1.618. Alternatively, he liked rectangles proportioned according to the square roots of numbers. His nudes were thus attempts to cram the subtle complexities of human flesh into a mathematical theorem, while also mapping their convolutions with the utmost precision. Psychology didn't really come into it, except that Uglow's own mentality – like that of most outstanding artists – was highly unusual.

*

As well as professional and social groupings, the painters of London were bound together, by friendships that did not necessarily follow stylistic lines: Uglow was close to his fellow 'Euston Road' disciple, Patrick George, but also to Kossoff; Auerbach was seeing Bacon on a weekly basis and had also developed a deep bond with Freud. On first sight, Auerbach's paintings had struck Freud as 'the most appalling, threatening kind of mess'. In time, though, he grew into a fervent admirer. 'I just love Frank!' he once exclaimed, and he wrote of the other painter's work as 'brimming with information conveyed with an underlying delicacy and humour', all qualities that he himself rated extremely highly.

Auerbach and Freud remained friends for over fifty years, a relationship that lasted longer than Freud's with Bacon or Auerbach's close collaboration with Kossoff. Indeed, it was a close bond between two great painters almost without parallel in art history, an alliance founded on mutual respect and admiration for each other's work. It endured for long periods in which neither artist was in fashion nor, consequently, had much money. This did not prevent Freud from behaving generously and gracefully, observing his own, idiosyncratic moral code, as Auerbach describes:

> I was really poor for a considerable time. I didn't think about it
> much, but I was not in any sense prominent. Lucian was very kind
> to me, and would give me something that I thought was enormously
> luxurious at Christmas like a bottle of Rémy Martin. He was often
> not well off himself, and there was no call for it. As far as I was
> concerned, although it sounds soppy, Lucian performed innumerable
> acts of kindness.

Auerbach's lover Stella West moved to Brentford in 1961 and he would regularly take the train there to visit her; occasionally Freud would come too. She remembered those evenings: 'We had the Saturday Night Nosh. I used to put the joint in the oven, turn it low, and then model for him [Auerbach] for a couple of hours, by which time the joint was done; sometimes my kids would bring their boyfriends; we had this big table in the room, Frank would sit at one end and I at the other, and it was wonderful.'

In the early 1960s, Auerbach twice painted Stella standing in the garden at Brentford, with two of her children, one daughter holding a guinea pig, the other a cat (among the rare occasions when he painted people partly from photographs). One of the versions of the picture hung in Freud's hall until the day he died. It is a picture that contains the most compelling sense imaginable of a person: her weight, presence, mass, gaze and personality summoned up in front of you in a way that is almost eerie.

Several of the so-called 'School of London' painters also had in common an affection for certain places: not just the metropolis itself, but – often – particular districts within it. In 1954, Auerbach had taken over from Leon Kossoff a small studio situated in North London between Mornington Crescent and Regent's Park. It was not a luxurious place: 'it had no indoor loo, no hot water, it was just a nineteenth-century box'. But it was an austere brick cube with a certain pedigree. Before Kossoff, Gustav Metzger had worked there, and – with an interval of occupation by a 'slightly dodgy actor' – the painter Frances Hodgkins before that.

In the early twentieth century Walter Sickert and his circle, the 'Camden Town Group', had given the area a place in the history of painting. By the mid-1960s Auerbach had already been painting there for a decade, and had established routines and patterns of work to which, another half-century later, he still adheres. His pictures fall into two categories. Firstly, there are pictures of people done in the studio from a small circle of models, who are friends and intimates as well. Then there are landscapes, also executed in the studio but on the basis of drawings made on walks around this neighbourhood, which Auerbach knows so intimately well. This process of walking and drawing is a means of importing new impressions – a daily set of data – back to the easel. It is a way of getting himself started, and also a fresh starting point:

I quite often feel washed up and stymied in the morning, because I wonder what to do. Then I go out, and do drawings and it feels quite different because you get this marvellous, refreshing rush of perception. And when you take the drawing in, you remember what sensations the picture's about. To work without that kind of input

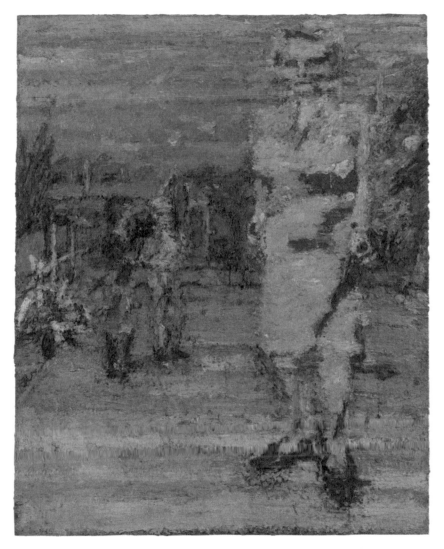

FRANK AUERBACH *E.O.W., S.A.W. and J.J.W. in the Garden I*, 1963

FRANK AUERBACH *Mornington Crescent with the Statue of Sickert's Father-in-Law III,*
Summer Morning, 1966

seems to me altogether too separated and scholarly to be interesting.
One wants some kind of quotidian life in the painting.

The places Auerbach has painted in this way are naturally all within walking
distance – some very close, others, such as Primrose Hill, a little further
away. The subject of a series of pictures from between 1965 and 1967 was
the road junction outside Mornington Crescent Underground station where
three roads join: Camden High Street, Crowndale Road and Mornington
Crescent itself. This is not exactly subtopia – it is a bit too close to the centre
– but certainly an urban jumble typical of London.

The critic Robert Hughes listed the sights and smells that assailed him on
exiting the Tube station en route to visit Auerbach: 'gooseneck streetlights,
traffic signals and metal v-barriers laid over a background of fish-and-chip
shops and off-track betting shops amid the roar and stink of traffic'. Behind,

and beneath, all this confusion and clutter are some older structures including a music hall, the Underground station itself, an ex-cigarette factory and a statue of the nineteenth-century politician Richard Cobden. Auerbach likes to mention the last of these, where relevant, in his titles, as 'Sickert's father-in-law' – a random artistic link to the past.

From all this sensory and architectural chaos, Auerbach managed to distil a series of paintings as ordered in their way as any by Mondrian. *Mornington Crescent with the Statue of Sickert's Father-in-Law III, Summer Morning* (1966) is scarcely naturalistic, though it is based on daily observation. Sky, road and pavement alike are ochre. Much of the image consists of lines – vehement brushstrokes – in red, blue and black, which pulse with rhythm. But the painting is also packed with preserved experience: feel of the sunshine, the hot London air. It is not necessary to go to a lot of different places to paint many landscapes. Paul Cézanne and John Constable extracted large numbers of masterpieces from a small acreage. Auerbach has done the same. After all, Camden Town is no worse a place than any other in which to examine the world. The same could be said of Willesden, a little further north and the haunt of Auerbach's friend Leon Kossoff.

*

In the summer of 1967 Kossoff began to make regular visits to a place so unglamorous as to be almost exotic – Willesden Sports Centre. This was a new building in Donnington Road, close to the house in Willesden Green to which the painter and his family had recently moved. Kossoff got into the habit of taking his young son there to teach him to swim. But quickly these excursions in the summer holidays began to have a second purpose.

Kossoff started to draw the pool, densely packed as it was with aquatic youngsters, diving, splashing and shouting. It was a scene of extreme animation and complexity: a municipal architectural box filled with noise and youthful humanity in which the illumination – through a wall of windows – altered every time the sun moved or a cloud drifted across it. He was fascinated by its mutability, and 'how the pool changed during the summer months and how, at different times of day, the changing of the light and rise and fall of the changing volume of sound seemed to correspond with changes in myself'.

Through the summers of 1967 and 1968 he drew it time and again; he also tried to paint it. But the paintings, he remembered, were initially 'terrible'.

In this mundane setting Kossoff had found a microcosm. Here before him were three of the four elements – air, earth and water – plus geometric architecture, ever-shifting light and massed, near-naked humanity. It was a subject with a certain classical quality – nymphs and youths bathing – while being utterly everyday. Furthermore, the pool and its users exemplified one of the qualities that, for Kossoff, made the activity of painting and drawing from life both compelling and dauntingly close to impossibility: the way nothing stays the same even for an instant. This was also true when he looked at a motionless person in his studio; how much more so when he ventured outside to confront the flux of London's streets or swimmers at Willesden Sports Centre.

The Greek pre-Socratic philosopher Heraclitus of Ephesus famously pointed out that it is impossible to step into the same river twice. In the interval between the first and second paddle, virtually every molecule of water in a flowing stream will have been replaced. A painter attempting to make a fixed image of a constantly moving target has a doubly elusive objective. The subject keeps changing, and so does the observing artist (Heraclitus might have added that the 'you' attempting to step back into the river is a little bit altered too). Kossoff has described this quandary:

> Every time the model sits, everything has changed. You have
> changed, she has changed. The light has changed, the balance has
> changed. The directions you try to remember are no longer there and,
> whether working from the model or landscape drawings, everything
> has to be reconstructed daily, many, many times.

The mid-1960s was a time of transition for Kossoff and, in a muted way, of crisis. He had just passed the age of forty – a landmark in most people's lives – and suffered a small professional disaster. His previous studio at Willesden Junction had flooded, damaging a number of works that had to be destroyed. What's more, his career and place in the art world seemed to be sinking, disappearing beneath the waters of fashion. In John Russell and Bryan Robertson's book *Private View: The Lively World of British Art*,

LEON KOSSOFF *Children's Swimming Pool, 11 o'clock Saturday Morning. August 1969*, 1969

published in 1965, there were dozens of profiles of artists – many of them now completely forgotten – handsomely illustrated with photographs of them and their work by Snowdon. Kossoff, however, featured in this volume only as a typographical error; in a list of miscellaneous artists, 'David Kossoff' – in fact a well-known actor – was mentioned. Although Russell and Robertson were two of the more influential and knowledgeable people in the art world, they were evidently in danger of forgetting who Leon Kossoff was.

Still, he kept doggedly drawing the swimming pool and its occupants, with some success, and painting it with much less. He was doing so one Saturday morning in August 1969 and worked for a few hours before scraping off what he had done. Frustrated, he went back to the swimming pool to draw, returned to his studio – which was now on the ground floor of the family home in Willesden Green – and began again. Finally, very quickly, as he put it later, 'the picture happened'. He gave it as a title a precise moment in the flux of time and space: *Children's Swimming Pool, 11 o'clock Saturday Morning. August 1969.*

*

The strangely impersonal formulation 'the picture happened', as if it had come into being of its own accord, expresses one of Kossoff's deepest beliefs about his art. To paint a picture that he considers 'finished', he has found, it is necessary to go beyond what he already knows and thinks he is doing, to enter a place of unknowing: 'Nothing really begins to happen in a painting until you reach the point where conscious intention breaks up and ceases to be the thing that's driving you.' This generally happens only after endless effort and repeated failure. Eventually, with luck, 'one's initial intent' dissolves. This is, Kossoff feels, 'a very perilous condition because it casts you into a world that's totally unfamiliar'. The results will be unexpected, because they are outside conscious control – 'every painting I've made that I consider finished has something in it that surprised or disturbed me' – but paintings made in this way are, in his view, the only ones that are worthwhile.

As a creed it has overtones of Zen Buddhism unexpected in a figurative painter working in a corner of north-west London. But what Kossoff discovered was a truth about creative acts that is echoed by many other artists. Lucian Freud would quote Picasso's answer to questions about how his work was going, using the words of a notice in Parisian trams: 'Don't talk to the driver.' Freud would add, 'because he doesn't know what he's doing'. As we have seen, Frank Auerbach also found that it was only in a 'crisis', after endless repetitions, that he found the 'courage' to make a picture as novel and audacious as it needed to be. The choice of words reveals the same level of intensity and effort.

Over the next few years, Kossoff painted a sequence of pictures of the swimming pool in Willesden. Socially and visually they could scarcely be more different from David Hockney's California pools yet they are equally memorable. Between them these very dissimilar pool pictures demonstrate that absolutely new ways of depicting the world could still be found with paint and brushes.

PORTRAIT SURROUNDED BY ARTISTIC DEVICES

As a young artist I greatly admired the works Hockney did at the end of his time at the Royal Collage: wunderbar, amazing, fantastische.

GEORG BASELITZ, 2016

Major new figurative painters were no longer expected to emerge in 1960s London, or anywhere else for that matter. Nonetheless, undeniably, and with rapidly increasing prominence, one did. Something unforeseen happened to Hockney in the spring of 1961 – surprisingly, to him at least, he started to earn money. One day in April, having just spent five of his last ten shillings on a taxi to the Royal College of Art, he arrived to discover a cheque for £100, the first prize for a competition he had won without even knowing he had entered. Not long afterwards, he received a commission to decorate one of the rooms on the P&O company's new liner, the SS *Canberra*. While other, older artists were assigned some of the more formal spaces, Hockney's task was to design a room for teenagers, called the Pop Inn.

More significantly for his long-term future, his works in the 'Young Contemporaries' exhibition had attracted the attention of the art dealer John Kasmin. Only a few years older than Hockney himself, Kasmin did not yet have a gallery of his own – at this point he was an employee of Marlborough Fine Art – but he was equipped with energy, taste, intelligence and chutzpah, all invaluable qualities in his profession.

Kasmin failed to interest his employers at Marlborough in Hockney's work, so instead he began to promote it on a freelance basis, beginning by buying a picture himself. Here, he felt, was a suitable case for promotion. 'The main thing was, Hockney was terribly shy and needy, and I knew I could help him.' Taking on Hockney – who was to become one of the most renowned painters in British history – might seem, in retrospect, like an obvious decision. But several influential voices advised against it. 'Lawrence Alloway was very rude about David,' Kasmin recalls. 'He thought I'd made a really wrong choice.' Hockney fell into neither of the categories Alloway advocated: Pop art and hard-edge abstraction. Indeed, he did not belong in any category at all, which was one of his great strengths. Furthermore, his work changed constantly and this also was a sign – but of inventiveness and inner confidence, rather than uncertainty. If you shift your style, he said some years later, it doesn't mean you are rejecting what you did before, just that you want to see 'what's round this next corner'.

Nonetheless, Alloway was not the only influential opinion-former in the art world who had doubts about Hockney. Writing several years later, when the painter was considerably more prominent than he was in 1961, the director of the Whitechapel Art Gallery Bryan Robertson still had reservations. He saw him as one of several 'young artists from the industrialized North of England' who – like 'pop vocal groups' from Merseyside and 'fresh, lively, unconventional young actors' – had made a place for themselves in 1960s London. He grouped Hockney geographically with John Hoyland and Peter Phillips (from Leeds and Birmingham respectively), artists who had 'edgy, sceptical intelligence' and an 'awareness of "what's in the air"'.

In addition, however, these painters from regional art schools had a quality about which Robertson was more ambivalent: 'a marked irreverence towards prevailing standards and aesthetic issues'; and about Hockney in particular, Robertson was clearly in two minds. He felt that the 'delicacy and subtlety' of his work sometimes degenerated into 'mere frailty and a slightly "camp" whimsicality'. His humour could be 'over thin and faux naive', but a 'tough, dry resilient' side of his sensibility asserted itself 'often enough – so far – to win the day'. That 'so far' revealed the writer's misgivings.

The problem was, as Auerbach later commented, that 'what David Hockney does is not laid down in the rule book for modern painting at all'. His art, like that of Francis Bacon and Lucian Freud, was not the kind expected by people who thought they knew the direction in which art was going. Indeed, he completely ignored their instructions. Auerbach again: 'We'd been told what modern art was, but Hockney's paintings broke every single rule about what modern art was supposed to be – and they were terrific.'

<center>*</center>

By the early summer of 1961, Hockney had enough money to fulfil an urge he, like many of his generation in Britain, had felt since childhood. He bought a ticket to New York where he had arranged to stay with Mark Berger, a fellow student at the RCA, who was American – like Kitaj he was taking advantage of the GI Bill to study in Britain – and also gay. It was Berger, in Derek Boshier's opinion, who 'brought David out of the closet'. Hockney stayed for three months, 'utterly thrilled' by the place, though more by the freedom and pizzazz of the city and the life that was lived there than by American art. New York 'was amazingly sexy and unbelievably easy'. This was a 'marvellously lively society', he thought; the bookshops were open twenty-four hours a day, the gay life was much more organized, Greenwich village never closed, you could 'watch television at three o'clock in the morning then go out and the bars would still be open'. Hockney felt completely free; this was the place for him.

He came back to London in the autumn, visibly changed. He had sold some prints to the Museum of Modern Art for $200 and spent the money on an American suit. The other modification was more radical. One afternoon he was watching television with Berger and another friend, when an advertisement for a hair dye called Lady Clairol was screened. The slogan was 'Is it true blondes have more fun?' On the spot, Hockney decided to go blond.

Thus, intuitively and naturally, Hockney had found a memorable public image. Artists had had these before – Whistler with his monocle, Dalí with his moustache – and they were to become more common as the 1960s wore on. Previously Hockney had been a black-haired student with a strong

Yorkshire accent and an evidently remarkable talent. But from the autumn of 1961, he was more than that: an intriguing personality. His serious, thick-framed glasses contrasted piquantly with the outrageous bottle-blond hair and flamboyant clothes. The combination suggested, accurately, that Hockney was open, pleasure loving, contemporary, and in the process of inventing himself.

Late in 1962, Hockney confided to an early interviewer from *Town* magazine that he was just off to Cecil Gee to buy a gold-lamé jacket. He wore it to his graduation ceremony at the Royal College, an event that almost did not occur because of a dispute between Hockney and the teaching staff – a conflict that was not about artistic style so much as the dignity of art itself as a way of understanding the world. He recalls:

> When I began at the Royal College, drawing in a life class was a compulsory activity. Then it altered, and they introduced what they called 'general studies'. I immediately attacked it and said, 'What does it mean, general studies? Why have you given up the drawing?' They said it was all to do with the Ministry of Education. There was a complaint that people were leaving art schools ignorant. I said that there's no such thing as an ignorant artist really, if they are an artist they *know* something.

This tussle with authority demonstrated Hockney's confidence in himself and his own judgment. He had spent very little time on the thesis that he was required to submit to pass the General Studies section of the course (it was on Fauvism). This was then given a fail by the examiners, and he was told that therefore he could not graduate. At this point he etched his own diploma, thinking – rightly – that he scarcely needed this institutional endorsement. After all, by that date, he already had a dealer and was beginning to become famous (as that interview for *Town* implied). He thought, 'Well, Kasmin's not going to ask for a diploma?' Why bother about all this, 'in painting of all things'?

In the event Robin Darwin, the principal, decided it would be absurd for Hockney *not* to be awarded the gold medal for painting – and he could not be given this unless he graduated. So Hockney's essay was reassessed, the

David Hockney, 1963. Photo by Snowdon

marks added up again, and it was conveniently discovered he'd passed after all. The college needed him, it seemed, more than he needed the college. A profile published in February 1962 was illustrated by an out-of-focus photograph and described him as 'an emergent blur'; very shortly after he emerged completely, and his image was far from indistinct.

On Wednesday 17 April 1963 Hockney's father Ken had wanted to stay overnight with David before attending the anti-nuclear armament Aldermaston March the next day; but David explained that he was busy as Lord Snowdon, Princess Margaret's husband, was coming to take pictures of him for the *Sunday Times Colour Section*. The images taken that day, and the article by David Sylvester on 'British Painting Now' which they accompanied, fuelled

DAVID HOCKNEY *Play within a Play*, 1963

Hockney's fame. He was not the only artist discussed – Francis Bacon, William Coldstream and Frank Auerbach were also included. But Hockney was the youngest and, in Snowdon's photographs, looked like a star. He regretted buying the gold-lamé jacket, however, complaining that he had only put it on twice – for this photo shoot and for his graduation – but people thought he wore one all the time.

In 1962 and 1963, Hockney often borrowed the vocabulary of Kasmin's favourite hard-edge and colour field artists – the strong colours, the stripes – and, with a visual abracadabra, transformed them back into landscape, people, objects and an illusion of space. In *Flight into Italy – Swiss Landscape* (1962), a record of a rapid jaunt to the Mediterranean made with two friends, the Alps are represented as a series of jagged red, blue, yellow, grey and white stripes. Hockney borrowed a characteristic motif of painters such as Morris Louis and Frank Stella, but he unfurled the stripes across the picture like a roll of carpet. The Americans' abstract fields of colour are transformed into an Alpine terrain, a uniquely updated version of a subject from Turner.

It was also in 1963 that Kasmin suggested Hockney should paint his portrait – though he didn't quite get what he expected. The result was a brilliantly witty mediation on the picture as illusion. The point about American painting, such as Kenneth Noland's, was its programmatic, almost ideological flatness. Hockney's portrait of Kasmin, *Play within a Play* (1963), is an elaborate fantasia on that theme. The illusion of the western picture, Hockney had already realised, is closely connected with the illusions presented on a proscenium stage. And that was exactly where he chose to place his dealer; in a shallow zone in front of a curtain or backdrop of his own invention and standing on naturalistically painted floorboards. Beside Kasmin is a chair, also carefully depicted using the devices of naturalism. This gives the depth of the area in which Kasmin is trapped. The front of this space is the glass on the picture, against which the dealer's hands and nose are tightly pressed. Kasmin was pressing the artist to paint the portrait, so he thought 'I'll put him in and I'll press *him*'.

However, *Play within a Play* was much more than a joke between friends. It was a comment, as profound as it was witty, about the nature of pictures, and an indication of the direction Hockney was to take. His

work was becoming more and more naturalistic and, simultaneously, more and more preoccupied with analysing the mechanisms of visual illusionism. This illusion of the visual world within the flat plane of the picture was exactly what the American critic Clement Greenberg and his followers were against. But, as Allen Jones noted, it was something that his contemporaries in London found impossible to give up; Hockney, for one, clearly did not want to. On the contrary, he was increasingly preoccupied by the myriad ways in which the illusory space of a picture could be created.

*

In the late spring of 1963, just after Kasmin finally opened his new gallery on Bond Street, Hockney made another visit to New York. On this trip he made greater inroads into the American cultural scene – meeting, among others, Dennis Hopper, Andy Warhol and a gifted young curator named Henry Geldzahler, who was to become a lifelong friend. Hockney had an exhibition coming up at the Kasmin Gallery in December; he was the first non-abstract artist to be shown there. When the exhibition opened, a number of striking recent works were included, among them *Play within a Play*. The show was a success, critically and financially, and as a result Hockney was able to depart at the end of the year for a long stay in America. This time he intended to venture further than New York.

Hockney's ultimate goal was Los Angeles, where he arrived in January 1964. This was a city where he would eventually spend much of his life but of which, in advance, he knew almost nothing – except what he had gathered from films and the pages of a homoerotic glamour magazine called *Physique Pictorial*. Initially, not having a car or even being able to drive, he had great difficulty in getting around at all. Quickly, however, he bought a vehicle, learnt how to drive it and was on his way to becoming an English Angeleno.

When Hockney arrived in LA, the massive freeway system was still in the process of construction. In the first week he passed the ramp of a half-finished road, rising into the sky. It struck him that it looked like a ruin (a reaction much like Frank Auerbach's to postwar London). 'My God,' he thought, 'this place needs its Piranesi; Los Angeles could have a Piranesi, and here I am!' Hockney was to become one of the greatest painters ever of

the architecture and lifestyle of Los Angeles, but it was not – or not often – the Piranesian aspect of the city that appeared in his pictures.

Throughout the next few years, Hockney continued his restless exploration on both sides of the Atlantic and beyond. In the summer of 1964 he taught at the University of Iowa, driving across the continent on the way. He saw the Grand Canyon and New Orleans with his friends Ossie Clark and Derek Boshier; the next year, with Patrick Procktor and Colin Self, he went to Colorado, San Francisco and Los Angeles again, before taking the boat back to London. The following January he was in Beirut, working on a series of etchings based on the poems of C. P. Cavafy.

His investigation of art, and the ways in which it could be made, was equally wide-ranging. He had begun what would become a lifetime's experimentation with different media; etching was just the first of a variety of types of printmaking he would use. Soon he was designing a theatrical production – Alfred Jarry's *Ubu Roi* at the Royal Court Theatre in London – and he would work on many more over the decade.

At the same time, Hockney was roving through art history. *Portrait Surrounded by Artistic Devices* (1965) is a visual anthology of art, from the Renaissance to late Modernism. Across the canvas there are Matisse-like blocks of pure colour; a sequence of turquoise and pearl-grey marks looks as if it has been lifted from a colour field abstraction. Through deft touches of chiaroscuro – that is, shadows and highlights – the grey oblongs that dominate the centre of the picture are transformed into a pile of cylinders. As with a skilful magician's act, the illusion is irresistible although we know it is a trick. Half-hidden behind them is a seated man in suit and tie, sharply drawn. He is, in fact, Kenneth Hockney, the artist's father, based on a drawing from life. Life and art, in Hockney's view, are not easily separated. The one flows into the other, a realization that is fundamental to Hockney's art:

> As if you could separate form from content! There's a serious flaw in that idea. Any serious artist knows that form and content are *one*. You can talk about them separately, but in any really good work of art they have to come together.

DAVID HOCKNEY *Portrait Surrounded by Artistic Devices*, 1965

To the right of Kenneth is a rectangle resembling a picture on the wall, a mass of brown brushmarks. Behind it, a multi-coloured arch and a single shadow create a space-frame, a bit like the ones Francis Bacon used in his paintings. As so often with Hockney, this painting is at once playfully entertaining and completely serious. The mystery it poses is this: when we come across a few tones or colours on a piece of canvas, or lines on a piece of paper, somehow we see objects, people and three dimensions. Indeed, we can't stop ourselves from doing so. Human beings, as Hockney says, have a deep *need* for pictures. They are one of the means by which we understand the world around us. But, in a way, they are just made up of 'artistic devices'. One way of seeing Hockney's art is as a lifelong journey into pictorial space.

*

Among the attractions of LA for Hockney was the sexual freedom of the gay scene there. Accordingly, he and Kasmin paid a visit, almost a pilgrimage, to the offices of *Physique Pictorial*. They were both surprised and amused to discover that this publication was based in an ordinary suburban street. The photographic studio had only two walls, Kasmin remembered, and 'this was where [Hockney's] dream of paradise was created'. This was another lesson in the illusionary nature of pictures: that 'you could make a glossy dream out of such shabby bits of plywood'. Hockney gave a lecture on *Physique Pictorial* at the ICA on his return to London, at Richard Hamilton's invitation. It was apparently much funnier than most such talks on American popular culture, and also novel in its focus on gay films and softcore photography.

Hockney's work was changing in ways that seemed somehow generated by the new city in which he spent much of his time over the next few years. In LA in 1964, Hockney noted, he began to paint 'real things' he had seen. 'All the paintings before that were either ideas or things I'd seen in a book and made something from.' He didn't do this in London, he later reflected, because the place didn't mean so much to him. He started by painting the urban landscape, then moved on to painting its people.

When Hockney began to work in LA again, in the second half of 1966, this depiction of reality began to dominate his work. The first picture he started after arriving was *Beverly Hills Housewife* (1966–67), an enormous portrait of a wealthy collector and patron of the arts named Betty Freeman. It was, like many contemporary works by Howard Hodgkin, as much a depiction of the setting and the sitter's possessions as of the person herself. Hockney described the picture as 'a specific portrait and a specific house, a real place that looks like that'. Nonetheless, his methods were only partly naturalistic. The huge image was executed in his small apartment cum studio, using a mixture of drawings and photographs – the latter being a new source for Hockney. The result had the lucid geometry of right angles, rectangles and straight lines that came from European Modernism, and was, paradoxically, almost a naturalistic idiom in LA since much of the domestic architecture of the city derived from the styles of architects such as Mies van der Rohe and Le Corbusier (one of the items in the painting was a lounger designed by the latter).

Two themes that dominated Hockney's work in LA in the years 1964–68, during each of which he spent periods living in California, were sex and water, often combined in the same image. A series of pictures, including *Boy About to Take a Shower*, *Man in Shower in Beverly Hills* (both 1964) and *Man Taking a Shower* (1965) repeated a favourite motif from *Physique Pictorial*. Water – and more generally, transparency – fascinated the artist as much as the male body:

> It seems to me an interesting thing to do, to draw transparency, because – visually – it's about something not being there, almost. The swimming pool paintings I did were about transparency: how would you paint water? A nice problem, it seemed to me. The swimming pool, unlike the pond, reflects light. Those dancing lines I used to paint on the pools are really on the surface of the water. It was a graphic challenge.

Hockney's pool pictures of 1966 and 1967 are among his most celebrated works, and the ones very obviously connected with his life in Los Angeles (the ubiquitous pools were a feature of the city that he noted on his first visit, even as his plane made its approach to the airport). These paintings are, however, still near-neighbours of abstraction. *Sunbather* (1966) is very close to a hard-edge painting – by Frank Stella, for example – consisting of a series of horizontal stripes. But Hockney has transformed one of the hard-edge stripes into a row of tiles edging the pool, and another, wider one into the poolside patio where the sunbather lies on a towel. Thus light, air and space appear in the image – and not just any light and space, the clear sharp atmosphere and sunshine of maritime California. Looking back on those early days there, Hockney muses, 'I used to say it was all about the sex, but now I wonder if I was really attracted by the space.'

The lower zone of *Sunbather* is covered in squiggly lines borrowed from another painter in Kasmin's stable, Bernard Cohen. Gillian Ayres remembers wandering into the Kasmin Gallery one day to find Hockney delivering a new painting. He and Kasmin were laughing about the fact that in it he borrowed some stripes from Cohen: 'they couldn't decide if that was an upper or a downer!' Kasmin might have been in two minds when he saw

the art that was closest to his heart being appropriated with cheeky aplomb, and transformed into its exact opposite.

Though only an image of a corner of the grounds of one house, *Sunbather* is a picture filled with a sense of place – and not that of a native. This is LA as seen through the eyes of an outsider, who is in love with it, just as Richard Smith's New York was depicted from the romanticized view of a traveller. Hockney's vision was puzzling to his friend Ed Ruscha, one of the artists Hockney met on his first trip to LA in 1964. Ruscha, an Angeleno who has himself painted and photographed the city prolifically, has talked about this outsider's perspective, which, for him, holds true both ways:

> David was one of many British people who have a true affinity to this city that I never really understood. I go to England and I see the soft edges to things, the humaneness of everything, the beauty of that place. It puzzles me that British people can come to Los Angeles and actually get excited about it. But there are notable British people who say California is the greatest! It's oily about the edges, it's gritty, but at the same time it promises something. I don't know what, the fountain of youth, maybe.

*

Back in the UK, on 9 January 1966, David Hockney was in the news once more. He was fed up with Britain in general, and London in particular, with its stuffiness, its staidness, its lack of freedom. He expressed himself freely to the journalist who wrote the 'Atticus' column in the *Sunday Times*, and his views appeared under the headline 'Pop Artist Pops Off'. Why, Hockney asked, did the pubs have to close at 11 o'clock? Why did television stop at midnight? He felt 'livelier' in the US, so he was going there:

> Life should be more exciting, but all they have [in London] is regulations stopping you from doing anything. I used to think London was exciting. It is, compared to Bradford. But compared with New York or San Francisco, it's nothing. I'm going in April.

BERNARD COHEN *Alonging*, 1965

DAVID HOCKNEY *Sunbather,* 1966

DAVID HOCKNEY *The Room, Tarzana*, 1967

Hockney stayed in Los Angeles – with brief excursions elsewhere – for two years. He had a teaching job at the University of California at Los Angeles (UCLA) where, initially, the class struck him as very dull, made up of would-be art teachers diligently accumulating their credits. Then, one day, in walked Peter Schlesinger, the eighteen-year-old son of an insurance salesman from the San Fernando Valley. He was to be the first great romance of Hockney's life.

For the next few years, his art was filled by a feeling beyond the sexual excitement he had felt on his initial arrival in LA. For a while, Hockney's pictures were concerned with love and happiness – two states virtually

excluded from Modernist art (and certainly from the world of Francis Bacon). Here was another of the unspoken taboos of the avant-garde that Hockney insouciantly ignored. A few years later a television interviewer asked Hockney to what he attributed his remarkable appeal to the general public. He replied, 'I'm not that sure.' It is indeed a complex phenomenon – in which the charisma of his personality and the virtuosity of his skill doubtless play a part. But, surely, the positivity of his work is important too. If he has a message, he has said, it is: 'Love life!'

At the beginning of 1967 Schlesinger moved into Hockney's apartment on Pico Boulevard in the Santa Monica area of the city. This was the first time the painter was not just in a sexual relationship, but living together with somebody as one half of a couple. While the romance was developing, Hockney's work was changing yet again. One day later in the year he saw an advertisement for Macy's department store, 'a colour photograph of a room'. This struck him firstly because it was 'so simple and such a direct view'. But it also contained an element new to Hockney's art: a diagonal.

Macy's advertisement, San Francisco Chronicle, *1967*

The space was viewed obliquely, rather than head-on, so that the line made by the bottom of the left-hand wall ran upwards across the picture plane, from left to right. This created a deeper, more oblique space, but one defined with the crystalline clarity that Hockney loved, for what one can only call temperamental reasons:

> It was so simple and beautiful, I thought, it's marvellous, it's like a
> piece of sculpture, I must use it. And of course I must put a figure on
> the bed, I don't want it just empty, so I'll paint Peter lying on the bed.

Schlesinger flew up to Berkeley, where Hockney was teaching, and posed lying on a table at the same angle as the bed in the Macy's photograph. Hockney also, to use a cinematic term, tracked back, enlarging the view in the photograph and thus creating a grander and more harmonious space. Then he transfigured it through a new element in his art: the fall of light. The room in the Macy's advertisement, he realized, was illuminated by the sun from the window, which cast shadows on the window blind, the carpet and was 'dancing around the room'. For the first time, the way light fell became an interesting subject for Hockney, joining the transparency of water and the 'dancing lines' of the reflections on its surface.

He entitled the resulting picture *The Room, Tarzana* (1967), because Schlesinger came from Encino, the neighbourhood next to Tarzana where Edgar Rice Burroughs had written the Tarzan books. The substitution was in case Schlesinger's parents saw the picture and discovered he had posed half-naked for this openly erotic image. Though coded, the point of the title was that this was Peter's room, the place inhabited by a person the artist loved.

The picture was thus a complex construction – a virtual collage – consisting of a found, photographic image, simplified and reimagined, with inserted into it the body of a person deeply known to the artist and observed from life. In the mid-1960s, photography was a new factor in Hockney's art; the lens-eye view of the world was something that he would work both with and against, grappling with it and meditating on it, from this point until the time of writing, fifty years later.

In *The Room, Tarzana*, however, photography merges with an element that had been in Hockney's consciousness for almost two decades by 1967:

the art of fifteenth-century Italy. Perhaps the first great painting he saw in reproduction was an *Annunciation* by Fra Angelico, a poster of which hung in the corridor at Bradford Grammar School where he had begun to study at the age of eleven. The light, clear colours of Fra Angelico's fresco had obviously lodged in Hockney's sensibility, as had the forms as precise as an illustration to Euclid. Pictures by Piero della Francesca have similar characteristics, and he too was one of Hockney's reference points (as he was for Euan Uglow and many other British painters).

Of course, the exposed bottom of a young man on a bed would not have been a subject for Fra Angelico, a Dominican friar who was beatified after his death. Somehow, however, Hockney imbued this subject – an erotic male nude – with the mood of a scene by the Florentine master: radiant innocence. This was no doubt how he felt then; it was also the spirit of the time. After all, the middle months of 1967 were remembered as the 'summer of love'. And San Francisco was its epicentre.

One of the extraordinary aspects of Hockney's paintings in the mid- to late-1960s – apart from their beauty – was the openness with which he revealed pleasure in the male body. This subject was common in art, of course, but seldom treated in British, American or European painting of the twentieth century. Rare, too, was to find it presented with such calm, matter-of-factness as if to say, this is an important part of my life, why should there be regulations or conventions stopping me from enjoying it? Such willingness to broach this kind of issue was one reason why the curator Norman Rosenthal once remarked that Hockney, from early on in his career, had been a 'moral force'.

*

After he returned to London in 1968, Hockney's art reached the opposite end of the spectrum from the loose, gestural action painting with which he had begun the decade. A few pictures from this period come close to Photo Realism, though Hockney never actually projected a photograph onto the canvas and then copied it, as true Photo Realists did. But *Early Morning, Sainte-Maxime* (1968–69) was painted by eye directly from a picture he had taken with his new, high-quality camera. He sometimes wondered, he

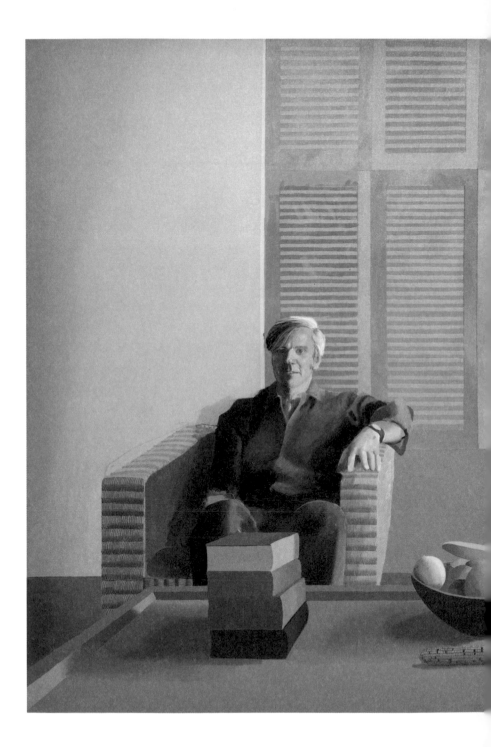

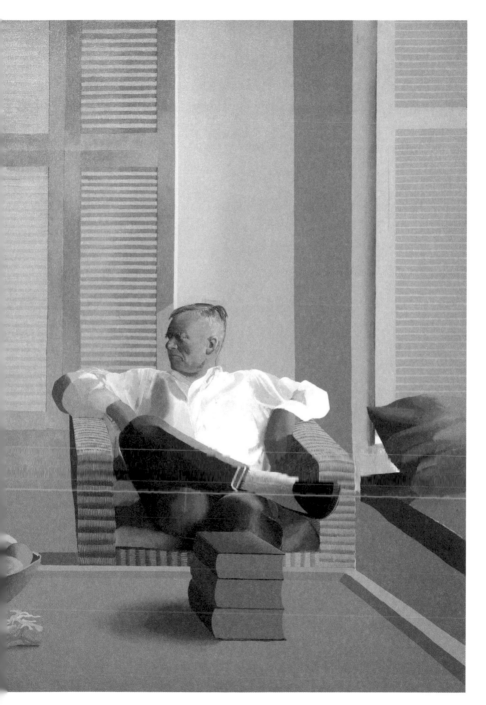

DAVID HOCKNEY *Christopher Isherwood and Don Bachardy*, 1968

confessed in 1975, whether it was the worst painting he had ever made. It is certainly very far from the best, and perfectly exemplifies the problem that was to obsess Hockney later in his career: that it is a grave limitation for figurative art to be dominated by the camera-lens view of things. That, he would exclaim again and again, was just not good enough.

The near-photographic Hockneys were few in number. But his greatest achievements of this period – which would become milestones in British and European art – owed something, albeit only a little, to images he took with his camera. These were the sequence of double portraits he painted over the following years. Back in California in 1968, he thought he would paint two friends, Christopher Isherwood and Don Bachardy, together. This, and the other portraits of couples that followed – *American Collectors (Fred and Marcia Weisman)* (1968), *Henry Geldzahler and Christopher Scott* (1969), *Mr and Mrs Clark and Percy* (1970–71) and *George Lawson and Wayne Sleep* (1972–75) – are complex amalgams, in part highly naturalistic and in part not naturalistic at all.

Hockney has described the way he went about painting Christopher Isherwood and Don Bachardy. First he made numerous drawings of the two sitters, 'to get to know their faces and what they are like'. Next he took 'a lot of photographs of them in a room, trying to get a composition'. He arranged a little still life of books and fruit on the table in front of them. But the actual painting was not done in Isherwood and Bachardy's house, but in a little apartment that Hockney and Peter Schlesinger had rented a few blocks away.

The picture, then, is a complex mixture: to some extent done from life, but also based on photographs, as well as being a formal invention of the artist's making. Reconciling these varying elements meant that these big double portraits involved Hockney in a lengthy struggle. He began to paint *Mr and Mrs Clark and Percy* in late spring of 1970, having made some drawings for it the year before. It wasn't finished until February 1971, some ten months later.

Hockney's aim was to represent 'the presence of two people in this room', but to do so generated numerous technical problems. He noted that to paint tones accurately, you have to 'look and look' at the subject in a certain space in a specific light. This was how a painter such as Freud, Uglow or

Coldstream would work, yet Hockney's picture was not done like that at all. Celia Birtwell and Ossie Clark posed frequently, but in Hockney's studio, this time in Powis Terrace. The whole matter was further complicated by the fact that the composition was *contre-jour* – against the light – so that the window had to be the brightest zone, and everything else keyed in to that. Consequently, although Hockney felt this was the closest he came to 'naturalism' – a word he preferred to realism – in certain ways the painting wasn't naturalistic at all, but a brilliantly realized intellectual recreation of appearances. Hockney doubted that 'you could ever actually stand in the room and take a photograph like that, see it like that'.

The evolution of Hockney's work in the ten years from 1960 had been astonishing and, from the point of view of Modernist theory, utterly retrograde. As we have seen, he had begun with Abstract Expressionism, then run through a range of idioms. First he had added a personal element in the form of words, then figures, objects and landscapes. The results were steadily more naturalistic.

In the spring of 1970 Hockney had had his first large retrospective exhibition at the Whitechapel Art Gallery. His work of the previous decade filled the entire building. The artist had helped, with Kasmin, to select the pictures for the show. In advance of the opening he felt trepidation, worrying that the earlier paintings, which he often hadn't seen since they were made, would look terrible and the whole affair would be an embarrassment. In fact, when he saw them, he was relieved, feeling that the majority held up well enough. What struck him most, however, was how 'protean' his work appeared.

In Frank Auerbach's view, Hockney belongs – like Bacon and Freud – to a British line of artistic mavericks, 'people who did exactly what they wanted to do, such as Hogarth, Blake, Spencer, Bomberg'. And, as Auerbach points out, what Hockney wants to do is continually changing: 'He has never donned a uniform, just as Bomberg refused to sign the Vorticist manifesto, early on, even though he was supposed to be a sort of Vorticist.' To this day, it is impossible to say what kind of painter Hockney is, except that he is his own sort. He has carried on breaking the rules and seeing what lies around the next corner for over half a century now.

CHAPTER SEVENTEEN

SHIMMERING AND DISSOLVING

It was a period of hope. When the Seventies came along, it was a bit more real.
The Sixties was more a dream: Kennedy, getting to the moon, all that stuff.

ANTHONY CARO, 2013

While Hockney was still at the Royal College of Art, on a showery evening in the autumn of 1961, Bridget Riley was hurrying home from her job at the J. Walter Thompson advertising agency in Berkeley Square when she took refuge from a rainstorm. The doorway on North Audley Street that she selected turned out to be the entrance of an art gallery, Gallery One. She peered in the window and the owner, Victor Musgrave, invited her to step inside and have a proper look round. Musgrave was a stalwart of bohemia. A poet as well as an art dealer, he preferred to dress in a corduroy suit with a pullover and no tie. He and his wife, Ida Kar, a passionately forceful woman of Russian-Armenian extraction and an outstanding photographer, had an open marriage (at one stage in the 1950s she shared one bedroom above the gallery with Musgrave's assistant Kasmin, while he occupied another). Gallery One had presented some of the most uncompromisingly avant-garde exhibitions in postwar London. But Musgrave's most important discovery would be Riley herself.

She gave him 'a very stiff review' of the work on his gallery walls; he, in return, wanted to know what made her so sure, asking her, 'What have you got in that bundle?' Riley was carrying some black-and-white gouaches

that couldn't have been more different from what she had to produce for J. Walter Thompson. Advertising was of great interest to other artists of the period – Richard Smith for one – but not to her. What Musgrave saw led him to offer her an exhibition the following spring, the first show she had ever had that was entirely devoted to her own work. She had just found her true path as an artist.

After six years as an art student, firstly at Goldsmiths' College then the Royal College of Art, Riley had left in 1955 with no sense of direction. 'I was at such a loss that I was quite desperate, that gave a real urgency to trying to find out what I could do, and how I could do it – whatever it was, about which I had no idea.' She described the next two years tersely as the 'continuation of a longer period of unhappiness'. She spent her time nursing her father after he was injured in a car accident, then suffered a serious breakdown, got a job as a shop assistant, and finally accepted the post at J. Walter Thompson. The question that tormented her constantly was what to paint:

> That is actually a very common state, one that happens to nearly all artists in the absence of a tradition. Because the tradition provided you with subject matter, and ways in which you could measure your degrees of competence – or not. It provided you with patrons. When none of that is there – which it isn't – it makes it even more important for you to find a way through.

Like many others she was galvanized by seeing the Jackson Pollock exhibition at the Whitechapel in 1958. It was clear, she concluded, 'that modern art was alive and I had something to react to'. The following summer Riley went on an art course in Suffolk led by Harry Thubron, a charismatic teacher at Leeds College of Art who based his teaching on the doctrine of the Bauhaus. His emphasis on the analytic study of colour and form proved to be just what she needed.

Riley studied the works of the Italian Futurist Giacomo Balla, who had found ways to represent movement through rhythmic lines flickering like multiple exposures on photographic film. She also set herself a task: to copy a small landscape by Georges Seurat, choosing his *Bridge at Courbevoie*

(1886–87), which analysed a quiet stretch of the river Seine into a tessellation of coloured dots. The object of Riley's exercise was to grasp the Pointillist master's thought process:

> Seurat is clear. You can follow what he thinks, and what he was
> thinking about was how to rationalize Impressionism. One cannot
> find a firm foundation in confused thinking. You need to know
> what you are trying to do if you are going to be at all serious
> and not waste your time.

Clarity – clear thinking, logical structure – obviously appealed deeply to her. Just as important to Riley's work as this careful analysis, however, was an emotional maelstrom. At the summer art course in Suffolk she met Maurice de Sausmarez, a colleague of Thubron's at Leeds. He was a mature artist sixteen years her senior, originally from Australia, whose own work consisted of landscapes and still lifes that splintered into geometric facets. De Sausmarez became both her artistic mentor and her lover.

In 1960, they went on a journey to Italy. She saw the work of Balla, Umberto Boccioni and other Futurists in Milan. In Pisa she experienced the tiger-striped medieval architecture of the Baptistery and the Duomo: Romanesque buildings throbbing with alternate bars of black and white stone. Another epiphany came in Piazza San Marco in Venice, when she watched the geometric pattern of the paving transformed by a sudden flurry of rain. She was fascinated by 'seeing something that was whole, temporarily shattered, then whole again'.

Outside Siena she painted the egg-shaped hills, just before a fierce storm erupted. The result, *Pink Landscape* (1960), is a buzzing mass of yellow, blue and pink dabs of paint like pixels or swarming insects. It was an attempt to capture the sensation of this gently undulating piece of countryside 'under intense heat, shimmering and dissolving, all the topographical structure simply fragmenting and disappearing'. Many would find the result beautiful; for Riley, however, it was a failure. This picture 'didn't vibrate, it didn't glitter, it didn't shine and it didn't dematerialize'.

The year ended with another kind of tempest. Riley and de Sausmarez split up in the autumn and she felt everything had ended: not just the

BRIDGET RILEY *Kiss*, 1961

romance, but her new take on twentieth-century art and how she might add to it. So she decided to paint one last picture, a mourning canvas, all in black. When she had finished she looked at it and a 'small voice' said that this didn't work. It didn't express anything; there was no contrast. So in the next picture she added an area of white, suggesting a meeting – or parting – of two forms, an upper one with a gently curved lower edge, like the contour of a body, and a lower rectangle. These are very, very nearly touching, but not quite. There is an immensely thin zone of white separating the two and the attenuation of that tiny space makes the whole picture

BRIDGET RILEY *Crest,* 1964

taut. Riley called it *Kiss* (1961). When she looked at it, the picture seemed to suggest further possibilities. So she said to herself, "'OK, just one more painting." I was off.'

Slowly Riley discovered that the best way to make a picture that shimmered and dissolved was to proceed the other way round; that is, not to paint a real sight as she had with *Pink Landscape*, but to start with forms and rhythms on canvas that vibrated with energy:

> Gradually I got the ingredients to completely reverse the order.
> I found that sometimes things *did* shine and sparkle and dematerialize although I hadn't set out to discover how to produce those effects.
> They came out of the dynamism of the visual forces that I was using.

Consequently, her works had a tremendous physiological and psychological charge. These were equivalents in abstract terms to the most powerful of visual sensations: not a placid rustic scene, but a landscape swirling in heat, just like the hills outside Siena before the thunderstorm broke.

*

Riley's exhibition at Gallery One opened in April 1962. The works were still entirely in black and white, but more complex than *Kiss*. In one painting, *Movement in Squares* (1961), a chequerboard of black-and-white squares becomes progressively thinner in one zone so that a vertical fissure seems to open up in the solid surface in front of you. It is beautiful and a little scary. When he 'came within range of Riley's violent black and white dazzle', the critic Andrew Forge felt as though he had been transformed into a television set (a TV screen was then, of course, made up of black-and-white lines); his 'whole visual field' began to 'jump and flicker'. Forge felt it was as if the artist had reached out and 'started to twiddle with knobs on one's box'.

Rather than a picture to look at, or into, this was work that *did* things to you. Stand in front of *Crest* (1964), for example, and the world begins to quiver. Something you normally expect to be static and stable – a panel covered with painted lines – undulates and pulses. In addition to black and white, the pigments Riley actually used, other colours – faintly luminous pinks, turquoises and greens – appear and disappear.

The artist was once told, to her intense irritation – 'as though it were some sort of compliment' – that 'it was the greatest kick' to smoke dope while looking at *Fall* (1963). People seeing Riley's work did not necessarily think about drugs, but many stood in front of a picture such as *Fall* or *Crest* and saw a vision of the future. Here was art, Jonathan Miller wrote, half-approvingly, in a review of Riley's work, clearly made 'by dint of ruthless mathematical calculation, whereby in pitting carefully calibrated patterns of stimuli against the rhythmic action of the observer's brain and retina a fantastic vibrato is established'. Miller – a qualified neurologist as well as a performer and author – assumed Riley's art to be derived from 'the striped, dotted or chequered cards used in experimental optics'.

Riley resented the notion that she was some sort of white-coated boffin, as much as she did the suggestion that her pictures were an ideal backdrop to getting high. In 1965, she made a public statement, expressing her surprise that anyone should think that her work represented 'a marriage of art and science'. In painting her pictures, she insisted, she had never 'made use of any scientific theory or any scientific data'. Nor had she studied optics, and her use of mathematics was 'rudimentary': merely a matter of halving, quartering, simple arithmetic. In other words she was not a scientist; she was an *artist*.

It was perfectly true that her works were built, element by element, in the way a technician might design a machine, as she herself acknowledged: 'I set out like an engineer to build from lines, from black and white – those being the most simple and strongest contrast – from lines, circles and triangles; and to find out what they could do.' But the poise and sense of inner structure in her pictures did not derive from science or technology; rather, it sprang from the most traditional of disciplines – life drawing.

At Goldsmiths' Riley had been taught by an artist named Sam Rabin, as noted before, who had asked her questions such as:

'What is the model doing?' You would think it was quite obvious, because you were both looking at her. He was hoping for an answer such as 'She's standing', or 'She's sitting'. Then he would say, 'And is your drawing standing?' He meant, was the balance and structure and weight articulated there?

In her student drawings that sense of equilibrium or otherwise, what she calls 'analysis of structure', are all visibly present. Those qualities are still there in her work of a decade and more later; it's just that the body is no longer present – the grin without the cat. Riley agrees with Ad Reinhardt, who said 'that abstraction could be practised only on the basis of life drawing'.

This was a time when excitement was in the air. Harold Wilson, the new leader of the Labour Party, spoke of the 'white heat' of the coming

BRIDGET RILEY *Nude*, 1952

scientific revolution: 'Since the war the world has been rushing forward at an unprecedented, an exhilarating speed. In two decades, the scientists have made more progress than in two thousand years.' In the early 1960s the future seemed to be arriving at an unprecedented rate. The signs were all around in the Russian and American space programmes, as well as more local phenomena such as the Post Office Tower in London – the construction of which began in 1961.

However traditional her artistic roots, Riley had come across a way of making pictures that was, almost accidentally, in tune with the Zeitgeist. Another glimpse of the future seemed to be found at the gallery that Kasmin opened at 118 Bond Street in April 1963. For Richard Morphet, whose advertising agency was just around the corner, stepping into it was like walking into the Space Age. You entered via an ordinary door, from what was then quite a normal shopping street, leading into a narrow corridor – 'a slightly claustrophobic introduction'. Then, suddenly, space expanded in a Tardis-like fashion: 'it all opened up, and it was very bright and white'.

Kasmin's was an outlandish space in comparison with most interiors in 1960s Britain. Visitors were fascinated as much by the room as the art shown in it. Indeed, Kasmin was slightly irritated that so many seemed to come in to examine the ribbed rubber floor. On this were placed two elegantly minimalist chairs by Mies van der Rohe – and that was it for furniture and fittings, except for the art. The first exhibition was of pictures by the American colour field artist Kenneth Noland, resembling gigantic targets or Catherine wheels of colour. This was the most audacious kind of colour field painting – utterly flat and yet dynamic. However, Kasmin wrote to the American critic Clement Greenberg, although 'the world of painters' was 'very excited and keen' on seeing Noland's work, it was slightly disappointing that 'the general public mostly discussed the beauty of the gallery and its lighting'.

*

In 1960s London previously solid boundaries were becoming porous and dissolving. Other distinctions that were starting to become blurred were those between painting, architecture and sculpture. John Hoyland was the

JOHN HOYLAND 7.11.66, 1966

youngest painter to exhibit in the 'Situation' exhibition. His paintings from
the mid-1960s were made up of squares and lozenges of soft red, orange and
green. There was a connection with the Abstract Expressionism of Mark
Rothko, but Hoyland's pictures do not have the looming, spiritual quality
that Rothko managed to impart to his oblong patches of colour. They do
have an imposing grandeur, but in a more architectural way than Rothko's.
Hoyland's paintings from 1966, a particularly productive year for him, though
clearly 'abstract', read like simple structures in space. They demonstrate the
truth of an observation by the Dutch artist M. C. Escher, that it is hard
to put down a few rectangles and not have someone say, 'This looks like a
house'. A picture such as *7.11.66* (1966) looks like an interior with walls and
a partition: a virtual room.

In these years too, drawing on his experience as a landscape and abstract
painter, Victor Pasmore was redesigning whole sections of Peterlee, a New
Town in County Durham. Its culminating feature was the Apollo Pavilion,
completed in 1969 – part building, part abstract sculpture (and of great use,

ANTHONY CARO *Early One Morning,* 1962

as it turned out, as a place for local teenagers to try out their skills as graffiti artists). Meanwhile, Richard Smith began to work on canvases shaped in such a way that they did not merely resemble, say, cigarette packets, but had oblong forms sticking out of the flat canvas just like the end of a giant fag carton. Smith wanted his paintings to 'enter the real world, come out into the spectator's space'.

In the case of the sculptor Anthony Caro, the opposite occurred. His sculptures took on many of the qualities of painting, such as bright colour. They looked, in fact, very much like geometric abstractions of the kind that might be painted by Smith or Robyn Denny; except the shapes in them had 'flown out of the frame' – just as Roger Hilton had advocated – and joined the viewers in the gallery. Caro had begun as a relatively conventional sculptor, fashioning human forms, a 'pretend person' from clay, plaster or bronze, as he later put it. For a while he had been Henry Moore's assistant. Then, in 1959, Clement Greenberg visited his studio and – in an extremely rare

example of a writer having a powerful effect on a visual artist – changed his art and his life. The two men were to become friends, as Caro recalled:

> I went to America soon after that, and saw a lot of abstract painting
> and talked to Clement Greenberg. He said, 'If you want to change
> your art change your habits.' When I came back to England, I went
> to the scrapyard in Canning Town and bought steel. I didn't know
> anything about steel.

Caro's welded-metal work became light, lyrical, completely abstract and – unlike the mainstream of sculpture since the Renaissance – painted in joyful reds, greens and yellows. To start with it looked like a Noland painting translated into three dimensions; but gradually it grew, in a description Caro accepted, more and more 'Matisse-y'. The colour and the lyricism were characteristic not just of Caro but also of a group of sculptors associated with him at St Martin's School of Art – Tim Scott, Phillip King, David Annesley and Michael Bolus among them. The colours they used were much the same as the ones increasingly worn by young people walking around London. But this, Caro felt, was not a case of art imitating life, rather of everything blending together:

> People say that the colours we used were Carnaby Street colours, and
> so on. I don't think so; that was the hopeful, optimistic attitude that
> was around and Carnaby Street partook of it and we did too. I think
> it was a very forward-looking time.

*

In mid-1960s London, fashion was increasingly echoing art and vice versa. After Allen Jones and his wife returned from New York in 1965, they settled near the area of Chelsea between the King's Road and the river Thames known as the World's End – the neighbourhood where, a decade before, Mary Quant had opened her first shop Bazaar on the King's Road, in partnership with her husband, Alexander Plunket Greene. This was the first of a wave of new fashion shops that were quickly spreading from Chelsea to Carnaby Street in the west of Soho. Quant was sometimes credited with coming up with

one of the emblematic garments of the decade: the mini-skirt. But Quant herself felt the garment was, effectively, crowd-sourced. She was making 'easy, youthful, simple clothes' in which young women could run and dance. When she made them short, the customers would say, 'shorter, shorter'.

By the time Allen Jones moved there, World's End was home to other boutiques, including one with a splendidly period name, Granny Takes a Trip. In a way, what was going on struck Jones as similar to the art world, in which everybody was looking to see what the new trend was, where the benchmark had now been placed. At the weekend the Joneses would put their twins in the pushchair and perambulate down the King's Road:

> Every Saturday was just a revelation of the move of fashion at that
> time, and the way the body was uncovered. There was an unspoken
> dialogue going on there. You went out and skirts were shorter, the
> body was being displayed in some new way. And you knew that the
> following week somebody would up the ante.

Jones himself began to do just this, breaking some art world taboos along the way. In New York he had been irked by the implicit regulations that the critic Max Kozloff had listed – that paintings must be flat, and so forth. Back in London, he decided to paint a picture 'that violated as many of these rules as possible'.

One of these was *First Step* (1966); Jones has said that in such pictures he was trying to create 'something very tactile and grab-able'. If the modelling was extreme enough and the contours hard enough, he felt, the picture plane itself would not disappear. This was still obviously a flat canvas; it was the forms that were coming out of it. Jones added a little shelf at the bottom of the picture just to point out that this, and the other paintings in the series, actually were on flat canvases.

In art world terms, the way that *First Step* edged out into the real world was mischievous. Of course, in the eyes of most of the inhabitants of that real world, the depiction of female legs in stockings or clinging, skin-tight rubber (as in *Wet Seal*, 1966) was more striking than theories about flatness versus the illusion of depth. The source for the image was a mail-order catalogue sent out by a lingerie firm, Frederick's of Hollywood

ALLEN JONES *First Step*, 1966

(the inventors of the push-up bra). For some time Jones's work had been increasingly concerned with gender and eroticism. In *Man Woman* (1963) the two figures seem to merge, or rather their clothes do, trousers, stockings, tie and high-heeled shoes all apparently adorning one multi-limbed, headless creature (much what conservative souls complained was happening to fashion in the 1960s, that you couldn't tell the difference any more between young men and women).

In other words, paintings such as *First Step* and its companion *Wet Seal* were a specialized kind of Pop art. But Jones's preoccupation with lingerie

Advertisement for Frederick's of Hollywood, c. 1960s

catalogues and fetishist magazines – a variety of imagery suggested by David Hockney – was eventually to get him into trouble, not only with old-fashioned puritans but also with a reinvigorated feminist movement. This did not happen, however, until his work crossed over the line from flat painting to three-dimensional sculpture. In 1969, he produced three works, which remain his most celebrated, but also his most notorious, divisive and controversial. *Hat-Stand*, *Chair* and *Table* represent women, fabricated in the manner of shop-window mannequins and clad in fetishist leatherwear (made by the firm that produced Diana Rigg's costumes for *The Avengers*), who have been turned into figurative items of furniture.

These provoked outrage: one had paint stripper poured over it. Jones insists that he was 'reflecting on and commenting on exactly the same situation that was the source of the feminist movement'. His misfortune, he feels, was to produce 'the perfect image of how women were being objectified'. Whatever view one takes, it is hard to believe that paintings of the same subjects would have caused such an uproar. Sculpture occupies the real world, and that gives it greater visceral impact.

*

While Jones was borrowing imagery from commerce and a – rather specialized – kind of fashion, clothes designers were doing the same thing in reverse: lifting avant-garde art and turning it into wearable and purchasable merchandise.

At the opening of 'The Responsive Eye' at the Museum of Modern Art, New York, in February 1965, Bridget Riley had an unpleasant surprise. This was a global survey of a brand new movement, Op art – so fresh, indeed, that it had only been named the previous October. It was a snappier way of discussing an exhibition at the Martha Jackson Gallery entitled 'Optical Paintings'. The implications of the new tag were spelled out by an art critic, Lil Picard: 'The new mathematical art equation reads POP – P = Op. That means drop the letter P and Op we go.' Of course, as is often the way with such trumpeted developments, Op art was a bit of an illusion. Many of the ninety-nine painters and sculptors involved in 'The Responsive Eye' had no interest in optics. Riley certainly didn't think that was what she was doing at all. 'I never set out to paint optical paintings, even though there was no such term as that.' As a look, however, it was the height of fashion. About half the people at the private view, Riley estimated, were wearing clothes based on her work. Photographs confirm that the dresses of many of the women present were indeed strongly reminiscent of Riley's paintings. From her point of view, those guests were 'completely covered in "me"' and she tried to avoid talking to them.

Some, it is true, were clad in designs derived from other artists' work. *Time* magazine, breathlessly covering the opening, reported that Gisela Oster, then wife of the painter and scientist Gerald Oster, 'gave her

husband some dazzling competition with a turquoise and white striped dress', but that the sculptor Marilynn Karp 'outstriped' her with an outfit in which the vertical black-and-white stripes on her dress continued down through her stockings and shoes. Another painter, Jane Wilson, was 'delightfully dizzy' in orange organdie with discs of grey and black. 'Op outfitted ladies showed a tendency to linger near the pictures that best harmonized with their clothes,' the author noted. Pat Coffin, a painter and modern-living editor of *Look* magazine, 'wrapped herself in a giant silk stole of peristaltic black dots on a white field' that *Time* claimed was designed by Bridget Riley (though this influence had been neither voluntary nor conscious).

What Riley hadn't appreciated, as she sat on the plane to New York, was that Op art in general and her work in particular had done something that artists in the past had often dreamed of accomplishing: it had jumped the fence around 'fine art' and got out into the world. But it should not happen, Riley strongly felt, in the manner she experienced in New York, where she was greeted 'by an explosion of commercialization, bandwagoning and hysterical sensationalism'. People in New York, and soon in London, were covered in designs derived from her individual idiom. Riley's work – or at least a pastiche of it – was all over their hats, their bags, their wallpaper, their furniture. Even, according to the British journalist Christopher Booker, their make-up. In crudely journalistic terms, Riley was a very hot artist. Her exhibition at Richard L. Feigen in New York, which ran at the same time as the MoMA exhibition, was sold out before it opened, with many works being bought unseen by collectors determined to have a Riley on their walls. But the vogue for her work went far beyond that; indeed, it was strong on both sides of the Atlantic.

On 13 March 1965, Hella Pick reported in the *Guardian* that a dress designer who had previously bought one of Riley's pictures attempted 'with a fanfare to present her with a dress copied from the painting'. Riley stalked off without the garment. According to the American critic John Canaday, the artist's gallery was bombarded with unwelcome offers from manufacturers of various products. 'The most ironic proposition to date,' he noted, 'has come from the manufacturer of a headache remedy.'

Fashion illustration by Antonio Lopez, New York Times Magazine, *c. 1966*

At MoMA, Riley was not only surrounded on all sides by tacky rip-offs and misunderstandings of her own works. She also had to suffer the added mortification of an encounter with a member of the museum's board who, observing her displeasure, reacted like a villain in a Bond film. 'So, you don't like it?' she remembered him snarling. 'We'll have you on the back of every matchbox in Japan!' Riley returned home with feelings of 'violation and disillusionment'. Her outrage was so widely publicized that when a bill to give artists copyright in their work was introduced in the US Congress it was known as 'Bridget's Bill'.

<p style="text-align:center">*</p>

Riley's art did not try to depict the world; it seemed to change it. And the extraordinary space-warping, mind-bending ways in which it did so made her pictures a natural source for science fiction. In an American television series called *The Time Tunnel*, for example, time travel was effected by

Bridget Riley, 1963. Photo by Ida Kar

entering what looks very much like an extrapolation from Bridget Riley's work *Continuum* (1963). This was a walk-in environmental painting, curving around itself to form a circular zone with a single narrow entrance. Once in the centre, the viewer was surrounded on all sides by darting and zinging lines. Ida Kar took a remarkable series of photographs of the artist inside her own creation: peering out, lying on the floor in the central space. *Continuum* was obviously a case of dissolving boundaries, of painting turning into something else, though whether sculpture, architecture or some undefined new category it is hard to say. The original work was destroyed, but *Continuum* was recreated in 2005.

<p style="text-align: center;">*</p>

Between 1964 and 1966 another, very different artist was at work on a painted labyrinth. *Mirror* (1966) depicts the artist himself – Frank Bowling – in the middle of a vortex of artistic styles: all the different ways of working in mid-1960s London at once. This picture is, like Gustave Courbet's *The*

Robert Colbert, Lee Meriwether and James Darren,
The Time Tunnel, *TV series, 1966–67*

FRANK BOWLING *Mirror*, 1966

Artist's Studio (1854–55), 'a real-life allegory', somehow incorporating more contradictory idioms than any painting of normal dimensions should, and gathering together all the stylistic possibilities that confronted a young painter at that point.

It was, Bowling says, looking back, 'a confusing time'. Though he gave this painting, which seems to describe all his choices and predicaments, both personal and aesthetic, the title *Mirror*, there is no looking glass among the objects on view. Presumably the whole picture is an image of the artist and his predicament. In the mid-1960s there was a clashing cacophony of styles and movements from which an artist could – in theory – choose. None of these was obviously the path into the future. Op art was, as it turned out, one of the last revolutionary styles to which a label could be given (and even this definition, as we have seen, was misleading). From now on, as Bridget Riley put it, what was needed was for each painter to till his or her own garden. But first it was necessary to choose which garden to till.

The floor of the lower space in *Mirror* is an exercise in the manner of the Hungarian-French painter Victor Vasarely, one of the forefathers of Op art. The lower room itself appears to be a kitchen but one constructed – as were the interiors of Howard Hodgkin – partly from borrowed fragments of abstract painting. The doors of the cupboards, for example, could have been sawn out of a hard-edge picture by Kenneth Noland hanging on the walls of the Kasmin Gallery. The empyrean upper zone, in contrast, is painted in a freer, looser manner as if executed by Patrick Heron or Mark Rothko. The ectoplasmic self-portrait descending the stairs has a strong flavour of Francis Bacon (all three figures in the painting were based on photographs taken *in situ* but then transformed and distorted). Finally, the domestic fittings – the tap, the sink, the Charles Eames chair – are much as they might be depicted by a Pop artist such as Richard Hamilton or Peter Blake.

The extraordinary thing about *Mirror* is that it doesn't collapse under the centripetal force of all the dissimilar ingredients it contains. This is because at the heart of the structure is an underlying matrix of geometry. Bowling was a keen student of a treatise by Jay Hambidge entitled *The Elements of Dynamic Symmetry*, published in 1926. From this he extracted the twirling structure that energizes and supports the whole of his picture.

In the centre is a spiral staircase, a real one that led from the Royal College of Art student studios upwards to the Victoria and Albert Museum. These stairs at the RCA had long been lodged in Bowling's imagination: they seemed, he felt, 'to symbolize something profound' in his career. In the painting, however, the stairs do not appear in their mundane reality, but transfigured: a winding, golden pathway, apparently in the process of dematerialization like the fittings of some spaceship. A few steps up from the bottom of the staircase is Bowling himself, also in semi-disembodied form. Above, stands his wife, Paddy Kitchen. The marriage was disintegrating while the picture was being painted and they finally divorced in 1966, just as it was being finished. At the top, swinging out into space, suspended by his arms, is the artist himself again.

After he completed the painting, Bowling felt stymied. His marriage was over; he felt in danger of being shunted onto a branch off the mainline of artists and labelled a 'black artist'. His work was not included in 'The New Generation: 1964', a large survey exhibition at the Whitechapel Art Gallery that included almost every notable young painter in London. Instead, two years later, in 1966, he was designated to represent Britain at the First World Festival of Negro Arts in Dakar, Senegal. Bowling found this 'aggressive and personally insulting'. He insisted, 'I'm not a black artist, I'm an artist. The tradition I imbibe and the cultural ramifications are British.' And so, in 1966, like many of his British contemporaries – Hockney, Jones and Smith among them – he moved to the United States. He settled in New York and became an abstract painter. It was not until the mid-1970s that he returned to work in London again.

CHAPTER EIGHTEEN

THE NON-EXISTENCE
OF ACTON

England gave me the freedom to be more myself, I suppose. Portugal was more restrictive. They didn't want you to be a modern artist there; here I don't care whether I am or not. I wouldn't have done these things if I'd stayed in Portugal, not on your life.

PAULA REGO, 2005

A lthough there was no such classification at the time, in retrospect, the maverick moderns were one of the most important groups of painters in London in the 1960s. That is, those who borrowed the vocabulary of abstraction but misused it to depict all manner of forbidden things: dreams, stories, feelings, remembered incidents, irony and political anger. Among these were Kitaj, Patrick Caulfield and Howard Hodgkin.

Every picture may depict a drama or relate a narrative, but in the opinion of Howard Hodgkin it is not a tale the viewer ever needs to comprehend. 'The picture', he once explained to the critic Robert Hughes, 'is *instead* of what happened. We don't need to know the story: generally the story's trivial anyway. The more people want to know the story the less they'll want to look at the picture.' The point is for us to respond to the painting in front of us, with the title as a (possibly allusive or elusive) guide.

'What is important,' Hodgkin insisted, 'is that what I feel, think and see turns into something. I mean, ideally, it starts off in my head, and ends up a *thing*.' His painting *Small Japanese Screen* (or *The Japanese Screen*) from 1962–63 is a case in point. Its origins lay in a specific event: an evening when the artist, his wife and some other friends went to dinner with the

313

HOWARD HODGKIN *Small Japanese Screen*, 1962–63

art dealer and – later – writer Bruce Chatwin. At the time Chatwin lived in a flat 'behind Hyde Park Corner'. He had been away on a journey in the Sudanese desert and the sitting room with its 'monochromatic desert-like atmosphere' contained only two works of art, one being an early seventeenth-century Japanese screen.

Years later Chatwin wrote an account of the painting and its origins. He remembered the painter collecting his impressions: 'Howard shambling round the room, fixing it with the stare I knew so well'. In the final painting, Chatwin felt, the screen was easily identifiable but the other guests had become 'a pair of gun-turrets' (he meant the eyes, disembodied like those of some visitor from outer space in a science-fiction film). Chatwin recognized himself as 'an acid green smear turning away in disgust, away from my guests, away from my possessions ... possibly back to the Sahara'.

Hodgkin, talking many years later still, pointed out that biliously green though it might be, 'oddly enough it was a very good likeness of Bruce in that period'. His sense of the emotional undertones encoded in the painting, though, was quite different. These began with his feelings for his host:

> I loved Bruce. But he was completely uninterested in my work, totally. In fact, as far as I know, he was totally uninterested in the work of any living artist. I can't think of one. His taste and knowledge stopped at Gauguin perhaps.

The sourness, greenness and turning away – Hodgkin speculated – were to do with Chatwin's unintentionally but hurtfully slighting attitude towards Hodgkin's painting. 'He had written some not deliberately unfriendly, but nonetheless patronizing remarks about my work. And that, I think, probably produced some of the sourness that was in that picture – my sourness.'

Two of the main participants in the creation of this picture – the subject and the artist – thus had rather different understandings of the emotional situation that was its hidden subject. Does it matter? Is it even possible to know? After all, as David Hockney has observed, it is hard indeed to be sure what is going on in a picture, even if you are the one who painted it. This is as true of the art of long ago as it is a picture such as *Small Japanese Screen*. A ceiling by Tiepolo – an artist Hodgkin much admired – is not

entirely about the apotheosis of some unremarkable Venetian aristocrat: it is also about the way the apricot light strikes the side of a cloud, or a Turk in a turban peeps out from behind the entablature.

Hodgkin felt he came from an anti-visual culture and railed against the 'tyranny of words' that he felt reigned in his native land. He informed an audience at the Slade in 1981: 'To be an artist in Britain is perhaps, even certainly, special, more traumatic and probably more fraught with the absolute certainty of failure than in any other country.'

<p style="text-align:center">*</p>

Hodgkin was a sensitive, indeed hypersensitive, man easily moved to tears in ordinary conversation, sometimes by subjects that would barely register on most people's emotional scales. Once he began to describe a still life by Jean-Baptiste-Camille Corot, previously owned by his cousin. 'It was just a vase with fresh flowers in it. *Marvellous* painting. It was one of only two still lifes Corot ever painted, now it's disappeared.' And as he spoke his eyes filled up, at the thought of that Corot: its simplicity, its directness – and its subsequent vanishing. Here is a clue to the meanings of his pictures. They are about intensely felt, small things: the mood in a room, a party, an erotic memory.

> I go to a place and accumulate things I've encountered – juicy human situations, that kind of thing. Then I come back and turn them into pictures, but it's not as quick a process as painting watercolours on the spot would be.

Indeed, the gestation of a Hodgkin was often a matter of years, during which time most days were spent not painting but 'working out' the picture in his head. The transmutations that the initial sights and feelings underwent could be positively alchemical. Bruce Chatwin's metamorphosis into an 'acid green smear' was at the most straightforwardly figurative end of Hodgkin's pictorial spectrum. In *Mr and Mrs E.J.P.* (1969–73) the collector Edward 'Ted' Power – the man who introduced himself to Allen Jones with the words 'Power's the name' – was transformed into an enormous, green translucent egg. This stands – according to the curator Paul Moorhouse – for his 'enveloping conversation'.

HOWARD HODGKIN *R.B.K.*, 1969–70

It was no doubt Hodgkin's sea-anemone-like responsiveness to atmospheres and undercurrents that made him feel lonely and embattled. He told Richard Morphet that the 1950s had been for him 'a decade of painful revolution'. However, by the evidence of his own paintings, in the 1960s Hodgkin was absolutely in the centre of the London art world.

His paintings of that decade and the next constitute a sort of gazetteer of artistic London and its inhabitants. Mind you, the cast of characters – and the locations – do not overlap with those of Bacon's Soho. He did not depict Wheeler's or the Colony Room, nor the roster of artists who assembled there. But the list of Hodgkin's pictures of this period would include the names of most of the prominent abstract and Pop artists in the city and many of the other inhabitants of the art world – critics, dealers, collectors, curators – who feature in these pages. In a sort of semi-private code, the subjects are often referred to only by initials – or, perhaps, addresses. Thus

Widcombe Crescent (1966) was the name he gave to his second picture of Robyn and Anna Denny, painted in Bath; Durand Gardens – which features in the title of two paintings from the early 1970s – signalled the Stockwell address of Richard and Sally Morphet.

Hodgkin's pictures were filled with private messages and, sometimes, visual jokes. When he painted *The Tilsons* (1965–67), for example, he seemed to hint at the vigorous idiom reminiscent of the children's toy blocks that the artist Joe Tilson used for his wooden reliefs. His use of street names as titles was also an indication that this was a most unusual, not to say, quixotic type of portraiture: as much a picture of an interior as of the people in it, as much of the social situation as of the interior. More specifically, his pictures are a record of Hodgkin's memory of how he felt at the time – and all of this transformed by a process he could never quite explain into a personal language of circles, rectangles, dots and stripes.

His portrait of the American painter R. B. Kitaj, *R.B.K.* (1969–70) was executed not on a canvas but on a wooden panel with a painted border, like a frame. This was the first indication of a new development in Hodgkin's pictures, which invariably came to be painted on wood, very often with the frame incorporated into the image. He explained: 'The more evanescent the emotion I want to convey, the thicker the panel, the heavier the framing.' In *R.B.K.* the subject is barely visible, seated in an interior but screened – or imprisoned – by thick green diagonal bars. It is as though Kitaj were sheltering or masked behind a barrier of abstract art.

<div align="center">*</div>

R. B. Kitaj, like Hodgkin, was a highly sensitive individual. He too felt that he was isolated and a loner, noting years later 'without hesitation' that he did not fit in England and never would 'in any comfortable way'. He was an elective outsider, despite his time spent studying at the Ruskin School of Drawing in Oxford. His feelings about the word-orientated culture of Britain, however, were the exact opposite of Hodgkin's. The latter sensed a general indifference and neglect towards those, like himself, who worked in a non-verbal medium. Kitaj, conversely, felt marginalized because he wanted to connect his art with literature and give verbal commentaries on

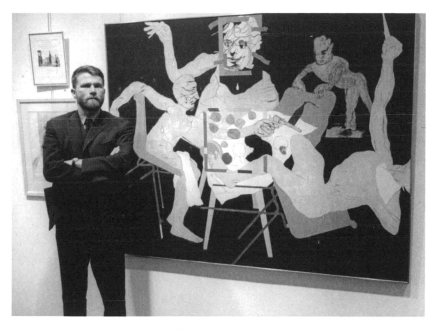

R. B. Kitaj in the Marlborough-Gerson Gallery, New York, 1965

it. Some of his early works, such as *The Murder of Rosa Luxemburg* (1960), done when he was at the Royal College of Art, actually had texts stuck to their surfaces. In this particular case, the ostensible theme is the execution of the left-wing Jewish thinker and revolutionary in Berlin in 1919. However, this is not a narrative painting of a historical event. Kitaj added layer after layer of association to the image – for example, he identified Luxemburg with his own Jewish grandmother Helene, forced to flee Vienna – though no one would be likely to guess any of these connections without the clues provided by the artist's notes and his choice of title.

For Kitaj, as for Hodgkin, titles were all-important. Even so, they don't necessarily help much. *The Ohio Gang* (1964) is not about the cronies of President Warren Harding (the usual meaning of the phrase), but Kitaj's own disparate 'cast of characters', including two friends, an actor and a poet. The naked woman pledges herself to one of them with the yellow ribbon, as in the film by John Ford; the maid is borrowed from Manet's *Olympia*, and she's pushing a pram because the artist had just bought one for his second

R. B. KITAJ *The Ohio Gang*, 1964

child. The painter admitted this picture didn't make much rational sense, but nonetheless it's one of his strongest.

Kitaj's first exhibition, at Marlborough Fine Art in 1963, was entitled 'Pictures with Commentary, Pictures without Commentary'. As a preface he quoted the Roman poet Horace's famous dictum, *ut pictura poesis* – 'as it is in painting, so it is in poetry'. In an interview two years later he developed this idea, stating, 'For me, books are what trees are for the landscape painter'.

This then was Kitaj's rebellion. When he was a child, he explained, he had thought that if T. S. Eliot could append notes to *The Waste Land*, then he could provide notes to his pictures 'and drive dogmatic formalists nuts

R. B. KITAJ *Synchromy with F.B. — General of Hot Desire*, 1968–69

into the bargain'. This was a revolt against the consensus formed in the 1950s and 1960s that a painting should be purely visual and that the more it told a story, the weaker it was. In this way Kitaj successfully annoyed everybody. He imagined them complaining, 'Here's Kitaj, the literary artist, doing it again! He doesn't even know yet that a picture is supposed to speak for itself.' He went on:

> And it won't just be abstractionists speaking. Francis Bacon talked like that. All through those conversations with Sylvester – it is the most boring thing, Bacon was always on about illustration, and how a picture doesn't need any literary meaning.

Yet, in other ways, Kitaj was unexpectedly close to Bacon. Kitaj tends to be grouped with Hockney and his contemporaries at the Royal College, but it was Bacon who had the greatest impact on him, having got under his skin when he was still living in New York, long before he came to Britain. Even then, Kitaj decided that Bacon and Balthus – the French-Polish painter – were his favourite postwar artists. He remembered how 'Harry Fischer [of Marlborough Fine Art] introduced Bacon to me over lunch at the Reform Club around 1962. We lived in the same district for his last twenty-five years and gossiped in the supermarket and streets.' Here is another demonstration of what a small social world the painters of London inhabited. Bacon might seem to belong with those who frequented the Colony Room and Wheeler's, but he was talking to all manner of artists of diverse generations including Kitaj, Hockney and Frank Bowling.

Kitaj remained a fervent admirer of Bacon, both as a man and a painter, and featured him in a number of pictures, most strikingly a diptych called *Synchromy with F.B. – General of Hot Desire* (1968–69). Of Bacon himself he said:

> I believe he sought to stun his audience. He was a stunning creature, a kind of mutant, not a human type I'd ever encountered – Gide's Immoralist arisen in painting. Like the Immoralist, his mode was the gratuitous act, only this time on those relentless canvases, strong stuff for friend and foe.

Kitaj and Bacon took opposing lines – the former adding a mass of commentary to his works, the latter adamantly refusing to provide any. Much though he revered the older painter, Kitaj did not – surely rightly – consider Bacon a great artist in quite the same category as Picasso, Matisse or Cézanne. Furthermore, Kitaj contended that Bacon's very refusal to put the meaning of his works into words was, well, a bit old-fashioned:

> He was talking like Roger Fry and Clem Greenberg, and he would have been astonished if you had said that to him, because he was the great immoralist, you know. He was such an iconoclast. But there is this feeling, even among the painters that I love most, that you don't

talk about it – I use the analogy of a Western like *Shane*. You don't know who the heroes are. You don't know where they come from. They ride into town. They do their art, and they don't talk about it. Then they ride away, and you don't know where they're going. That's what art is supposed to be. Cool.

In the 1980s, Kitaj developed the habit of exhibiting his pictures with 'prefaces' – explanatory notes, sometimes placed next to the work on the gallery wall. But these pieces of prose weren't necessarily enlightening. Kitaj added copious references to poetry, historical events and autobiographical incidents, but the pictures themselves tended to remain enigmatically mysterious.

This is the case with the Bacon diptych – why is F.B. wearing that homburg hat and utterly uncharacteristic costume? And why is he juxtaposed with a brutally explicit female nude? Kitaj and Bacon were both painters who depicted sexuality – *Hot Desire* – and squalor. But this sort of body, clearly, was not the variety Bacon himself desired. Another link between the two painters is that they both had roots in Surrealism. At a deeper level, however, they didn't want or expect their pictures to make sense. 'I don't mean to explain the mystery away, or to say what everything in the picture means', Kitaj confessed, 'I can't.' The paradox is that Bacon's paintings – which he firmly insisted had no narrative – are often rather easier to decode than Kitaj's. The more the latter added glosses and notes to his works, the more mystifying they became.

*

Another way of defining this individualistic group of maverick Modernists might be to say that they were all in some sense Romantics. Kitaj admitted as much: 'Romance provides some of my happiest moments: sexual romance, the romance of picture making, the romance of books, the romance of big city streets and political historical romance.' It was the last that preoccupied Paula Rego, an artist with a multiple cultural identity. After growing up in Lisbon, she attended the Slade, then returned to Portugal with Victor Willing, an older fellow student, whom she married. Though she and Willing kept a pied-à-terre in Camden from the late 1950s, much of her work of the

PAULA REGO *Stray Dogs (The Dogs of Barcelona),* 1965

1960s was done in Portugal and concerned with Iberian themes (it was not until the 1970s that the couple settled permanently in London).

One of Rego's most striking pictures from this time, *Stray Dogs (The Dogs of Barcelona)* (1965), was sparked by a report that the authorities in Barcelona had decided to reduce the number of stray dogs in the city by feeding them poisoned meat. The casual cruelty of this struck Rego as emblematic of the behaviour of the Franco and Salazar dictatorships. But there is far more in the picture, a mixture of collage and painting, revealing the artist's personal anxieties and feelings. Rego was suffering panic attacks at the time she was at work on it. 'Fear is something you have all the time', she has said. 'Not of other people. I like other people because they make me feel less fearful. But just this, you wake up in the morning and you feel this horrible sinking feeling inside you.' Fear is an underestimated ingredient in art. It is crucial, for example, in the work of Goya, whom Rego greatly admires.

In contrast, as the critic Christopher Finch once observed, Patrick Caulfield was a romantic 'disarmed by his own irony'. If Kitaj rebelled against one art world taboo – the one that forbade paintings to be literary – Caulfield disobeyed another that outlawed anything 'decorative'. In 1999, he described his intentions when he was setting out as a young painter:

> I thought I'd like to do something decorative, which was a bit of a dirty word in fine art. It wasn't considered correct. Decoration was something you left to interior decorators. I didn't want misty, tortuous, tentative Englishness. I just wanted it to be very clear cut, straightforward – and decorative.

Caulfield's art was based on a taste for the half-forgotten and outmoded. He wasn't interested in painting his immediate surroundings since to do this, he felt, 'would be extremely boring'.

> I used to look at slightly historical things, like a decorative art book from 1932, or 'continental' interiors from 1961. They were distanced from me, slightly out of my time, or maybe in my time but from when I was young. I suppose you could be more objective if you didn't feel that you were painting what was around you.

French recipe card used as source for Santa Margherita Ligure

But neither was Caulfield, as he pointed out early on, a Pop artist. This was true in that his sources were not advertising, films or comic strips. Caulfield claimed that his clear bold line was inspired not by cartoons but by looking at the heavily restored ancient Cretan mural at Knossos on his first foreign holiday.

Holidays were a theme that underlay Caulfield's work, but not in any straightforward fashion; he didn't, for example, paint the places he visited. Instead he depicted the idea – the dream – of a continental holiday as he, and increasing numbers of British people in the 1960s, experienced it. 'The subjects are imaginary,' he wrote in 1970, 'so that they are particular yet stereotyped images.' And the dream in question was of southern Europe; America never much interested Caulfield.

Santa Margherita Ligure (1964) was based not on a visit to Liguria in northern Italy, but on a French recipe postcard, with the characteristically vivid but unreal hues of early colour reproduction. A sailing boat has been inserted at exactly the right point to punctuate the composition. And Caulfield did not imitate the photographic look of the postcard, but instead stretched the sea into an expansive field of ultramarine, with the distant harbour reduced to a few stray lines. The rest of the scene has been translated into the artist's individual language of firm lines and Mondrian-like

PATRICK CAULFIELD *Santa Margherita Ligure,* 1964

chromatic simplicity: just red, white, yellow, blue and black. The proportions have been altered and refined, and the image made more ambiguous. In the postcard the bouquet of roses is clearly placed in the setting: it's on a table, and the table is on a balcony overlooking the bay. Caulfield introduces doubts about that. The flowers, vase and table appear to be outside the framed sea view, and the latter is oddly tilted as if painted on a window – or is it another picture, a poster perhaps, leaning out from the wall?

The answer is that this is a dispatch from Caulfield-land. By his own account, Caulfield came from 'nowhere'. This was his way of describing his native Acton, in West London; 'It isn't awful, it just doesn't exist.' To be precise, he explained, he hailed from a part of South Acton known colloquially as 'Bagwash City' because of the 'damp rather attractive smell' of soap and water, mixed with drying and ironing smells. His mother worked there in a laundry. 'Nowhere' is a good place for dreaming, and the sixteen-year-old Caulfield dreamt of being an artist, having seen *Moulin Rouge* – John Huston's 1952 film about Henri de Toulouse-Lautrec – in an Acton cinema.

When he left school aged fifteen, Caulfield was faced with a succession of 'ghastly jobs', such as drilling holes in gas rings in the Park Royal Industrial Estate area of north-west London. He also worked in the design department of the food production company Crosse & Blackwell, 'mainly washing

brushes and varnishing chocolates for display' (the latter, an exercise in creating an elaborately lustrous still life, turned out to be a good preparation for Caulfield's later career as a painter).

Caulfield emerged a fledgling painter and a unique kind of dandy. 'No matter how apparently casually he is dressed, he is also immaculate,' his dealer, Leslie Waddington, once said. 'He is the sort of man whose jeans have to be ironed.' This was the legacy, perhaps, of those early years spent in the atmosphere of the laundry; on the other hand, he expressed his horror of questioning and interviews – like all dandies, he liked to be detached – by complaining that the process made him feel as if his soul were being dry-cleaned. He had one thing in common with Lucian Freud: what Frank Auerbach described as 'a very strong sense of the self-preservation of his talent'. Caulfield explained it thus:

> I never let anybody see my work in progress. If somebody sees it and they make a comment, I lose it. If they say it's terrible, I lose it; if they say it's marvellous, I lose it; or, if they say you ought to have more blue – it doesn't matter. You've got to concentrate on the feeling you have. I think it was Cézanne who said that you have to retain your own sensation. That's very important. It's difficult to do that.

As a painter Caulfield abundantly bore out the truth of Lucian Freud's dictum that 'anyone marvellous is full of jokes'. In a painting called *Wine Bar*, he explained, he inscribed the word 'Quiche' on the blackboard menu as a private message to his friend the painter John Hoyland. The latter was a great frequenter of wine bars but, on the other hand, a person who would have thought the slogan 'real men don't eat quiche' a biblical truth.

These private jokes, which will pose insoluble conundrums to the art historians of the future, aren't the point of the pictures, however. 'They're merely reasons to help me do the painting,' says Caulfield. 'Because, if you're imagining something, you need lots of mental crutches en route to help you to do it. If you think somebody would think that was funny if they could see it, it helps.' Some of his paintings were in fact remarkably close to being of nothing, that is to say, to being abstract. Indeed, they come into the category Frank Bowling defined as 'jokes about abstraction'. For this

PATRICK CAULFIELD *Corner of the Studio,* 1964

reason, Caulfield's painting of the 1960s is sometimes very close, in formal terms, to paintings from the same period by John Hoyland.

Caulfield's *Corner of the Studio* (1964) is almost minimalist. The surface is nearly entirely monochrome: a field of blue, with a couple of roughly triangular forms scattered on it, plus a sprinkling of jagged lines and bubble-like circles. This is just enough to create a space. But Caulfield goes one step further and places just off-centre a bright red stove, outlined in firm dark lines like those used by Hergé to draw the *Adventures of Tintin.*

Thus with the sparest of means Caulfield creates an atmosphere, an ambience, a sense of a time that isn't quite the present, but not quite the real past either. The stove, as can be seen in a contemporary photograph, isn't quite like the one that Caulfield himself had in his studio, which was a more up-to-date paraffin-burning model. It's an older, coal-burning type, the sort that heated the office of Inspector Maigret or might have warmed an artist of the 1920s and 1930s, such as Mondrian or René Magritte, both of whom Caulfield much admired.

*

It was not just artists such as Kitaj and Caulfield who were prone to romanticism. For good or ill the mid-1960s were a romantic era. The tastes of what had been dubbed 'Swinging London' in a celebrated *Time* magazine article were similar to those of the original nineteenth-century decadents: dandy-

ism, excesses of every kind, indulgence in what Baudelaire called 'artificial paradises'. Looking back, Caulfield reflected that he personally had seen little of it – 'it's difficult to swing if you haven't got any money'. He had spent the early 1960s as an art student, working in the holidays – as he had when he left school – in such places as the Pepsi-Cola factory in North Acton. What little he saw of Swinging London was through his dealer, Robert Fraser.

Fraser's gallery was as prominent as Kasmin's; they were jointly the most fashionable places to see new art in London. But while Kasmin was an advocate of abstract art – with a few exceptions, notably David Hockney – Fraser was the principal London dealer in Pop, though he too showed some abstract painting. Among the artists he represented at one time or another were Andy Warhol, Jim Dine, Bridget Riley (who had moved from Victor Musgrave's Gallery One), Derek Boshier, Richard Hamilton and Caulfield.

Fraser had a fastidious eye. Bridget Riley tells the story of how she and he were hanging an exhibition of her 'very small drawings, using blacks, whites, greys and pencil notes'. These looked lost against the walls and they did not know what to do. She came back later in the day, and found Fraser 'had painted the entire place black – walls, ceiling, all the woodwork, everything was completely black. And so these little light, pale studies, very fragile pieces of paper, shone, and were set off in an amazing way.'

This acute sense of visual style was applied not only to contemporary art but to the covers of rock LPs. Fraser was a good friend of Paul McCartney and the other Beatles, as well as the Rolling Stones, and in the habit of dropping into McCartney's house on Cavendish Avenue in St John's Wood for dinner and chatting late into the night. He was instrumental in persuading the band to commission Peter Blake and his wife Jann Haworth to design the cover of *Sgt. Pepper's Lonely Hearts Club Band*. The Beatles had already commissioned another image, but Fraser persuaded them it was 'bad art, badly drawn'. The American Pop artist Claes Oldenburg felt that 'Robert really had an eye for draughtsmanship: very few dealers have.'

As a dealer Fraser had many virtues, though paying his artists, or other bills, was not among them. However, in other ways, he was recklessly extravagant, drawn to excess in every way. Caulfield recounted an occasion when they had arrived too late for the opening of an exhibition in Milan

because of having missed their plane. Since they found themselves in Italy, Fraser suggested they went on to Rome, where they ended up in the luxurious palazzo and beachside villa of a rich actor. The people, and the setting, were those of Federico Fellini's film *La Dolce Vita* (1960): everyone on drugs, except Caulfield, who instead was drinking as much as he could and absorbing the 'absolute luxury'. 'It would appear glamorous from the outside,' Caulfield reflected, his irony kicking in, 'but it wasn't glamorous at all. It was rather painful.' The reality of it consisted of not sleeping, getting sunburnt, and not being able to talk to anybody because he didn't speak Italian (Caulfield was equally unimpressed by swinging parties in which everybody sat in stoned silence).

This Italian journey was not as painful, however, as what happened to Fraser in 1967. On the evening of Sunday 12 February a group of friends were gathered at Redlands, a country house near West Wittering in Sussex owned by Keith Richards of the Rolling Stones. With Richards were Mick Jagger, his then girlfriend Marianne Faithfull, George Harrison, the antiques dealer and collector Christopher Gibbs and Fraser. These were the stylistic leaders of Swinging London. Gibbs was an old Etonian like Fraser, and perhaps the first man to wear flared trousers and floral shirts.

On that Sunday evening at Redlands, Harrison had just left when, as Gibbs recalled, they were 'rudely interrupted by a lot of people from the West Sussex Constabulary'. Everybody was horrified when all these people wearing identical clothes knocked at the door. Although most of those present were high in one way or another, there was no actual evidence apart from a box of white pills in Fraser's pocket. In his gentlemanly way, he explained to the police that these had been prescribed for a medical condition; they, however, insisted on taking a few away for analysis. They turned out to be pure heroin, a surprise to other members of the party, and very bad news for Fraser in particular.

On 22 June, Jagger, Richards and Fraser appeared in court in Chichester. A few days later, they were found guilty and, after a night in Lewes Prison, were taken back to court for sentencing. Jagger and Fraser were handcuffed together, with Jagger additionally shackled to a policeman. A photographer named John Twine took their picture through the window of the police van

RICHARD HAMILTON *Swingeing London 67*, 1968–69

as they raised their shackled hands. Fraser was given six months' impris-
onment, Richards a year and Jagger three months. The photograph made
a strong impression on Richard Hamilton, who was badly upset by what
had happened, feeling as he did that 'Robert's was the best gallery I knew
in London' and that he had been unfairly treated: 'The gallery was empty,
poor Robert was in jail, it was an awful mess. And so unjust, the British
legal system seemed to me to have treated him particularly badly.'

The secretary of Fraser's gallery had kept a file containing every reference
to his name in print, sent by a press-cuttings agency. Eventually, she handed
it over to Hamilton, who found it – in the words of Richard Morphet – 'a
mine of extraordinary information' that included 'innumerable reports of
the same incident, varying at the whim of reporters'. Initially, Hamilton
made a lithographic print from a mosaic of these cuttings. Then he honed
in on one: the photograph by John Twine of the two men handcuffed in

the police van. This was the basis for six paintings, done the following year. The original image was obtained from the *Daily Mail*, trimmed and edited, then silkscreened over oil paint. In some versions this was conventionally worked in an academic manner, in others he treated it much more broadly.

The image itself is ambiguous. It might seem that Fraser and Jagger were lifting their hands to shield themselves from view, but Fraser later claimed they were so outraged by their treatment that they brandished the handcuffs for the world to see. This, then, is an image of defiance and – one would guess – was orchestrated by Fraser with characteristic visual flair. Hamilton called his series of pictures *Swingeing London 67* (1968–69). This was a reference to the trial judge's comment, 'there are times when a swingeing sentence can act as a deterrent'. The two men's hands bring to mind *The Times* leader by the new editor William Rees-Mogg that came out shortly after the sentencing under the headline, 'Who breaks a butterfly upon a wheel?' The shackled hands seem to flutter, at once defensive and protesting.

Swingeing London 67 is a piece of Pop art in that it is about mass media, but no longer in the cool ironic, celebratory fashion that Hamilton had famously defined as 'witty, sexy, gimmicky, glamorous, big business'. The coolness and irony were still there, but this was work that was also angry and political. The mood of the age was shifting from romance to rebellion; and art was changing too. The following year, again at Fraser's suggestion, Richard Hamilton designed a cover for the Beatles' next record – known as the *White Album*. Instead of filling it with imagery, as Blake had done for *Sgt. Pepper*, Hamilton elected to leave it completely blank. Painting, temporarily, was on its way out and ideas were coming in.

EPILOGUE

I know that Duchamp thought he had made figurative painting impossible; and that something has been made impossible is an exciting thought. It makes one feel that one is doing something secret, something that might almost be illegal.

LUCIAN FREUD, 2004

In the 1970s Kitaj visited the prehistoric cave paintings of Altamira in northern Spain with his children. He was expecting to be bored. Instead, he was 'shocked at the quality of drawing, at how wonderful it was'. So, he concluded, 'it's been like that ever since the beginning' and, moreover, 'they're never going to stop drawing the human face with two eyes and a mouth'.

In these few words Kitaj expressed what might be called the 'steady-state' theory of art history. This appeals to painters, particularly figurative ones, for an obvious reason. They are, essentially, still trying to do what the artists of Altamira were doing superlatively well tens of thousands of years ago. It is hard to argue that painting has progressed, in terms of quality at least. Gary Hume, a successor of the painters discussed in this book, said in 1999, 'I'm a caveman still, in my cave, painting the world out there.'

Against the steady-state theory is the artistic version of the Big Bang thesis. That is, that art began in a certain time and place – effectively, the caves – and has been shooting away from that point ever since. And the direction of travel cannot be reversed. Thus, you could not in the twentieth or twenty-first century work like Giotto, or Caravaggio. To do so would be an act of pointless copying, and not creative at all. Many others, including numerous artists, would go further and argue that certain techniques, idioms and genres simply become outmoded. Therefore, painting – certainly figurative painting – was and is widely held to have been rendered obsolete by the advent of photography.

It is not necessary here to adjudicate between these two points of view – except to say that the last claim can't be quite true. Some of the most glorious achievements in the annals of painting came after Daguerre's announcement in 1839 – Cézanne, Van Gogh, Picasso, Rothko, Pollock, Matisse. And also, of course, those recorded in this book.

The currents of history are felt and understood differently in particular times and spaces. The German painter Georg Baselitz noted recently, 'If you had painted works in the style of Freud or Auerbach in Germany after the war, you wouldn't have had a chance.' The notion that abstraction was the inevitable end point was, according to Baselitz, universal in postwar West Germany.

Even in London, however, many believed in the unassailable triumph of abstraction. As Victor Pasmore said to Paula Rego at the Slade in the early 1950s (wrongly as it turns out), 'Nobody paints like that anymore!' Furthermore, though Freud and Auerbach survived in 1960s London, they could scarcely be said to have been thriving. Still, London proved more resistant to the triumph of the modern than many places.

No doubt there were many reasons why this was so. One was the conservatism of British art education. Consequently, the painters we have been considering were sometimes taught by people, such as Bomberg and Coldstream, for whom working from life was not an academic exercise, but a matter of the utmost urgency and excitement. Others, including Riley and Hockney, were instructed in the tradition inculcated by Henry Tonks at the Slade in the early twentieth century. This was derived from the methods of nineteenth-century French masters and, ultimately, from the Renaissance. This perhaps was why people in London, Kitaj believed, 'draw better than anyone in the world'. The Modernists and Mavericks in these pages were, however, among the last to be trained in this way; in the 1970s serious instruction in drawing was largely dismantled, thus severing a lineage that stretched back to Altamira.

Another reason, perhaps, was the simple existence of Francis Bacon. He was, without question, the most successful British painter, internationally speaking, yet his work was defiantly figurative. His example demonstrated that there were, at the very least, exceptions to the laws of art historical progress.

*

The painters of London all made their own idiosyncratic accommodations with history. Bacon himself took the view that photography had fundamentally altered the rules of the game, making the detailed copying of appearances – what he termed 'illustration' – outmoded and pointless. Hence his opinion that painting now was a desperate struggle against almost impossible odds, a battle to find a configuration of paint that felt like reality without imitating it.

Uninterested in, but also unthreatened by photography, Freud had found his own criterion. In the present situation, he felt, all a painter could do was search for truth. Of course, this is as elusive a measure as any, but Freud recognized it when he encountered it, and to him it was more a metaphysical quality than a stylistic attribute. 'For myself, I am only interested in art that is in some way concerned with truth. I could not care less whether it is abstract or what form it takes.'

Less dramatic, and more irreverent in his revolt against the 'manifest destiny' doctrine of Modernism, Hockney – writing in 1976 – declared that he had 'come to see that a great deal of the work passing itself off as modernist was junk'. If you come to a dead end, Hockney concluded, 'you simply somersault back and carry on'.

For his part, Auerbach firmly believes in the pointlessness of replicating what has already been done – if you did not paint in a new manner, the result would just 'look like a picture'. To that extent, he accepts the ratchet effect of time on art. But, rather than see history as an inexorable march ever onwards, Auerbach decided that it was best, in effect, to divert the arrow of time into a loop:

> There were certain painters, Kandinsky is a prime example, who painted in a not very distinguished way, then at the point of turning towards abstraction painted some distinguished pictures. But when he'd crossed over they become for me rather mediocre again. So it's the *process* of abstracting that makes for the tension and excitement. So I thought the thing to do is to cross that border again, and again and again.

Interestingly, Bridget Riley, though her work is very different from his, concurs. The point at which she, for her part, has elected to pause is slightly different – after the early Modernists passed the frontier into abstraction:

> Something that has bedevilled art in this century is the idea
> of progress, which is based on a reading of the history of early
> Modernism that is in fact not quite right. There was at one stage
> a great deal that needed to be cleared up, and many doors that
> needed to be opened. But after those doors had been opened, there
> weren't more and more doors that also needed opening, or at least
> there weren't any *real* doors. What was needed was to till the garden!
> By that I mean it was necessary to investigate the territory that
> had been opened up.

*

By the mid-1970s, abstraction had ceased to look like the inevitable future and become a type of picture making. Increasingly, the crucial distinction was between painting and other ways of making art. Moreover, it was the latter – land art, performance, installation, video – that now looked like the future. Even Tate curators, those bellwethers of changing taste and fashion, had begun to declare painting – once more – dead, over and out. It was true that the majority of the most impressive artists who emerged in London in the 1970s and 1980s – Richard Long, Tony Cragg, Antony Gormley, Anish Kapoor and Gilbert & George among them – were sculptors rather than painters, in so far as their work could be classified in traditional terms at all.

Yet Bacon's ascent into the pantheon of art history was undisturbed by this development. In 1971, in his own view at least, his career culminated in a retrospective at the Grand Palais in Paris. But perhaps the most profound works of his career came just afterwards: a series of triptychs concerned with the suicide of his lover, George Dyer, a day and a half before the opening. In these, the two poles of his art – visceral realism and tragic drama – were finally fused.

Unaffected by fashion, Hockney's renown continued to spread. He ceased, however, to be a London painter, having been based in the city, at least intermittently, through the 1960s. In 1972, tired of English life and unhappy with the naturalism of his work – which he had begun to see as a 'trap' – he moved to Paris and, at the end of the decade, back to LA. Here he stayed for twenty years, exploring Cubism, theatrical design, photography and its shortcomings, in a myriad of manners, with tremendous intellectual vitality and – just like Bacon – in a manner no bossy critic or historian would ever have predicted.

In 1974, Freud had an exhibition at the Hayward Gallery. From then on, he felt, things got better, and a lot more so in the 1980s. It was not until the 1990s, when Freud was in his seventies, however, that he began to be seen as a towering figure in painting across the ages. In 1970, that would have seemed an astonishing idea.

Gillian Ayres, like many of the others who have featured in these pages, also carried on regardless. Fellow teachers at St Martin's used to warn the students: 'Don't listen to her, she'll make you want to paint!' Her reaction was to use pigment on canvas with ever more abandon. She produced paintings of enormous length, then others of astonishing thickness and interwoven complexity, then yet another new idiom of unprecedented freedom and power. She, and such dedicated abstract painters as Riley and Bowling, had long, distinguished and productive careers ahead of them. They demonstrated the continuing vitality of abstraction: there remained plenty of possibilities in this way of working.

The same could be said of Michael Andrews, Leon Kossoff, Allen Jones, Howard Hodgkin, Peter Blake, Euan Uglow and Patrick Caulfield. All these cultivated their own, quite different, garden plots, to use Riley's metaphor. Nobody told artists what to do any more, as Hodgkin put it; no critics or curators, or at least increasingly few, declared that painting had to be this or that. This, Hodgkin felt, made it very much more difficult in some ways, but, on the other hand, meant that painters had enormous freedom.

However, not all the artists of the 1960s had such a flourishing future. Some years ago, I was lining up to go into the lunch given in honour of the artist representing Britain at the Venice Biennale. I fell into conversation

with an elderly man whose face I couldn't quite place who was standing behind me in the queue. After a bit he remarked in a melancholy tone, 'In 1970, this lunch was given for me'. It was Richard Smith.

For a while in the late 1960s and early 1970s Smith and Robyn Denny continued to occupy centre stage in London. 'I was the right kind of artist for that kind of time', Smith recalled in 2001, 'I just expected to be in international group shows. Then … I don't know.'

He had a major Tate retrospective in 1975, then bit by bit, faded from prominence. Much the same happened to Denny, who was more optimistic about the situation than Smith. 'Robyn Denny keeps saying, "Our time will come, Dick. Our time will come. And he's been saying this for years and years. Years and years and years."' It never happened during their lifetimes, which does not necessarily mean it never will. This period is still close; in art, judgments and reputations always remain provisional. Artists can disappear, as Freud did in the late 1950s and 1960s, but also reappear as he did in the 1980s and 1990s.

*

When, in 1976, Kitaj used the phrase 'School of London', people immediately 'jumped on it', as he remembered. There were attempts to characterize it, and also to deny it existed. As we have seen, there was no common factor. The major painters of London were all idiosyncratic mavericks, even when they were Modernists. Equally, there were interconnections and overlaps – social, stylistic, temperamental – sometimes crossing the frontier between figurative and non-figurative. Several artists, notably Auerbach and Hodgkin, effectively set their tents up on the border zone itself.

None of this, however, contradicts Kitaj's fundamental outsider's insight: 'I just found myself in a city where a lot of wonderful painters were working; I felt that I had observed something.' In that, I hope the reader will agree, he was absolutely correct.

Notes

Unless otherwise noted, all quotations from Frank Auerbach, Gillian Ayres, Georg Baselitz, Frank Bowling, Anthony Caro, John Craxton, Dennis Creffield, Jim Dine, Anthony Eyton, Terry Frost, David Hockney, Allen Jones, John Kasmin, James Kirkman, R. B. Kitaj, John Lessore, Richard Morphet, Henry Mundy, Victor Pasmore, Robert Rauschenberg, Bridget Riley, Ed Ruscha, Richard Smith, Daphne Todd, John Virtue and John Wonnacott are from conversations with the author, 1990–2018.

Full publication details for works cited in abbreviated form below can be found in the Bibliography.

Chapter 1
11 'He was totally alive…': quoted in Warner, 1988.
11 'The destruction in the West End…': quoted in Clark & Dronfield, 2015, p. 177.
11 'The silence, the absolute dead silence…': quoted in Yorke, 1988, pp. 124–25.
14 'exotic and somewhat demonic aura': Bernard, 1995, p. 45.
14 The critic John Russell: Russell, 1974, p. 7.
14 'one of the greatest portrayers…': Bernard & Birdsall, 1996, p. 7.
15 'genius of painting hovers over Paris…': Sickert, 1947, p. 183.
19 'Through his singular talent…': Bernard & Birdsall, 1996, p. 9.

Chapter 2
22 'being young and extremely tactless…': Smee, 2006, p. 9.
23 In the words of John Russell: all quotations from Russell, 1971, pp. 10–11.
23 'nearer to what I feel about the psyche…': Chris Stephens, 'Francis Bacon and Picasso', http://my.page-flip.co.uk/?userpath=00000013/00012513/00073855/&page=5
28 Kathleen Sutherland, who dined there: Berthoud, 1982, p. 129.
28 'Actually there is no paint at all…': Sylvester, 1975, p. 192.
30 'this way and that across his stubble…': Richardson, 2001, p. 12.
31 'to be one of the very few English painters…': Rothenstein, 1984, pp. 161–62.
31 'real painting is a mysterious…': ibid.
31 'mysterious because the very substance…': ibid.
33 'complete interlocking of image and paint…': ibid.
33 'It was like one continuous accident…': Sylvester, 1975, p. 11.
34 'If you go to some of those great stores…': ibid., p. 46.

35 'The moment the story is elaborated…': ibid., p. 22.
35 'our quarrel was with Michelangelo': Hughes, 1997, p. 495.
36 'I think it would be more exciting…': Sylvester, 1975, p. 65.

Chapter 3
40 The directive from the Ministry of Education: Johnstone, 1980, p. 203.
41 One of Minton's pupils was Humphrey Lyttelton: Spalding, 1991(1), pp. 90–91.
43 'We talked about the difference of attitude…': Townsend, 1976, p. 75.
43 It runs directly into what David Hockney: Hockney & Gayford, 2016, p. 19.
43 A decade before, Coldstream: Laughton, 1986, pp. 109 ff.
44 'Of course encourage him…': ibid., p. 116.
44 This could no more be done without alteration: Gowing, 1981, p. 24.
45 On the one hand, Coldstream wrote: Laughton, pp. 109–10.
45 Yet if one did that: ibid., p. 110.
45 Coldstream had a go too: ibid.
46 The process is described by Coldstream's biographer: ibid., p. 119.
46 Gowing wondered how he would find Coldstream: Gowing & Sylvester, 1990, pp. 15–16.
49 Nevertheless, Coldstream was afflicted by doubts: the following quotations from Coldstream are from David Sylvester's interview with the artist, recorded 1962, in ibid., p. 25.
50 In 1947, Cyril Connolly: *Horizon* (April 1947), quoted in Sandbrook, 2006, p. 253.
52 The process was recorded by William Townsend: quotations in this paragraph from Townsend, 1976, p. 72.
54 When she got there, her biographer Frances Spalding: quotations and information in following passage, Spalding, 2012(1).
55 'Each painting is an exploration…': Yorke, 1988, p. 293.
55 Clough's origins were curiously similar: Spalding, 2012(1).
55 'I like paintings…': Yorke, 1988, p. 297.
56 'The original experience…': ibid.

Chapter 4
61 'Although I had painted most of my life…': Cork, 1988, p. 41.
61 'What David did for me…': McKenna, 1993.
62 'I look upon *Nature*…': Cork, 1988, p. 19.
63 'prodigious speed and certitude': ibid., p. 32.
63 'the artist's consciousness of mass…': ibid., p. 34.

63 'The sense of Touch and associations…': ibid., p. 40.
64 'poetry in mankind…': ibid.
67 'Once I watched him draw…': Sylvester, 1995, p. 17.

Chapter 5
69 'One wants to do this thing of…': Sylvester, 1975, p. 28.
69 'the dirt and weariness…': *Horizon* (April 1947), quoted in Sandbrook, 2006, p. 253.
71 'Corsica is proving very exciting…': Spalding, 1991(1), p. 110.
73 'an impression of great fragility…': Cressida Connolly, obituary of Kitty Godley *Guardian*, 19 January 2011.
76 'I take readings from a number of positions…': Gowing, 1982, p. 60.
77 'dead birds, hares and monkeys…': Melly, 1997, p. 89.
78 'painstaking exactness…': Townsend, 1976, p. 82.
78 There was no hesitation: Melly, 1997, p. 70.
79 'some heads which I like better…': Peppiatt, 2006, p. 144.
79 Bacon wrote that he would be back: ibid.
80 'the whole world…': Harrison, 2005, p. 81.
81 'newspaper photographs and clippings…': ibid., p. 83.
81 'people walking over them and crumpling them…': ibid., p. 81.
82 'slightly out of focus…': ibid., p. 59.
82 'as a snail leaves its slime…': quoted in Peppiatt, 2006, p. 65.
82 'liquid whitish accents…': Harrison, 2005, p. 104.
85 'impervious to interpretation…': ibid., p. 56.
86 'there was an aspect of his work…': Albert Hunter, quoted in Peppiatt, 2006, p. 64.
86 'I can't explain my art…': Gruen, 1991, p. 8.

Chapter 6
88 'The church was bombed…': Blow, National Life Stories: Part 3.
91 The *Daily Mail* was furious: for the following quotations, and the Gear affair, see Massey, 1995, pp. 14–17.
93 'Here's something to make you laugh, May': Wilson, 2005, p. 156.
94 Gowing met up with Kenneth Clark: Walker, 2016, p. 56.
96 Paula Rego, a young student at the Slade: Eastham & Graham, 2011.
96 On 26 October 1950: Townsend, 1976, p. 90.
97 A few months later: Walker, 2016, pp. 57–58.
98 One was Kenneth Martin: Garlake, 1998, p. 104.
100 'Very few artists know what…': Caiger-Smith, 1993, p. 10.

101 'the sort of so-called non-
figurative painting…': ibid., note
to cat. 15.
101 Around that time, he defined his
works: ibid.
103 'capable of carrying not only
himself…': see Alloway, 1954, p. 30.
103 The nine divided: see Alloway,
1954, *passim*.
104 'very often in the course of
working…': Garlake, 1998, p. 205.
104 He wrote to Terry Frost: ibid.,
note to cat. 11.
106 Pasmore was characteristically
quixotic: Moffat, 2014.

Chapter 7
108 In a later interview with the
American critic: Gruen, 1991,
pp. 6–7.
108 While struggling to explain to
David Sylvester: Sylvester, 1975,
p. 182.
108 Bacon had said much the same
earlier: ibid., p. 48.
111 With Lacy, Bacon experienced: see
Peppiatt, 2015, pp. 74–75, also for
following quotations.
111 According to John Richardson:
Richardson, 2009.
111 On another occasion: ibid.
112 As Bacon later reflected, 'People
say…': Peppiatt, 2015, p. 74.
113 'He was not secretive…': and
following quotations, Albert
Hunter, quoted in Peppiatt, 2006,
p. 64.
114 'I had dinner with [Francis Bacon]
nearly every night…': Peppiatt,
1996, p 193.
114 There is at least one account of
Bacon and Freud getting into a
fight: Luke, 1991, p. 183.
114 He would generally go round to
Bacon's studio: Smee, p. 16.
114 Posing for him: William Hppr,
et al
117 First he defined himself: Freud,
1954, p. 23.
118 'Since the model is so
faithfully…': ibid., p. 26.
120 Even so, Diamond was 'slightly
miffed': Gayford, 1993, p. 24.
120 'My work is purely
autobiographical…': Russell, 1974,
p. 13.
120 'it can only be like a travel book':
Gowing, 1982, p. 56.
121 'could he portray…': Russell, 1974,
p. 27.
121 This represented the Prime
Minister, Winston Churchill: see
Berthoud, 1982, pp. 183–200.
122 On occasion Sutherland used
photography: ibid., p. 189.
122 Years later, on the last occasion:
Farson, 1988, p. 172. It seems
from this account that the incident
occurred in the 1960s.

122 Strangely, Lucian Freud was
eventually commissioned: see
Smee, 2006, pp. 22–23.
122 'my eyes were completely going
mad': Feaver, 2002, p. 27.
122 'He talked about packing a lot
of things…': ibid., p. 28.
123 It was after this, in 1959, that
Freud was approached by *Time*
magazine: for his account of this,
see Smee, 2006, pp. 22–23.

Chapter 8
125 'I remember the extraordinary
effect…': Lessore, 1986, p. 55.
127 'awful but also rather beautiful':
Higgins, 2013.
127 'like the moon's capital…': Bowen,
1945, p. 173.
128 She was struck immediately by
Auerbach: Hughes, 1990(1), p. 133.
128 'Leon and I were perhaps a bit
rougher…': ibid., p. 29.
129 'The world I grew up in was fairly
medieval…': McKenna, 1993.
129 Then he discovered Rembrandt's
A Woman Bathing in a Stream: ibid.
130 Later on, in 1943: Moorhouse,
1996, p. 10.
130 'Drawing is making an image…':
quoted in Wilcox, 1990, p. 33.
131 At the National Gallery he had
been in the habit: Kendall, p. 12.
131 'heavily worked and very black':
http://benuri100.org/artwork/
portrait-of-n-m-seedo/
131 In the 1950s one of those figures:
see Hyman, 2001, pp. 142–45.
131 'the most exciting stories that I had
ever read…': Seedo, 1964, p. 336.
132 'The struggle that he was engaged
in…': ibid.
133 As penniless students, he and
Kossoff: Hughes, 1990(1), p. 33.
133 The work flourished again fully
himself: Lampert, 2015, p. 38.
133 'The whole situation was obviously
more tense and fraught…': ibid
133 Equally, knowing her as well: ibid.
134 Not only were the pictures
themselves: Lampert, 2015, p. 50.
134 'Frank's painted me with tears…':
Hughes, 1990(1), p. 134.

Chapter 9
137 The attraction was that: Craig-
Martin, 2010, p. 3.
138 In 1950, Britain accounted for ten
per cent: Hennessy, 2006, p. 106.
138 'Over the Atlantic lay the land of
Cockaigne…': Jarman, 1987, p. 46.
138 One of these was Reg Smith,
better known as Marty Wilde:
Hennessy, 2006, p. 19.
138 The music that would inspire Marty
Wilde: Craig-Martin, 2010, p. 7.
139 The occasion was a meeting of the
'Independent Group': see Massey,
1995, pp. 33–53.

139 If you stepped out of an
Independent Group gathering:
ibid., p. 49.
139 A few years later, writing in 1959:
ibid., p. 50.
141 The ICA was the headquarters:
ibid., pp. 19–31.
141 Alloway summarized Read's
argument: ibid., p. 73.
141 The Independent Group members
were in revolt: Greenberg, 1961,
pp. 3–21.
141 The other part of Greenberg's
thesis: ibid.
142 Alloway took the opposite point of
view: Alloway, 1958.
145 Another version has the term
originating: according to an
interview with McHale's son,
www.warholstars.org/articles/
johnmchale/johnmchale.html
145 In 1957, Richard Hamilton
produced: Morphet, 1992, p. 149.
145 The critic John Russell saw this
new mood: Sandbrook, 2006,
pp. 72–73.
146 Evenings at the ICA were now
spent talking: Craig-Martin, 2010,
pp. 5–6.
146 From this Hamilton took away a
subversive conclusion: ibid., p. 6.
146 'I was asked, "What can you
do?"…': ibid.
146 'It's like making a world…': ibid.,
p. 2.
147 The voluptuous curves: see Tate
online catalogue, www.tate.org.uk/
art/artworks/hamilton-hommage-
a-chrysler-corp-t0695.
150 In the 1950s Hamilton was a prime
mover: on 'This is Tomorrow', see
Massey, 1995, pp. 95–107; Morphet,
1992, pp. 148–49.
152 For the art display, and to publicize
the exhibition: Morphet, 1992, pp.
148–49.
153 In 1952, Berger organized an
exhibition: Hyman, 2001, pp.
115–19.
153 'Does this work help or encourage
men…': Berger, 1960, p. 18.
153 This exhibition, Berger informed
the readers: Hyman, 2001, p. 115.
153 Accordingly, when Bryan
Robertson: ibid., p. 116.
154 He picked out two, Edward
Middleditch and Derrick Greaves:
Spalding, 1991(2), p. 7.
155 'That was my life at the time…':
ibid.
155 Sylvester described how these
painters: Sylvester, 1954,
pp. 62–64.
157 'The wretched critic's term haunts
us all…': Spalding, 1991(2), p. 7.

Chapter 10
158 This was why, towards the end of
November 1956: Mellor, 1994, p. 28.

341

160 'At last we can see for ourselves…':
Heron, 1998, p. 100.
161 'To produce something
spontaneously…': Cohen, 2009.
162 'I was trying to produce…': ibid.
162 One must concern oneself:
quoted www.portlandgallery.
com/exhibitions/506/30341/
alan-davie--the-eternal-conjurer-
anthropomorphic-figures-
no1?r=exhibitions/506/alan-davie-
-the-eternal-conjurer#
162 Another British painter who got
an early view: Lynton, 2007, p. 109.
163 Professor Meyer Schapiro of
Columbia University: for Schapiro
and his visit, see O'Donnell, 2016.
163 William Scott felt this: Lynton,
2007, p. 109.
163 David Hockney, a nineteen-year-
old: Hockney, 1976, p. 41.
164 Francis Bacon was 'terribly
disappointed': Gruen, 1991, p. 10.
165 William Green, another member: on
Green see Mellor, 1994, pp. 16–19.
167 At a certain moment the canvas:
Rosenberg, 1962, p. 36.
168 The critic Mel Gooding observed:
Gooding, 1994, p. 136.
169 At twenty-one he had already set
up: on Rumney see Miles, 2010,
pp. 62–65.
170 'an archetypal outsider…':
Thompson, 2000.
171 Rumney's exhibit, *The Change*
(1957): see Tate online catalogue,
www.tate.org.uk/art/artworks/
rumney-the-change-to5556
171 In 1956, writing in a prospectus:
Sandbrook, 2006, p. 55.

Chapter 11
175 'Abstract painting, that is
painting…': Denny, 1964, pp. 6–8.
175 Lawrence Alloway was enthused:
Whiteley, 2012, p. 119.
176 One day in that same year, 1959:
Farson, 1993, p. 117.
176 Nonetheless, there he was in
Cornwall: ibid.
176 At that point in his career: for an
extended discussion of Bacon in St
Ives, see Tufnell, 2007, *passim*, and
Harrison, 2005, pp. 136–53.
177 According to the Irish painter Louis
le Brocquy: Farson, 1993, p. 117.
177 William Redgrave, a local artist:
Harrison, 2005, p. 139.
178 The painter and critic Giles Auty:
Farson, 1993, p. 118.
178 The Bacon scholar Martin
Harrison: Harrison, 2005, p. 141.
180 Also in 1959, the same year the
Tate: for a discussion of 'Place', see
Whiteley, 2012, pp. 141–45.
182 Roger Coleman, the young critic:
ibid., p. 142.
182 'the silliest exhibition I have ever
seen…': ibid., p. 143.

182 The edge was a 'clear hinge…': ibid.,
p. 139.
184 A sign of this came that same year:
Mellor, 1994, p 47.
184 A visitor described it: Sandbrook,
2006, p. 247.
185 Clothes were increasingly part
of the way artists: Mellor, 1994, p. 77.
186 'Situation: An Exhibition of British
Abstract Painting', at least in the minds
of the artists involved: ibid., p. 75.
186 Accordingly, in the words of
William Turnbull: ibid., p. 77.
186 The main criterion for including
a work: Mellor, 1994, p. 90.
186 Alloway, the Chairman, wrote
in *ARTnews*: Mellor, 1994, p. 91,
quoting *ARTnews* (September 1960).
186 Over the month of the show:
Whiteley, 2012, pp. 150–51.
189 Hodgkin described the experience:
Hodgkin, 1981.
189 One day, William Coldstream
asked: Moorhouse, 2017, p. 14.
190 He always began: Hodgkin and
Tusa, 2000.
193 Alloway later argued: Whiteley,
2012, p. 151.

Chapter 12
195 According to Hockney, the staff:
Hockney, 1976, p. 42.
199 At the Royal College, Derek
Boshier's circle: for Boshier's
experiences at the RCA, see
Boshier & Reeve, *passim*.
199 At eight years old, in his home
town: Hockney, 1976, p. 28.
200 Ronald Brooks Kitaj – usually
'R. B.': for Kitaj's early career, see
Livingstone, 1985, pp. 8–11.
201 Kitaj, Hockney remembered:
Hockney, 1976, p. 40.
201 'I naturally thought I wouldn't have
a chance…': Sykes, 2011, p. 52.
202 'Being the way they were, they
thought, he can draw…': Hockney,
1976, p. 42.
202 Hockney thought: 'It's quite
right…': ibid., p. 41.
204 Hockney thought 'it was
probably…': ibid., p. 42.

Chapter 13
206 The Tate Trustees agreed to the
show: for the genesis of the 1962
Bacon exhibition at the Tate see
Peppiatt, 1996, pp. 230–38.
207 Bacon later told David Sylvester:
Sylvester, 1975, p. 13.
207 Soby, author of studies of Joan
Miró: for Soby's interpretation and
tribulations, see Martin Harrison,
'Bacon's Paintings', in Gale &
Stephens, 2008, pp. 41–45.
208 A list of potential subjects:
Gale & Stephens, 2008, p. 149.
209 'I want very, very much to do the
thing…': Sylvester, 1975, p. 65.

210 She added Bacon because: Riley,
1999, p. 7.
210 'Art,' Hegel concluded…': Hegel,
1975, p. 10.
211 When Bacon's Tate exhibition:
Peppiatt, 1996, pp. 234–37.
211 When the paintings were all
installed: Farson, 1993,
pp. 150–52.
212 Lacy's consumption: Peppiatt,
2015, p. 76.
212 Bacon wrote in a letter to the Tate
Gallery: Gale & Stephens, 2008,
p. 144.
212 We have seen that Bacon often:
on Bacon and photography, see
Harrison, 2005, *passim*.
213 The question for him: for this and
following quotations, Sylvester,
1975, pp. 38–41.
217 John Deakin staggered into the
French House: Farson, 1988,
p. 178.
219 Freud was not formally
interviewed: the 1977 interview is
in Gruen, 1991, pp. 315–24.
219 The conversation did not go well:
Peppiatt, 2015, p. 41.
219 A decade later Freud told John
Russell: Russell, 1974, p. 5.
220 'At Clarendon Crescent…': Feaver,
2002, p. 30.
222 In a celebrated book: on the naked
and the nude, see Clark, 1957, pp.
1–25.

Chapter 14
227 'I paint about communication…':
from Smith's notes to *Trailer*,
quoted Mellor, 1994, p. 126.
227 For *Trailer* Freeman had shot: on
Smith and cigarette-packet design,
see ibid., pp. 126–29.
228 His art dealer in Manhattan: see
Burn, 2000.
229 On the other hand, in Pop terms:
the following quotations are ibid.
230 At one ICA discussion: Whiteley,
2012, p. 146, n. 22.
231 This was the year that Blake
painted: on *Self-Portrait with
Badges*, see Daniels, 2007, and
Jonathan Jones, 'Portrait of the
Week', *Guardian*, 2 February
2002, www.theguardian.com/
culture/2002/feb/02/art
231 In the mid-1950s, when they
were still young art students: on
Smith and Blake's tastes in music,
clothes and haircuts, see Burn,
2000.
233 Noland told Kasmin: Hucker, 2013.
236 The November 1962 edition
of a magazine: Tate, 2013, p. 99.
Tate's study is the primary source
for Boty's life and art in the
following paragraphs.
239 Many people, she explained: ibid.,
p. 72.

243 He was born in February 1934: on Bowling's art and career, see Gooding, 2011.

Chapter 15
246 'London, like the paint I use…': Moorhouse, 1996, p. 36.
246 The art critic Andrew Forge: quoted in Richard Morphet, obituary of Helen Lessore, *Independent*, 8 May 1994.
250 'being in an enormous bed…': Miles, 2010, p. 40.
251 Bruce Bernard remembered: Bernard, 1995, p. 50, and subsequent quotations, pp. 50-53.
253 In January 1963: Calvocoressi, 2017, p. 14, subsequent quotations from Andrews, ibid., p. 9.
255 'I climbed up and down…': Rothenstein, 1984, p. 218.
256 the model represented a problem: Gowing & Sylvester, 1990, p. 25.
259 Auerbach's lover Stella West: Hughes, 1990(1), p. 114.
262 The critic Robert Hughes: ibid., p. 160.
263 He was fascinated by its mutability: Moorhouse, 1996, p. 20.
264 'Every time the model sits…': , ibid., p. 22.
265 Still, he kept doggedly drawing: Hicks, 1989, p. 44.
266 'Nothing really begins to happen…': McKenna, 1993.

Chapter 16
267 One day in April: Sykes, 2011, pp. 93-94.
267 More significantly for his long-term future: ibid., pp. 83-89.
268 'The main thing was…': Walsh, 2016.
268 Writing several years later: Robertson, 1965, p. 235.
269 He bought a ticket to New York: Sykes, 2011, pp. 95 ff.
269 New York 'was amazingly sexy…': ibid., p. 95.
270 Late in 1962, ibid., p. 110.
270 This tussle with authority: ibid., pp. 106-11.
271 On Wednesday 17 April 1963: ibid., pp. 123-24.
274 In the late spring of 1963: ibid., pp. 128 ff.
274 'My God,' he thought, 'this place needs its Piranesi…': ibid., p. 145.
277 he and Kasmin paid a visit: ibid., pp. 149-50.
277 In LA in 1964, Hockney noted: Hockney, 1976, pp. 103-4.
277 Hockney described the picture: ibid.
279 on 9 January 1966: Sykes, 2011, p. 169.
283 he saw an advertisement for Macy's: Hockney, 1976, p. 124.

285 He sometimes wondered: ibid., p. 160.
288 Hockney has described the way: ibid., pp. 152-57.
288 Hockney's aim was to represent: ibid., pp. 203-4.
289 In the spring of 1970: ibid.

Chapter 17
290 'It was a period of hope…': Hucker, 2013.
290 The doorway on North Audley Street: for Riley's meeting with Musgrave, and quotation, Miles, 2010, p. 79.
291 She spent her time nursing her father: Riley's activities are detailed in Moorhouse, 2003, p. 221.
293 When she had finished: this incident and subsequent quotations are from Kimmelman, 2000.
295 When he 'came within range…': Follin, 2004, p. 44.
296 The artist was once told: ibid., p. 63.
296 Here was art, Jonathan Miller wrote: ibid., pp. 38-40.
296 In 1965, she made a public statement: Riley, 1999, pp. 66-68.
297 This was a time when excitement: Sandbrook, 2006, p. 7.
298 However, Kasmin wrote to the American: Sykes, 2011, p. 132.
300 Smith wanted his paintings to 'enter the real world…': Robertson, 1965, p. 12.
302 But Quant herself felt the garment was: Polan & Tredre, 2009, p. 103.
305 At the opening of 'The Responsive Eye': Follin, 2004, p. 192.
305 *Time* magazine, breathlessly covering the opening: ibid., pp. 190-91.
306 she was greeted, 'by an explosion…': Riley, 1999, p. 66.
306 On 13 March 1965, Hella Picha Follin, 2004, p. 192.
306 According to the American critic John Canaday: ibid., p. 178.
307 'So, you don't like it?': ibid., p. 192.
308 *Mirror* (1966) depicts the artist himself: for an account of Bowling's painting and the circumstances of its making, see Gooding, 2011, pp. 47-50.

Chapter 18
313 'The picture', he once explained to the critic Robert Hughes: Hughes, 1990(2), p. 284.
315 At the time Chatwin lived in a flat: Auping, 1995, pp. 14-15.
316 He informed an audience at the Slade in 1981: Hodgkin, 1981.
316 In *Mr and Mrs E.J.P.* (1969-73) the collector: Moorhouse, 2017, p. 106.
317 He told Richard Morphet that the 1950s: Auping, 1995, p. 12.
317 'The more evanescent…': Moorhouse, 2017, p. 35.

318 He too felt that he was isolated: Livingstone, 1985, p. 18.
319 Some of his early works, such as *The Murder of Rosa Luxemburg*: for Kitaj's notes on this picture, see Morphet, 1994, p. 82.
319 *The Ohio Gang* (1964) is not about the cronies: ibid., p. 84.
320 As a preface he quoted the Roman poet: Livingstone, 1985, p. 16.
320 When he was a child, he explained: Morphet, 1994, p. 48.
322 He remembered how 'Harry Fischer…': ibid., p. 44.
322 'I believe he sought to stun his audience…': ibid.
323 Kitaj admitted as much: 'Romance provides…': Livingstone, 1985, p. 16.
325 One of Rego's most striking pictures: for the genesis of *Stray Dogs*, see McEwen, 1992, pp. 76-77.
325 'Fear is something you have all the time…': Eastham & Graham, 2011.
325 In contrast, as the critic Christopher Finch: Wallis, 2013(1), p. 53.
326 Caulfield claimed that his clear bold line: for Caulfield's visit to Knossos, see Livingstone, 1999, p. 25.
326 'The subjects are imaginary…': Wallis, 2013(1), p. 59.
326 *Santa Margherita Ligure* (1964) was based: Wallis, 2013(2).
327 To be precise, he explained: Livingstone, 1999, p. 23.
327 When he left school aged fifteen: ibid.
330 Looking back, Caulfield reflected: Vyner, 1999, p. 141.
330 Bridget Riley tells the story: ibid., pp. 146-47.
330 He was instrumental in persuading the band: for the *Sgt. Pepper* cover, see ibid., pp. 186-90.
330 Caulfield recounted an occasion: ibid., pp. 140-42.
331 On the evening of Sunday 12 February: for detailed accounts of the bust, see ibid., p. 178 ff.
332 The photograph made a strong impression on Richard Hamilton: for an account of Hamilton's *Swingeing London 67* series, see Morphet, 1992, pp. 166-68.
332 'The gallery was empty, poor…': Vyner, 1999, pp. 204-5.

Epilogue
336 Less dramatic, and more irreverent: Hockney, 1976, p. 194.
339 'I was the right kind of artist…': Burn, 2000.
339 'Robyn Denny keeps saying…': ibid.

Bibliography

Alloway, Lawrence, *Nine Abstract Artists*, London, 1954

—, 'The Arts and the Mass Media', *Architectural Design* (February 1958)

Auping, Michael et al., *Howard Hodgkin Paintings*, London, 1995

Berger, John, *Permanent Red: Essays in Seeing*, London, 1960

Bernard, Bruce, 'Painter Friends', in *From London: Bacon, Freud, Kossoff, Andrews, Auerbach, Kitaj*, exh. cat., London, British Council, 1995

— & Derek Birdsall (eds), *Lucian Freud*, London, 1996

Berthoud, Roger, *Graham Sutherland: A Biography*, London, 1982

Bird, Michael, *Sandra Blow*, Aldershot, 2005

Blow, Sandra, Interview with Andrew Lambirth, Part 3. National Life Stories: Artists' Lives, British Library, 7 October 1996

Boshier, Derek & Olivia Reeve, 'Derek Boshier in conversation with Octavia Reeve', Royal College of Art Blog, 30 June 2016, www.rca.ac.uk/news-and-events/rca-blog/derek-boshier/

Bowen, Elizabeth, *The Demon Lover and Other Stories*, London, 1945

Burn, Gordon, 'The Invisible Man', interview with Richard Smith, *Guardian*, 11 April 2000

Caiger-Smith, Martin (ed.), *Roger Hilton*, exh. cat., London, South Bank Centre, 1993

Calvocoressi, Richard, *Michael Andrews: Earth Air Water*, exh. cat., London, Gagosian Gallery, 2017

Clark, Adrian & Jeremy Dronfield, *Queer Saint: The Cultured Life of Peter Watson*, London, 2015

Clark, Kenneth, *The Nude*, London, 1957

Cohen, Louise, 'Interview with Alan Davie', 2009, www.tate.org.uk/context-comment/articles/remembering-alan-davie

Collins, Ian, *John Craxton*, Farnham, 2011

Cork, Richard, *David Bomberg*, exh. cat., London, Tate Gallery, 1988

Craig-Martin, Michael, 'Richard Hamilton in Conversation with Michael Craig-Martin', in *Richard Hamilton*, eds Hal Foster & Alex Bacon, Cambridge, Mass., 2010

Daniels, Stephen, 'A Study in denim', *Tate Etc.*, 10 (Summer 2007)

Denny, Robyn (interview), 'Situation: The British abstract scene in 1960', *Isis*, 6 June 1964, pp. 6–8

Eastham, Ben & Helen Graham, 'Interview with Paula Rego', *White Review* (January 2011), www.thewhitereview.org/feature/interview-with-paula-rego/

Farson, Daniel, *Sacred Monsters*, London, 1988

—, *The Gilded Gutter Life of Francis Bacon*, London, 1993

Feaver, William, *Lucian Freud*, exh. cat., London, Tate Gallery, 2002

—, and Paul Moorhouse, *Michael Andrews*, exh. cat., London, Tate Gallery, 2001

Follin, Frances, *Embodied Visions: Bridget Riley, Op Art and the Sixties*, London, 2004

Freud, Lucian, 'Some thoughts on painting', *Encounter*, 3:1 (July 1954), pp. 23–24

Gale, Matthew & Chris Stephens (eds), *Francis Bacon*, exh. cat., London, Tate Britain, 2008

Garlake, Margaret, *New Art, New World: British Art in Postwar Society*, New Haven & London, 1998

Gayford, Martin, 'The Duke, the photographer, his wife, and the male stripper', *Modern Painters*, 6:3 (Autumn 1993), pp. 23–26

—, *Man with a Blue Scarf: On Sitting for a Portrait by Lucian Freud*, London, 2010

Gooding, Mel, *Patrick Heron*, London, 1994

—, *Frank Bowling*, London, 2011

Gowing, Lawrence, *Eight Figurative Painters*, New Haven, 1981

—, *Lucian Freud*, London, 1982

— and David Sylvester, *The Paintings of William Coldstream (1908–1987)*, exh. cat., London, Tate Gallery, 1990

Greenberg, Clement, *Art and Culture: Critical Essays*, Boston, 1961

Gruen, John, *The Artist Observed*, Chicago, 1991

Harrison, Martin, *In Camera: Francis Bacon, Photography, Film and the Practice of Painting*, London, 2005

Hegel, G. W. F., *Hegel's Aesthetics: Lectures on Fine Arts*, trans. T. M. Knox, Oxford, 1975

Hennessy, Peter, *Having it So Good: Britain in the Fifties*, London, 2006

Heron, Patrick, *Painter as Critic: Selected Writings*, ed. Mel Gooding, London, 1998

Hicks, Alistair, *The School of London: The Resurgence of Contemporary Painting*, Oxford, 1989

Higgins, Charlotte, 'Leon Kossoff's love affair with London', *Guardian*, 27 April 2013

Hockney, David, *David Hockney by David Hockney*, ed. Nikos Stangos, London, 1976

— and Martin Gayford, *A History of Pictures: From the Cave to the Computer Screen*, London, 2016

Hodgkin, Howard, 'How to be an artist', The William Townsend Memorial Lecture, 15 December 1981, https://howard-hodgkin.com/resource/how-to-be-an-artist

— and John Tusa, 'John Tusa interviews Howard Hodgkin', 7 May 2000, https://howard-hodgkin.com/resource/john-tusa-interviews-howard-hodgkin

Hucker, Simon (moderator), 'The New Situation: Kasmin, Caro & Miller recall the Sixties', 24 April 2013, www.sothebys.com/en/auctions/2013/the-new-situation-l13144/the-new-situation-art-in-london-in-the-sixties/2013/07/kasmin-caro-miller-recall-the-sixties-london-art-scene.html

Hughes, Robert, *Lucian Freud: Paintings*, London, 1988

—, *Frank Auerbach*, London, 1990(1)

—, *Nothing if Not Critical: Selected Essays on Art and Artists*, London, 1990(2)

—, *American Visions: The Epic History of Art in America*, London, 1997

Hyman, James, *The Battle for Realism: Figurative Art in Britain during the Cold War, 1945–60*, New Haven & London, 2001

Jarman, Derek, *The Last of England*, ed. David L. Hirst, London, 1987

Johnstone, William, *Points in Time: An Autobiography*, foreword by Sir Michael Culme-Seymour, London, 1980

Kendell, Richard, *Drawn to Painting: Leon Kossoff's Drawings and Paintings After Nicholas Poussin*, London, 2000

Kimmelman, Michael, 'Not so square after all', Interview with Bridget Riley, *Guardian*, 28 September 2000

Kitaj, R. B., *The Human Clay: An Exhibition*, exh. cat., London, Arts Council, 1976

Lampert, Catherine, *Frank Auerbach: Speaking and Painting*, London, 2015

Laughton, Bruce, *The Euston Road School: A Study in Objective Painting*, Aldershot, 1986

Lessore, Helen, *A Partial Testament: Essays on Some Moderns in the Great Tradition*, London, 1986

Livingstone, Marco, *R. B. Kitaj*, Oxford, 1985

—, *Pop Art: A Continuing History*, London, 1990

—, *Patrick Caulfield*, exh. cat., London, Hayward Gallery, 1999

Luke, Michael, *David Tennant and the Gargoyle Years*, London, 1991

Lynton, Norbert, *William Scott*, rev. edn, London, 2007

McEwen, John, *Paula Rego*, London, 1992

MacInnes, Colin, *England, Half English*, London, 1961

McKenna, Kristine, 'Painting's quiet man: Leon Kossoff', *LA Times*, 13 May 1993

Massey, Anne, *The Independent Group: Modernism and Mass Culture in Britain, 1945–59*, Manchester, 1995

Mellor, David, *The Sixties Art Scene in London*, exh. cat., London, Barbican Art Gallery, 1994

Melly, George, *Don't Tell Sybil: An Intimate Memoir of E.L.T. Mesens*, London, 1997

Miles, Barry, *London Calling: A Countercultural History of London Since 1945*, London, 2010

Moffat, Isabelle, 'Richard Hamilton and Victor Pasmore, *an Exhibit*, 1957', from 'The Artist as Curator #1', *Mousse Magazine*, 42 (February 2014), http://moussemagazine.it/taac1-b/

Moorhouse, Paul, *Leon Kossoff*, exh. cat., London, Tate Gallery, 1996

— (ed.), *Bridget Riley*, exh. cat., London, Tate Gallery, 2003

— Francis Bacon and Friends, exh. cat., London, National Portrait Gallery, 2017

Morphet, Richard, *Richard Hamilton*, exh. cat., London, Tate Gallery, 1992

—, *R.B. Kitaj: A Retrospective*, exh. cat., London, Tate Gallery, 1994

Peppiatt, Michael, *Francis Bacon: Anatomy of an Enigma*, London, 1996

—, *Francis Bacon in the 1950s*, exh. cat., Norwich, Sainsbury Centre for Visual Arts, 2006

—, *Francis Bacon: Studies for a Portrait: Essays and Interviews*, New Haven and London, 2008

—, *Francis Bacon in your Blood: A Memoir*, London, 2015

Polan, Brenda & Roger Tredre, *The Great Fashion Designers*, New York and Oxford, 2009

O'Donnell, C. Oliver, 'Meyer Schapiro, Abstract Expressionism, and the paradox of freedom in art historical description', *Tate Papers*, 26 (Autumn 2016), www.tate.org. uk/research/publications/tate-papers/26/meyer-schapiro-abstract-expressionism

Richardson, John, *The Sorcerer's Apprentice: Picasso, Provence and Douglas Cooper*, London, 2001

—, 'Bacon Agonistes', *New York Review of Books*, 17 December 2009

Riley, Bridget, 'Bridget Riley in conversation with Isabel Carlise', in *Bridget Riley: Works 1961–1998*, exh. cat., Kendal, Abbot Hall Art Gallery, 1998

—, *The Eye's Mind: Collected Writings 1965–2009*, ed. Robert Kudielka, London, 1999

Robertson, Bryan, *Alan Davie, Catalogue of an Exhibition of Paintings and Drawings from 1936–1958*, exh. cat., London, Whitechapel Art Gallery, 1958

—, John Russell & Lord Snowdon, *Private View*, London, 1965

—, *Richard Smith: Paintings 1958–1966*, exh. cat., London, Whitechapel Art Gallery, 1966

Rosenberg, Harold, *The Tradition of the New*, London, 1962

Rothenstein, John, *Modern English Painters: Volume Three Hennell to Hockney*, new edn, London, 1984

Russell, John, *Francis Bacon*, London, 1971

— Tom Jopling, Frank Proud', exh. cat., London, Arts Council, 1974

Sandbrook, Dominic, *White Heat: A History of Britain in the Swinging Sixties*, London, 2006

Seedo, N. M., *In the Beginning was Fear*, London, 1964

Sickert, Walter, *A Free House!*, ed. Osbert Sitwell, London, 1947

Smee, Sebastian, Bruce Bernard & David Dawson, *Freud at Work*, London, 2006

Spalding, Frances, *John Minton: Dance Till the Stars Come Down*, London, 1991(1)

—, Introduction, *The Kitchen Sink Painters*, exh. cat., London, The Mayor Gallery, 1991(2)

—, 'Prunella Clough and the art of "saying a small thing edgily"', *Guardian*, 30 March 2012(1)

—, *Prunella Clough: Regions Unmapped*, Farnham, 2012(2)

Sykes, Christopher Simon, *Hockney: The Biography, Volume I: 1937–1975, A Rake's Progress*, London, 2011

Sylvester, David, 'The Kitchen Sink', *Encounter*, December 1954, pp. 61–63

—, *Interviews with Francis Bacon*, London, 1975

—, 'Against the odds', in *Leon Kossoff: Recent Paintings*, exh. cat., London, British Council, 1995

—, *Looking Back at Francis Bacon*, London, 2000

Tate, Sue, *Pauline Boty: Pop Artist and Woman*, exh. cat., Wolverhampton Art Gallery, 2013

Thompson, John R., 'Nan Kivell, Sir Rex De Charembac (1898–1977)', *Australian Dictionary of Biography*, vol. 15, Melbourne, 2000

Townsend, William, *The Townsend Journals: An Artist's Record of his Times, 1928–51*, ed. Andrew Forge, London, 1976

Tufnell, Ben, *Francis Bacon in St Ives: Experiment and Transition 1957–62*, London, 2007

Vyner, Harriet, *Groovy Bob: The Life and Times of Robert Fraser*, London, 1999

Walker, Neil (ed.), *Victor Pasmore: Towards a New Reality*, exh. cat., London, 2016

Wallis, Clarrie, *Patrick Caulfield*, exh. cat., London, Tate, 2013(1)

—, 'Fun, exotic and very modern', in *John* (summer 2013)(2)

Walsh, John, 'The Spider-Man of art dealers', *Christie's Magazine* (November–December 2016)

Warner, Marina, 'Lucian Freud: the unblinking eye', *New York Times Magazine*, 4 December 1988

Whiteley, Nigel, *Art and Pluralism: Lawrence Alloway's Cultural Criticism*, Liverpool, 2012

Wilcox, Tim (ed.), *The Pursuit of the Real: British Figurative Painting from Sickert to Bacon*, exh. cat., Manchester City Art Gallery, 1990

Wilson, A. N., *After the Victorians: The World Our Parents Knew*, London, 2005

Wishart, Michael, *High Diver*, London, 1977

Yorke, Malcolm, *The Spirit of Place: Nine Neo-Romantic Artists and their Times*, London, 1988

Picture Credits

2 Photo The John Deakin Archive/Getty Images; 13 Photo Ian Gibson Smith; 18 Photo The John Deakin Archive/Getty Images; 21 Ink and chalk on paper, 54.8 × 76.2 (21½ × 30). Tate, London. © Estate of John Craxton. All Rights Reserved, DACS 2018; 24 Oil on three boards, each: 94 × 73.7 (37 × 29). Tate, London. Presented by Eric Hall 1953. © Tate, London 2018; 26 Photo © Sam Hunter; 29 Oil on canvas, 144.8 × 128.3 (57 × 50½). Tate, London. © Tate, London 2018; 32 Oil and pastel on canvas, 197.8 × 132.1 (65⅞ × 52). Museum of Modern Art, New York (229.1948). Photo Prudence Cuming Associates Ltd. © The Estate of Francis Bacon. All Rights Reserved, DACS/Artimage 2018; 42 Estate of John Minton. Courtesy Special Collections, Royal College of Art, London; 47 Oil on canvas, 71.1 × 91.4 (28 × 36). Private collection. Bridgeman Images; 48 Photo Humphrey Spender. Courtesy Bolton Council; 53 Oil on canvas, 107.5 × 132.8 (42¼ × 52¼). Tate, London. Presented by the Trustees of the Chantrey Bequest 1958. © Tate, London 2018; 54 Photo courtesy Gillian Ayres; 57 Oil on canvas, 88.9 × 41.9 (35 × 16½). Private collection. © Estate of Prunella Clough. All Rights Reserved, DACS 2018; 58 Oil on canvas, 98.9 × 119.3 (38⅞ × 46⅞). Tate, London. © Tate, London 2018; 60 Oil on board, 59.8 × 49.5 (23½ × 19½). Private collection. © The Estate of David Bomberg. All Rights Reserved, DACS 2018; 66 Oil on canvas, 69.8 × 90.8 (27½ × 35¾). Museum of London. © The Estate of David Bomberg. All Rights Reserved, DACS 2018; 70 Oil on canvas, 99 × 75.5 (39 × 29¾). Image courtesy Gallery Oldham. © Estate of John Craxton. All Rights Reserved, DACS 2018; 75 Oil on canvas, 105.5 × 74.5 (41½ × 29¼). British Council. © The Lucian Freud Archive/Bridgeman Images; 80 Photo © Sam Hunter; 84 Oil on canvas, 93 × 76.5 (36⅝ × 30⅛). Arts Council Collection. Photo Prudence Cuming Associates Ltd. © The Estate of Francis Bacon. All Rights Reserved, DACS/Artimage 2018; 85 Sergej M. Eisenstein (dir.), USSR 1925; 90 Photo Edwin Sampson/ANL/REX/Shutterstock; 92 Oil on canvas, 178 × 127 (70 × 50). Laing Art Gallery, Newcastle upon Tyne. © The Artist's Estate; 95 Photo Charles Hewitt/Picture Post/Getty Images; 99 Mixed media on masonite, 152 × 91.4 (59⅞ × 36). Collection Albright-Knox Art Gallery, Buffalo, New York. Gift of Seymour H. Knox, Jr., 1958. © The Sandra Blow Estate Partnership. All Rights Reserved, 2018; 102 Oil on canvas, 61 × 50.8 (24 × 20). Southampton City Art Gallery. © Estate of Roger Hilton. All Rights Reserved, DACS 2018; 105 Gouache on paper, 31.8 × 27 (12½ × 10¾). © Estate of William Scott 2018; 109 Photo The John Deakin Archive/Getty Images; 110 Oil on canvas, 152.4 × 118.1 (60 × 46½). Hamburger Kunsthalle, Germany. Photo Hugo Maertens. © The Estate of Francis Bacon. All Rights Reserved, DACS/Artimage 2018; 116 Oil on copper, 17.8 × 12.8 (7 × 5). © Tate, London 2018; 119 Oil on canvas, 152.4 × 114.3 (60 × 45). Walker Art Gallery, National Museums Liverpool. © The Lucian Freud Archive/Bridgeman Images; 121 Photo Hulton-Deutsch Collection/Corbis via Getty Images. Courtesy The Estate of Graham Sutherland; 126 Oil on board, 152.4 × 152.4 (60 × 60). Accepted by HM Government in Lieu of Inheritance Tax and allocated to The Samuel Courtauld Trust, The Courtauld Gallery in 2015. © Frank Auerbach, courtesy Marlborough Fine Art; 129 Courtesy Marlborough Fine Art; 132 Oil on board, 77 × 58 (30¼ × 22¾). Collection of Anne and Torquil Norman. © Leon Kossoff; 135 Oil on canvas, 76.2 × 50.8 (30 × 20). Private collection. © Frank Auerbach, courtesy Marlborough Fine Art; 140 Collage, 35.8 × 23.8 (14⅛ × 9⅜). Tate, London. Presented by the artist 1995. © Trustees of the Paolozzi Foundation, Licensed by DACS 2018; 143 Oil wood photo-collage and record on hardboard, 94 × 154.9 (37 × 61). Whitworth Art Gallery, The University of Manchester. © Peter Blake. All Rights Reserved, DACS 2018;

148; Oil paint, metal foil and digital print on wood, 122 × 81 (48 × 31⅞). Tate, London. Purchased with assistance from the Art Fund and the Friends of the Tate Gallery 1995. © R. Hamilton. All Rights Reserved, DACS 2018; 149 Photo Bettmann/Getty Images; 151 Collage, 26 × 24.8 (10¼ × 9¾). Kunsthalle Tübingen. Photo flab/Alamy Stock. © R. Hamilton. All Rights Reserved, DACS 2018; 154 Courtesy Derrick Greaves/James Hyman Gallery, London; 156 Oil on hardboard 122 × 77.5 (48 × 30½). Ferens Art Gallery, Hull Museums. Bridgeman Images; 161 Oil on board, 160 × 243.8 (63 × 96). Tate, London. © The Estate of Alan Davie. All Rights Reserved. DACS 2018; 166 Courtesy British Pathé; 167 Associated British Picture Corporation. Keystone Pictures USA/Alamy Stock Photo; 172–73 Ripolin on board, 4 panels: 230 × 91.5 (90½ × 36), 230 × 111.8 (90½ × 44), 230 × 274.4 (90½ × 108), 230 × 335 (90½ × 131⅞). Courtesy Gillian Ayres; 174 Courtesy Gillian Ayres; 180 Oil on canvas, 274.3 × 152.4 (108 × 60). Tate, London. © The Estate of Patrick Heron. All Rights Reserved, DACS 2018; 181 Oil paint and ink on paper, 23.8 × 15.6 (9⅜ × 6⅛). Tate, London. Purchased with assistance from the National Lottery through the Heritage Lottery Fund, the Art Fund and a group of anonymous donors in memory of Mario Tazzoli 1998. © The Estate of Francis Bacon. All Rights Reserved, DACS 2018; 183 Oil on canvas, 178.5 × 178 (70¼ × 70). National Galleries of Scotland. © Estate of William Turnbull. All Rights Reserved, DACS 2018; 185 Photo Mark and Colleen Hayward/ Redferns. © The Estate of Robyn Denny. All Rights Reserved, DACS 2018; 187 Oil and Ripolin on board, diptych, 305 × 320 (120 × 126). Courtesy Gillian Ayres; 188 Gouache on board, 22 × 25 (8⅝ × 9⅞). Collection of the artist. Courtesy the Estate of Howard Hodgkin; 190; Photo Tony Evans/Getty Images; 191 Oil on canvas, 91.5 × 127 (36 × 50). Collection Mr and Mrs John L. Townsend III. Courtesy the Estate of Howard Hodgkin; 193 Oil on linen, mounted on canvas, 121.9 × 182.9 (48 × 72). © National Portrait Gallery, London; 196 Oil on canvas, 122 × 122 (48 × 48). Private collection. © Allen Jones; 197 Oil on canvas, 213.4 × 334.6 (84 × 131¾). Tate, London. Presented by the Trustees of the Chantrey Bequest 1952. © Tate, London 2018; 198 Photo Tony Evans/Getty Images. © Allen Jones; 203 Photo © Geoffrey Reeve/Bridgeman Images; 208 Oil with sand on canvas, three panels, each 198.1 × 144.8 (78 × 57). The Solomon R. Guggenheim Foundation/Photo 2018 Art Resource, NY/ Scala, Florence. © The Estate of Francis Bacon. All Rights Reserved, DACS 2018; 214 Photo The John Deakin Archive/ Getty Images; 215 Oil on canvas, 198 × 147.5 (78 × 58). Private collection. © The Estate of Francis Bacon. All Rights Reserved, DACS/Artimage 2018; 218 Oil on canvas, 30.2 × 24.8 (11⅞ × 9¾). Private collection. © The Lucian Freud Archive/Bridgeman Images; 220 © Estate of Roger Mayne/Museum of London; 223 Oil on canvas, 61 × 61 (24 × 24). Collection of Steve Martin. © The Lucian Freud Archive/Bridgeman Images; 226 Oil on canvas, 213 × 173 (83⅞ × 68⅛). Private collection. © Richard Smith Foundation. All Rights Reserved, DACS 2018; 231 Oil on hardboard, 172.7 × 120.6 (68 × 47½). Tate, London. Presented by the Moores Family Charitable Foundation to celebrate the John Moores Liverpool Exhibition 1979. © Peter Blake. All Rights Reserved, DACS 2018; 234 Oil on canvas, 121.5 × 120.4 (47⅞ × 47¾). Private collection. © Derek Boshier. All Rights Reserved, DACS 2018; 237 Oil on canvas, 231.1 × 81.3 (91 × 32). Tate, London. Purchased with assistance from the Art Fund 1996. © David Hockney; 238 Oil on canvas, 122.4 × 153 (48⅛ × 60¼). Tate, London. © Pauline Boty. Courtesy Whitford Fine Art; 241 Photo © Michael Ward Archives/National Portrait Gallery, London. © Pauline Boty. Courtesy Whitford Fine Art; 242 Photo Tony Evans/Getty Images; 244 Oil on canvas, 145 × 101.5 (57⅛ × 40). © Frank Bowling. All Rights Reserved, DACS 2018; 245 Collection of the artist; 247 Oil on canvas, 168 × 213.7 (66⅛ × 84⅛). Tate,

Acknowledgments

London. © The Estate of Helen Lessore; 249 Photo John
Deakin Archive/Getty Images; 251 Oil on hardboard,
121.9 × 182.8 (48 × 72). Pallant House Gallery, Chichester.
Estate of Michael Andrews, courtesy James Hyman Gallery,
London; 254 Oil on board, 122 × 122 (48 × 48). Museo
Thyssen-Bornemisza, Madrid. Estate of Michael Andrews,
courtesy James Hyman Gallery, London; 257 Oil on board,
244 × 91.5 (96 × 36). University of Liverpool Art Gallery
& Collections/Bridgeman Images. © The Estate of
Euan Uglow, courtesy Marlborough Fine Art; 261 Oil on
board, 190.5 × 152.4 (75 × 60). Private collection. © Frank
Auerbach, courtesy Marlborough Fine Art; 262 Oil on
board, 121.3 × 152.5 (47¾ × 60). Private collection.
© Frank Auerbach, courtesy Marlborough Fine Art; 265 Oil
on board, 152.5 × 205 (60 × 81). Private collection. © Leon
Kossoff; 271 Photo Snowdon/Trunk Archive; 272 Oil on
canvas and plexiglass, 182.9 × 198.1 (72 × 78). Photo Fabrice
Gibert. © David Hockney; 276 Acrylic on canvas, 152.4 ×
182.9 (60 × 72). Collection Arts Council, Southbank Centre,
London. Photo Richard Schmidt. © David Hockney;
280 Egg tempera and oil on linen, 198 × 177.8 (78 × 70).
© Bernard Cohen. All Rights Reserved, DACS 2010;
281 Acrylic on canvas, 182.9 × 182.9 (72 × 72). Collection
Museum Ludwig, Cologne. © David Hockney; 282 Acrylic
on canvas, 243.8 × 243.8 (96 × 96). © David Hockney;
283 Photo Whitechapel Art Gallery; 286–87 Acrylic on
canvas, 212.1 × 303.5 (83½ × 119½). Photo Fabrice Gibert.
© David Hockney; 293 Tempera on board, 121.9 × 121.9
(48 × 48). Photo Anna Arca. © Bridget Riley 2018.
All Rights Reserved; 294 Emulsion on board, 166 × 166
(65⅜ × 65⅜). British Council Collection. Bridget Riley
Archive. © Bridget Riley 2018. All Rights Reserved; 297
Conte and pastel on paper, 43 × 21.2 (17 × 8½). Bridget Riley
Archive. © Bridget Riley 2018. All Rights Reserved; 299
Acrylic on canvas, 213.4 × 304.8 (84 × 120). Photo courtesy
The John Hoyland Estate and Pace Gallery. © Estate of John
Hoyland. All Rights Reserved, DACS 2018; 300 Steel &
aluminium, painted red, 290 × 620 × 333 (114 × 244 × 143).
Tate, London. Presented by the Contemporary Art Society
1965. © Courtesy Barford Sculptures Ltd. Photo John Riddy;
303 Oil on canvas plus shelf, 92 × 92 (36¼ × 36¼). Collection
of the artist. © Allen Jones; 304 Private collection; 307 ©
Estate of Antonio Lopez & Juan Ramos; 308 © National
Portrait Gallery, London; 309 Photo Tseng Kwong Chi/
Muna Tseng Dance Projects; 311 Oil on canvas, 318 × 216.8
(122 × 85⅜). Tate, London. Presented by the artist, Rachel
Scott, and their four children: Benjamin and Sacha Bowling,
Marcia and Iona Scott 2013. © Frank Bowling. All Rights
Reserved, DACS 2018; 314 Oil on hardboard, 41 × 51
(16 × 20). Courtesy the Estate of Howard Hodgkin; 317 Oil
on wood, 109.1 × 139.5 (43 × 54⅞). Tate, London. Courtesy
the Estate of Howard Hodgkin; 318 Photo Fred W.
McDarrah/Getty Images; 320 Oil and graphite on canvas,
183.1 × 183.5 (6⅛ × 6¼). Museum of Modern Art,
New York. Philip Johnson Fund (109.1965). Courtesy
Marlborough Fine Art. © R. B. Kitaj Estate; 321 Oil on
canvas, diptych, each: 152 × 91 (59⅞ × 35⅞). Private
collection. Courtesy Marlborough Fine Art © R. B. Kitaj
Estate; 324 Collage and oil on canvas, 160 × 185 (63 × 72⅞).
Collection Francisco Pereora Coutinho. © Paula Rego.
Courtesy Marlborough Fine Art; 326 French recipe card;
327 Oil on board, 122 × 244 (48 × 96). Private collection.
© The Estate of Patrick Caulfield. All Rights Reserved,
DACS 2018; 329 Oil on board, 91.4 × 213.4 (36 × 84).
Leslie and Clodagh Waddington. © The Estate of Patrick
Caulfield. All Rights Reserved, DACS 2018; 332 Oil on
canvas and screen print, 67 × 85 (26¾ × 33½). Private
collection. © R. Hamilton. All Rights Reserved, DACS 2018

This book has been a long time in the making.
The earliest conversations folded into this text
are now over twenty-five years old. A slightly
eerie, though fascinating, part of the process
was listening again to recordings of my own
voice questioning and responding to others,
some now dead, decades ago. Their thoughts
and memories fill *Modernists & Mavericks*
and are, in a way, its subject.

I should like to thank again all those I have
talked to over the years, and most of all those
who helped me generously during the gestation
of this project: Frank Auerbach, Gillian Ayres,
Frank Bowling, Anthony Eyton, David Hockney,
Kasmin, James Kirkman, John Lessore, Richard
Morphet, Henry Mundy, Rachel Scott, Angus
Stewart and John Wonnacott.

In addition, Gillian Ayres, Frank Bowling,
David Dawson, Catherine Lampert, Allen Jones
and Daphne Todd kindly read sections of the
text and made many invaluable suggestions.
A student of mine, Maggie Armstrong, taught
me a lot about Sandra Blow. My son Tom gave
stalwart assistance in reading early drafts and
my daughter Cecily also contributed crucial
advice. The members of the team at Thames
& Hudson, particularly Michela Parkin, Julia
MacKenzie, Poppy David, Maria Ranauro and
Anna Perotti, have done a marvellous job of
editing, picture research and design. It has been
a pleasure to collaborate with them.

Index

Page numbers in *italic* refer
to the illustrations

Abstract Expressionism
35–36, 45, 88, 89, 141, 144,
160–74, 175, 198–99, 202,
203, 289, 299
Abstraction 88–106
Ambiguity 187–90
Bacon and 178–79
hard-edge paintings
182–84, 192, 230
Hilton and 100–4
Pasmore turns to 94–98
Royal College of Art and
198–99
'Situation' exhibitions
186–87, 192–93
Action Artist (film) 165, *166*
action painting 160–62,
165–8, 170–74
Adams, Robert 103
Agnew's 37
Aitchison, Craigie 247
Alloway, Lawrence 103–4,
139, 141–43, 145, 146, 175,
182, 185, 186, 192–93,
204, 268
Altamira cave paintings
334, 335
American Embassy library
137, 152
Andrews, Michael 2, 228,
247, 248, 249, 251–55, 338
All Night Long 252
Colony Room I 251–52, *251*
The Deer Park 252
Good and Bad at Games 252
Portrait of Timothy Behrens
253–54, *254*
Angelico, Fra 285
Annesley, David 301
Art informel 89
Artists International
Association (AIA) 93,
100, 170, 171
ARTnews 166–67, 186
Arts Council 89–91, 120
Atlas, Charles 152
Attlee, Clement 8, 93
Auden, W. H. 44
Auerbach, Frank 7, 8, 15,
129, 144, 158, 189–90,
247–50, 249, 255, 266
and Abstract
Expressionism 160,
164–65
on attitudes to painting
25, 197
on Bacon 22, 37, 107
on Bomberg 61, 64–68
on Coldstream 50
on 'crossing the border' 366

early life 127–28, 133–36
exhibitions 130, 134–36,
204–5
and Freud 76, 115, 220–21,
259
on Hockney 269, 289
and Kossoff 125–27, 128,
130–31, 136
in the 1960s 259–63, 335
E.O.W. Nude 133–34, *135*
*E.O.W., S.A.W. and J.J.W. in
the Garden I* 261
*Mornington Crescent with
the Statue of Sickert's Father-
in-Law III* 262, 263
*Rebuilding the Empire
Cinema* 126
Summer Building Site 133
Austin Reed 184–85, *185*
Auty, Giles 178
Ayer, A. J. 67
Ayres, Gillian 8, 10, *174*,
278, 338
and abstraction 93, 100,
101–3, 187–90
action paintings 168, 170,
171–74
at Camberwell 41–42, 49,
50–4, *54*, 56, 137
exhibitions 169, 170, 186,
192–93
on the Independent Group
141
Cumuli 187, 188
Hampstead Mural 171–74,
172–73
Ayrton, Michael 19

Bachardy, Don *286–7*, 288
Bacon, Francis 2, 8–10, 21,
26, 42, 49, 59, *116*, 189–90,
247–48, 249
and abstraction 164,
178–79
Bomberg on 61–62
destroys paintings 37,
112, 113
early life 25–39, 79
exhibitions 22–23, 37,
51, 83, 168, 177, 206–7,
211–12, 337
and Freud 114–17
influence of 162, 203, 311,
335, 337
John Berger and 153
Kitaj and 321–23
make-up 30
in the 1950s 107–14
in the 1960s 206–16
obsession with paint
27–33
opposition to 'illustration'
120–22, 210, 321

Picasso's influence 23–25,
36, 108, 211, 224
and photography 81–82,
210, 212–16, 336
portraits 108–12, 250–51
relationships 85–86,
109–12, 176–77
in St Ives 176–78
screaming popes 85–87,
113
on shadows 107
studios 80–81, *80*
travels 79–80
Van Gogh paintings 177
working methods 113–14
Crucifixion 36, 38, 141, 209
Figure in a Landscape 27,
28–30, *29*
Figure Study II 33
Figures in a Garden 38
Heads 79, 83–7, *84*
Painting 1946 32, 33–35,
37, 38–39, 79, 209
Portrait of Lucian Freud
117
Sketch of reclining figure
181
Study for a Portrait 110, *111*
*Study for Portrait of
Henrietta Moraes* 215
*Three Studies for a
Crucifixion* 206–11, *208*
*Three Studies for Figures
at the Base of a Crucifixion*
22–23, 24, 25, 27, 33, 35,
38, 212
*Three Studies of Lucian
Freud* 6
Wound for a Crucifixion 37
Balla, Giacomo 291, 292
Balthus 322
Banham, Reyner 139–41,
146
Barber, Chris 142
Barker, George 17
Barr, Alfred H. 39, 78–79
Baselitz, Georg 267, 335
Bath School of Art and
Design 189
Battleship Potemkin 83, *85*,
86, 212
Baudelaire, Charles 81, 330
Bauhaus 25, 291
BBC 163, 233
The Beatles 185, *185*, 330,
333
Beaux Arts Gallery 134–36,
154–55, 246–48, 250,
252–53
Behrens, Timothy 2, 248,
249, 250, 253–54, *254*
Belcher, Muriel 212–13, 251
Bell, Graham 50

Bellamy, Richard 228
Bellingham-Smith, Elinor
164, 212
Belmondo, Jean-Paul 239
Belton, Ron 176, 178
Berger, John 55, 131,
153–54, 155
Berger, Mark 269
Bergman, Ingmar 123–24
Berkeley, Bishop 63–64
Berlemont, Gaston 118
Bernard, Bruce 14, 19, 250,
251–52
Bernard, Jeffrey 14, 250,
252
Birtwell, Celia 289
Blackwood, Caroline 114
Blake, Peter 142–45, 147,
230–33, 239, 240, 311, 338
Got a Girl 143
*Sgt. Pepper's Lonely Hearts
Club Band* 330, 333
Self-Portrait with Badges
231–33, *231*
Blake, William 68, 202, 289
Bloomsbury Group 23
Blow, Sandra 88, *90*, 98, 168
*Construction, Rock and
Water* 98
Painting 1957 98, *99*
Boccioni, Umberto 62, 292
Bolus, Michael 301
Bomberg, David 44, 59–68,
95, 125, 128, 130, 165, 204,
289, 335
*Evening in the City of
London* 66, *66*
The Mud Bath 62
Self-Portrait 60
Bonnard, Pierre 178
Booker, Christopher 306
Borough Polytechnic 59–62,
65–68, 125
Boshier, Derek 195, 199,
203, 233–36, 269, 275, 330
England's Glory 235
Special K 234, 235–36
Botticelli, Sandro 71, 239
Boty, Pauline 199, 233,
236–42, 241, 243
*The Only Blonde in the
World* 238, *238*, 240
Scandal '63 239–41, *241*
*With Love to Jean-Paul
Belmondo* 239
Boucher, François 239
Bowen, Elizabeth 127
Bowling, Frank 10, 179,
195, 198, 199, 202, 228,
242, 243–45, 308–12, 322,
328, 338
Cover Girl 243–45, *244*
Mirror 308–12, *310*

Bradford School of Art 201
Brancusi, Constantin 141
Braque, Georges 125, 185
Bratby, John 154–57, *154*, 235
 The Toilet 155, *156*
Braun, Felix 20
Brausen, Erica 39, 79, 177
Britten, Benjamin 44, 89
Bronowski, Jacob 68
Brown, Oliver 14
Brownjohn, Robert 227
Buhler, Robert 114, 197
Burgess, Guy 58
Burri, Alberto 88–89, 98
Burroughs, Edgar Rice 284

Calder, Alexander 205
Camberwell School of Art 40–42, 49, 51, 53–54, 56, 93, 137, 142
Camden Town Group 154, 260
Campbell, John W. 142
Canaday, John 306
Canberra, SS 267
Cardin, Pierre 243
Carnaby Street 184, 301
Caro, Anthony 9, 204, 290, 300–1
 Early One Morning 300
Carone, Nicolas 88
Carrà, Carlo 62
cars 149, *149*, 152
Caulfield, Patrick 9, *313*, 325–31, 338
 Corner of the Studio 329, *329*
 Santa Margherita Ligure 326–27, *327*
 Wine Bar 328
Cavafy, C. P. 275
Cézanne, Paul 76, 93, 111, 266, 255, 263, 322, 328, 335
Chardin, J.-B.-S. 82
Chatwin, Bruce 315, 316
Chomsky, Noam 97
Chrysler Corp 147–49, 152
Churchill, Winston 121–22, *121*
Cimabue 209
Clark, Kenneth 18, 22, 38, 51, 94–95, 96, 123, 222
Clark, Ossie 199, 275, 288–89
Claude Lorrain 187
clothes 184–85, 194, 243, 301–6
Clough, Prunella 54–56
 Cranes and Men 57
Cochrane, Peter 205
Cocteau, Jean 77, 78, 165

Coffin, Pat 306
Cohen, Bernard 230, 278–79
 Alonging 280
Coldstream, William 8, *48*, 54, 69, 147, 189
 approach to painting 43–49, 52–53, 59, 76–77, 96, 101–3, 108
 early life 18, 42–51
 and photography 74, 81–82
 at the Slade 50, 253–55, 256, 335
 teaches at Camberwell 49
 St Pancras Station 46, *47*, 50
Coleman, Roger 182, 185
Collages 139, 147, 150, 152, 184–85
Colony Room 250–52, *251*, 254, 317, 322
Colour 194–95, 300–1
colour field painting 178, 233, 243, 246, 273, 298
Colquhoun, Robert 11, 12, 17–18, *18*, 19
Communist Party 51, 153
Connolly, Cressida 73–74
Connolly, Cyril 19, 50, 69, 155
Constable, John 31, 187, 263
Constructivism 89, 94, 98, 103
Cordell, Frank 145
Cork, Richard 63
Corot, J.-B.-C. 316
Courbet, Gustave 221, 308–11
Courrèges, André 243
Cragg, Tony 337
Claxton, John 12–17, 19–21, 22, 28, 43, 69, 71, 77
 Beach Scene 70
 Dreamer in Landscape 19–20, *21*
Creffield, Dennis 61, 67, 68
Crosland, Anthony 171
Cubism 23, 125, 338
Cuthbertson, Penelope 224

Dada 139, 169
Dalí, Salvador 77, 269
Darwin, Robin 179, 201, 270–71
Davie, Alan 161–62, 168, 202
 Birth of Venus 161
Dawson, David 224
de Kooning, Willem 160, 162, 255
de Maistre, Roy 27
de Sausmarez, Maurice 292

Deakin, John 2, *18*, *109*, 212–13, *214*, 217–19, *218*, 248–50, *249*, 252
Debord, Guy 169
Degas, Edgar 200
del Renzio, Toni 139, 146
Delaunay, Robert 62
Denny, Anna 190–91, *191*, 318
Denny, Robyn 144, 145, 159, 166, 169, 170, 175, 176, 180 82, 186, 190–92, *191*, 210, 227, 229, 258, 300, 318, 339
 Great Big Biggest Wide London 184–85, *185*
Diamond, Harry 118–20
Dine, Jim 145, 228, 330
Doré, Gustave 219
Dubuffet, Jean 203
Duchamp, Marcel 85, 147, 150, 197, 334
Dyer, George 112, 212, 337

Eardley, Joan 9
Eisenstein, Sergei 83
Elgar, Edward 89
Eliot, T. S. 200, 320
Elizabeth II, Queen 245
Ellis, Clifford 189
Encounter 117, 120, 122, 155
Epstein, Jacob 73
Ernst, Max 139
Escher, M. C. 299
Euston Road School 41–42, 49–54, 67, 76, 96, 108, 147, 159
Eyton, Anthony 48–49

Fairlie, Henry 170
Farson, Daniel 211–12, 217–18
Fauvism 195, 270
Fawkes, Wally 41
Feigen, Richard L. 306
Fellini, Federico 331
Feminism 304–5
Fenton, Rudolf 240–41
Festival of the Arts (1951) 89–91
Festival of Britain (1951) 89, *95*, 96, 97–98, 133
Festival Pattern Group 98
films 138, 150, 165–66
Finch, Christopher 325
Fischer, Harry 206–8, 322
Forge, Andrew 246, 253, 295
Formby, George 16
Fraser, Robert 330–33
Frederick's of Hollywood 302–3, *304*
Freeman, Betty 277

Freeman, Robert 225–27
Freud, Lucian 2, 6, 8, *13*, 37, 56, 158–59, 247–51, 266, 336
 and Bacon 22, 27, 30, 33, 86, 111, 112, 114–17, 212–13
 early years in London 11, 12–21
 exhibitions 78, 91, 217, 338
 financial problems 216–17
 friendship with Auerbach 259
 in Greece 69, 71–72
 John Berger and 153
 and Kitty Garman 72–76, 78, 115
 in the 1950s 114–24
 in the 1960s 216–24, 335
 nudes 221–24
 observation 76–77
 opposition to 'illustration' 120–21
 and Sandra Blow 88–89
 studios 219–21
 and Surrealism 77–78
 working methods 115, 117–20, 122–23
 Francis Bacon 115, *116*, 218
 Girl with Leaves 78
 Girl with Roses 74, *75*
 Girl with a White Dog 74
 Interior at Paddington 118–20, *119*
 John Deakin 217–19, *218*
 Naked Girl 221–24, *223*
 The Painter's Room 20
 Time magazine cover 122, 123–24
Freud, Sigmund 15, 77, 78
Frost, Terry 40–41, 93–94, 100, 103–4, *144*, 168
Fry, Roger 93, 322
Futurists 62, 164, 291, 292

Gainsborough, Thomas 231, 232
Gaitskell, Hugh 91
Gallery One 290–91, 295, 330
Gargoyle Club 114
Garman, Kitty 73–76, *75*, 78, 115
Gauguin, Paul 93, 108, 252, 315
Gear, William, *Autumn Landscape* 91, *92*, 98
Geldzahler, Henry 274, 288
General Motors *149*
George V, King 93
George, Patrick 259
Gertler, Mark 62
Giacometti, Alberto 39, 83, 153

Gibson Smith, Ian *13*
Gilbert & George 242, 337
Giotto 172, 236, 334
Godard, Jean-Luc 239
Goethe, J. W. von 20
Goldsmiths' College 16, 44,
 296–97
Gooding, Mel 168–69
Gordon, 'Lucky' 240–41
Gormley, Antony 337
Gowing, Lawrence 44,
 46, 76, 94–95
Goya, Francisco 34, 107,
 209, 325
Grant, Duncan 23
Greaves, Derrick 154–55,
 154, 157
Green, William 165–66, *166*
Greenberg, Clement
 141–42, 274, 298,
 300–1, 322
Greenwood, Michael
 171, 173
Grierson, John 44
Group 2 150–52
Group 6 152
Gruen, John 108
Guggenheim, Peggy 161
Guston, Philip 88

Haley, Bill 231
Hall, Eric 28, 86, 115, 212
Hals, Frans 221
Hambidge, Jay 311
Hamilton, Richard 97,
 104–6, 137–39, 145–50,
 225, 227, 277, 311, 330
Hers is a Lush Situation 147
Hommage à Chrysler Corp.
 147–49, *148*
*Just what is it that makes
 today's homes so different, so
 appealing?* 151, 152
Swingeing London 67
 332–33, *332*
Hancock, Tony 165–66, *167*
Hanover Gallery 79, 83, 177
hard-edge painting 182–84,
 192, 230, 273, 278
Harrison, Martin 81, 178, 208
Hart, George Overbury
 'Pop' 145
Hatton Gallery, Newcastle
 106
Haworth, Jann 330
Hayes, Colin 197
Hayward Gallery 338
Hazlitt, William 52
Heath, Adrian 93–94,
 100, 103
Hegel, G. W. F. 210
Henderson, Nigel 137,
 152, 155

Hepworth, Barbara 18
Heraclitus of Ephesus 264
Herbert, Albert 113–14
Hergé 329
Heron, Delia 168
Heron, Patrick 8–9, 158,
 160, 163, 168, 170, 176–78,
 187, 311
*Black Painting – Red,
 Brown and Olive: July 1959*
 175–76, 179–80
*Horizontal Stripe Painting:
 November 1957–January
 1958* 180
Hill, Anthony 94, 98, 103
Hilton, Roger 9, 18, 100–4,
 168, 176–78, 180–81,
 202, 300
*August 1953 (Red, Ochre,
 Black and White)* 102, 104
February 1954 104
Himmler, Heinrich 81,
 208, 209
Hitchens, Ivon 91
Hitler, Adolf 208, 209
Hockney, David 8, 9, 17, 23,
 203, 271, 335, 336
on Abstract Expressionism
 163–64
appearance 269–70
at the Royal College 195,
 199–205, 270–71
double portraits 288–89
exhibitions 274, 289
on Freud 222
on Hollywood films 138
on Kitaj 201
in the 1960s 219, 267–89
paintings of tea packets
 235–36
and photography 284,
 285–88
problems of depiction 43
and Renaissance art 285
swimming pool pictures
 278–79
theatre designs 275
in the US 229, 266, 269,
 274–75, 277–85, 338
on ways of seeing 59, 63, 67
words in paintings 202
Beverly Hills Housewife 277
*Christopher Isherwood and
 Don Bachardy* 286–87
Doll Boy 203
*Early Morning, Sainte-
 Maxim* 285–88
*Flight into Italy – Swiss
 Landscape* 273
Mr and Mrs Clark and Percy
 199, 288–89
Play within a Play 272,
 273–74

*Portrait Surrounded by
 Artistic Devices* 275–76,
 276
The Room, Tarzana 282,
 284–85
Sunbather 278–79, *281*
*Tea Painting in an
 Illusionistic Style* 236, *237*
The Third Love Painting
 203
*We Two Boys Together
 Clinging* 203, *203*
Hodgkin, Howard 10, 31,
 189–92, *190*, 222, 277, 311,
 313–18, 338
Memoirs 188, 189–90
Mr and Mrs E.J.P. 316
Mr and Mrs Robyn Denny
 190–91, *191*
R.B.K. 317, *318*
Small Japanese Screen
 313–16, *314*
The Tilsons 318
Widcombe Crescent 318
Hodgkins, Frances 260
Hofmann, Hans 100
Hogarth, William 289
Hollywood 137–38,
 142, 143
Horace 320
Horizon 14, 19, 50, 69
Hornsey College of Art 164
Horton, Percy 200
House, Gordon 185, 192
Hoyland, John 268, 298–99,
 328, 329
7.11.66 299, *299*
Hughes, Robert 35, 115,
 262–63, 313
Hume, Gary 334
Hunter, Sam 26, 80, 81

Impressionism 46,
 125, 292
Independent Group 139–42,
 143, 145, 150, 155
Ingres, J.-A.-D. 44, 200
Institute of Contemporary
 Arts (ICA) 97, 104–6,
 138–42, 146, 149, 160, 169,
 180–82, 225–28, 230, 277
Isherwood, Christopher
 286–87, 288

Jagger, Mick 144, 232,
 331–33
Jaray, Tess 193
Jarman, Derek 138
Jarry, Alfred 275
Jeffress, Arthur 39, 79
John, Augustus 15, 73,
 91, 146
John, Gwen 44

John Moores Painting Prize
 157, 175–76, 179, 180
Johnstone, William 40
Jones, Allen 9, 137, 164, 195,
 198–99, *198*, 200, 201, 204,
 205, 219, 225, 228–30, 274,
 301–5, 338
The Artist Thinks 195, *196*,
 198–99
Chair 304
First Step 302–3, *303*
Hat-Stand 304
Man Woman 198, 303
Table 304
Wet Seal 302, 303

Kafka, Franz 117
Kahneman, Daniel 82
Kandinsky, Wassily 93, 336
Kapoor, Anish 337
Kar, Ida 290, 308, *308*
Karp, Marilynn 306
Kasmin, John 88, 160, 175,
 205, 216, 233, 267–68, 270,
 273–74, 277–79, 289, 290,
 298, 330
Kasmin Gallery 243, 246,
 274, 278, 298, 311
Keeler, Christine 240–41
Kelly, Ellsworth 184, 229, 230
Kiff, Ken 164
King, Phillip 301
Kirkman, James 216–17
Kitaj, R. B. 9–10, 195,
 200–4, 225, 269, 313,
 318–23, *319*, 325, 334,
 335, 339
*The Murder of Rosa
 Luxemburg* 319
The Ohio Gang 319–20, *320*
Synchromy with F.B. 321,
 322, 323
Kitchen, Paddy 179, 312
Kitchen Sink School
 153–57, 235
Klee, Paul 93, 210
Klein, Yves 162
Kline, Franz 160, 162, 255
Knight, Laura 15, 91
Knights, Winifred 44
Kossoff, Leon 9, 61, 67,
 125–27, 128–33, *129*, 136,
 144, 189–90, 246–48, 250,
 259, 260, 263–66, 338
Children's Swimming Pool
 265–66, *265*
Head of Seedo 131–33, *132*
Kozloff, Max 230, 302

Labour Party 297–98
Lacy, Peter 86, 109–12, *109*,
 176–77, 211, 212
Lamothe, Louis 200

Lanyon, Peter 9, 168, 176
le Brocquy, Louis 177
Lefevre Gallery 22–23, 27, 31, 33
Léger, Fernand 43
Lehmann, John 19, 71
Leicester Galleries 14
Leigh Fermor, Patrick 69
Leonardo da Vinci 173
Lessore, Helen 125, 154, 154, 246–48, 252–53
Symposium I 247–48, 247
Lessore, John 130–31, 247, 252–53
Lewis, Wyndham 62, 82, 95
Lichtenstein, Roy 230
Lightfoot, Jessie 28, 86
Lissitsky, El 94
London Gallery 77, 78
Long, Richard 337
Lopez, Antonio 307
Los Angeles 274–75, 277–82, 338
Louis, Morris 273
Luxemburg, Rosa 319
Lyttelton, Humphrey 40, 41, 142

MacBryde, Robert 17, 18, 19
McCartney, Paul 330
McHale, John 145, 150, 152
Maclean, Donald 58
McLuhan, Marshall 146, 227, 233
Macmillan, Harold 194
MacNeice, Louis 71
Macy's department store 283–84, 283
Magritte, René 77, 329
Malevich, Kasimir 93, 94
Mann, Felix 122
Manchester City Art Gallery 91
Manet, Edouard 55, 319
Mann, Thomas 14
Manvell, Roger 85
Marlborough Fine Art 123, 177, 192, 206–7, 216–17, 225, 267–68, 320, 322
Martha Jackson Gallery, New York 305
Martin, Anne 159
Martin, Kenneth 98, 103
Martin, Mary 103
Marx, Karl 94
Matisse, Henri 43, 65, 93, 108, 224, 275, 301, 322, 335
Matsumoto, Hiroko 243
Medley, Robert 91
Megaw, Dr Helen 98
Melly, George 77, 78, 142
Melville, Robert 207

Mesens, E. L. T. 77, 78, 141
'Metavisual Tachiste Abstract' (1957) 168–71
Metzger, Gustav 260
Michelangelo 35, 64, 101, 165
Middleditch, Edward 154–55, 154
Pigeons in Trafalgar Square 155
Mies van der Rohe, Ludwig 277, 298
Miles, Barry 169
Miller, Jonathan 296
Ministry of Education 40, 270
Minton, John 19, 20, 41, 71, 79, 113, 142, 158–59, 165–66, 168, 197, 250
Jam Session 41, 42
Miró, Joan 39, 205, 207
Mondrian, Piet 89, 93, 101, 106, 141, 146, 171, 210, 227–28, 258, 263, 329
Monet, Claude 55, 125, 197, 229
Monitor (BBC) 233, 235
Monroe, Marilyn 150, 238–39, 240
Moore, Henry 23, 73, 141, 300
Moorhouse, Paul 316
Moraes, Henrietta 212–16, 214–15, 251–52
Morley, Lewis 239, 240
Morley, Malcolm 195–97
Morphet, Richard 225, 227, 230, 246, 298, 317, 318, 332
Moynihan, Rodrigo 45, 104, 106
Portrait Group 197–98, 197
Mulligan, Gerry 232
Mundy, Henry 40, 53, 54, 100, 188, 192
murals 171–74, 184–85
Murphy, Myles 247
Musée des Beaux-Arts, Liège 168
Museum of Modern Art (MoMA), New York 39, 78–79, 160, 269, 305–7
Musgrave, Victor 290–91, 330

Nadar 81
Namuth, Hans 167
Nan Kivell, Rex 168, 169–70
Nash, Paul 44
National Gallery 11, 129, 131
Nazis 50, 81, 209, 212

Neo-Romantics 19, 23, 35, 43, 56
Neumann, John von 146
New York 35–36, 45, 159–60, 162–63, 227–29, 269, 274, 305–7
Newman, Barnett 35, 185, 199, 229
Newton, Eric 182, 211
Nicholson, Ben 18, 23, 93, 95–97, 141, 168, 178
Nietzsche, F. W. 37, 210
Nine Abstract Artists 103–4
Noland, Kenneth 233, 243, 273, 298, 301, 311

Oldenburg, Claes 145, 330
Op art 150, 305–8, 311
Origo, Iris 127
Orpen, William 15
Oster, Gisela 305–6

Packard, Vance 233–35
Palmer, Samuel 19–20, 46
Paolozzi, Eduardo 97, 137, 139, 147, 152, 155
Dr Pepper 140
Paris 10, 15, 43, 45, 51, 89
Pasmore, Victor 8, 18, 37, 42–43, 45–46, 49–52, 56–59, 88, 94–98, 103–6, 168, 299–300, 335
The Coast of the Inland Sea 97
The Gardens of Hammersmith No. 2 58, 58
The Quiet River: The Thames at Chiswick 52, 53
restaurant mural 95, 96
Pathé films 166, 170
Pavlova, Anna 87
Penrose, Roland 141, 205
Peppiatt, Michael 219
Perlin, Bernard 144
Peterlee, County Durham 299–300
Phillips, Peter 195, 202, 204, 233, 268
Photo Realism 285
photography 45, 74, 81–82, 120–22, 210, 212–16, 284–88, 334–36
Picard, Lil 305
Picasso, Pablo 21, 22, 30, 43, 51, 125, 141, 185, 266, 322, 335
influence of 16, 23–25, 36, 69, 78, 108, 161, 171, 211, 224
Guernica 20
Pick, Hella 306
Piero della Francesca 146, 248, 258, 285

Pinsent, Christopher 46–48
Piper, John 93
Piranesi, Giovanni Battista 64, 165, 274–75
'Place' exhibition (1959) 180–82, 227
Pointillism 56, 292
Pollock, Jackson 141, 153, 160–65, 167–68, 171–74, 178, 199, 202, 210, 291, 335
Pop art 138, 144–52, 155, 199, 229, 233–45, 246, 333
'Pop Goes the Easel' (BBC) 233, 235, 236
Pope-Hennessy, James 114
Poussin, Nicolas 24, 25, 162, 187
Powell, Anthony 117
Power, E. J. 'Ted' 205, 316
Presley, Elvis 143, 232
Price, Cedric 230
Procktor, Patrick 204, 275
Profumo, John 240–41, 248
Purcell, Henry 89

Quant, Mary 232, 301–2

Rabin, Sam 44, 296
Raphael 44, 71
Rauschenberg, Robert 194
Rawsthorne, Isabel 212–13
Ray, Johnnie 232
RBA Galleries 204
Read, Herbert 36, 38, 141, 145, 182
The Rebel (film) 165–66, 167
Redfern Gallery 95, 168, 169, 170
Redgrave, William 177–78
Rees-Mogg, William 333
Regatta Restaurant 95, 96, 97–98
Rego, Paula 10, 96, 313, 323–25, 335
Stray Dogs (The Dogs of Barcelona) 324, 325
Reinhardt, Ad 297
Rembrandt 31, 34, 112, 129, 131, 165, 209, 248
Renaissance art 44, 88, 206, 236, 246, 275, 285, 335
Renoir, Pierre Auguste 125
Richards, Keith 331–32
Richardson, John 30, 38, 111
Riley, Bridget 10, 40, 44, 98, 210, 290–98, 305–8, 308, 311, 330, 335, 337, 338
Continuum 308
Crest 294, 295–96
Fall 296
Kiss 293–95, 293

Movement in Squares 295
The Nude 297
Pink Landscape 292, 295
Rivers, Larry 233
Roberts, William 62
Robertson, Bryan 153, 264–65, 268
Rodchenko, Alexander 94
Rodin, Auguste 82
Rogers, Claude 49, 50–51, 91
Rolling Stones 330, 331
Rosenberg, Harold 166–67
Rosenthal, Norman 285
Ross, Alan 71, 79
Rothenstein, John 206–7, 211, 212
Rothermere, Lady 73
Rothko, Mark 35, 160, 162, 164, 178, 185, 199, 299, 311, 335
Royal Academy Schools 146
Royal College of Art 9, 86, 312
 attitudes to abstraction 198–99
 Auerbach at 128, 133
 Bacon at 30, 113–14
 Bowling expelled from 179
 Hockney at 270–71
 in the 1960s 194–205
 Peter Blake at 144
 'Sketch Club' 113, 158–59
 'Young Contemporaries' exhibitions 154, 204–5, 267
Royal Society of British Artists 186
Rumney, Ralph 169, 170, 180–82
The Change 171
Ruscha, Ed 86, 279
Russell, John 14, 23, 38, 145–46, 219, 232, 264–65
Russell, Ken 233

St Ives 8–9, 96, 176–78
St Martin's School of Art 128, 130, 301, 338
Sargent, John Singer 65
Sartre, Jean-Paul 83
Schapiro, Meyer 163
Schlesinger, Peter 282–84, 288
'School of London' 248, 250, 260, 339
Schwitters, Kurt 139
Scott, Ridley 199
Scott, Tim 301
Scott, William 103–4, 162–63, 175–76
Still Life with Frying Pan 105

sculpture 9, 103, 182, 300–1, 304–5, 337
Second World War 11–12, 17–19, 127, 194
Seedo, N. M. 131–33, *132*
Self, Colin 275
Seurat, Georges 291–92
Shahn, Ben 144
Shakespeare, William 89, 97
Sharrer, Honoré 144
Sherman, Cindy 242
Sickert, Walter 15, 21, 35, 65, 76, 143, 154, 162, 209, 260
'Situation' exhibitions 186–87, 192, 210, 227, 229, 238, 243, 246, 299
Situationist International 169
'60 Paintings for '51' (1951) 91, 120, 197–98
Slade School of Fine Art 44, 50, 96, 137, 147, 204, 253–56, 335
Sleigh, Sylvia, *The Situation Group* 192–93, *193*
Smee, Sebastian 114
Smith, Jack 154–55, *154*
Smith, Matthew 15, 31, 178
Smith, Richard 9, 144, 159, 180–82, 210, 219, 225–32, 279, 291, 300, 339
Flip-Top 226, 227
Panatella 227
Smithson, Alison and Peter 145, 152, 155
Snowdon, Lord 220, 265, 271–73, *271*
Soby, James Thrall 207–8
Socialist Realism 51, 55, 153
South Hampstead High School for Girls 171–74, *172–73*
Spalding, Frances 54–55
Spear, Ruskin 195, 197–98, 205
Spencer, Stanley 44, 78, 289
Spender, Humphrey *48*
Spender, Stephen 11, 19
Stella, Frank 184, 273, 278
Stephen, John 184
Stevenson, Adlai 232
Stewart, Angus 177
Still, Clyfford 160
Sunday Times 232, 271–73, 279
Surrealism 16, 43, 63, 69, 77–78, 87, 108, 112, 139, 144, 161, 164, 169, 323

Sutherland, Graham 11, 20, 22, 23, 30, 37–38, 43, 121–22, 168
Portrait of Winston Churchill 121–22, *121*
Sutherland, Kathleen 28
Swinging London 232, 243, 329–31
Sylvester, David 28, 34, 36, 83, 85, 108, 134–36, 153, 155–57, 207, 209, 213, 271–73, 321
Symbolists 108

Tachisme 45, 89, 160, 170
Tapié, Michel 89
Tate Gallery 93, 144, 155, 159–60, 163, 175, 180, 206–7, 211–12, 225, 337, 339
'This is Tomorrow' (1956) 150–52, 155
Thomas, Dylan 17
Thompson, D'Arcy Wentworth 97, 98
Thubron, Harry 291, 292
Tibble, Geoffrey 45
Tilson, Joe 318
Time magazine 122–24, 137, 305–6, 329–30
The Time Tunnel (TV series) 307–8, *309*
The Times 37, 91, 163, 333
Tiepolo, Giovanni Battista 315–16
Titian 165, 221, 222
Todd, Daphne 255–58
Tonks, Henry 44–45, 335
Tooth, Arthur & Sons 205
Townsend, William 42–43, 52, 78, 96
Trailer (film) 225–27, 230
Transition Gallery 37
Tunnard, John 97
Turnbull, William 137, 182–83, 185, 186
 No. 1 1959 183, 184
 15 – 1959 (Red Saturation) 182–84, *183*
Turner, J. M. W. 31, 46, 52, 55, 96, 187, 189, 229
Twine, John 331, 332–33

Uglow, Euan 247, 248, 255–59, 285, 288–89, 338
Nude, 12 vertical positions from the eye 255–58, *257*
Uhlman, Diana 100
United States of America 160–68, 227–35, 274–85, 305–8, 338
Ustinov, Peter 127–28

Valéry, Paul 209
Van Dyck, Anthony 120
Van Gogh, Vincent 53, 76, 93, 136, 155, 177, 182, 197, 255, 335
Vasarely, Victor 311
Vaughan, Keith 19
Velázquez, Diego de 31, 81, 82, 83, 85–86, 112, 113, 120, 248
Venice Biennale 120, 157, 182, 338–39
Virtue, John 248
Voelcker, John 150
Vuillard, Edouard 22, 30

Waddington, Leslie 328
Walker Art Gallery, Liverpool 120
Ward, Michael 239, *241*
Ward, Rowland 12
Ward, Stephen 240
Warhol, Andy 229, 238, 239, 245, 274, 330
Watson, Peter 12, 14, 16, 19, 141
Watteau, Jean-Antoine 232
Weight, Carel 195, 197–98, 204
Wells, H. G. 139
West, Estella Olive (Stella) 128, 133–34, *135*, 259–60, *261*
Westwood, Sons & Partners 184
Wheeler's 248–50, *249*, 317, 322
Whistler, J. A. M. 46, 52, 269
Whitechapel Art Gallery 150–52, 153, 164, 268, 289, 291, 312
Wilde, Marty 138, 144, 157
Willing, Victor 323
Wilson, Harold 297–98
Wilson, Jane 306
Wind, Edgar 200
Wishart, Lorna 73
Wishart, Michael 27, 114–15
Witt, John 206
Wonnacott, John 107, 164, 204–5, 210–11, 250, 254–55
Wyndham, Francis 249–50

'Young Contemporaries' exhibitions 154, 204–5, 267